RUBENS AND REMBRANDT
IN THEIR CENTURY

IN MEMORIAM

FRITS LUGT JACOBA LUGT-KLEVER

1884 – 1970 1888 – 1969

Rubens and Rembrandt in Their Century

Flemish & Dutch Drawings of the 17th Century

from The Pierpont Morgan Library

FELICE STAMPFLE

The Pierpont Morgan Library

Oxford University Press

NEW YORK · OXFORD · TORONTO

1979

PARTICIPATING INSTITUTIONS

INSTITUT NÉERLANDAIS · PARIS
5 April to 10 June 1979

KONINKLIJK MUSEUM VOOR SCHONE KUNSTEN · ANTWERP
22 June to 9 September 1979

THE BRITISH MUSEUM · LONDON
27 September 1979 to 13 January 1980

THE PIERPONT MORGAN LIBRARY · NEW YORK
3 April to 31 July 1980

LIBRARY OF CONGRESS CATALOGING IN PUBLICATION DATA
Pierpont Morgan Library, New York.
Rubens and Rembrandt in their century.
"In memoriam: Frits Lugt, 1884–1970; Jacoba Lugt-Klever, 1888–1969."
"Participating institutions, Institut néerlandais, Paris, [and others]"
Bibliography: p. 24–28. Includes index.
1. Drawing, Flemish—Exhibitions. 2. Drawing—17th century—Belgium
—Flanders—Exhibitions. 3. Drawing, Dutch—Exhibitions. 4. Drawing
—17th century—Netherlands—Exhibitions. 5. Rubens, Peter Paul, Sir,
1577–1640—Exhibitions. 6. Rembrandt, Harmenszoon van Rijn, 1606–
1669—Exhibitions. I. Stampfle, Felice. II. Lugt, Frits, 1884–1970. III.
Lugt-Klever, Jacoba, 1888–1969. IV. Institut néerlandais, Paris. V.
Title.
NC258.P53 1979 741.9'492'07401471 79–9113
ISBN 502–6446

This catalogue and exhibition have been made possible
in part by a grant from the National Endowment for the Arts,
a Federal Agency of the United States Government.

Cover Illustration: Cat. No. 68. Rembrandt van Rijn, *Woman Carrying a Child Downstairs*

TABLE OF CONTENTS

FOREWORD

THIS volume contains one hundred thirty Flemish and Dutch drawings of the golden century of Rubens and Rembrandt from the collection of The Pierpont Morgan Library. Our aim has been to show significant and representative works of the artists of that time, many of them forerunners, pupils, or followers of the two great masters. This is the first survey from the Morgan Library of any of the European schools of draughtsmanship represented in its collection, with essays, full provenances, and bibliographical references for each of the drawings. It is published on the occasion of a series of exhibitions of these drawings in Paris, Antwerp, London, and New York. It marks the first time that the Morgan Library has shown such an extensive exhibition of its drawings abroad—or for that matter in the United States.

The book is the result of a long-planned exchange of exhibitions and publications between the Institut Néerlandais in Paris and the Morgan Library, two institutions which have so much in common in their collections and their public programs. For a number of years there had also been discussions between the Directors of The British Museum and the Morgan Library about the possibility of an exchange of exhibitions between their institutions. Consequently the drawings described and illustrated in this volume will be shown as well in London, and we are deeply grateful to the Trustees of The British Museum for sending a group of their finest drawings by Michelangelo for an exhibition at the Morgan Library from 24 April to 28 July 1979. The Institut lent us a splendid exhibition, *Rembrandt and His Century: Dutch Drawings of the Seventeenth Century*, which was held at the Morgan Library from 8 December 1977 to 19 February 1978.

Frits Lugt and his wife, who created the Fondation Custodia to maintain the collections they had formed, and the Institut Néerlandais, the perfect

center for research and enjoyment of them, had a long and close association with the Morgan Library. During the war years from 1941 to 1945, the Lugts were in the United States, mostly at Oberlin College and its museum (which, incidentally, during those years looked after the great collection of Rembrandt etchings from the Morgan Library). It was at this time that the Lugts determined to have a permanent home for their collections and the kind of active institute for study and pleasure they had come to know in America. The Morgan Library was an important source of this kind of inspiration for Mr. and Mrs. Lugt. He and his wife last visited the Morgan Library in 1960 on a trip around the world to celebrate their fiftieth wedding anniversary. From May 1965 to the time of his death in 1970, at the age of eighty-six, he was one of the twenty Honorary Fellows of the Library.

Frits Lugt is honored throughout the world as a collector and as a student of the history of collectors and collections. He wrote two indispensable guides for art historical studies, the dictionary of collectors' marks on prints and drawings (*Marques de collections*, 1921 and 1956) and that of sales catalogues (*Répertoire des catalogues de ventes 1600–1900*, 1938–64), and his studies of drawings are equally distinguished. He prepared, among others, a series of catalogues of the Dutch and Flemish drawings in the major public collections in Paris, notably the special catalogues of Rembrandt drawings and early Netherlandish drawings in the Louvre. For all of these reasons, it is most fitting that we dedicate this volume to him and to his wife.

Frits Lugt's standards of scholarship have been maintained superbly at the Institut by the Director of the Fondation Custodia, Carlos van Hasselt, who has been in every way concerned in planning this volume and the exchange exhibitions. He has worked with Miss Felice Stampfle, Curator of Drawings and Prints in the Morgan Library, and we are indebted to them both, above all, for the success of the exhibitions and publications. We are also most grateful to Mr. and Mrs. Eugene V. Thaw, benefactors of the Morgan Library, for permitting us to show not only the gifts which they have already made to the Library, but some of those promised to us. We are also thankful to Miss M. van Berge, Curator of the Fondation Custodia; to Dr. David M. Wilson, Director of The British Museum, Mr. John Gere, Keeper of Prints and Drawings there, and Mr. Reginald Williams; to Dr. Gilberte Gepts, Director of the Koninklijk Museum voor Schone Kunsten, Antwerp, Mr. Marc Vandenven, Assistant, and Mme Diana Verstraeten, Secretary to the Ministerie van Nederlandsche Cultuur. At the Morgan Library, Miss Stampfle was ably assisted

10

by Mrs. Helen B. Mules, Miss Mary Laura Gibbs, and Miss Jane V. Shoaf. Mr. A. J. Yow, Mrs. Patricia Reyes, and Mr. Timothy Herstein prepared the drawings for travel and exhibition. Mr. David W. Wright, Registrar, has helped us in scheduling the exhibitions at the Institut Néerlandais, Paris; the Koninklijk Museum voor Schone Kunsten, Antwerp; The British Museum, London; and at The Pierpont Morgan Library where the drawings will be shown in 1980 following their return from Europe. The photographs for the illustrations were taken by Mr. Charles V. Passela, of our staff, assisted by Mr. Marc M. Teatum. Mr. Francis Mason, Assistant Director of the Library, has helped in many ways with this publication and with the exhibitions. Our friends at The Stinehour Press and The Meriden Gravure Company have printed a volume which is worthy of the great draughtsmen of Holland and Belgium. This publication and the exhibition have been made possible, in part, by a grant from the National Endowment for the Arts, a federal agency.

CHARLES RYSKAMP
Director

INTRODUCTION

THE Netherlandish drawings in the Morgan Library now total about four hundred fifty sheets, of which some three hundred fifty are Dutch and the remainder Flemish. These holdings in terms of those of the great European cabinets are small, but among American institutions where the Netherlandish schools have not been collected systematically—with the possible exception of their greatest representative, namely Rembrandt—the collection is probably the largest in numbers and certainly the peer of any other in quality. It is, as a distinguished European scholar and connoisseur once characterized it, a classic collection within its limits.

The core of the Morgan Library's collection of drawings of all European schools is the collection formed by Charles Fairfax Murray (1849–1919), the British artist and *marchand-amateur*; it was purchased *en bloc* by J. Pierpont Morgan in 1910 with the exception of slightly more than a hundred sheets. The Netherlandish drawings acquired at this time numbered approximately three hundred and the collection was not expanded until the 1950's when, under the directorship of Mr. Frederick B. Adams, a regular program of acquisition began, in a large part made possible by the generosity of the Library's Association of Fellows. It might be noted that the drawings sold after Fairfax Murray's death, at Christie's in London on 30 January 1920, were for the most part very probably those which he as an inveterate collector brought together in the years following the 1910 sale to Pierpont Morgan.

Fairfax Murray noted in the introduction to the third and fourth volumes of his catalogue which appeared in 1912, two years after Mr. Morgan's acquisition of the collection, that he began his collection of drawings in Italy "thirty-five years ago," that is, in 1877 or thereabouts, but that "the greater part of the drawings were purchased in England during the last thirty years, notably

from the Palmerston, Aylesford, Holford, Robinson, and Knowles Cabinets, and other sources too numerous to mention." From about 1869 until 1883, when he was associated with John Ruskin as a copyist and architectural draughtsman, Fairfax Murray was chiefly resident in Italy, but it is unlikely that he acquired many, if any, Dutch or Flemish drawings from Italian sources. In the later 1880's and in the 1890's, however, he was active on the auction scene in London, when the collections he mentioned were being dispersed. Many of the drawings included in the present exhibition were acquired at this time. Seven drawings come from Lord Palmerston's collection; eight from the Earl of Aylesford; four from the sale of Robert Stayner Holford; and twelve from the various sales of Sir John Charles Robinson, better known as J. C. Robinson, the versatile director of the South Kensington Museum and Surveyor of the Queen's Pictures under Queen Victoria. As is clear from Fairfax Murray's notebooks, he was not always bidding exclusively for himself, but sometimes bought a lot of several drawings at the behest of a client who was interested in a single drawing and Fairfax Murray then retained the other drawings for himself. On more than one occasion he appears to have traded drawings and other works of art with Sir John Charles Robinson; it was in this manner that he acquired Rubens' great figure study for *Daniel in the Lions' Den* (No. 12). The prices which drawings commanded in that period are almost unbelievably minimal in the light of today's market. The *Young Man Holding a Skull and Tulip* (No. 39), Goltzius' great fantasy portrait, was one of a lot of four drawings that sold for £25 in 1909; in an annotated copy of the sale catalogue Agnew is shown as the buyer, recalling the fact that Fairfax Murray was associated with the London art firm over a period of many years. The late Frits Lugt who was also active in the London sale rooms in these years once remarked that Fairfax Murray, together with J. P. Heseltine, was perhaps his greatest rival.

The exhibition focuses on the two great masters who dominate the seventeenth century in the Southern and the Northern Netherlands. As far as possible the exhibition presents their forerunners and contemporaries, as well as their successors. In the main, however, the choice of drawings was governed by a wish to display the best and most significant examples of Flemish and Dutch draughtsmanship which the Morgan collection affords, beginning with artists born after 1550 and ending with those born about a hundred years later.

The Flemish section of the exhibition, though small in comparison with that

14

of the Dutch, is choice. It begins with a small group of landscape drawings by four artists who were among the early Northern travelers to Italy. The landscape by Lodewijk Toeput (No. 1), who remained in Italy and translated his name to Lodovico Pozzoserrato, presents a pretty vista of the North Italian coastline; the attractive sheet by Paul Bril (No. 2), hints of the Italian scene in its background of sea and mountains. The latter drawing has added interest in its connection with the print by Comte de Caylus in the series of his engravings after the drawings in the Cabinet du Roi, that is, of Louis XIV. Tobias Verhaeght (No. 3) and Jan Brueghel the Elder (No. 4) are artists closely associated with Rubens, the former as his early teacher, the latter as a friend and collaborator. David Vinckboons, represented by three diverse sheets (Nos. 7–9), could as well have figured in the Dutch section of the exhibition since he was one of the stream of Flemish artists who emigrated to Holland in this period though he always retained his Flemish character and style. By happy coincidence, three drawings in this section of the exhibition depict handsome country houses that can be identified by name although in only one instance is the artist's name known. Hendrik Hondius the Elder not only signed his delicately tinted rendering of the storied Château de Tervueren near Brussels (No. 6), but he also dated it, 1605. Unlike the historic Château, the beginnings of which dated back to the Middle Ages, "Het Blauw Hof" (the "Blue House") at Logenhage, built by the Spaniard Edouard Ximenes in 1597 (No. 5), was probably still new when an unknown draughtsman carefully recorded it in full detail, to the end that it may have been the basis for the illustration in Antonius Sanderus' great topographical work, the *Flandria Illustrata*, first published in the 1640's. The large and exceptionally fine watercolor of the country house "Het Keysers Hof" (No. 19), the name inscribed on the back of the sheet in an old Flemish hand once thought to be that of Rubens, is the subject of much speculation among art historians as to the identity of the artist who produced it and a number of related sheets of rural sites now scattered in various collections.

The nine vital drawings by Peter Paul Rubens—there are actually fourteen if one counts each of the small drawings of classical gems and coins— reveal different aspects of his genius as a draughtsman. There are several spontaneous pen sketches in which he developed compositional schemes for paintings. The compositional sketch for the portrait of the Marchesa Brigida Spinola Doria, the painting in the National Gallery, Washington, D.C. (No. 10), is a rarity from Rubens' Genoese period, and the sheet with the intricate

web of studies in which the artist explored solutions for a painted representation of a Descent from the Cross (No. 14) is a fascinating example of its kind that brings the spectator into immediate contact with the complexity of the creative process. At the opposite pole is *The Adoration of the Magi*, the explicit, finished drawing for an illustration in an edition of the *Roman Missal* published by the Plantin Press in Antwerp (No. 11), a drawing of the kind which Rubens executed as a pleasant Sunday pastime. The dynamic pair of triumphant angels (Nos. 15, 16) are also directly connected with the city of Antwerp, being studies for façade sculptures of the new Jesuit church of St. Charles Borromeo; so, too, the sketch of the dignified Jesuit priest in the dress of a Chinese scholar (No. 18) was also perhaps connected in some way, at least tangentially, with Rubens' program of decoration for the interior of the church. The study for the figure of Daniel (No. 12) in the painting *Daniel in the Lions' Den* in the National Gallery, Washington, D.C., is a superb example of Rubens' chalk drawings where his draughtsmanship finds its most beautiful expression; accompanying it is the recently acquired study of a lion for the same picture (No. 13). The small sketches of classical gems and coins (No. 17), probably those in his own collection, witness his antiquarian interests. The two eminent painters who followed Rubens' lead, but were never strictly speaking his pupils, are substantially represented in the exhibition: Jordaens by a sequence of five drawings (Nos. 22–26), among them a major large-scale portrait (No. 22); and Van Dyck by six sheets, including a sensitive study from the model which he used for his painting of the *Lamentation* executed for the Abbot Scaglia (No. 33), and his delightful view of the English "hill town" of Rye penned as he waited for transport across the Channel (No. 32). There is token representation for various of the satellite figures around Rubens, many of them like Jan Brueghel (No. 4), Jan Wildens (No. 21), and Frans Snijders (No. 20) his friends as well as collaborators in the area of their specialties. Only Snijders, however, is shown in terms of his specialty of animals and still life. Jan Wildens, whose name has been proposed as the creator of the "Het Keysers Hof" watercolor, is unquestionably the author of the *Harvest Scene* (No. 21) that was engraved to illustrate August in a series of The Months published in 1614.

The large Dutch section of the exhibition, a total of ninety-four sheets, opens with four exceptionally fine drawings by the Haarlem Mannerist Hendrick Goltzius. *The Judgment of Midas*, a large study strikingly worked up in color and then translated into an equally sizable engraving, was executed just before the artist's trip to Italy late in 1590 (No. 36); the rhythmic pen drawing of a

16

mountainous coastal landscape reflects the Lowlander's impressions of the Alpine country he encountered on his journey to and from the South (No. 37); and in the fantasy portrait of a young man, the *memento mori* of 1614 (No. 39) executed only two years before the artist's death, Goltzius' virtuosity in the manipulation of the pen is seen at its peak. The *Sense of Touch* (No. 38), which came to light relatively recently in a private American collection, is clearly to be paired with the *Sense of Sight* in the Fitzwilliam Museum, Cambridge, but the remaining drawings for what must have been a sequence of the Five Senses have yet to be discovered. As diverse in style and technique as the drawings by Goltzius are the four sheets by Bloemaert, a Utrecht artist who was of the same generation as the Haarlem master. In the *Holy Family*, he is working in preparation for a chiaroscuro print (No. 40); in the monochrome *St. Roch* (No. 41), an independent work of art, he employs an unusual rosy tempera for which one art historian jokingly but not inappropriately suggested the term "rosaille." Where Bloemaert's *Landscape with Farm Buildings* (No. 42) is decorative and Mannerist in vein, the *Clump of Trees* (No. 43) is more directly related to nature though the choice of trees with a tangle of exposed roots is dictated by Mannerist taste. Among the three drawings by Jacques de Gheyn II is the extraordinary *Mountain Landscape* (No. 44), which affords an interesting comparison with the landscape by his master Goltzius (No. 37). The fantasy of the *Garden Grotto* with its multiple images (No. 45) stands in strongest contrast to the sober sheet of the *Soldier* (No. 46), one of De Gheyn's designs for the 117 illustrations of a Dutch military manual that was translated into four languages. It is the chimerical illusionism of his father's *Garden Grotto* that inspired the grotesque heads by Jacques de Gheyn III (No. 60).

It is, however, to the landscape of Holland and their immediate environment that Dutch artists turned increasingly for inspiration as the seventeenth century proceeded. Among the earlier generation of landscapists represented in the exhibition are Claes Jansz. Visscher of Amsterdam who recorded and annotated the skyline of the port of Enkhuizen (No. 47); Esaias van de Velde (No. 50); Willem Buytewech whose *Peasant Woman of De Zijpe* (No. 53) combines landscape and genre; Pieter Molijn whose pastoral night scene (No. 54) is a subject less usual than the winter landscape (No. 55); and the prolific Jan van Goyen whose restless wanderings are signaled in the lively notations of scenes in the vicinity of three different towns (Nos. 57–59). Representative of a somewhat later generation are two landscapists of the first rank, Aelbert Cuyp whose *Watermill* (No. 104) displays his distinctive use of black chalk in com-

bination with yellow wash, and Jacob van Ruisdael whose *Sun-Dappled Trees* is a signed early work of quiet beauty (No. 117).

It is to be expected that Holland's greatest artist should have the largest representation in the Dutch section of the exhibition. The thirteen drawings by Rembrandt himself and the sixteen by pupils and other artists within the orbit of his influence constitute only slightly less than a third of the Dutch drawings. The drawings by the master himself are concentrated in the decades of the 1630's and 1650's with a single sheet from the opening years of the 1660's (No. 78). (The Library's drawing *The Blind Tobit and Anna with the Goat*, a drawing Benesch assigned to the late 1640's [Benesch, 1973, III, no. 584, fig. 755] was omitted from the exhibition as it has not found universal acceptance.) The drawings of the 1630's show Rembrandt in his role as observer of the intimate life of women and children (Nos. 67–69), of the theatre (No. 70), and of local pageantry (No. 71). The lovely study of a young mother carrying her child down a steep flight of stairs (No. 68) and the trenchant observation of the artist's sleeping wife (No. 69) are among the finest of their kind. The three religious compositions (Nos. 72, 73, 77) belong to the period of the artist's maturity, the rich decade of the 1650's, from which the sole landscape in the Library's collection also comes (No. 74). The two representations of scenes from the Passion (Nos. 72, 73), a preoccupation of the artist in these years, are particularly moving in the depth of feeling they convey. The two colorful drawings of Indian princes and soldiers (Nos. 75, 76) come from the celebrated series after the group of Indian miniatures of the Mughal School, which Rembrandt himself is presumed to have owned and possibly was compelled to dispose of at the time of his bankruptcy in 1656. The small but powerful *Old Scholar* (No. 78) is typical of the last period of the artist's activity when he drew very little, but always forcefully and frequently with the reed pen.

Of the comprehensive list of more than fifty Rembrandt pupils and followers who are known by name, seven are represented in the exhibition, at least as plausible if not always firm attributions. There is no problem of attribution in connection with the three drawings by Jan Lievens the Elder whose strong male portrait (No. 81) is signed and whose authorship of the two landscapes on Japanese paper (Nos. 82, 83) can hardly be questioned. Lievens, Rembrandt's friend and senior by one year, was never in Rembrandt's studio but Philips Koninck is reported by Houbraken to have been a pupil, presumably in the master's middle period. Koninck's authorship of the *Visitation* (No. 96) and the *Fiddler and Masquerader* (No. 97) is unquestioned, but

18

this is not true of the interesting drawing of the historic Buitenhof at The Hague (No. 98) as it appeared on 7 March 1660. Gerbrand van den Eeckhout, who is reported to have entered Rembrandt's studio in Amsterdam at age fourteen and remained there for five years between 1635 and 1640, was one of the artist's most talented pupils; *The Adoration of the Magi* (No. 106), a study for the painting of 1665 in Moscow, bears witness to his ability as well as his debt to his teacher. Lambert Doomer was probably in Rembrandt's studio around 1640 when the master painted the portraits of his parents; his two drawings are notable souvenirs of his trip along the Rhine in Germany (Nos. 112, 113). Samuel van Hoogstraten was also in Rembrandt's atelier in the early 1640's and *Christ Sinking beneath the Cross* (No. 114) reveals his debt to Rembrandt in its form if not its spirit. Van Hoogstraten has in recent years been credited with the authorship of the two drawings of camels (Nos. 115, 116), which in their time Fairfax Murray and Frits Lugt assigned to Rembrandt. The two drawings of seated women, each of genuine merit, are both tentatively attributed; the quick sketch of the sleeping maidservant (No. 121) is assigned to the well-known genre painter Nicolaes Maes who was a pupil of the mature Rembrandt; the familiar Rembrandtesque subject of the old woman reading the Bible (No. 122), is ascribed to the little-known Abraham van Dyck, a specialist in genre pictures of old men and women. Equally, or perhaps even more, speculative is the assignment of the unusual "cityscape" of rooftops (No. 128) to Johannes Leupenius, a surveyor and landscapist to whom such a subject perhaps would have been congenial. Each of the Rembrandt School drawings for which no attribution has been proposed has more than routine interest: the one (No. 79) as a copy after a sixteenth-century Italian drawing at Chatsworth; the other (No. 80) as an example of a pupil's timid drawing boldly corrected by the master's pen.

Another sizable group of drawings in the exhibition are those of some of the numerous Dutch artists who traveled to Italy during the course of the seventeenth century. Among the earliest of these were Bartholomeus Breenbergh and Herman van Swanevelt. Both were members of the Schildersbent, that is, the band or club of painters founded in 1623 by the Netherlandish artists in Rome who called themselves *Bentvueghels*, each of them receiving a *Bent* name—not always flattering—in a mock baptism with wine. Breenbergh, *Het Fret* (the Ferret), in his *Temple of the Sibyl* (No. 62) pays tribute to a famous classical monument and the brilliant Italian light that dazzled all the Northern artists. The two drawings by the Hermit of the *Bent*, Van Swanevelt (Nos. 63,

64), reveal as well the influence of Claude Lorrain to whose work he was exposed in Rome where he is said to have lived in the same house as the Frenchman. Asselijn, Wijck, Berchem, Dujardin, and Romeijn belong to the second generation of Dutch landscapists who spent varying periods of time in Italy. The drawings by Asselijn and Wijck (Nos. 94, 95) depict aspects of the actual Italian scene, but those by Dujardin and Romeijn use Italian motives in imaginary compositions (Nos. 110, 111). Berchem's chalk landscapes, if not done on the spot, at least convey the impression of the observed scene (Nos. 99, 100); his *Shoeing the Mule* (No. 101), the kind of drawing much esteemed in his time, was like Asselijn's *Aqueduct at Frascati* (No. 94) designed to be reproduced by a printmaker. De Bisschop's spectacular panoramic view of Rome taken from the Porta del Popolo (No. 118) would seem to document a visit to Rome as surely as any written evidence, just as the *View of Urbino* (No. 129) by Van Wittel, known to the *Bentvueghels* as *De Toorts* or *Piktoors* (the Torch), would speak for his presence in Italy were the large body of substantial documentation of his activity not known.

The Italianate motives in the background of Adriaen van de Velde's bucolic landscape (No. 123) were perhaps owed to his knowledge of the work of his more traveled countrymen, but there can be no doubt that he knew first hand the model for his red chalk drawing of a mule (No. 124), an example of his work as one of the animal specialists of the period. The drawing by Adriaen van de Velde's slightly older brother Willem (No. 120)—known as the Younger to distinguish him from his father—along with that by Ludolf Backhuyzen (No. 119) stand in token representation of those Dutch artists who specialized in marine subjects. The study by Adriaen van Ostade for one of his well-known etchings and his attractive watercolors are outstanding examples of the period's leading specialist in peasant genre (Nos. 88–91). They find good company in the animated subjects of his brother Isaac (No. 108) and Cornelis Dusart (No. 130). Caspar Netscher's *Woman at a Window* (No. 125) might also be thought of as a genre subject though not in the category of peasant or low life; his touching likeness of his small daughter (No. 126) finds a sympathetic pendant in the earlier drawing of infant twins by Salomon de Bray (No. 61).

With the appearance of this exhibition catalogue, somewhat more than a quarter of the Morgan Library's Netherlandish drawings have been made accessible with full illustration and as complete documentation as could be assembled at this time. It is a substantial beginning towards the definitive catalogue of the drawings of this school, and it is hoped that in time it will be

possible to publish such a definitive work as the first in a series of catalogues of the Library's complete holdings of European drawings. Such a series, initially contemplated more than thirty-five years ago by the Library's first director, is surely warranted by the importance of the collection.

The final task connected with the compilation of an exhibition catalogue is the pleasurable one of acknowledging the debt the author owes to the numerous scholars and colleagues—so many of them friends of long standing—who have helped to make it possible. It is with true gratitude that I thank them for sharing their knowledge and expertise. The greatest debt is owed to my friend Mr. Carlos van Hasselt, Director of the Fondation Custodia, with whom an exchange of exhibitions between our two institutions was first projected on the occasion of a visit to Paris some years ago. Mr. van Hasselt has been of the utmost support and assistance at all stages of the preparation of the exhibition and its catalogue. The provenance section of the catalogue entries, in particular, has benefited from the informed supervision of his watchful eye. If my associates and I have produced a catalogue that is a worthy companion of the model volume that accompanied the Fondation Custodia's exhibition to New York in 1977–78, it is due in no small part to his helpful interest. I am also most grateful to Professor R.-A. d'Hulst, Professor Michael Jaffé, and Dr. An Zwollo who kindly agreed to write the text for catalogue entries Nos. 22, 13, and 129. In addition to Mr. van Hasselt, various other Dutch friends and colleagues were also exceedingly generous in their assistance. Professor J. G. van Gelder and Dr. Ingrid van Gelder–Jost supplied valuable information, particularly in connection with their special interests in Aelbert Cuyp and Jan de Bisschop, and dispensed warm hospitality in Utrecht on more than one occasion. At the Rijksprentenkabinet in Amsterdam I was made most welcome by Dr. J. W. Niemeijer and his helpful staff, especially by Miss L. C. J. Frerichs, Mr. P. Schatborn, and Mr. M. D. Haga, but also by Mrs. D. de Hoop Scheffer who later coped helpfully with numerous queries by mail. I also consulted Mr. K. G. Boon, Director-Emeritus of the Rijksprentenkabinet, and had a useful exchange of correspondence with Professor J. Q. van Regteren Altena, Mr. Jaap Bolten, Mr. F.G.L.O. van Kretschmar, and Dr. M. van der Mast. Messrs. A.W.F.M. Meij and J. Giltay facilitated my working visit to the Print Room of the Boymans–van Beuningen Museum at Rotterdam on a long holiday weekend. I was privileged to spend a period of some weeks working among the remarkable facilities of the Rijksbureau voor Kunsthistorische Documentatie in The Hague, where Dr. An Zwollo could not have

been more helpful. In Belgium, a sojourn at the Rubenianum, Antwerp, where Dr. Nora De Poorter was of assistance during my visit and also later, in correspondence, was similarly productive. I am indebted as well to other Belgian colleagues, Miss Eliane de Wilde and Mr. W. Laureyssens.

In London, as in many years past, I was extended every courtesy by Mr. J. A. Gere and Mr. John Rowlands at the Print Room of the British Museum and at the Witt Library of the Courtauld Institute where Mr. Rupert Hodge was his customary helpful self. Thanks are further owed to a number of others whom I consulted on a variety of points: Mr. Keith Andrews, Mr. Richard Day, Miss Shaunagh FitzGerald, Mrs. Helene Muensterberger, Professor Giles H. Robertson, Mr. M. S. Robinson, Mr. Francis Russell, Mr. James Byam Shaw, and Mr. Julien Stock.

Among the German colleagues who were invariably prompt and helpful correspondents, I am grateful in particular to Dr. Hans-Ulrich Beck, Dr. Bernard Schnackenburg, and Professor Werner Sumowski, but also to Dr. Wolfgang Adler, Dr. Margret Klinge, Dr. Hans Mielke, Mrs. Ruth-Maria Muthmann, and Dr. Eckhard Schaar. Other colleagues on the Continent whose help I am pleased to acknowledge include Miss Roseline Bacou, Miss Mària van Berge, and Mrs. Françoise Viatte in Paris; Dr. Caterina Marcenaro and Dr. Vincenzo Oddi in Genoa; Professor Marcel Roethlisberger in Geneva; and Dr. Per Bjurström and Dr. Börje Magnusson in Stockholm.

On this side of the Atlantic, I have benefited especially from the knowledge of Professor Egbert Haverkamp-Begemann whose presence in New York made him a ready target for questions of all kinds, but I am also indebted to many others, including Mr. Clifford S. Ackley, Professor Julius S. Held, Professor Frances Huemer, Miss Katherine Jordan, Professor J. Richard Judson, Mrs. Ruth S. Kraemer, Mr. Robert Light, Mrs. Anne-Marie Logan, Miss Elizabeth Roth, Professor Seymour Slive, Mr. Walter Strauss, and Dr. Robert R. Wark. I have also gratefully drawn upon the valuable resources of The Frick Art Reference Library, New York. Through the courtesy of the University of Texas at Austin I have had access to copies of the notebooks of Fairfax Murray owned by the University.

As on all other occasions, I have been assisted at every turn by the members of the Department of Drawings and Prints at the Morgan Library, and it is with deep appreciation that I acknowledge the large role they have played in the preparation of the exhibition and its catalogue. Mrs. Helen B. Mules, Assistant Curator, has had a valuable part in this project since the very begin-

ning; Miss Mary Laura Gibbs, Assistant Curator, worked ably until her resignation in August 1978; and Miss Jane V. Shoaf, Assistant, has contributed most helpfully in the later stages of the work on the catalogue. Mrs. Cara Dufour Denison, the Associate Curator, while concerned in large part with the administration of the Department, has also been of assistance when time permitted. Mr. A. J. Yow, Conservator, and Mrs. Patricia Reyes, Associate Conservator, have aided in the technical description of the drawings, and, with Mr. Timothy Herstein, Assistant, have with their customary care prepared the drawings for the long sojourn abroad. Finally, I must acknowledge with gratitude the generous support of The Andrew W. Mellon Foundation.

FELICE STAMPFLE

WORKS AND EXHIBITIONS
CITED IN ABBREVIATED FORM

WORKS

Albertina, 1928
Otto Benesch, *Beschreibender Katalog der Handzeichnungen in der Graphischen Sammlung Albertina, II: Die Zeichnungen der niederländischen Schulen des XV. und XVI. Jahrhunderts*, Vienna, 1928.

Bartsch
Adam Bartsch, *Le Peintre-graveur*, 21 vols., Würzburg, 1920–22.

Bénard, *Cabinet de M. Paignon Dijonval*, 1810
M. Bénard, *Cabinet de M. Paignon Dijonval: État détaillé et raisonné des dessins et estampes . . .* , Paris, 1810.

Benesch, *Werk und Forschung*, 1935
Otto Benesch, *Rembrandt: Werk und Forschung*, Vienna, 1935.

Benesch, 1954–57
Otto Benesch, *The Drawings of Rembrandt*, 6 vols., London, 1954–57.

Benesch, 1973
Otto Benesch, *The Drawings of Rembrandt*, enlarged and edited by Eva Benesch, 6 vols., London, 1973.

Bernhard, *Rembrandt*, 1976
Marianne Bernhard, *Rembrandt Handzeichnungen*, Munich, 1976.

Bernhard, *Rubens*, 1977
Marianne Bernhard, *Rubens Handzeichnungen*, Munich, 1977.

Bernt, *Maler*, 1948
Walther Bernt, *Die niederländischen Maler des 17. Jahrhunderts*, 3 vols., Munich, 1948.

Bernt, *Zeichner*, 1957–58
Walther Bernt, *Die niederländischen Zeichner des 17. Jahrhunderts*, 2 vols., Munich, 1957–58.

Bock-Rosenberg, 1930
Max J. Friedländer, ed., *Staatliche Museen zu Berlin, Die Zeichnungen alter Meister im Kupferstichkabinett: Die niederländischen Meister*, by Elfried Bock and Jakob Rosenberg, 2 vols., Berlin, 1930.

Bredius-Gerson
A. Bredius, *Rembrandt: The Complete Edition of the Paintings*, revised by H. Gerson, 2 vols., London, 1969.

Briquet
C. M. Briquet, *Les Filigranes: Dictionnaire historique des marques du papier*, 4 vols., Geneva, 1907.

Burchard-d'Hulst, 1963
Ludwig Burchard and Roger-A. d'Hulst, *Rubens Drawings*, 2 vols., Brussels, 1963.

Churchill
W. A. Churchill, *Watermarks in Paper in Holland, England, France, etc., in the XVII and XVIII Centuries and their Interconnection*, Amsterdam, 1935.

Eisler, *Flemish and Dutch Drawings*, 1963
Colin Eisler, *Drawings of the Masters: Flemish and Dutch Drawings from the 15th to the 18th Century*, New York, 1963.

Fairfax Murray
J. Pierpont Morgan Collection of Drawings by the Old Masters Formed by C. Fairfax Murray, 4 vols., London, 1905–12.

Gerson, *Koninck*, 1936
Horst Gerson, *Philips Koninck*, Berlin, 1936.

Glück-Haberditzl, 1928
Gustav Glück and Franz Martin Haber-

ditzl, *Die Handzeichnungen von Peter Paul Rubens*, Berlin, 1928.

Glück, *Van Dyck*, Klassiker der Kunst, 1931
Gustav Glück, *Van Dyck: Des Meisters Gemälde*, Klassiker der Kunst, Stuttgart, 1931.

Goossens, *Vinckboons*, 1954
Korneel Goossens, *David Vinckboons*, Antwerp–The Hague, 1954.

Goris-Held, *Rubens in America*, 1947
Jan Albert Goris and Julius S. Held, *Rubens in America*, New York, 1947.

Great Drawings of All Time, 1962
Ira Moskowitz, ed., *Great Drawings of All Time, II: German, Flemish and Dutch Drawings* (text on Flemish drawings by Egbert Haverkamp-Begemann; text on Dutch drawings by J. G. van Gelder), New York, 1962.

Heawood
Edward Heawood, *Watermarks, Mainly of the 17th and 18th Centuries*, Hilversum, Holland, 1950.

Held, *Selected Drawings*, 1959
Julius S. Held, *Rubens: Selected Drawings*, 2 vols., London, 1959.

Hind, *Dutch Drawings*
Arthur M. Hind, *Catalogue of Drawings by Dutch and Flemish Artists . . . in the British Museum, III: Dutch Artists of the XVII Century (A–M)*, 1926; *IV: Dutch Artists of the XVII Century (N–Z)*, London, 1931.

Hind, *Flemish Drawings*, 1923
Arthur M. Hind, *Catalogue of Drawings by Dutch and Flemish Artists . . . in the British Museum, II: Drawings by Rubens, Van Dyck and other Artists of the Flemish School of the XVII Century*, London, 1923.

Hind, *Rembrandt*, 1915
Arthur M. Hind, *Catalogue of Drawings by Dutch and Flemish Artists . . . in the British Museum, I: Drawings by Rembrandt and his School*, London, 1915.

Hofstede de Groot, *Rembrandt*, 1906
Cornelis Hofstede de Groot, *Die Handzeichnungen Rembrandts*, Haarlem, 1906.

Hofstede de Groot
Cornelis Hofstede de Groot, *A Catalogue Raisonné of the Works of the Most Eminent Dutch Painters of the Seventeenth Century Based on the Work of John Smith*, 8 vols., London, 1907–27.

Hollstein
F. W. H. Hollstein, *Dutch and Flemish Etchings, Engravings and Woodcuts ca. 1450–1700*, 19 vols., Amsterdam, 1949–69.

d'Hulst, *Jordaens*, 1956
Roger-A. d'Hulst, *De tekeningen van Jakob Jordaens*, Brussels, 1956.

d'Hulst, *Jordaens*, 1974
Roger-A. d'Hulst, *Jordaens Drawings*, 4 vols., London–New York, 1974.

Judson, *De Gheyn II*, 1973
J. Richard Judson, *The Drawings of Jacob de Gheyn II*, New York, 1973.

Le Blanc
Charles Le Blanc, *Manuel de l'amateur d'estampes*, 2 vols., Amsterdam, 1970–71 (reprint of Paris edition, 4 vols., 1854–90).

Lugt
Frits Lugt, *Les Marques de collections de dessins & d'estampes*, Amsterdam, 1921.

Lugt S.
Frits Lugt, *Les Marques de collections de dessins & d'estampes, Supplément*, The Hague, 1956.

Lugt, *Collection Dutuit, Louvre*, 1927
Frits Lugt, *Les Dessins des écoles du nord de la Collection Dutuit au Musée des Beaux-Arts de la ville de Paris*, Paris, 1927.

Lugt, *École flamande, Louvre*, 1949
Frits Lugt, *Musée du Louvre. Inventaire général des dessins des écoles du nord: École flamande*, 2 vols., Paris, 1949.

Lugt, *École hollandaise, Louvre*
Frits Lugt, *Musée du Louvre. Inventaire général des dessins des écoles du nord: École hollandaise*, 3 vols., Paris, 1929–33.

Lugt, *Maîtres des anciens Pays-Bas nés avant 1550, Louvre*, 1968
Frits Lugt, *Musée du Louvre. Inventaire général*

des dessins des écoles du nord: *Maîtres des anciens Pays-Bas nés avant 1550*, Paris, 1968.

Lugt, *Répertoire*
Frits Lugt, *Répertoire des catalogues de ventes publiques*, 3 vols., The Hague, 1938–64.

MacLaren, *The Dutch School*, Plates, 1958, Text, 1960
Neil MacLaren, *National Gallery Catalogues: The Dutch School*, London, Plates, 1958, Text, 1960.

Mauritshuis, 1977
Mauritshuis, *The Royal Cabinet of Paintings: Illustrated General Catalogue*, The Hague, 1977.

Morgan Library, *First* [and subsequent] *Report to the Fellows*, 1950 [etc.]
The Pierpont Morgan Library, *First Annual Report to the Fellows of the Pierpont Morgan Library*, New York, 1950, etc. (*Reports* edited by Frederick B. Adams, Jr. through 1968; by Charles Ryskamp 1969 to date; entries on drawings by Felice Stampfle).

Morgan Library, *Review of Acquisitions 1949–1968*, 1969
The Pierpont Morgan Library, *A Review of Acquisitions 1949–1968*, New York, 1969.

Oldenbourg, *Rubens*, Klassiker der Kunst, 1921
Rudolf Oldenbourg, *P. P. Rubens: Des Meisters Gemälde*, Klassiker der Kunst, Stuttgart-Berlin, 1921.

Popham, *Dutch and Flemish Drawings*, 1932
A. E. Popham, *Catalogue of Drawings by Dutch and Flemish Artists . . . in the British Museum, V: Dutch and Flemish Drawings of the XV and XVI Centuries*, London, 1932.

Reznicek, *Goltzius*, 1961
E. K. J. Reznicek, *Die Zeichnungen von Hendrick Goltzius*, 2 vols., Utrecht, 1961.

Schnackenburg, *Van Ostade*, 1971
Bernard Schnackenburg, *Die Zeichnungen der Brüder van Ostade*, dissertation, University of Munich, 1971 (unpublished).

Stechow, *Dutch Landscape Painting*, 1966
Wolfgang Stechow, *National Gallery of Art-Kress Foundation Studies in the History of European Art: Dutch Landscape Painting of the Seventeenth Century*, London, 1966.

Thieme-Becker
Dr. Ulrich Thieme and Dr. Felix Becker, *Allgemeines Lexikon der bildenden Künstler von der Antike bis zur Gegenwart*, 37 vols., Leipzig, 1907–50.

Tietze, *European Master Drawings*, 1947
Hans Tietze, *European Master Drawings in the United States*, New York, 1947.

Valentiner
Wilhelm R. Valentiner, *Die Handzeichnungen Rembrandts*, 2 vols., New York, 1925–34.

Van Mander
Carel van Mander, *Dutch and Flemish Painters*, Translation from the *Schilderboek*, New York, 1936.

Vey, *Van Dyck*, 1962
Horst Vey, *Die Zeichnungen Anton van Dycks*, 2 vols., Brussels, 1962.

Von Sick, *Berchem*, 1930
Ilse von Sick, *Nicolaes Berchem, ein Vorläufer des Rokoko*, Berlin, 1930.

EXHIBITIONS

Ann Arbor, Michigan, *Italy Through Dutch Eyes*, 1964
Ann Arbor, Michigan, University of Michigan Museum of Art, *Italy Through Dutch Eyes: Dutch Seventeenth Century Landscape Artists in Italy*, catalogue by Wolfgang Stechow, 1964.

Berlin, *Pieter Bruegel*, 1975
Berlin, Staatliche Museen Preussischer Kulturbesitz, *Pieter Bruegel d. Ä. als Zeichner*, catalogue by Matthias Winner *et al.*, 1975.

Cambridge–New York, *Rubens*, 1956
Cambridge, Massachusetts, Fogg Art Museum, Harvard University, and New York, The Pierpont Morgan Library, *Drawings and Oil Sketches of Peter Paul Rubens from American Collections*, catalogue by Agnes

Mongan, 1956 (entries on Morgan Library drawings by Felice Stampfle).

Chicago, *Rembrandt*, 1935–36
Chicago, Illinois, Art Institute of Chicago, *Loan Exhibition of Paintings, Drawings, and Etchings by Rembrandt and His Circle*, 1935–36.

Chicago, *Rembrandt after Three Hundred Years*, 1969
Chicago, Illinois, Art Institute of Chicago, and elsewhere, *Rembrandt after Three Hundred Years*, catalogue of drawings by E. Haverkamp-Begemann and Anne-Marie Logan, 1969.

Hartford, *The Pierpont Morgan Treasures*, 1960
Hartford, Connecticut, Wadsworth Atheneum, *The Pierpont Morgan Treasures*, 1960.

London, Guildhall, 1895
London, Art Gallery of the Corporation of London, *Catalogue of Drawings by the Old Masters . . .* , lent by Sir J. C. Robinson, 1895.

London, *The Lawrence Gallery, First Exhibition*, 1835
London, Royal Academy of Arts, *The Lawrence Gallery, First Exhibition, A Catalogue of One Hundred Original Drawings by Sir P. P. Rubens, collected by Sir Thomas Lawrence, late President of the Royal Academy*, 1835.

London, *Rubens*, 1977
London, British Museum, *Rubens Drawings and Sketches*, catalogue by John Rowlands, 1977.

London, and elsewhere, *Flemish Drawings . . . Collection of Frits Lugt*, 1972
London, Victoria and Albert Museum, and elsewhere, *Flemish Drawings of the Seventeenth Century from the Collection of Frits Lugt, Institut Néerlandais, Paris*, catalogue by Carlos van Hasselt, 1972.

Minneapolis, *Fiftieth Anniversary*, 1965–66
Minneapolis, Minnesota, Minneapolis Institute of Arts, *Fiftieth Anniversary Exhibition 1915–1965*, 1965–66.

Morgan Library, *Landscape Drawings*, 1953
New York, The Pierpont Morgan Library, *Landscape Drawings and Water-Colors, Bruegel to Cézanne*, catalogue by Felice Stampfle, 1953.

Morgan Library, *Major Acquisitions, 1924–1974*, 1974
New York, The Pierpont Morgan Library, *Major Acquisitions of the Pierpont Morgan Library 1924–1974: Drawings*, catalogue by Felice Stampfle, 1974.

Morgan Library, and elsewhere, *Treasures from the Pierpont Morgan Library*, 1957
New York, The Pierpont Morgan Library, and elsewhere, *Treasures from the Pierpont Morgan Library, Fiftieth Anniversary*, 1957.

New York, *Bloemaert*, 1973
New York, Metropolitan Museum of Art, *Abraham Bloemaert 1564–1651, Prints and Drawings*, [checklist by Janet S. Byrne], 1973.

New York, Metropolitan Museum, *Rembrandt*, 1918
New York, Metropolitan Museum of Art, *Handlist of Works by Rembrandt*, 1918.

New York Public Library, *Morgan Drawings*, 1919
New York, New York Public Library, *Drawings from the J. Pierpont Morgan Collection*, essay by Frank Weitenkampf, no checklist, 1919.

New York–Cambridge, *Rembrandt*, 1960
New York, The Pierpont Morgan Library, and Cambridge, Massachusetts, Fogg Art Museum, Harvard University, *Rembrandt Drawings from American Collections*, catalogue by Felice Stampfle and Egbert Haverkamp-Begemann, 1960.

New York–Paris, *Rembrandt and His Century*, 1977–78
New York, The Pierpont Morgan Library, and Paris, Institut Néerlandais, *Rembrandt and His Century*, catalogue by Carlos van Hasselt, 1977–78.

Paris, *Rembrandt*, 1908
Paris, Bibliothèque Nationale, *Exposition d'oeuvres de Rembrandt*, 1908.

Poughkeepsie, Vassar, *Seventeenth Century Dutch Landscapes*, 1976
 Poughkeepsie, New York, Vassar College Art Gallery, *Seventeenth Century Dutch Landscape Drawings and Selected Prints*, catalogue by Curtis O. Baer and students, 1976.
Princeton, *Rubens before 1620*, 1971
 Princeton, New Jersey, The Art Museum, Princeton University, *Rubens before 1620*, catalogue edited by John Rupert Martin, 1971.
San Francisco, *Rembrandt from Morgan Collection*, 1920
 San Francisco, California, San Francisco Art Association, *Drawings and Etchings by Rembrandt from the J. Pierpont Morgan Collection*, 1920.
Stockholm, *Morgan Library gästar Nationalmuseum*, 1970
 Stockholm, Nationalmuseum, *Pierpont Morgan Library gästar Nationalmuseum*, 1970.
Washington, D.C., and elsewhere, *Seventeenth Century Dutch Drawings*, 1977
 Washington, D.C., National Gallery of Art, and elsewhere, *Seventeenth Century Dutch Drawings from American Collections*, catalogue by Franklin W. Robinson, 1977.
Worcester, *Rembrandt*, 1936
 Worcester, Massachusetts, Worcester Art Museum, *Rembrandt and His Circle*, 1936.

CATALOGUE

NOTICE *Additions and/or corrections have been made in the following entries since the publication of the French edition of the catalogue: Nos. 2, 15, 19, 21, 24, 27, 29, 33, 34, 35, 46, 54, 63, 75, 77, 86, 87, 101, 110, 112, 113, 118, 119, 123, 127, 130. The several irregularities in the chronological arrangement are due to the fact that more firmly documented birth dates for some of the artists came to hand after the ordering and printing of the illustrations.*

FLEMISH DRAWINGS

Lodewijk Toeput, called Pozzoserrato
Antwerp 1550 – 1605 Treviso, Italy

1. *Landscape with St. John on Patmos*

Pen and black ink, gray and blue washes; extraneous spots of green wash. Gold on edges of drawing from former mount.
8¼ × 11⅞ inches (210 × 302 mm.).
Watermark: cross-bow within a circle surmounted by a trefoil (cf. Briquet 756, 766). See watermark no. 8.
Numbered on verso at upper center in an old hand in pen and brown ink, *B6 31*.

Flemish in technique and Italian in subject, this drawing is entirely characteristic of the draughtsmanship of the Fleming from Malines who spent the latter half of his life in Italy, chiefly in Treviso. The delicate pen work in the background and the sensitive application of the blue and gray washes favored by northern artists of his generation reveal his Flemish origin; other practitioners of this technique were Paul Bril (see No. 2), Tobias Verhaeght (see No. 3), Joos de Momper, and Jan Brueghel the Elder (see No. 4). The background is witness to Toeput's pleasure in the beauty of the Italian seacoast. The town stretching the length of the narrow peninsula and the placid inlet where a fishing boat has furled its sail no doubt reflect his experience of the region near Venice. The town is similar in kind to the view of a city on the water in the background of the Louvre's landscape drawing illustrating Aesop's fable of the raven and the scorpion. This sheet, which Charles Sterling connected with the print made after it by Raphael Sadeler (*Old Master Drawings*, VI, December 1931, pp. 44–48, pl. 4), was the key to the later reassembling of Toeput's drawing *oeuvre*, chiefly

through the efforts of Luigi Menegazzi and Wolfgang Wegner. (For the former's latest publication, see "Disegni di Lodewijk Toeput detto Pozzoserrato," *Musées Royaux des Beaux-Arts de Belgique, Bulletin*, 1964, pp. 187–89; for the latter's, "Drawings by Pozzoserrato," *Master Drawings*, I, no. 4, 1963, pp. 27–32.) The second of two drawings in the Hermitage at Leningrad, also illustrating subjects from Aesop, *Fortune and the Boy* and *Hercules and the Carter* (repr. by Menegazzi, 1958, figs. 51, 52), is dated 1598 and was engraved the following year by Jan Sadeler. It is conceivable that in addition to this Aesopian series of landscapes, Toeput contemplated a series of saints in landscapes suitable for engraving. If so, the style of *St. John on Patmos* suggests that it could not have been too far removed in date from the Aesopian sequence. It may or may not be significant for such a hypothesis that the measurements of the Aesopian sheets and the present drawing are more or less the same. A landscape drawing of the same format in the collection of Janos Scholz, New York, incorporates a small seated figure that might be intended to represent a saint (repr. by Menegazzi, 1958, p. 43, fig. 62). See also the *Landscape with St. Jerome* reproduced in the catalogue of Bernard Houthakker, Amsterdam, 1973, no. 40.

PROVENANCE: P. H. Lankrink (Lugt 2090); Henry S. Reitlinger (no mark; see Lugt S. 2274a); his sale, Part VII, London, Sotheby's, 23 June 1954, lot 780; Mathias Komor, New York (Lugt S. 1882a).

BIBLIOGRAPHY: Morgan Library, *Sixth Annual Report to the Fellows*, 1955, pp. 69–71, repr.; Luigi Menegazzi, "Ludovico Toeput (il Pozzoserrato)," *Saggi e memorie di storia dell'arte*, I, 1957, p. 201, fig. 60 (published separately as *Il Pozzoserrato*, Venice, 1958, pp. 39, 41, and

31

61, and fig. 60); Wolfgang Wegner, "Neue Beiträge zur Kenntnis des Werkes von Lodewyck Toeput," *Arte Veneta*, XV, 1961, p. 113; Licia R. Collobi and Carlo L. Ragghianti, *Disegni dell'Accademia Carrara di Bergamo*, Florence, 1962, p. 54, under no. 108.

Acc. no. 1954.8

Purchased as the gift of Mr. Walter C. Baker

Paul Bril
Antwerp 1554 – 1626 Rome

2. *Wooded Ravine with Distant Harbor View*

Pen and brown ink, brown, gray, and blue washes, heightened with white. A few small losses at left margin, one tinted green.

7¼ × 10¹³⁄₁₆ inches (184×275 mm.).

Watermark: none visible through lining.

Inscribed on verso of the mount, in graphite in an eighteenth-century hand, *No 9 paul bril*; in another hand, *36 frs.*

Mariette in his comments in the sale catalogue of the Crozat collection (Paris, 10 April 1741) remarked that Paul Bril's drawings were as much sought after by collectors as his paintings, adding that this explained why some of his drawings are carefully finished works of "belle exécution" ("La réputation de Paul Bril s'accrut à un tel point, que non-seulement on fut curieux de ses tableaux; mais qu'on voulut aussi avoir de ses Desseins. Les principaux amateurs lui en demanderent avec empressement, & voilà pourquoi l'on en trouve qui sont d'une si belle exécution; car ne les faisant pas pour son Etude particulière, il se donnoit tout le tems qu'il falloit pour les terminer avec soin," pp. 108–09). It is to this category of finished works that the present sheet belongs although it is neither signed nor dated as are a great many of the artist's finished drawings, including a sizable number among the half a hundred sheets in the Cabinet des Dessins at the Louvre. The regard in which the Morgan landscape has justly been held in the past is suggested by the existence of at least two old copies: one formerly in the collections

of the Duke of Rutland and Dr. J. G. Adam (pen and brown ink, 206×304 mm.; reproduction in R.K.D.) and another weaker copy owned by Charles Duits, London, in 1950 (reproduction in R.K.D.). Furthermore, the drawing appears to have been engraved, in the reverse, by the Comte de Caylus (1692–1765. See Marcel Roux, *Inventaire du fonds français, graveurs du XVIIIᵉ siècle*, Bibliothèque Nationale, Département des Estampes, Paris, 1940, p. 70, no. 95: "Paysage montagneux et boisé [à dr.] avec, à g., une rivière et un pont d'une seule arche. Cabinet du Roi H.Oᵐ 178×L.Oᵐ 270."). At the time Caylus made his engraving his model was, as he indicated in his print, in the Cabinet du Roi with a proper ascription to Paul Bril. This would seem to mean that earlier the Morgan sheet had belonged to the great collector Eberhard Jabach (1618–1695), originally of Cologne but resident in Paris for nearly sixty years, and it therefore must have been among the drawings that Jabach sold to Louis XIV in 1671. One cannot overlook the fact, however, that Jabach is known to have had copies made of some of the originals he owned (Roseline Bacou in *Collections de Louis XIV*, Orangerie des Tuileries, Paris, 1977, pp. 17–18; in at least one instance the original of a drawing he had sold to the King was found in his possession after his death). This may possibly be the explanation for the existence of one or more of the copies of the Morgan drawing noted above.

When and how the drawing left the royal collection is not known. It may have been among the eight drawings engraved by Caylus between 1720 and 1740 as belonging to the Cabinet du Roi but no longer to be found at the Louvre's Cabinet des Dessins, as Frits Lugt observed in the discussion of Bril's drawings in his 1949 catalogue of the Louvre's Flemish drawings (I, p. 22). Its old mount is undoubtedly French in origin, economically utilizing the stock of the mount by piecing it at the sides as was the practice in the construction of Mariette's mounts. The eighteenth-century notation on the verso indicates that the drawing apparently once sold

for 36 francs. As far as could be determined at this time, the Morgan sheet cannot be specifically identified with any of the Bril drawings listed in the "second collection" of Jabach which is described in the inventory of 1696 recently rediscovered in the archives of the library of the Louvre (see Roseline Bacou, "Everard Jabach: Dessins de la seconde Collection," *La Revue de l'art*, 1978, nos. 40–41, pp. 141–50).

The landscape corresponds closely to that represented in a small painting on copper, of more or less identical measurements (185 × 275 mm.; location unknown), attributed to Paul Bril but not of first quality, judging from the small reproduction in the photographic archive of K. Goossens that is now in the Rubenianum at Antwerp. Three additional wayfarers are introduced in the painting, one seated with a backpack, one standing with a staff, and another disappearing down the woodland road. The drawing, in its general compositional scheme, particularly the left half with the arched bridge over a winding river, the round tower, and rocky mountains, also has much in common with *Landscape with St. Jerome*, another small painting on copper, formerly in the collection of J. C. Morris, London, and later sold at Sotheby's (26 March 1969, lot 82, repr.). This painting is signed with Bril's monogram and dated 1592, and it could well be that the Morgan sheet also originated in the last decade of the sixteenth century since its ornamental Mannerist character is so pronounced. The great tree at the left with its tangle of exposed roots and vines winding up its trunk, and all its fellows whose varying silhouettes act as a repoussoir in so many of Bril's landscape compositions, may go back to the large British Museum drawing of a single noble specimen most likely studied from nature (Popham, *Dutch and Flemish Drawings*, 1932, V, p. 137, no. 3).

The late Otto Benesch, in correspondence, associated the Morgan drawing with a landscape painting in the Herzog Anton Ulrich–Museum in Brunswick, Germany, where it is attributed to Gillis van Coninxloo (*Verzeichnis der Gemälde*, 1969, p. 44, no. 74), erroneously in Benesch's view. The Brunswick painting (sometimes described as possibly a contemporary copy and sometimes attributed to Frederik van Valckenborch) is in a loose way reminiscent of the Morgan drawing in that it shows a woodland path on the left and an arched bridge set against a mountainous background on the right. There is no true correspondence, however, as in the case of the Morgan drawing with the painting known through the reproduction in the Goossens archive.

PROVENANCE: Presumably Eberhard Jabach (possibly trace of his paraph at lower center edge; Lugt 2959–60); possibly Cabinet du Roi, i.e., Louis XIV (according to engraving by Caylus); Charles Fairfax Murray; J. Pierpont Morgan (no mark; see Lugt 1509).

BIBLIOGRAPHY: Fairfax Murray, III, no. 144, repr.

EXHIBITIONS: Morgan Library, *Landscape Drawings*, 1953, no. 51, repr.; Hartford, *The Pierpont Morgan Treasures*, 1960, no. 71.

Acc. no. III, 144

Tobias Verhaeght
Antwerp 1561 – 1631 Antwerp

3. *Landscape with Fishermen Seining on a Lake*

Pen and brown ink, brown and blue washes, over **black chalk**.
10⅟₁₆ × 12¾ inches (256 × 323 mm.).
Watermark: none.
Signed with monogram and dated in pen and brown ink at lower left, *TVH* (interlaced) / *1616*.

More often than not Verhaeght's drawings depict imaginary, frequently fantastic, panoramic mountain landscapes. Such compositions with their steep crags and winding rivers hark back to the Lowlander's impressions of Alpine scenery encountered on his way to or from Italy sometime before 1590. There is a hint of these picturesque mountain views in the background of the present drawing, but the peaceful rusticity of the main motif is Flemish in its inspi-

33

ration. The thatched cottages, the pollarded trees, the streams and ponds of the rural Flemish scene are also reflected in two drawings in the Albertina, Vienna, and two further sheets in the Landesmuseum at Brunswick (see respectively *Beschreibender Katalog der Handzeichnungen in der Graphischen Sammlung Albertina, II: Die Zeichnungen der niederländischen Schulen des XV. und XVI. Jahrhunderts* [text by Otto Benesch], Vienna, 1928, nos. 266–67, pl. 69; Eduard Flechsig, *Zeichnungen alter Meister im Landesmuseum zu Braunschweig: Niederländer des 15. und 16. Jahrhunderts*, 1923, no. 59). *Landscape with Couple Setting out Falconing* in Budapest, of which there is a copy attributed to Hieronymus Cock in the De Grez Collection in the Musées Royaux des Beaux-Arts de Belgique at Brussels, is likewise a compilation of Flemish motifs (Teréz Gerzi, *Netherlandish Drawings in the Budapest Museum: Sixteenth Century Drawings*, Amsterdam, 1971, no. 291, repr.). The fact that the Morgan drawing is dated might be thought to provide a clue for the dating of these other examples but since the bold formula of Verhaeght's drawing style changed very little during his career, the chronology of his drawn work is uncertain. There is another signed drawing from the year 1616 in the Metropolitan Museum, New York (Inv. no. 58.72), a typical mountain landscape with pilgrims on the road; the signed mountain landscape with Tobias and the Angel in the Hermitage is dated the following year.

In 1590 Verhaeght was Dean of the Antwerp Guild and for a few months during the following year he received the teenage Rubens as a pupil in his studio. He possibly owed his selection as the first teacher of Rubens to the fact that Rubens was related to the young woman whom Verhaeght married in 1592. By 1616 when he affixed his monogram to the Morgan sheet, he had long since been outstripped by his former pupil, but in such an example as this, it is possible to understand Verhaeght as a plausible source for the beginning of Rubens' interest in landscape.

The seining motif, likewise with two men in a boat and three pulling the net, occurs again in a fanciful landscape in the collection of P. and N. de Boer, but in very summary form and in reverse (see Singer Museum, Laren N.H., *Oude tekeningen: Een keuze uit de verzameling P. en N. de Boer*, 1966, no. 244, pl. 57). Interestingly enough, the left half of the De Boer sheet echoes the view of the woodland road but with a shepherd and two sheep substituted for the conversational group at the left of the Morgan drawing.

PROVENANCE: Professor Joseph Brassine, Liège (d. 1955); Colonel and Mme J. F. W. Hendriksz (daughter of Professor Brassine), The Hague.

BIBLIOGRAPHY: Morgan Library, *Eighth Annual Report to the Fellows*, 1958, pp. 68–69.

Acc. no. 1957.5

Jan Brueghel the Elder
Brussels 1568 – 1625 Antwerp

4. *Cargo Vessels and Rowboats off a Wharf*

Pen and brown ink, brown and blue washes. Foxing throughout.
7⅝ × 11⅝ inches (194 × 296 mm.).
Watermark: illegible fragment. See watermark no. 56.
Inscribed on verso at upper center in graphite, *N°3*; at lower right, *N°5*. Inscribed in pen and brown ink on old mount, in center, *N/55*; at upper left, *136*; upper right, *4N/L26*.

The unhurried scene of coastal life which the artist renders here must have been familiar to him somewhere near the city of Antwerp where he chose to live even when employed as court painter in Brussels. The easy control of the fluid pen line in the range of accents from the bold pressures in the right foreground to the fleeting touch in the boats in the left distance, coupled with the deft application of the delicate blue wash along the horizon, marks the drawing as a late work. It is probably near in time to the *Shore with Sailboats in a Storm* of 1614 in the Print Room in Berlin (Bock-Rosenberg, 1930, I, p.

34

16, no. 724, pl. 15). The locale represented in the two drawings is not very different; one might imagine that the boats at the left in the Berlin sheet are attempting to moor at the end of the very wharf where, in the Morgan drawing, a man leans against one of the pilings. This figure, like the three in the center, demonstrates a feeling for telling gesture and attitude. The drooping lines of the horse at the right suggest that he had just hauled a heavy load of barrels or casks for which such low carts were often used. According to the ever-helpful marine authority Mr. M. S. Robinson, these sprit-rigged vessels were the normal small cargo vessels of the period, which in the eighteenth and nineteenth centuries would have been called "tjalks." For what is known about them, he refers the reader to J. van Beylen, *Schepen van de Nederlanden*, Amsterdam, 1970. Brueghel's drawings of sea views are relatively few. There is a more elaborate wharfside scene in the earlier drawing in the British Museum which Winner pointed out was used in the preparation of the Munich painting of a fish market dated 1603 (see the exhibition catalogue *Pieter Bruegel*, 1975, under no. 124); and a drawing of two ships at sea in the collection of Professor J. Q. van Regteren Altena, Amsterdam (see the exhibition catalogue *Kabinet van tekeningen . . . uit sen Amsterdamse verzameling*, Museum Boymans–van Beuningen, Rotterdam, and elsewhere, 1976–77, no. 34, pl. 104).

PROVENANCE: George Knapton; General George Morrison (by bequest from Knapton); Knapton-Morrison sale, London, T. Philipe, 25 May – 3 June 1807, lot 136 (to Mr. Peters for £11, according to Georgina Morrison's notations in the copy of the sale catalogue at Colnaghi's); Sir Joseph Hawley; possibly sale, M. de Salicis . . . and property of a Baronet [Sir Henry Hawley], London, Christie's, 16 July 1891, one of six in lot 222, "A Coast Scene, by John Brueghel; and various other drawings"; Charles Fairfax Murray; J. Pierpont Morgan (no mark; see Lugt 1509).

BIBLIOGRAPHY: Berlin, *Pieter Bruegel*, 1975, under no. 124.

Acc. no. I, 115a

Flemish School
c. 1600

5. *View of "Het Blauw Hof" at Logenhage*

Pen and brown ink, brown and gray-blue washes; squared in black chalk.
Coat of arms on separate piece of paper ($1\frac{1}{2} \times 2\frac{1}{8}$ inches [38 × 55 mm.]), pasted onto upper left corner of sheet.
$5\frac{7}{8} \times 10\frac{13}{16}$ inches (148 × 276 mm.).
Watermark: none visible through lining.

The identity and history of the country house depicted here is owed entirely to the expert researches of Jonkheer F.G.L.O. van Kretschmar of The Hague, whose assistance was sought shortly after the acquisition of the drawing. His findings were published in *Master Drawings*, XVI, no. 1, 1978. The key to the solution of the problem lay in the coat of arms drawn on a separate piece of paper and pasted over the upper left corner of the sheet. These arms Van Kretschmar soon traced as those of the Spanish family known variously as Ximenes d'Aragona and Ximenes Pereta. The Ximeneses were among those families which followed the Spanish Crown to the Southern Netherlands. They settled in Antwerp and remained there for several generations. Two brothers, the older Ferdinand, aged seventy-five, who died in 1600, and Rodriguez Nonius, aged fifty-two, who died in 1591, were the first to be buried in the cathedral at Antwerp (*Verzameling der graf en gedenkschriften van de provincie Antwerpen*, Antwerp, 1856, I, p. 34). Rodriguez Nonius had a son, Edouard Ximenes Pereta, who is described in *Nobiliaire des Pays Bas et du Comté de Bourgogne* by J.S.F.J.L. de Herckenrode (1870, IV, p. 2157ff.) as knight of the Order of St. Etienne, Seigneur of Leugenhage (or Logenhage) in the district called "Land van Waas." There, it is further stated in 1597, he built a beautiful house known as "Blauthoff" or "Het Blauwhoff." It is also noted that in 1623 Edouard Ximenes "op't Blauwhoff" became a "Buytenburgher" of Antwerp, that is, a burgher living outside the city. Earlier the Chronicle of the Dukes of Brabant, printed in Antwerp in 1612,

had carried a dedication to him dated 1606.

The house is illustrated and its history given in the Latin text of the great topographical work *Flandria Illustrata*, first published in Cologne in 1641–44 by Antonius Sanderus, Canon at Ypres. In the edition published by Carolus and Johannes Baptist de Vos at Brussels in 1735, the engraving of the house appears twice, once as no. 10 on the fifth plate after page 264 at the end of Liber V, in Volume III, and again on page 22 of the "Auctarium ad Tomum Secundum." The latter bears the explanatory legend, in the center of the area of the sky, "Logenhaghen / Domus Dni. de Ximenes," without mention of artist or engraver.

Edouard Ximenes built "Het Blauw Hof" on the site of the old manor of Leugenhage or Logenhage in the parish of Bazel in the "Land van Waas," which he acquired about 1579. The manor, a house built of wood on stone foundations with a roof of straw and ferns, with its courtyard, stables, and outbuildings surrounded by an earthwork, was pulled down to make way for the splendid residence shown in the drawing. Built of a local blue stone which gave it its popular name, the residence was surrounded first by a moat and then by a crenelated wall. Access was gained through a lofty gatetower approached by a drawbridge at the center of the wall, and watchtowers were provided at the corners. The main house with a double stairway at the entrance, and three elaborate dormer windows, was situated to the back and right of the extensive courtyard; the servants' quarters were located on either side of the courtyard with an ornamental wellhead in the center of the left section. It has been suggested that the building with a tall spire standing free in the moat and approached by a small drawbridge may have served as a prison or a private chapel. Van Kretschmar remarked that the wooden structure at the far right corner of the moat was perhaps a remnant of the outbuildings of the former manor house.

Since the engraving representing Het Blauw Hof in *Flandria Illustrata* carries neither the name of the engraver nor that of the draughtsman responsible for the design, it provides no clue for the identity of the author of the Morgan drawing. With further investigation it may in time be possible to associate him with one of the known names of the numerous draughtsmen and engravers employed in the illustration of Antonius Sanderus' monumental project. Sanderus in his "Argumentum Operis" states that Hendrik Hondius II (1597–1651) engraved the illustrations for the work. Hondius' name, however, appears only on the portraits and on the maps and plans, and the greater part of the engraved topographical views, like that of Logenhage, are not signed. The draughtsmen and engravers along with the relevant documentation are discussed at length by G. Caullet in chapter VI of his *De gegraveerde: Onuitgegeven en verloren geraakte teekeningen voor Sanderus "Flandria Illustrata,"* Antwerp, 1908, pp. 58–85; among them are Arrasus or D'Arras, Vedastus du Plouich (his name coupled with *invenit et fecit* occurs with some frequency), the Monogrammist I.D., Pieter Stevens, Louis de Bersacques, Louis du Tielt, Jacobus de la Fontaine, Nicasius Fabius, and Hieronymo Niffo or Nipho.

A View of Waesten, an anonymous drawing used for *Flandria Illustrata*, II, p. 626, was sold at Christie's, 8 December 1976, lot 62 (information of Dr. An Zwollo).

PROVENANCE: R. M. Light & Co., Boston.
BIBLIOGRAPHY: Morgan Library, *Seventeenth Report to the Fellows, 1972–1974,* 1976, p. 163; F.G.L.O. van Kretschmar, "Towards the Identification of a Flemish Château," *Master Drawings,* XVI, 1978, pp. 45–48, pl. 36.

Acc. no. 1972.8

Hendrik Hondius the Elder

Duffel (near Malines) 1573 – after 1649
The Hague

6. *The Château of Tervueren*

Pen and brown ink, watercolor in blue, gray-green, and pink, over traces of black chalk.
5$\frac{13}{16}$ × 8¾ inches (147 × 223 mm.).
Watermark: crown. See watermark no. 11.

Signed with monogram and dated at lower left: *Hh.* (interlaced) *f. 1605.* Various dealers' numbers inscribed in graphite on verso, *119, 10,* and *7306.*

Hondius, engraver, draughtsman, and publisher, was born and trained in the Southern Netherlands, in Brussels under a goldsmith and in Antwerp under Jan Wierix and Jan Vredeman de Vries. After 1597, however, when he became a member of the painters' guild at The Hague, he resided in that city until the end of his life except for short trips to Cologne, Paris, and London. He must have made the present drawing during the course of a visit to the south in 1605. Tervueren, near Brussels, is an ancient village where St. Hubert died about 727; today it is known for its museum of African art. The first château on the site was built around 1200, and subsequently rebuilt and enlarged from time to time. It was restored under Archduke Albert, who became governor of the Spanish Netherlands in 1595, and it remained intact until the middle of the eighteenth century when there were further restorations; it was demolished in 1781 (see Eugène de Seyn, *Dictionnaire historique et géographique des communes belges,* Turnhout, 3rd ed. [1950], II, pp. 1296–97).

Hondius' view obviously shows the castle before the Archduke's restoration. Its appearance towards the end of the seventeenth century is recorded in an engraving in Jacques Le Roy, *Castella & praetoria nobilium Brabantiae . . . ,* Leyden, 1699, p. 60. The text beneath the engraving provides the following information: "TER-VUREN, dans la Majeurie de Vilvorde est un bourg & château celebre depuis le tems des Normans, que Marguerite fille d'Edvuard I. Roy d'Angleterre, & femme de Jean II. Duc de basse Lorraine, a, avec de grand frais, & par de superbes bâtimens, changé de forteresse qu'il estoit, en un très beau palais accompagné de promenades, de jardins, & d'un parc à bestes fauves."

If this prettily tinted drawing was made for a specific purpose, it has yet to be discovered among Hondius' engraved works. The artist was meticulous in his refined rendering of the moated castle with its high round towers at the corners —remnants, no doubt, of the earliest fortified building—along with the stepped gables and the ornamental cresting along the roof ridge of the large structure with the blue roof that was perhaps the Great Hall added to the ancient fortress by Margaret Plantagenet (1275 – after 1333), wife of Jean II, of the House of Lorraine, Duke of Brabant. (See Christopher Butkens, *Trophées sacrés et prophanes du Duché de Brabant,* The Hague, 1724, I, p. 368. This reference is owed to Jonkheer F.G.L.O. van Kretschmar.) Hondius also indicated the reflections of the architectural forms in the water before he gave the drawing the hallmark of his approval by affixing his monogram and the date. He apparently neglected to erase the black chalk indications of a small stepped gable that was part of his first tentative outline and proved to be misplaced in the final ordering of the architectural units. The drawing was originally part of an album containing some two hundred fifty landscape drawings of the sixteenth and seventeenth century, apparently brought together in Flanders or Holland in the seventeenth or eighteenth century by a collector with a special interest in landscapes. The album, according to Popham, was acquired by Alfred Jowett when it was sold on 26 June 1934 at the disposal of the library of Lord Treowen at Llanover House. Another drawing by Hondius, showing the château from the opposite direction and executed in pen and wash over red chalk (7 × 10⅛ inches; 178 × 258 mm.), was also in the album (sale, London, Sotheby's, 7 July 1966, no. 31, repr.; reference is made in the Sotheby catalogue to a drawing of the château by Van Orley in the Louvre, which was cited by Frits Lugt as the basis for the identification of the castle as Tervueren [*Maîtres des anciens Pays-Bas nés avant 1550, Louvre,* 1968, no. 188, repr.]). A drawing in the Bruegel tradition in the Robert Lehman Collection, Metropolitan Museum, New York, represents the château from very much the same point of view as the Morgan sheet (New York, Metropolitan Museum, *XV–XVI Century Northern Drawings from*

37

the Robert Lehman Collection, exhibition catalogue by George Szabo, 1978, no. 6, repr.). The word *vueren* is decipherable in the middle of the first line of the inscription, which is for the most part illegible, including the date which Dr. Szabo suggests may be read either 1564 or 1604. The latter date seems the more plausible. Yet another view of the château, in this instance from a different direction, is found in a drawing attributed to Jan Brueghel (London, P. & D. Colnaghi, *Exhibition of Old Master Drawings*, 2–26 July 1963, no. 27, repr.).

PROVENANCE: Lord Treowen (no mark; see Lugt S. 2841c); his sale, Llanover House, Monmouthshire, Bruton, Knowles & Co., 26 June 1934, lot 997 (folio 100a of the album; to R. E. A. Wilson); Alfred Jowett, Killinghall, Yorkshire; Baron Paul Hatvany, London; his sale, London, Christie's, 27 November 1973, no. 214, repr. (to Colnaghi's).

BIBLIOGRAPHY: A. E. Popham, "Mr. Alfred Jowett's Collection of Drawings at Killinghall," *Apollo*, XXVII, 1938, p. 138, fig. VIII.

EXHIBITION: London, P. & D. Colnaghi and Co., *Exhibition of Old Master Drawings*, 1974, no. 25, repr.

Acc. no. 1978.40

Gift of Mrs. Christian H. Aall

David Vinckboons

Malines 1576 – 1632 Amsterdam

7. *Landscape with Susanna and the Elders*

Apocrypha, History of Susanna 12–64

Pen and brown ink, gray and blue washes; outlines incised with the stylus for transfer.
14⅛ × 19¹¹⁄₁₆ inches (359 × 500 mm.).
Watermark: fleur-de-lis. See watermark no. 16.

Like a number of Vinckboons' drawings, this one was made with an engraving in view. It is part of a series of large, elaborately worked landscapes with small-scale biblical scenes that were engraved by Jan van Londerseel (1570/75–1624/25), who worked extensively after Vinckboons' designs. Hollstein (XI, pp. 100–02) lists around two dozen subjects which Van Londerseel reproduced after Vinckboons for popular distribution.

The Morgan drawing is particularly diverting in its representation of an early seventeenth-century formal garden with its parterres, its arbors and trellises, and its fountains. The variety of birds and animals brings to mind Carel van Mander's report that Vinckboons, still a young man at the time of the publication of the *Schilderboeck* in 1604, "made miniatures of such subjects as small animals, birds, fish, and trees which he did from life." The peacocks, the swans, and the turkey that are so at home in Susanna's garden may well have been first studied in such miniatures, and the same was perhaps true of the less exotic creatures like the stag, the rabbits, and the goats. The stag, it is interesting to note, was replaced by a doe in Van Londerseel's print, possibly with iconographic intent just as the mating rabbits may be a deliberate reference to the implications of the subject of Susanna and the Elders. The female satyrs of the fountain and the herms of the pergola would also seem to be allusive as well as ornamental in their presence. Van Londerseel's engraving (Hollstein, XI, p. 100, no. 7), which is in the reverse of the drawing, follows the drawn design very faithfully in the first two states with the exception of the change of the stag to a doe and the addition of another tree on that side of the composition; the engraver did, however, allow himself one small and unsuccessful liberty in attempting to show the full spread of the turkey's tail from the back without altering its profile pose and also chose, for reasons of his own, to add a beard to one of the female satyrs. There was a major change, however, in the third state of the engraving where the group of Susanna and the Elders has been transformed into Bathsheba at the Fountain, a contingency perhaps anticipated in the presence of a figure on the balcony of the château in the Morgan drawing. Such a figure would then be identified as David. Other comparable large Vinckboons drawings, with small biblical scenes, which were engraved by Van Londerseel are the *Healing of the Man Born Blind*, Rijksmuseum, Amsterdam (Inv. no. 1948:30. L. C. J. Frerichs, *Keuze van tekeningen bewaard in het Rijks-*

prentenkabinet, Amsterdam, 1963, no. 36, repr.; see Hollstein, XI, p. 101, no. 24, where the subject is changed to *Healing of the Man Possessed of a Devil*); *Temptation of Christ*, Kunsthalle, Hamburg (Inv. no. 22648. Konrad Renger in exhibition catalogue, Berlin, *Pieter Bruegel*, 1975, no. 279, pl. 306; Hollstein, XI, p. 101, no. 17); *Agony in the Garden*, British Museum (Inv. no. 1930.4.14.5. Goossens, *Vinckboons*, 1954, p. 31, fig. 15; Hollstein, XI, p. 101, no. 26); *Three Marys at the Tomb*, British Museum (Inv. no. 1946.7.13.135. Goossens, *Vinckboons*, 1954, p. 32, fig. 16); *Christ and His Disciples on the Way to Emmaus*, Fondation Custodia, Institut Néerlandais, Paris (Inv. no. 1972-T.1. New York–Paris, *Rembrandt and His Century*, 1977–78, no. 118, pl. 29; Hollstein, XI, p. 101, no. 28). Of these drawings, only the Amsterdam example is dated (1601), but it seems plausible that the entire series was produced around the same time, surely within the same decade. There is a small drawing of Bathsheba, signed with the monogram and dated 1618, in an album in the Kupferstichkabinett, Berlin (Robert Oertel, "Ein Künstlerstammbuch vom Jahre 1616," *Jahrbuch der Preussischen Kunstsammlungen*, LVII, 1936, p. 101, fig. 3), but it does not appear to have any connection with the change of subject in the third state of Van Londerseel's print.

PROVENANCE: Private collection, Belgium; Clifford Duits, London; H. Terry-Engell Gallery, London; Sven Gahlin, London; Seiferheld & Company, New York.

BIBLIOGRAPHY: Morgan Library, *Fourteenth Report to the Fellows, 1965 & 1966*, 1967, pp. 115–16; Morgan Library, *Review of Acquisitions 1949–1968*, 1969, p. 175; New York–Paris, *Rembrandt and His Century*, 1977–78, under no. 118.

EXHIBITION: Morgan Library, *Major Acquisitions, 1924–1974*, 1974, no. 40, repr.

Acc. no. 1964.6

Gift of the Fellows

8. *Village Kermis*

Pen, black and some brown ink, watercolor and tempera in varying shades of blue, red, and green.
8⅛ × 11⁹⁄₁₆ inches (205 × 294 mm.).
Watermark: none.

Signed with monogram and dated in brush and white tempera at lower left, *DVB 1603*. Inscribed on verso, in pen and brown ink in a seventeenth-century hand at upper left, *David Vinckeboons*; in pen and brown ink in later hand, *£50 – extra*; in pencil at lower left, *Collection of the | Marquis Vindé | & Miss James*; in black chalk at lower right, *No. 1367* (inventory number of the collection of the Vicomte Morel de Vindé).

This fresh, delightfully colorful scene of peasant merrymaking, carefully signed and dated, was clearly designed as an independent work. It was obviously not made with an engraving in mind as was the preceding drawing. Nor does it connect with a painting although in a general way it may be compared with the painted *Kermis* in Dresden (Goossens, *Vinckboons*, 1954, pl. 38), a much more elaborate composition but similarly structured with boats on a tree-lined stream at the left, an inn or house with *al fresco* diners at the right, and dancers circling in between. Like Vinckboons' important master drawing in Copenhagen (Goossens, pl. 30; Berlin, *Pieter Bruegel*, 1975, no. 280, pl. 313), the Morgan sheet represents another variation on the popular theme of the kermis, here a small village celebration in contrast to the enormous carnival participated in by peasants and burghers alike in the large-scale composition. That the Morgan scene is a true kermis is indicated by the church and the white-robed religious procession with its red banners in the background at the left. The kermis (kirk-mis[mass]) originally was the mass or service commemorating the anniversary of the foundation of a church, and on such occasion there was also a fair or festival, the latter gradually usurping the meaning of the word. Vinckboons' peasants owe a debt to Pieter Bruegel the Elder (note, among others, the bagpiper seated at the table at the right), but they have an electric energy and exuberance of their own. The artist's talent for rendering details of nature is seen at its best in the delicate white tracery of the reeds and foliage in the immediate foreground and the almost impressionist handling of the gray, white, and rose reflections in the water below the first boat. Another drawing of a peasant kermis, dated 1603 and executed in

pen and wash, figured in the Roerich Museum sale at the American Art Association–Anderson Galleries, 27–28 March 1930, no. 98; it is now in the collection of P. and N. de Boer (Singer Museum, Laren N.H., *Oude tekeningen: Een keuze uit de verzameling P. en N. de Boer*, 1966, no. 254, pl. 60).

PROVENANCE: Paignon Dijonval (1708–1792), Paris; Charles-Gilbert, Vicomte Morel de Vindé (according to inscription on verso; no mark; see Lugt 2520); sold in 1816 to Samuel Woodburn (no mark; see Lugt 2584); Thomas Dimsdale (Lugt 2426); Samuel Woodburn; Miss James, London (according to inscription on verso); her sale, London, Christie's, 22–23 June 1891, one of two in lot 171; Charles Fairfax Murray; J. Pierpont Morgan (no mark; see Lugt 1509).

BIBLIOGRAPHY: Bénard, *Cabinet de M. Paignon Dijonval*, 1810, p. 67, one of three in no. 1367; Fairfax Murray, III, no. 164, repr.; J. S. Held, "Notes on David Vinckeboons," *Oud Holland*, LXVI, 1951, p. 242.

EXHIBITION: Berlin, *Pieter Bruegel*, 1975, no. 281, pl. 307.

Acc. no. III, 164

9. *Consul Fabius Receiving His Father, Quintus Fabius Maximus*

Pen and brown ink, gray, brown, and blue washes. 7⅛ × 11⅜ inches (181 × 289 mm.).
Watermark: none.
Inscribed on verso, probably by the artist, in red chalk, *D. Vinckeboons*.

The important personage whom the leading figure at the extreme right of this drawing is greeting with some emotion appears with an equally impressive cortege in the other half of this composition which has been in the Rijksmuseum, Amsterdam, since 1919. The subject has been identified at the Rijksprentenkabinet as an incident in the life of the famous Roman Quintus Fabius Maximus surnamed the Cunctator (*Plutarch's Lives* in Loeb Classical Library series, trans. by Bernadotte Perrin, Cambridge, Massachusetts, III, 1958, pp. 187–89). Five times a consul himself, the Cunctator was honored by the elevation of his son to the same post. On an occasion when the new consul was conferring about the war (indicated in the background of both drawings), his distinguished father came into his presence on horseback. The young consul immediately ordered his father to dismount and come to him on foot if he had need of the consular offices. To the surprise of the bystanders, who thought such treatment demeaning to the father, Fabius Maximus quickly dismounted and hurried to embrace and congratulate his son who had properly put Roman law and its representative ahead of the relationship of parent and child.

It is Fabius the son and his retinue who are represented in the Morgan sheet, he being distinguished by a moustache and short chin tuft whereas Fabius Maximus, who is seen advancing to the left in the Amsterdam drawing, wears the long beard of an older man. These two main figures are clad in an approximation of Roman armor, but for what reason, one wonders, do their followers, with a single exception, appear in contemporary costume with ruffs, and slashed doublets and pantaloons. In many essentials, the Morgan sheet may be compared with a panel painting in the Stern collection, Paris; there the protagonists of the Morgan and Amsterdam sheets are represented embracing (R.K.D. photograph L. 4797). A note on the photograph of this work, which carries the title *The Reconciliation of Jacob and Esau*, makes reference to an engraving which is yet to be located.

The finesse of the fluid pen line and the delicate washes of the Morgan and Amsterdam sheets are evidence of Vinckboons' native Flemish style, which he never lost during his long residence in Holland. The relatively large scale of the figures suggests that the composition is the work of the artist's maturity, perhaps to be dated at the end of the first decade of the seventeenth century. The trend towards the use of larger figures is observable in the British Museum's series of four drawings illustrating the parable of the Prodigal Son. This series, which is stylistically compatible with the present drawing, can be dated around 1608 on the basis of

40

the date of Claes Jansz. Visscher's engravings after the sequence.

PROVENANCE: P. & D. Colnaghi and Co., London.

BIBLIOGRAPHY: Morgan Library, *Twelfth Report to the Fellows, 1962*, 1963, p. 75; Morgan Library, *Review of Acquisitions 1949–1968*, 1969, p. 175.

Acc. no. 1961.31

Gift of the Fellows

Peter Paul Rubens

Siegen, Germany 1577 – 1640 Antwerp

10. *Study for the Portrait of Marchesa Brigida Spinola Doria*

Pen and brown ink, occasionally point of brush, brown wash, preliminary indications in black chalk; also further work in black chalk. Crease at upper center; loss at lower right corner and also along right margin.
12⅞ × 7⅟₁₆ inches (315 × 178 mm.).
Watermark: none.
Inscribed by the artist in pen and brown ink: on cornice, *gout* (gold; formerly read as *hout* [wood]); below first capital, *goudt* (gold); on curtain, *Root* (red).

Very few compositional sketches establishing the pose and costume, and sometimes the setting for a painted portrait, have survived among Rubens' drawings. This full-length study is one such rare example and is further unusual in that it relates to his activity as a portraitist in Genoa, a period for which drawings of any kind are in short supply. As L. Baldass was the first to note (according to Burchard, 1950), the drawing is preparatory for the radiant painting of the Marchesa Brigida Spinola Doria, now in the Kress Collection, National Gallery, Washington, D.C. (see Eisler, pp. 101ff., figs. 95–96), which bears an inscription on the verso giving the name and age (22) of the sitter and the date 1606. The Marchesa, baptized on 9 May 1583, was married on 9 July 1605 to her cousin Giacomo Massimiliano Doria after the granting of the requisite papal dispensation for consanguinity. The resplendent white satin gown in which she is portrayed in the Washington picture has given

rise to the surmise that she may have been represented in her wedding finery, the portrait conceivably having been commissioned in connection with her marriage in the summer of 1605, but delayed in completion until 1606.

Norris, followed by Held and Müller Hofstede, suggested that the head in the drawing shows the countenance of an older attendant of the young Brigida who relieved her mistress of the chore of posing, but the pretty painted face for all its polished elegance and perfection of contour still shares an intangible kinship of expression with the quickly indicated countenance of the drawing. Irregularities of contour which suggest age are possibly little more than the accidents of the swiftly moving pen which similarly did not pause to regularize the outlines of architectural detail. Perhaps, as Jaffé remarks, "the face in the drawing could be Brigida's own, not yet glamourized for the painting."

Whether or not Brigida or a lady-in-waiting posed for Rubens, he undoubtedly must have made a separate true portrait study of the young woman's head, very likely in the red and black chalk of the life-size likenesses of the young Gonzaga princes, the drawings now in Stockholm, made in 1604. It was in black chalk that the artist first plotted the outlines of the Morgan figure and setting before taking up his pen and then his brush, and somewhere along the way perhaps again using chalk to shade certain areas. Occasionally, as in the detail of foliage, he drew hastily with the point of the brush. Within this mix of chalk, ink, and wash, all suggestive of speed in their application, he brought into focus the volume of the stately figure and even managed to convey textures. If the young woman did not pose for Rubens on the terrace off the *piano nobile* of the Doria Palace, it is surroundings of comparable grandeur that the artist obviously suggests. In his essay on Rubens' portrait paintings in Italy, in the catalogue of the 1977 exhibition in Cologne, Müller Hofstede remarks that, as far as he knows, none of the architectural motives in the Genoese portraits can be specifically identified (p. 75, note 26).

41

It is nevertheless puzzling that Rubens should have bothered to designate the color of the gold capital and cornice, and to describe the curtain as red if he himself were, so to speak, the designer of the painted architecture. Rubens' interest in Genoese architecture is, of course, well known through his publication *Palazzi antichi di Genova, palazzi moderni di Genova*, Antwerp, 1622. Eisler (p. 102) calls attention to the fact that an early nineteenth-century print of the palace (1818) shows urns similarly placed on a balustrade on a terrace of the *piano nobile* of a wing added by the Spinola to the Doria Palace that might be compared with the similar feature in the drawing (see Pasquale Rotonda, *Il Palazzo di Antonio Doria a Genova*, Genoa, 1958, p. 194, fig. 137). On the whole the drawing and painting are remarkably close, but one very noticeable omission in the drawing is the lack of any hint of the gown's numerous jeweled fasteners on the sleeves, bodice, and skirt, and the heavy rope of jewel-studded ornament worn baldric fashion, or the striping of the undersleeves, and the hair ornaments. All ornament is also lacking in the related *"modello"* drawing in the École des Beaux-Arts, Paris, which Müller Hofstede first published in 1965 in the Baden-Württemberg yearbook (p. 110) as an anonymous copy after Rubens but wishfully upgraded as an original in the recent Cologne catalogue (no. 40). Presumably the representation of the ornaments would have been undertaken at some stage in the actual execution of the painting. It might be remarked that the ornamental details of costume and jewels are similarly omitted in the Albertina drawing (Glück-Haberditzl, no. 233; E. Mitsch, *Die Rubenszeichnungen der Albertina*, Vienna, 1977, p. 122, no. 52, repr. p. 123) that is related to the Louvre's full-length portrait of Helena Fourment formerly in the Rothschild Collection, Paris (Oldenbourg, *Rubens*, Klassiker der Kunst, 1921, p. 425), a painting of c. 1638–39 where the figure is posed in an architectural setting very much as in Rubens' National Gallery portrait of the Marchesa painted more than thirty years earlier.

The Kress painting unfortunately has been cut down, but the drawing, like the lithograph made after the uncut painting in 1848 by Pierre-Frédéric Lehnert (Eisler, text fig. 21), preserves the full composition. The lithograph shows slightly more of the composition at the left and at the lower edge than the drawing, which has itself probably been slightly trimmed at the lower edge and two sides. Where the drawing shows only six vase forms or balusters in the balustrade, for example, there are seven indicated in the lithograph. The lithograph reveals that the painting originally bore at lower left the inscription BRIGIDA SPIVOLA [*sic*] DORIA / ANN: SAL: 1606 / AET. SUAE 22, and when the painting was cut down this information was apparently transferred to the verso much to the advantage of future art historians.

PROVENANCE: Uzielli, Switzerland; Dr. Edmund Schilling, London (acquired in Paris); private collection, New York (acquired from Schilling in the 1950's).

BIBLIOGRAPHY: Christopher Norris, "Rubens in Retrospect," *Burlington Magazine*, XCIII, 1951, pp. 4 and 7, repr.; Julius S. Held, "Rubens' Pen Drawings," *Magazine of Art*, XLIV, 1951, p. 286; Michael Jaffé, "A Sheet of Drawings from Rubens' Second Roman Period and His Early Style as a Landscape Draughtsman," *Oud Holland*, LXXII, 1957, pp. 2 and 6, fig. 4; Held, *Selected Drawings*, London, 1959, pp. 32 and 127, no. 73, pl. 84; Justus Müller Hofstede, "Bildnisse aus Rubens' Italienjahren," *Jahrbuch der Staatlichen Kunstsammlungen im Baden-Württemberg*, II, 1965, pp. 110–11, fig. 64; Bernhard, *Rubens*, 1977, pp. 33 and 185, repr.; Christopher Brown, *Dutch and Flemish Painting*, Oxford, 1977, no. 12, repr.; Colin Eisler, *Paintings from the Samuel H. Kress Collection: European Schools Excluding Italian*, Oxford, 1977, pp. 101–03, note 5, text fig. 20; Michael Jaffé, *Rubens and Italy*, Oxford, 1977, pp. 77 and 115, note 22, fig. 261; Frances Huemer, *Portraits*, I, Corpus Rubenianum Ludwig Burchard, XIX, Brussels, 1977, p. 170, no. 41a, fig. 121; Genoa, Palazzo Ducale, *Rubens e Genova*, 1977–78, pp. 152, 176 note 23, 187 fig. 56; Morgan Library, *Eighteenth Report to the Fellows, 1975–1977*, 1978, pp. 243, 290–91, pl. 13.

EXHIBITIONS: London, Wildenstein and Company, *A Loan Exhibition of Works by Peter Paul Rubens*, catalogue by Ludwig Burchard, 1950, no. 55, repr.; London, *Rubens*, 1977, no. 29, repr.; Cologne, Wallraf-Richartz-Museum, *Peter Paul Rubens, Katalog I, Rubens in Italien*, catalogue by Justus Müller Hofstede, 1977, no. 39, repr.

Acc. no. 1975.28

Gift of a Trustee

42

11. *The Adoration of the Magi*

Matthew 2:1–11

Pen and brown ink, brown wash, over faint indications in black chalk; outlines incised with the stylus for transfer. 11½ × 7½ inches (292 × 191 mm.).

Watermark: eagle (similar to Briquet 1367–68). See watermark no. 13.

Initials (of a collector?) inscribed in black ink at lower left are now almost entirely obliterated.

The learned Antwerp publisher Balthasar Moretus, grandson of Christopher Plantin, was Rubens' lifelong friend, and for a period of almost thirty years the artist designed title pages and illustrations for the Plantin-Moretus Press. This work seems to have been a kind of pleasant leisure activity for him, apparently reserved for Sundays and holidays. Moretus writing on 13 September 1630 to Balthasar Corderius, who had inquired about designs by Rubens on behalf of an author, explained: "Rubens refuses to design them unless the drawing can be postponed for three months. I myself usually alert him six months in advance so that he has time to reflect upon a title and execute it at his leisure, and only on holidays, as he does not do this kind of work on workdays; else he would ask 100 florins for a single design (Max Rooses, *Correspondance de Rubens* . . . , Antwerp, 1887–1909, V, p. 335).

Among Rubens' earlier commissions for the famous press were the designs for the edition of the *Roman Missal* published in Antwerp in 1613. This folio edition of the *Missal*, one of the many profitable liturgical publications on which the press enjoyed a monopoly in the Netherlands and in Spain, was planned with the innovation of ten full-page illustrations instead of the previous eight. It was the two additional scenes that Rubens designed along with two further border decorations. (The other eight were those by Marten de Vos carried over from the 1606 edition; the remaining borders were both designed and engraved by Theodoor Galle.) The Morgan *Adoration* is the preparatory design for one of these two additional large plates; the design for the other plate, the *Ascension of Christ*,

has apparently been lost. One of Rubens' border designs is also in the Morgan Library (Acc. no. III, 183; actually a group of six small hasty sketches that were probably cut from a single sheet. See J. Richard Judson and Carl van de Velde, *Book Illustrations and Title Pages*, Corpus Rubenianum Ludwig Burchard, XXI, London-Philadelphia, 1978, p. 93, no. 7a).

The Morgan *Adoration*, worked with care in every detail for the guidance of the printmaker, was engraved in the reverse by Moretus' brother-in-law Theodoor Galle. Rubens' anticipation of the reversal of the design in the engraved illustration is indicated by the fact that he showed the Christ Child extending his left hand to grasp the left hand of the kneeling Caspar, the oldest Magus. Galle received seventy-five florins for his engraved plate on 13 February 1613. In contrast, Rubens was accustomed to be paid at the rate of a modest twenty florins for a folio page, twelve for a quarto, and eight for an octavo, preferring customarily, however, to accept books from the press in lieu of cash. Presumably the discrepancy in remuneration is to be explained in terms of the longer period required for the time-consuming task of engraving the copper-plate, an arrangement that would not be countenanced in later centuries. An impression of the plate with minor alterations brushed in by Rubens in brown ink is preserved in the Cabinet des Estampes, Bibliothèque Nationale, Paris (Inv. no. c 10487); these changes were incorporated in the plate by the engraver when it was revised almost immediately in the *Roman Breviary* of 1614, for which Rubens designed eight further full-page illustrations and the title page. In addition to the title page, the *Breviary* contains ten full-page illustrations.

The left section of the drawing dominated by the figure of the Virgin and the classical column echoes the composition of Rubens' picture of the subject commissioned by the City Council of Antwerp in 1609. (For the oil sketch at Groningen, see R.-A. d'Hulst, *Olieverfschetsen van Rubens uit Nederlands en Belgisch openbaar bezit*, Amsterdam, 1968, pp. 89–96, no. 2; for the reworked

43

painting in the Prado, Madrid, Oldenbourg, *Rubens*, Klassiker der Kunst, 1921, p. 26; Matias Díaz Padrón, *Museo del Prado: Catálogo de pinturas*, Madrid, 1975, I, pp. 226–29, no. 1638, II, p. 163, repr.) The beautiful luminous group of the Virgin and Child was repeated once more with slight variation in the artist's later *Adoration* in the church of St. John at Malines (Oldenbourg, p. 164, c. 1617–19).

This drawing was included in one of the exhibitions of the drawings from the famous collection of Sir Thomas Lawrence organized by the English dealer Woodburn, but it does not bear Lawrence's stamp and was never in the possession of the English artist. It was actually acquired by Woodburn in the Goll van Franckenstein sale in 1833, three years after Lawrence's death in 1830, and subsequently included in the 1835 Lawrence exhibition. Woodburn, according to Lugt (under no. 2445), somewhat curiously justified the inclusion in the exhibition of such "posthumous purchases," as it were, by stating that Lawrence during his lifetime had authorized the acquisition of certain drawings when they became available at a good price.

PROVENANCE: Possibly Samuel van Huls, former burgomaster of The Hague; his sale, The Hague, Swart, 14 May 1736, Album L, lot 524, "Pierre Paul Rubens. L'Adoration des Rois et un autre"; Jonkheer Johann Goll van Franckenstein the Elder (1722–1785; his *No. 972* in black ink on verso; Lugt 2987); Cornelis Ploos van Amstel Jb Czn; his sale, Amsterdam, Van der Schley . . . Roos, 3 March 1800, Album X, lot 1 (to I. de Vos for 15 florins); Jacob de Vos (1735–1831; no mark; see under Lugt 1450); Jonkheer Pieter Hendrik Goll van Franckenstein (1787–1832); his sale, Amsterdam, de Vries . . . Roos, 1 July 1833, Album Q, lot 8; Samuel Woodburn (no mark; see Lugt 2584); unidentified collector (trace of initials at lower left); Sir John Charles Robinson (no mark; see Lugt 1433); Charles Fairfax Murray; J. Pierpont Morgan (no mark; see Lugt 1509).

BIBLIOGRAPHY: Max Rooses, *L'Oeuvre de P. P. Rubens*, Antwerp, 1886–92, V, pp. 58–67, no. 1253; Max Rooses in *Bulletin-Rubens: Annales de la commission officielle instituée par le conseil communal de la ville d'Anvers*, Antwerp, 1897, pp. 199–200; Fairfax Murray, I, no. 230, repr.; Glück-Haberditzl, 1928, pp. 36–37, no. 68, repr.; Frank van den Wijngaert, *Inventaris der Rubeniaansche prentkunst*, Antwerp, 1940, p. 57, under no. 294; Herman F. Bouchery and Frank van den Wijngaert, *P. P. Rubens en het Plantijnsche Huis*, Antwerp, 1941, pp. 47, 61, 122, pl. 36; Hans

Gerhard Evers, *Rubens und sein Werk: Neue Forschungen*, Brussels, 1943, p. 209; Otto Benesch, *Artistic and Intellectual Trends from Rubens to Daumier*, Cambridge, Massachusetts, 1943, p. 7; Goris-Held, *Rubens in America*, 1947, p. 42, no. 102, pl. 106; Julius S. Held, "Drawings and Oil Sketches by Rubens from American Collections," *Burlington Magazine*, XCVIII, 1956, p. 123; Antwerp, Rubenshuis, *Tekeningen van P. P. Rubens*, exhibition catalogue by Ludwig Burchard and Roger-A. d'Hulst, 1956, p. 56, under no. 48; Held, *Selected Drawings*, 1959, I, no. 139, II, pl. 151; Konrad Renger, "Rubens dedit dedicavitque: Rubens' Beschäftigung mit der Reproduktionsgrafik," *Jahrbuch der Berliner Museen*, XVI, 1974, pp. 130–31, note 33; Bernhard, *Rubens*, 1977, p. 222, repr.; J. Richard Judson and Carl van de Velde, *Book Illustrations and Title Pages*, Corpus Rubenianum Ludwig Burchard, XXI, London-Philadelphia, 1978, no. 8a, pp. 98f, 142, 177, 447f, 452, fig. 52.

EXHIBITIONS: London, *The Lawrence Gallery: First Exhibition*, 1835, p. 23, no. 100, "Adoration of the Kings—highly finished for an engraver to work from: pen and bistre. Size, 11½ inches × 7⅓. From the collection of M. Goll van Falkenstein"; Montreal, Montreal Museum of Fine Arts, *Five Centuries of Drawings*, 1953, no. 13; Cambridge–New York, *Rubens*, 1956, no. 12, repr.; Hartford, *The Pierpont Morgan Treasures*, 1960, no. 72; Stockholm, *Morgan Library gästar Nationalmuseum*, 1970, p. 47, no. 59, repr.; Princeton, *Rubens before 1620*, 1972, pp. 139–40, no. 11, repr.; Antwerp, Plantin-Moretus Museum, *P. P. Rubens als Boekillustrator*, catalogue by J. Richard Judson, 1977, p. 21, no. 2d.

Acc. no. I, 230

12. *Seated Nude Youth*

Black chalk heightened with white tempera on light gray paper.
19¹¹⁄₁₆ × 11¾ inches (500 × 299 mm.).
Watermark: serpent? See watermark no. 52.

Rubens' gifts as a draughtsman find most eloquent expression in his large-scale chalk studies which are preparatory for the figures of his paintings. Happily, they constitute a large section of the surviving drawn *oeuvre*. Such studies, usually from the model, were executed to fix and refine details of figure and costume after the overall composition had been worked out in exploratory sketches in pen and wash or in a fluid oil sketch. In some cases these studies were intended for the use of workshop assistants who frequently carried out the master's designs in great part, but they were also a stage in Rubens' customary

working procedure when he was executing a painting in its entirety, especially in his earlier periods. The figure of Daniel was definitely a drawing for his own guidance. The superb study of a powerful youth with his eyes upturned in supplication and his hands locked in prayer was employed for the principal figure in the painting *Daniel in the Lions' Den*, formerly in the Hamilton Palace Collection (sale, London, Christie's, 6–7 November 1919, no. 57) and since 1966 in the National Gallery, Washington, D.C. The painting was specifically described by the artist in his famous letter of 18 April 1618, addressed to Sir Dudley Carleton, the English diplomat and connoisseur, in connection with the negotiations for the exchange of Carleton's collection of antique marbles for paintings by Rubens: "Daniel in the midst of many lions, done from nature; original work entirely by my hand" (Ruth Magurn, *The Letters of Peter Paul Rubens*, Cambridge, Massachusetts, 1955, p. 60). Since details of the painting appear in Jan Brueghel's *Noah and His Family Leading the Animals into the Ark* in the Wellington Museum, Apsley House, London, which is signed and dated 1615 (Jaffé, 1970, pp. 8–9, fig. 2) and also figure in Brueghel's *Allegory of Sight* of 1617 in the Prado, it is assumed that the preparatory drawings for the National Gallery painting were made around 1614–15.

While Rubens surely drew the Morgan figure from life, it may well be, as Jaffé remarked, that he posed his model with clasped hands and crossed legs on the inspiration of the figure of St. Jerome in a drawing at the Louvre by the sixteenth-century Italian artist Girolamo Muziano (Lugt, *École flamande, Louvre*, 1949, II, no. 1219); this sheet, a study for the altarpiece of the *Penitent St. Jerome*, Bologna, is a drawing that he might himself have owned, or equally he may have known and owned the print *St. Jerome in the Wilderness* (1573) by Cornelis Cort after Muziano (Le Blanc, II, p. 52, no. 102).

The young long-haired studio model, who may perhaps be recognized in other studies as distinct from an older short-haired model, is here invested with extraordinary physical vitality and, at the same time, imbued with the intensity of feeling—tellingly focused in the upturned face and the strong, blunt-fingered hands—that the Bible story demands. The figure called forth a tribute from the late Ludwig Burchard, the distinguished Rubens specialist who was a scholar not given to superlatives. When he saw the drawing in the original for the first time, he remarked, "it is the highest one could desire in a Rubens drawing."

This drawing was one of a group of drawings Fairfax Murray acquired from Sir John Charles Robinson by exchange on 3 March 1890 for a manuscript attributed to Francesco di Giorgio and a drawing by Dürer purchased at the Bredalbane sale; in addition to Rubens' *Daniel*, properly associated at the time with the Hamilton Palace picture, the exchange group included drawings by Giulio Romano, the School of Holbein (3), Van Dyck (2), German School, Correggio (attributed), Francia, and School of Perugino. The other drawings which have been connected with the National Gallery's painting are all studies of lions, the most celebrated of which are the two in the British Museum (Glück-Haberditzl, nos. 98–99). These various animal drawings were discussed at length by Jaffé in the National Gallery's *Report and Studies, 1969*; for his further discussion of the sheet that recently entered the Morgan Library, see No. 13 below.

PROVENANCE: William Bates (Lugt 2604); his sale, London, Sotheby's, 19 January 1887, probably part of lot 337, "P. P. Rubens. Various Studies and Sketches (7)" (to Robinson for £1.8) or possibly part of lot 242, "Large Drawings by Old Masters (12)" (to Robinson for £1.18); Sir John Charles Robinson; by exchange, 3 March 1890, to Charles Fairfax Murray (according to his autograph manuscript notebooks, University of Texas, Austin); J. Pierpont Morgan (no mark; see Lugt 1509).

BIBLIOGRAPHY: Émile Michel, *Rubens: Sa vie, son oeuvre et son temps*, Paris, 1900, p. 190; Fairfax Murray, I, no. 232, repr.; Glück-Haberditzl, 1928, p. 41, no. 97, repr.; Goris-Held, *Rubens in America*, 1947, p. 41, no. 95, repr.; Tietze, *European Master Drawings*, 1947, p. 122, no. 61, repr.; Agnes Mongan *et al., One Hundred Master Drawings*, Cambridge, Massachusetts, 1949, p. 71, repr.; Julius S.

Held, *Peter Paul Rubens*, Library of Great Painters, New York, 1953, p. 10, repr.; Michael Jaffé, "Rubens en de Leeuwenkuil," *Bulletin van het Rijksmuseum*, III, no. 3, 1955, p. 64, fig. 8; Ruth S. Magurn, *The Letters of Peter Paul Rubens*, Cambridge, Massachusetts, 1955, p. 441, letter 28, note 2; Held, *Selected Drawings*, 1959, I, no. 85, II, pl. 95; *Great Drawings of All Time*, 1962, II, no. 257, repr.; Burchard-d'Hulst, 1963, II, no. 110, repr.; Achilles Stubbe, *Peter Paul Rubens*, New York, 1966, p. 86, repr. p. 38; Michael Jaffé, "Some Recent Acquisitions of Seventeenth-Century Flemish Painting," *National Gallery of Art: Report and Studies in the History of Art 1969*, Washington, D.C., 1970, p. 17, fig. 18; Bernhard, *Rubens*, 1977, p. 283, repr.; Cecile Kruyfhooft and Simone Buys, "P. P. Rubens et la peinture animalière," *Zoo Antwerpen*, 1977, p. 67, repr. p. 14.

EXHIBITIONS: Detroit, Detroit Institute of Arts, *An Exhibition of Sixty Paintings and Some Drawings by P. P. Rubens*, 1936, section v, no. 4; Worcester, Massachusetts, Worcester Art Museum, *Art of Europe during the XVIth – XVIIth Centuries*, 1948, no. 41; Cambridge, Massachusetts, Fogg Art Museum, Harvard University, *Seventy Master Drawings: Paul J. Sachs Anniversary Exhibition*, 1948, no. 30; Philadelphia, Philadelphia Museum of Art, *Masterpieces of Drawing*, 1950–51, no. 51, repr.; Cambridge–New York, *Rubens*, 1956, no. 14, repr.; Morgan Library and elsewhere, *Treasures from the Pierpont Morgan Library*, 1957, no. 90, repr.; New York, Wildenstein and Company, *Masterpieces*, 1961, no. 66, repr.; Princeton, *Rubens before 1620*, 1972, pp. 140 and 168, no. 12, repr.; London, *Rubens*, 1977, no. 69, repr.

Acc. no. I, 232

13. *Study of a Sleeping Lion*

Black chalk heightened with white chalk on light gray paper.
9⅞ × 16½ inches (250 × 420 mm.).
Watermark: none.

Rubens studied captive beasts, presumably in the menagerie of the Archdukes Albert and Isabella at Brussels: crocodile, hippopotamus, fox, wolf, bear, boar, tiger, and lion. He made drawings in chalk of a lion and of a lioness, roused and at rest. On the basis of these life studies (Jaffé, pp. 9–16, figs. 5 and 12–15), he made in some instances also more elaborate studies in more complex media, with the requirements of picture making in mind (Jaffé, figs. 3, 4, 11); but in other instances he appears to have used the life studies more or less directly in his painting. Where the beast was to be studied in ex-

pressive movement, especially movement to be observed in foreshortening, he was aided by his experience of studying small bronzes *all'antica* of the type produced in Padua and other North Italian workshops during the sixteenth century; and he corrected this experience of art by observation of nature (Jaffé, figs. 6–8).

For the Morgan Library's study of a recumbent lion snoozing, it is clear that he neither had, nor had need of, such aid. It is the finest known to survive of a group of his drawings made in front of the cage. The lion in sleep, as we can see from a rehearsal drawn by Rubens, which has been partially cut by a collector's trimming of the sheet, must have shifted the angle of loll of its left forepaw, but the chief concentration is on the tousled weight of the maned head and the upturn of the right forepaw on which that weight rests. The mask and the paw were introduced by Rubens, each with an appropriate adjustment of angle, at the left of his *Daniel in the Lions' Den*, the second of a list of twelve pictures which he offered to Sir Dudley Carleton by his letter of 28 April 1618 with the comment "Daniel in the midst of many lions, done from nature. Original work entirely by my hand. 8 × 12 ft." (Ruth Magurn, *The Letters of Peter Paul Rubens*, Cambridge, Massachusetts, 1955, letter 28, pp. 60, 441). The painting has been in the National Gallery of Art, Washington, D.C. (Ailsa Mellon Bruce Fund), since 1966. Since the lower right-hand corner of this painting is represented hanging high on the left wall in Jan Brueghel's *Allegory of Sight* (Matias Díaz Padrón, *Museo del Prado: Catálogo de pinturas*, 1975, I, no. 1394, pl. 28), dated 1617, all the studies of lions preparatory to it must have been drawn by some date that year. We have Rubens' word, in writing to Carleton, that not only the brute beasts in his painting were "cavati dal naturale," but the protagonist himself; and the major portion of the study drawn by Rubens from the human model has long been one of the famous treasures of the Morgan Library (see No. 12).

A study of very similar character to the pres-

46

ent *Study of a Sleeping Lion* was used by Rubens in his *modello* for the Dresden *St. Jerome* (Jaffé, p. 16, figs. 16, 17; see also J. Müller Hofstede, "Vier Modelli von Rubens," *Pantheon*, XXV, 1967, pp. 440–42, figs. 7, 8, 11), to be slightly modified by him in the full-scale execution. Since the Dresden picture has generally been agreed to have been painted about 1615, and since the group of the lion and lioness at the right of the *Daniel in the Lions' Den* appears in a painting of *Noah and His Family Leading the Animals into the Ark* (The Wellington Museum, Apsley House, London) which is signed and dated 1615 by Jan Brueghel, there is a strong case for believing that the whole known group of chalk studies of lions drawn by Rubens were of 1614–15.

Text by Michael Jaffé

PROVENANCE: A. Paul Oppé, London; Stefan Zweig, London and New York; H. Eisemann, London; Victor Koch, London; Schaeffer Galleries, New York.

BIBLIOGRAPHY: Burchard-d'Hulst, 1963, p. 176, under no. 110 (as Rubens); Justus Müller Hofstede, review of Burchard-d'Hulst, *Master Drawings*, IV, 1966, p. 450, under no. 110 as one of a group of "rather poor works by pupils"; Michael Jaffé, "Some Recent Acquisitions of Seventeenth-Century Flemish Painting," *National Gallery of Art: Report and Studies in the History of Art 1969*, Washington, D.C., 1970, p. 16, note 27, fig. 15 (as Rubens); Morgan Library, *Eighteenth Report to the Fellows, 1975–1977*, 1978, pp. 243, 290.

Acc. no. 1977.41

Gift of the Fellows with the special assistance of a number of Fellows and Trustees in honor of Miss Felice Stampfle

14. *Studies for "The Descent from the Cross"*

Mark 15:42–46

Pen and brown ink, brown wash, and occasionally point of brush, on light brown paper. Verso: Full-length figure of St. Andrew; slight indication of a head in black chalk. 13⁹⁄₁₆ × 9¹⁄₁₆ inches (345 × 233 mm.).
Watermark: none.
Numbered in brown ink at upper right, *3*; in graphite at lower left in a more modern hand, *6*; in graphite on verso at lower left, *2*.

Nowhere are Rubens' thought processes in the evolution of a composition better illustrated than in the intricate web of line and wash on this single sheet. Julius Held has logically analyzed this fascinating complex, showing the sequence in which Rubens most likely developed his ideas. He points out that the artist must have begun with the sketch of the isolated head of Christ now visible upside down in the lower left quadrant, then for reasons of his own turned the sheet in the opposite direction and drawn the group of Christ and the two women, giving, even at this early stage of invention, beautiful expression to the emotion of the woman supporting the upper body of the Christ. One observes that this time Rubens was careful to place the head of Christ nearer the upper margin of the sheet to allow more space for the full group, but in the end he was still short of space and was compelled to work on a smaller scale in the final version at the lower right, where he added the cross and the three male figures on ladders.

It was this last solution of the problem that the artist employed in the main for the picture now at the Hermitage in Leningrad (Oldenbourg, *Rubens*, Klassiker der Kunst, 1921, no. 90), one of the two paintings of the subject to which the recto of the drawing is related. In the Leningrad painting, a work in which Rubens' studio participated, the female figure on the left stands rather than kneels and the horizontal member of the cross is missing, but the three men and the ladders appear much as indicated in the drawing though the youthful St. John is substituted for the bearded St. Joseph of Arimathaea on the ladder at the right. Sir Karl Parker was the first to connect the drawing not only with the Leningrad painting but also with the painting in the museum at Lille (Oldenbourg, no. 89; Paris, Grand Palais, *Le Siècle de Rubens*, 1977–78, pp. 201–02, no. 53, repr.), a studio work known to have been in progress in March 1617. There the relationship is primarily in the figure of the Christ, which, although in the reverse direction, is perhaps closer to the figures of the Thaw sheet than is the figure of the Leningrad picture where the head, being supported by St. John, does not fall so far down-

47

ward. It is interesting in this connection that the figure of Christ is the section of the Leningrad picture worked by Rubens' own hand.

Such dual use of a drawing was not unusual with Rubens and his studio, and in this instance the sheet was put to further service since the verso, as Dobroklonsky first pointed out, bears the impressive preparatory study for the figure of St. Andrew on the outside of the right wing of the triptych of the Miraculous Draught of Fishes in Nôtre Dame au delà de la Dyle, Malines, Belgium, painted for the Fishmongers Guild in 1618–19 (Oldenbourg, no. 174). The study is the last in a sequence of three related drawings that as a group are also instructive in Rubens' working procedures. The first, in the Staatliche Graphische Sammlung, Munich, is simply a black chalk study from life of a powerful bearded man in a short, heavy tunic, and the second, the sheet in the Statens Museum for Kunst, Copenhagen, carries two black chalk sketches showing the transformation of the model into St. Andrew with his long voluminous robe and x-shaped cross. The likeness of the model still lingers in the head of the Thaw figure, which also retains the position of his left arm and the empty hand that in the painting holds a fish. The faintly indicated head in black chalk at the top of the sheet and the scarcely visible chalk lines at the back of the saint's head and in the area of the left foot show that Rubens began this drawing in the same medium as the Munich and Copenhagen sheets.

In view of the drawing's connection with these several paintings and the consistency of style on recto and verso, it has been possible to place it with reasonable confidence in the years 1617–18. Held, who discusses the problem of the date at some length, notes that Oldenbourg's suggestion of 1613–15 for the Leningrad picture may well be too early.

PROVENANCE: Mrs. G. W. Wrangham; Edward Wrangham; Baskett & Day, London.

BIBLIOGRAPHY: Karl T. Parker, "Some Drawings by Rubens and His School in the Collection of Mrs. G. W. Wrangham," *Old Master Drawings*, III, June 1928, pp.

1–2, pl. 1; M. V. Dobroklonsky, "Einige Rubenszeichnungen in der Eremitage," *Zeitschrift für bildende Kunst*, LXIV, 1930–31, p. 32; Karl T. Parker, "Peter Paul Rubens (1577–1640): Study of a Standing Man," *Old Master Drawings*, XI, December 1936, pp. 50–51, pl. 46; Hans G. Evers, *Rubens und sein Werk*, Brussels, 1943, p. 137, pl. 45; Antwerp, Rubenshuis, *Tekeningen van P. P. Rubens*, exhibition catalogue by Ludwig Burchard and Roger-A. d'Hulst, 1956, under no. 65; Held, *Selected Drawings*, 1959, I, p. 22, II, p. 109, under no. 36, no. 42, pl. 39; Burchard-d'Hulst, 1963, pp. 160–61, under no. 96; Julius S. Held, "Some Rubens Drawings—Unknown or Neglected," *Master Drawings*, XII, 1974, pp. 252–53; M. Varshavskaya, *Rubens' Paintings in the Hermitage Museum*, Leningrad, 1975, pp. 104–13, under no. 14, repr. p. 108; Anne-Marie Logan, "Rubens Exhibitions 1977," review, *Master Drawings*, XV, 1977, p. 409, cat. no. 146.

EXHIBITIONS: London, Baskett & Day, *Exhibition of Drawings*, 1972, no. 8, repr.; Morgan Library, and elsewhere, *Drawings from the Collection of Mr. and Mrs. Eugene V. Thaw*, catalogue by Felice Stampfle and Cara D. Denison, 1975, no. 11, repr.; Antwerp, Koninklijk Museum voor Schone Kunsten, *P. P. Rubens Paintings – Oil Sketches – Drawings*, 1977, no. 146, repr.

Mr. and Mrs. Eugene V. Thaw
Promised gift to The Pierpont Morgan Library

15. *Angel Blowing a Trumpet, Facing Right*

Black chalk, heightened with white tempera, some lines partially accented in pen and black ink; squared for enlargement in black chalk. Old tear at upper right; long vertical crease in right quarter.
9$\frac{11}{16}$ × 11$\frac{3}{16}$ inches (245 × 285 mm.).
Watermark: illegible fragment. See watermark no. 53.

Rubens' most important commission in Antwerp was his work for the then new Jesuit church of St. Charles Borromeo. The cornerstone was laid on 15 April 1615 and the church was dedicated on 12 September 1621. Built by the Jesuit architect Pieter Huyssens in succession to François Aguilon and originally dedicated to St. Ignatius of Loyola, the church was famed as one of the most beautiful and opulent of the Jesuit Order until the fire of 1718. Rubens' contribution comprised not only the two great paintings for the high altar, now in the Kunsthistorisches Museum, Vienna, and the extensive cycle of

thirty-nine ceiling paintings for the aisles and galleries, but designs for the decorative elements of the façade as well. Few preparatory drawings for these extensive projects survive. According to Martin, only two drawings and a handful of oil sketches for the interior cycle are known (Corpus Rubenianum Ludwig Burchard, I, 1968, pp. 33, 37). Drawings connected with Rubens' work for the decoration of the façade are scarcely much more numerous. Burchard-d'Hulst in the 1956 catalogue under no. 67 and in the 1963 catalogue under no. 116 tally seven in all. The two Morgan sheets (the present drawing and the one following) and the *Cartouche Supported by Cherubs* in the British Museum (Held, *Selected Drawings*, 1959, no. 172, fig. 58) are the most impressive of the group. As Ludwig Burchard was the first to observe some years ago, the Morgan *Angels* served as models for the relief sculptures in the spandrels of the central portal of the church (Held, fig. 60), above which is the relief of the great cartouche with the monogram of Christ (Held, fig. 59) based on the British Museum design. The Morgan sheets, rhythmically drawn in black chalk, are experimentally accented here and there in black ink in successful furtherance of the effect of relief, and in the drawing for the left spandrel Rubens has used a compass to plot the first member of the moldings of the arch. Both drawings, like the London sheet, are squared for enlargement, presumably for the purpose of the execution of large-scale cartoons that the sculptor must have required for his guidance. Who the sculptor was is not known for certain. He has been variously identified as Hans van Mildert and as Colijns de Nole (or members of the De Nole family). Rubens' full-bodied angels, baroque descendants of the winged victories on the great Roman arches of Constantine and Titus, suffered in translation into stone, so much so that the originality of the present sculptures has sometimes been questioned; it is known that much of the original sculptural decoration was replaced following vandalism at the time of the French Revolution. (Held in his *Selected Drawings* summarizes

the problem of the sculpture and the literature in his entry on these drawings, nos. 144–45.)

The two Morgan drawings were separated for more than two hundred years until in 1957 the angel of the right spandrel was reunited in New York with its companion of the left spandrel. As far as is known, they were last together in the collection of Jonathan Richardson, Sr., the English painter-collector whose drawings were sold at auction in London on 22 January 1747 and the following seventeen nights, mostly in undescribed lots. Now that the drawings can once more be placed side by side, the sweeping curve of the arch of the portal is revealed in the full grandeur of Rubens' conception, and his dynamic inventiveness shows to full advantage in the counterpoint of pose, gesture, and movement provided by the two figures so similarly yet variously disposed in the triangles of the spandrels. The drawings are usually dated 1617–20.

PROVENANCE: Jonathan Richardson, Sr. (Lugt 2184); Charles Fairfax Murray; J. Pierpont Morgan (no mark; see Lugt 1509).

BIBLIOGRAPHY: Fairfax Murray, I, no. 233, repr.; Glück-Haberditzl, 1928, p. 46, no. 128; Goris-Held, *Rubens in America*, 1947, p. 42, no. 106; Julius S. Held, "Drawings and Oil Sketches by Rubens from American Collections," review in *Burlington Magazine*, XCVIII, 1956, p. 123, fig. 25; Michael Jaffé, "Rubens' Drawings at Antwerp," *Burlington Magazine*, XCVIII, 1956, p. 314, note 5; Held, *Selected Drawings*, 1959, I, no. 144, II, pl. 149; Christopher White, *Rubens and His World*, London, 1968, p. 54, repr.; John Rupert Martin, *The Ceiling Paintings for the Jesuit Church in Antwerp*, Corpus Rubenianum Ludwig Burchard, I, Brussels, 1968, pp. 28–29; Frans Baudouin, *Rubens en zijn eeuw*, Antwerp, 1972, p. 104, fig. 59; John Rupert Martin, *The Decorations for the Pompa Introitus Ferdinandi*, Corpus Rubenianum Ludwig Burchard, XVI, Brussels, 1972, p. 102; Konrad Renger, "Rubens dedit dedicavitque: Rubens' Beschäftigung mit der Reproduktionsgrafik," *Jahrbuch der Berliner Museen*, XVI, 1974, p. 140, note 58; Frans Baudouin, *Pietro Pauolo Rubens*, New York, 1977, p. 154, fig. 108; E. Mitsch, *Die Rubenszeichnungen der Albertina*, Vienna, 1977, p. 84, under no. 34.

EXHIBITIONS: Detroit, Detroit Institute of Arts, *An Exhibition of Sixty Paintings and Some Drawings by P. P. Rubens*, 1936, section v, no. 3; Cambridge–New York, *Rubens*, 1956, p. 21, no. 19, repr.; Antwerp, Rubenshuis, *Tekeningen van P. P. Rubens*, catalogue by Ludwig Burchard and Roger-A. d'Hulst, 1956, p. 68, no. 67, repr.; Newark, New Jersey, The Newark Museum, *Old Master Drawings*,

1960, no. 33a; Allentown, Pennsylvania, Allentown Art Museum, *Gothic to Baroque*, 1960, no. 94; Iowa City, Art Department, University of Iowa, *Drawing and the Human Figure, 1400–1964*, 1964, no. 58; Princeton, *Rubens before 1620*, 1972, p. 142, no. 14, repr.; London, *Rubens*, 1977, no. 140, repr.

<div style="text-align: right">Acc. no. I, 233</div>

16. *Angel Blowing a Trumpet, Facing Left*

Black chalk, heightened with white tempera, some lines partially accented in pen and black ink; squared for enlargement in black chalk.
9¹³⁄₁₆ inches (249 mm.), right margin; 10¹¹⁄₁₆ inches (271 mm.), top margin; 1¼ inches (32 mm.), left margin; 1¼ inches (32 mm.), lower margin. The drawing has been trimmed along the curve of the spandrel which arches to the left.
Watermark: none visible through lining.

Inscribed on mount at lower center in pen and brown ink in Richardson's hand, *Rubens*. Numbered on verso at left in pen and brown ink, *7*.

See the text for No. 15.

PROVENANCE: Jonathan Richardson, Sr. (Lugt 2184; Richardson's press marks on verso of the mount, *Fa33/DD39/T* [or *J*]; Lugt 2983–84); Henry S. Reitlinger (no mark; see Lugt S. 2274a); his sale, London, Sotheby's, 23 June 1954, lot 781 (to Asscher); Martin B. Asscher, London.

BIBLIOGRAPHY: Cambridge–New York, *Rubens*, 1956, under no. 19; Antwerp, Rubenshuis, *Tekeningen van P. P. Rubens*, exhibition catalogue by Ludwig Burchard and Roger-A. d'Hulst, 1956, p. 68, under no. 67; Michael Jaffé, "Rubens' Drawings at Antwerp," *Burlington Magazine*, XCVIII, 1956, p. 314, note 5; Morgan Library, *Eighth Annual Report to the Fellows*, 1958, pp. 69–70; Held, *Selected Drawings*, 1959, I, no. 145, II, pl. 150; Burchard-d'Hulst, 1963, p. 185, under no. 116; John Rupert Martin, *The Ceiling Paintings for the Jesuit Church in Antwerp*, Corpus Rubenianum Ludwig Burchard, I, Brussels, 1968, pp. 28–29; Frans Baudouin, *Rubens en zijn eeuw*, Antwerp, 1972, p. 104, fig. 60; John Rupert Martin, *The Decorations for the Pompa Introitus Ferdinandi*, Corpus Rubenianum Ludwig Burchard, XVI, Brussels, 1972, p. 102; Konrad Renger, "Rubens dedit dedicavitque: Rubens' Beschäftigung mit der Reproduktionsgrafik," *Jahrbuch der Berliner Museen*, XVI, 1974, p. 140, note 58; Frans Baudouin, *Pietro Pauolo Rubens*, New York, 1977, p. 154, fig. 109; Bernhard, *Rubens*, 1977, p. 319, repr.; E. Mitsch, *Die Rubenszeichnungen der Albertina*, Vienna, 1977, p. 84, under no. 34.

EXHIBITIONS: Newark, New Jersey, The Newark Museum, *Old Master Drawings*, 1960, no. 33b; Princeton,

Rubens before 1620, 1972, p. 142, no. 15, repr.; Morgan Library, *Major Acquisitions, 1924–1974*, 1974, no. 41, repr.; London, *Rubens*, 1977, no. 142, repr.

<div style="text-align: right">Acc. no. 1957.1</div>

Gift of the Fellows with the special assistance of Mr. Walter C. Baker and Mr. and Mrs. Carl Stern

17. *Six Studies of Heads after Antique Gems and Coins*

(a) *Head of a Bearded Hellene*

Pen and brown ink, black chalk at nape of neck.
2⁵⁄₁₆ × 2 inches (58 × 51 mm.).
Watermark: none visible through lining.

(b) *Head of Medusa*

Pen and brown ink.
1³⁄₈ × 1½ inches (35 × 38 mm.).
Watermark: none visible through lining.

(c) *Head of Medusa*

Pen and brown ink.
2⅛ × 2³⁄₁₆ inches (54 × 55 mm.).
Watermark: none visible through lining.

(d) *Head of a Hellenistic Ruler*

Pen and brown ink.
1⁵⁄₁₆ × 1³⁄₁₆ inches (33 × 30 mm.).
Watermark: none visible through lining.

(e) *Alexander the Great with a Lion Skin*

Pen and brown ink, brown wash, over faint indications in black chalk.
2⁵⁄₁₆ × 2 inches (59 × 50 mm.).
Watermark: none visible through lining.

(f) *Head of a Hellenistic Ruler*

Pen and brown ink.
1⁵⁄₁₆ × 1³⁄₁₆ inches (33 × 31 mm.).
Watermark: none visible through lining.

Rubens, who was instructed in Latin and Greek by Rombout Verdonck as a pupil at the Latin School of Our Lady in Antwerp, was throughout his life interested in all aspects of classical culture and art. He became himself a collector and connoisseur of the antique, with a special bent for archaeology, and corresponded internationally with other collectors and scholars. In addition to the antique marbles acquired prin-

cipally in the famous exchange with Sir Dudley Carleton in 1618 (see No. 12), he collected coins and engraved gems and cameos, and it is known from his correspondence with his friend Nicolas-Claude Fabri de Peiresc (1580–1637) that he and the learned French scholar and antiquarian contemplated a publication on gems and cameos. The project which was to have been illustrated by engravings after Rubens' designs got no further than the production of a frontispiece and a few sheets of engravings. The recent discovery by Dr. van der Meulen-Schregardus of unpublished documents in the Bibliothèque Nationale, Paris (Mss. Fr. N. Acq. 1209 and Fr. 9530), and the Bibliothèque Municipale, Besançon (Ms. Chifflet 189), has extended the knowledge of the contents of Rubens' gem cabinet and brought together the drawings and engravings that can be associated with his collection and the projected publication.

The Morgan group of six small drawings are witness to the care with which Rubens studied and recorded these miniature examples of antiquity. There is little doubt that they were all drawn with a view to the illustrations of the book he and Peiresc were planning. One of them, in fact, can almost certainly be identified with the engraved gem that is described as "Alexander Macedo cum spolio leonis" in the index of the casts of some fifty gems Rubens sent to Peiresc in 1628 (Bibl. Nat. Ms. Fr. 9530, discussed and transcribed by Van der Meulen-Schregardus on pp. 26–27 and 202–09), after Rubens' sale of the originals to the Duke of Buckingham in 1626. It is perhaps the most beautiful of the Morgan group; the fact that it is among the very few of all the known Rubens drawings of this kind that are painstakingly and subtly worked up in wash may indicate that it was an especially cherished piece. It is, likewise, the only Morgan example that appears on one of the eight engraved sheets surviving from the projected publication on gems. (The Rijksprentenkabinet, Amsterdam, preserves six of these engraved sheets, the largest single set in one place; the other two may be seen in the British Mu-

seum, London.) The Alexander head is shown, in reverse, facing a head of Minerva in the lower right half of one of the two sheets of four profile heads engraved by Lucas Vorsterman, who began work for Rubens sometime before 1618. The date the engraver secured his own copyright (July 1622) after his quarrel with Rubens provides a *terminus ante quem* for the drawing and most likely its companions as well. None of the other Morgan heads can be as specifically linked with the documents. Van der Meulen suggests that the model of the *Head of a Bearded Hellene* (a) may have been among the portraits (Homer) listed in the 1628 index of the casts of some of the gems in Rubens' collection; that the gems copied in the two drawings of the head of Medusa (b and c) were possibly among those inherited by Rubens' son Albert and listed in the catalogue of the latter's collection drawn up after his death in 1657 by Jean Chifflet, Canon of Tournai (Besançon, Bibliothèque Municipale, Ms. Chifflet 189); and that either coins or gems might have been transcribed in the drawings of the heads of Hellenistic rulers (d and f).

Among the surviving groups of classical heads drawn by Rubens after coins or gems, the group of five in the British Museum from the Payne Knight Bequest (London, *Rubens*, 1977, nos. 138a–e) is nearest to the Morgan examples. These five also appear to have links with the gem index of 1628, and, in one case, the actual sardonyx cameos of Medusa they record are to be found among the dozen-and-a-half gems from Rubens' collection preserved in the Cabinet des Médailles, Paris. Another group of thirty drawings in the British Museum, mostly showing the heads of Roman emperors, is based in large part on coins as is the set of ten in the Devonshire collection at Chatsworth (Glück-Haberditzl, 1928, nos. 28–37). The drawings in all these sets were apparently cut out from larger sheets at quite an early date; in the case of the Chatsworth examples and five of the British Museum set of thirty drawings this must have been done in the late seventeenth century since each small head bears the stamp of P. H.

51

Lankrink who died in 1692. (The thirty British Museum drawings are probably identical with the thirty listed in the sale of T. Philipe, London, 13–22 March 1817, as lot 675: "Rubens Gems – the original drawings – master sketches in pen and ink by the hand of Rubens, thirty in number, from the collection of Mr. P.H. with the etchings" [i.e., Antique Greek and Roman Coins, Gems, etc. Engraved from Original Drawings of Rubens by G. van der Gucht, 30 May 1740].) It will be noted that each of the Morgan drawings carries the blind stamp of Sir Thomas Lawrence (d. 1830) and so had already been cut out when they were in his possession.

In contrast to these small drawings of heads are Rubens' large drawings in the Stedelijk Prentenkabinet, Antwerp, and the St. Annen–Museum, Lübeck, respectively copied after the famous cameos, the "Gemma Tiberiana" in the Cabinet des Médailles, Bibliothèque Nationale, Paris, and the "Gemma Augustea" in the Kunsthistorisches Museum, Vienna.

PROVENANCE: Paignon Dijonval (1708–1792), Paris; Charles-Gilbert, Vicomte Morel de Vindé, Paris (no mark; see Lugt 2520); sold in 1816 to Samuel Woodburn (no mark; see Lugt 2584); Sir Thomas Lawrence (Lugt 2445); his sale, London, Christie's, 4–8 June 1860, lot 813; sale of a "Well-Known Amateur" ("Brooke" according to annotation in British Museum copy of catalogue and also Fairfax Murray's autograph manuscript notebooks, University of Texas, Austin; "Hope" according to Lugt, *Répertoire*, no. 50106), London, Sotheby's, 20 June 1891, lot 194 (to Murray for £3); Charles Fairfax Murray; J. Pierpont Morgan (no mark; see Lugt 1509).

BIBLIOGRAPHY: Bénard, *Cabinet de M. Paignon Dijonval*, 1810, p. 66, possibly part of no. 1347: "Dix-huit d'études d'antiquités et de medailles: à la plume sur papier blanc; h. 2 po. sur 1 po"; Fairfax Murray, III, no. 162, repr.; Goris-Held, *Rubens in America*, 1947, p. 43, nos. 113–18; Nancy T. DeGrummond, *Rubens and Antique Coins and Gems*, dissertation, University of North Carolina at Chapel Hill, 1968, p. 186, XXIX, fig. 75(a); p. 186, XXX, fig. 76(b); p. 187, XXXI, fig. 77(c); p. 187, XXII, fig. 78(d); pp. 78, 186, XXVIII, fig. 79(e); p. 187, XXXIII, fig. 80(f); Hermance Marjon van der Meulen-Schregardus, *Petrus Paulus Rubens Antiquarius, Collector and Copyist of Antique Gems*, dissertation, University of Utrecht, 1975, p. 90, note 26, p. 146(a); p. 90, note 26, p. 117(b); pp. 28 and 90, note 26, p. 116(c); pp. 28, 67, 90, note 26, pp. 147–48(d); pp. 28, 55, 59, 90, note 26, p. 96, note 43, p. 128(e); pp. 28, 67, 90, note 26, p. 147(f), all repr. fig. XI.

EXHIBITIONS: London, *The Lawrence Gallery: First Exhibition*, 1835, p. 14, no. 35; Cambridge–New York, *Rubens*, 1956, no. 25, repr.; New York, Wildenstein and Company, *Gods and Heroes: Baroque Images of Antiquity*, 1968–69, no. 44, repr.

Acc. no. III, 162

18. *Jesuit Priest in Chinese Costume*

Black and some green chalk.
$16\frac{11}{16} \times 9\frac{5}{8}$ inches (424 × 244 mm.).
Watermark: none visible through lining.
Inscribed at lower right in black chalk, now barely legible, *A.Dyck*.

The imposing figure of a tall elderly European man in Chinese robes and a high felt cap is one of four drawings of men in Chinese dress; a related fifth sheet depicts an Asian in similar if shorter robes, but very different headgear, the distinctive, high transparent horsehair cap peculiar to Korea. The other representations of men in Chinese dress are in the collections of Wolfgang Burchard, London, the Nationalmuseum, Stockholm, and Robert Smith, Washington, D.C. (the former Hobhouse drawing); the present owner of the sheet of the Korean (formerly in the collection of Lady Du Cane) is unknown. All of the drawings are sizable in scale and executed in black chalk with the addition of some red chalk in the faces except in the case of the Morgan figure. The touches of turquoise or green chalk indicating the color of the broad bands of the collar and the girdle in the Morgan drawing also occur in the Stockholm and Washington examples. The latter drawing bears the date *17 Januaris* and an inscription in Latin which reads in Wortley's translation: "Note that the dark color is not peculiar to Chinese scholars but to the Fathers of the Society of Jesus, except for the blue facings which are common to all. The Chinese, furthermore, do not use one color only in their clothing, but any color they like, except yellow, which is reserved for the King." It was this inscription which explained the conjunction of the European faces and the Chinese robes; it refers obliquely to the known historical

fact that it was the eminent Italian Jesuit missionary and scientist Matteo Ricci (1552–1610) whose adoption of the ceremonial square bonnet and silk robes of the Chinese scholar in 1594 helped him to penetrate the upper reaches of the Chinese intellectual aristocracy and even the Ming Court in imperial Peking itself (See the *New Catholic Encyclopedia*, XII, 1967, pp. 470–71).

Like the Morgan drawing, the Stockholm and Washington sheets are inscribed with Van Dyck's name, but the attribution to Rubens has been generally accepted since Clare Stuart Wortley published the group of drawings in 1934. She associated them, though not dogmatically, with the Jesuit festival in Antwerp on 23–24 July 1622, celebrating the canonization of St. Francis Xavier and St. Ignatius of Loyola that had taken place in Rome earlier in the year on 12 March, the account of the festival being owed to an anonymous Jesuit in a small publication of the Plantin Press in 1622. On the second day, the unknown writer noted, there was a great procession in which all the regions of the East where the two celebrated Jesuit missionaries had worked were represented. Students marching as Chinese converts were described by the anonymous Jesuit as dressed in "togas of cotton and wide, and also in girdles hanging down even to the ground," and further wearing on their heads an "almost square pileus." Rubens, as Wortley pointed out, is known to have been in Antwerp at this time and so may have seen the procession or even participated in it as he was a member of the Jesuits' lay guild who marched with lighted candles.

Rubens, however, undoubtedly had other opportunities to familiarize himself with the dress of the Jesuit Fathers in the Far East. As the illustrator of the treatise on optics (1613) by François Aguilon, Rector of the Jesuit College in Antwerp, which was published by the Plantin Press in 1613, and as decorator of the great new church of the Jesuits in Antwerp (see No. 15), on which construction began in 1615 under Aguilon, he must have been *au courant* with im-

portant events at the Jesuit College. If a Jesuit missionary to China like Nicolas Trigault (1577–1628), who made two propaganda journeys through Europe in 1615 and in 1616–17, were in the Netherlands, such news would have surely reached him. Evers (*Peter Paul Rubens*, Munich, 1942, p. 493, footnote 184) made the reasonable suggestion that this group of drawings of Jesuits in oriental robes might have been made in connection with the preparation of *The Miracles of St. Francis Xavier* (Oldenbourg, *Rubens*, Klassiker der Kunst, 1921, p. 205), one of the two monumental paintings for the high altar of the new Jesuit church. As was first noted by Burchard and d'Hulst (p. 183), it is in this painting, which celebrates the missionary activities of the saint, that the Korean headdress of the Du Cane drawing is worn by one of the spectators. If the drawings were to be associated with the painting, they would be dated some time before 1617. The Jesuit church accounts show that payment for the paintings was owing to Rubens on 13 April 1617, from which, Martin states (*The Ceiling Paintings for the Jesuit Church in Antwerp*, Corpus Rubenianum Ludwig Burchard, I, Brussels, 1968, p. 30), "one may infer that the altarpieces were completed, or were very near completion, by that date."

In a recent article, Anne-Marie Logan and Egbert Haverkamp-Begemann suggest not altogether convincingly that the inscribed Washington drawing, which represents the same figure as that in the Stockholm sheet, is Van Dyck's copy after Rubens even though the inscription on the drawing may be in Rubens' hand (*La Revue de l'art*, no. 42, 1978, pp. 97, 99, note 70).

PROVENANCE: Charles Fairfax Murray; J. Pierpont Morgan (no mark; see Lugt 1509).

BIBLIOGRAPHY: Fairfax Murray, III, no. 179, repr. (as Van Dyck); Clare Stuart Wortley, "Rubens's Drawings of Chinese Costume," *Old Master Drawings*, IX, December 1934, p. 43, pl. 44; Goris-Held, *Rubens in America*, 1947, p. 44, no. 122, pl. 108; Held, *Selected Drawings*, 1959, I, no. 105, II, pl. 123; Burchard-d'Hulst, 1963, I, p. 231, under no. 147.

Acc. no. III, 179

Flemish School. Formerly attributed
to Rubens

c. 1610

19. *Landscape with Farm Buildings: "[Het] Keysers Hof"*

Pen and brown ink, watercolor in blue, green, yellow,
and red, over faint indications in black chalk; old loss at
lower edge somewhat to right of center.
9⅛ × 18¹⁵⁄₁₆ inches (232 × 480 mm.).
Watermark: hunting horn (cf. Briquet 7837–39). See
watermark no. 40.
Inscribed in pen and brown ink at lower left, *P. P. Rubens*; on verso below center, in a seventeenth-century
Flemish hand, *dits keyzers hof*.

This fresh landscape is among the most brilliant
of a group of nine sizable drawings in horizontal
format all representing views of Flemish farms
executed in pen and watercolor. Earlier collec-
tors and scholars credited the group to Rubens,
accepting the tradition represented by the neatly
inscribed "P. P. Rubens" that five of the sheets,
the Morgan one included, bear in the lower left
corner, but critical opinion in the main now re-
jects his authorship on the basis of style and a
conflict of date. Jaffé and Held further suggest
that the drawings may be the work of more than
one hand. With one exception each drawing
carries on the verso a note of identification in
a contemporary Flemish hand, once thought to
be Rubens', and including in most instances a
date ranging from 1606 to 1610. The sites re-
ferred to are all small places near Antwerp, no-
tably Deurne, Ruggeveld, and Zwijndrecht. In
connection with the last-named place, Ludwig
Burchard, in a lecture in 1926 at the Kunstge-
schichtliche Gesellschaft in Berlin, pointed out
that Rubens owned property here and elsewhere,
some inherited from his mother, and it seemed
a plausible assumption that the drawings might
record the artist's exploration of the countryside
near Antwerp during the years immediately fol-
lowing his return from Italy late in 1608 when
he was summoned home by the last illness of his
mother (this aspect of Burchard's lecture was
summarized by Paul Wescher, "Federzeichnun-

gen von Rubens im Berliner Kupferstichkabi-
nett, II," *Berliner Museen*, XLVII, 1926, pp. 92–
93). Four of the drawings, the examples in Ant-
werp (Delen, *Écoles flamande . . .*, 1938, I, no.
190), Berlin (Inv. no. 5546. Bock-Rosenberg,
1930, I, p. 254), London (Hind, *Flemish Draw-
ings*, 1923, II, p. 33, no. 107), and Paris (Lugt,
École flamande, Louvre, II, 1949, p. 60, no. 1272),
are dated 1609, and another in Berlin, 1610
(Inv. no. 1540. Bock-Rosenberg, 1930, I, p. 253);
but two other dated drawings, in the British
Museum (Hind, 1923, II, p. 33, no. 106) and
Amsterdam, are inscribed 1606, a year when
Rubens was still in Italy. With Held's publica-
tion, in the Princeton catalogue of 1972, of an
early drawing in the Louvre, *St. Ignatius Contem-
plating the Heavens*, the design for an illustration
in the *Vita Beati P. Ignatii . . .*, Rome, 1609, an
example of Rubens' landscape style at the pe-
riod of the Flemish farm landscapes became
available for comparison. The obvious diver-
gence in style has made it still more unlikely
that Rubens could have drawn the Flemish farm
scenes.

Just who the unknown Flemish draughtsman
was remains a problem. Various names have
been put forward but none with firm conviction.
Frits Lugt in his catalogue of the Louvre's Flem-
ish drawings (see cat. no. 1271) suggested an
artist comparable to such figures as Gillis Peeters,
Gillis d'Hondecoeter, and Jan Wildens. Since
then, the latter's authorship has been rejected cat-
egorically by Dr. Wolfgang Adler whose mono-
graph on Wildens is to be published shortly, and
Professor Held as well has withdrawn his tenta-
tive suggestion of this name. Dr. Adler, in recent
correspondence, states that he is convinced of
Rubens' authorship of these landscapes and will
discuss them in a forthcoming publication on
Rubens. Apropos Gillis d'Hondecoeter, it might
be said that some of the drawings attributed to
him present certain analogies with the group of
farm views, but nothing actually conclusive; at-
tention might also be drawn to *Landscape with the
Prodigal Son*, a signed and dated (162[0]) paint-
ing, which in 1965 was in the hands of P. de

Boer in Amsterdam. The picture shows a central motif of farm buildings under what (in a photograph) appears to be a stormy sky with a large tree at the right, its branches and foliage partially tipped with the light filtering through the storm clouds, in an effect somewhat similarly suggested in the Morgan sheet, which truly preserves a *plein-air* image of a midsummer day with a hint of storm in the dark blue sky.

The other drawings of the group are *Het Crayenhof te Zwijndrecht* (1606) in the Rijksprentenkabinet, Amsterdam; *De hoeve bij de luÿthagen* (1609) in the Cabinet des Estampes de la Ville d'Anvers (Musée Plantin-Moretus), Antwerp; *Moated Grange with Bridge-House* (1606) and *De gastes*[?] *hoef duer dueren* (1609) in the Print Room, British Museum; *Baseliers Hof* (1609) and *De hoeve byet ruhgen velt* (1610) in the Kupferstichkabinett, Berlin; *Het huys Bekelaar . . .* (1609) in the Cabinet des Dessins, Musée du Louvre; and *De hoeve bij Swyndrecht* (undated) formerly in the collection of Robert von Hirsch (sale, London, Sotheby's, 21 June 1978, lot 33) and now in the National Gallery of Scotland, Edinburgh. According to the Hirsch sale catalogue, there is yet another drawing in an English private collection. In their catalogue of European drawings in the Yale University Art Gallery, Haverkamp-Begemann and Logan attribute the drawing *Meadows and Trees near Duren* (no. 590) to the circle of the draughtsman of this group of drawings whom they refer to as the "Master of the Farm Landscapes." They also make the suggestion that no. 591 of the Yale catalogue is a copy after a lost drawing by the "Master." The most comprehensive summary of all these drawings is that of Mielke and Winner in their recent critical catalogue of the Rubens drawings in the Kupferstichkabinett, Berlin.

PROVENANCE: Sir John Charles Robinson (Lugt 1433); his sale ("Well-Known Amateur"), London, Christie's, 12–14 May 1902, lot 337; Charles Fairfax Murray; J. Pierpont Morgan (no mark; see Lugt 1509).

BIBLIOGRAPHY: Max Rooses, *Rubens*, London, 1904, I, p. 52; Fairfax Murray, I, no. 231, repr.; Hind, *Flemish Drawings*, 1923, II, p. 33, no. 107; Bock-Rosenberg, 1930, I, pp. 253–54, under no. 1540; A. J. J. Delen, *Catalogue des dessins anciens: Écoles flamande et hollandaise (Cabinet des Estampes de la Ville d'Anvers)*, Brussels, 1938, I, under no. 190; Bryan Holme, ed., *Master Drawings*, New York, 1943, no. 63, repr.; Goris-Held, *Rubens in America*, 1947, p. 44, no. 125, repr.; Agnes Mongan *et al.*, *One Hundred Master Drawings*, Cambridge, Massachusetts, 1949, p. 68, repr.; A. M. Frankfurter, "Arcadia on Paper," *Art News*, LI, February 1953, p. 45, repr.; Thomas Craven, *Rainbow Book of Art*, New York, 1956, p. 35, repr.; Julius S. Held, "Drawings and Oil Sketches by Rubens from American Collections," review in *Burlington Magazine*, XCVIII, 1956, p. 123, repr.; Michael Jaffé, "A Sheet of Drawings from Rubens' Second Roman Period and His Early Style as a Landscape Draughtsman," *Oud Holland*, LXXII, 1957, no. 1, pp. 9, 14–18; Held, *Selected Drawings*, 1959, I, p. 9; E. Haverkamp-Begemann and Anne-Marie Logan, *European Drawings and Watercolors in the Yale University Art Gallery 1500–1900*, Yale University, New Haven–London, 1970, under no. 590; Julius S. Held, "Rubens and the *Vita Beati P. Ignatii Loiolae* of 1609," in Princeton, *Rubens before 1620*, 1972, p. 132, fig. 64; Bernhard, *Rubens*, 1977, p. 206, repr.; Hans Mielke and Matthias Winner, *Die Zeichnungen alter Meister im Berliner Kupferstichkabinett: Peter Paul Rubens, kritischer Katalog der Zeichnungen*, Berlin, 1977, pp. 119–20, under no. 46 (entry by Mielke).

EXHIBITIONS: Baltimore, Maryland, Johns Hopkins University, *Exhibition of Landscape Painting from Patinir to Hubert Robert*, catalogue by Georges de Batz, 1941, no. 17; Cambridge, Massachusetts, Fogg Art Museum, Harvard University, *Seventy Master Drawings: Paul J. Sachs Anniversary Exhibition*, 1948, no. 31; Minneapolis, Minneapolis Institute of Arts, *Watercolors by the Old Masters*, 1952, no. 10; Morgan Library, *Landscape Drawings*, 1953, no. 54, pl. VI; Cambridge–New York, *Rubens*, 1956, p. 15, no. 9, repr.; Morgan Library and elsewhere, *Treasures from the Pierpont Morgan Library*, 1957, p. 41, no. 89, repr.

Acc. no. I, 231

Frans Snijders
Antwerp 1579 – 1657 Antwerp

20. *Still Life with Dead Game Birds and Deer*

Pen and brown ink, brown wash; squared in black chalk. Stain and old repair at lower right corner; traces of various old folds.

$10\frac{1}{2} \times 14\frac{3}{4}$ inches (266×375 mm.).

Watermark: hunting horn within a shield (cf. Heawood 2645). See watermark no. 41.

Inscribed in a later hand in graphite at lower right, *F. Snyders.*

"The talent of Snyders is to represent beasts but

especiallie Birds altogether dead and wholly without anie action." So wrote the agent Toby Matthews from Louvain to his patron Sir Dudley Carleton, the English collector, in February 1616/17 (W. Noël Sainsbury, *Original Unpublished Papers Illustrative of the Life of Sir Peter Paul Rubens*, London, 1859, pp. 17–18). In the presence of the rather pathetic heap of dead game birds in this typical example of Snijder's draughtsmanship, one can appreciate this seventeenth-century assessment of the artist's gifts. The bird-catcher who furnished Snijders with his luckless models appears to have snared a variety of specimens: the long-billed snipe hanging limply over the edge of the table, the crumpled little partridges on the right, the long-tailed pheasant, and perhaps a lark or two at the left. Equally "altogether dead" is the roe deer, which, like the birds, frequently figures in Snijders paintings and drawings and often in the very same position. In contrast to these stilled lives is the vitality of the two dogs straining on the leash and the abundance of the basket of fruit where the pen line is electric with energy and movement. The drawing was apparently used in preparation for the signed painting in vertical format, which was sold at Parke-Bernet, New York, 13–14 June 1955, lot 325, and is in the possession of Victor Spark, New York. The painting differs from the drawing in a few details; the legs of the dogs, for instance, are shown full length and the drapery beneath the deer extends to the floor while the roses and tulips have been rearranged in a different vase. Greindl connected the drawing with a horizontal painting formerly in the collection of Lady Portarlington and in 1932 in the hands of D. A. Hoogendijk, Amsterdam; there the greatest difference is the substitution of a squirrel for the vase of flowers.

It is characteristic of the artist to introduce animals in lively action—squirrels, cats, and monkeys as well as dogs—into his still-life compositions. A mastiff, a cat, and a squirrel respectively animate the scene in the three other still lifes by Snijders in the Library (Acc. nos. I, 235, 235b–c).

56

PROVENANCE: Charles Fairfax Murray; J. Pierpont Morgan (no mark; see Lugt 1509).
BIBLIOGRAPHY: Edith Greindl, *Les Peintres flamands de nature morte au XVIIᵉ siècle*, Brussels, 1956, p. 56.
Acc. no. I, 235a

Jan Wildens
Antwerp 1586 – 1653 Antwerp

21. *Harvest Scene*

Pen and brown ink, gray, brown, and some blue washes, point of brush and gray wash (in foliage), over faint indications in black chalk; some lines incised with the stylus. 10⁵⁄₁₆ × 14¹³⁄₁₆ inches (262 × 377 mm.).
Watermark: hunting horn, possibly within a coat of arms (cf. Heawood 2646). See watermark no. 42.

This summer harvest scene is a study, in reverse, for the engraving of August in a series of The Months designed by Wildens and published in 1614. Among the other known studies for the engravings are *February* in the Rijksprentenkabinet at Amsterdam (Inv. no. 1940.636); *April* at one time in the collection of A. Mos at Arnhem (sale, Amsterdam, R. W. P. de Vries, 7–8 November 1928, lot 675); *May* in the Fine Arts Museum at Budapest (Inv. no. 1914–22) with autograph replica at P. Prouté, Paris, in 1967; *June* in the Lugt Collection, Institut Néerlandais, Paris (Inv. no. 4490; London and elsewhere, *Flemish Drawings . . . Collection of Frits Lugt*, 1972, no. 121, pl. 93), with another version in the De Grez Collection (Inv. no. 4068), Brussels (formerly ascribed to Adam Willaerts); *July* in Munich (Wolfgang Wegner, *Kataloge der Staatlichen Graphischen Sammlung München, I: Die niederländischen Handzeichnungen des 15.–18. Jahrhunderts*, Berlin, 1973, no. 1072, pl. 133) with another, possibly a copy, in the Kupferstichkabinett, Berlin (Inv. no. 14521. Bock-Rosenberg, 1930, I, p. 320); and *December* also in Munich (Wegner, no. 1073). The task of engraving the series was divided among three printmakers: Hendrik Hondius the Elder (*January, April, May,* and *July*); Jacob Matham (*February, September, November,* and *December*); and Andries Stock who engraved the Morgan drawing (along with *March, June,* and *October*). In this simple, early

landscape, Wildens, friend and collaborator of Rubens, looks back to the Bruegel tradition in theme and style. One is reminded of Pieter Bruegel's painting *The Harvesters* in the Metropolitan Museum of Art, New York, where harvesters pause for rest and refreshment at high noon at the edge of a grain field. It has been suggested that Wildens carried a duplicate set of the designs for The Months (perhaps even proofs of the engravings?) with him on his travels, which almost certainly took him to Italy as there are a great many of his paintings in Genoa. Dr. Wolfgang Adler, whose forthcoming monograph on Wildens will include the Morgan drawing as no. z9, writes that among Wildens' paintings at the Galleria di Palazzo Bianco in Genoa representing The Months, that devoted to August does not correspond to the Morgan drawing and its relevant print, as do the other paintings with their respective prints. He mentions, however, that the painting in the Flor Burton sale at Antwerp, 14 March 1927, lot 29, repr., as School of Rubens, relates to the Morgan drawing; its present location is unknown. The Burton painting is in the same direction as the drawing, which it follows in its essential elements, the chief differences being in the staffage.

Two drawings, one representing February and the other March, were sold at Sotheby Mak van Waay B.V., Amsterdam (3 April 1978, lots 16 and 17). It is possible that two series of drawings and eventually prints were executed.

PROVENANCE: Sale, London, Sotheby's, 22 November 1974, lot 124; Yvonne Tan Bunzl, London.

BIBLIOGRAPHY: Morgan Library, *Eighteenth Report to the Fellows, 1975–1977*, 1978, p. 296.

Acc. no. 1975.20

Gift of the Fellows with the special assistance of Mr. E. Powis Jones

Jacob Jordaens
Antwerp 1593 – 1678 Antwerp

22. *Portrait of a Young Woman*

Black and red chalk, some pen and brown ink, especially in the hair, gray and brown wash over traces of charcoal,

on paper tinted with light brown wash except in areas reserved for highlights, such as the collar and face. Losses at all corners.
16½ × 10⅝ inches (419 × 277 mm.).
Watermark: none visible through lining.
Inscribed in graphite at lower right, barely visible, *P P Rubens.* Inscribed in pen and red ink on old blue mount at lower left, *P. P. Rubens.*; at lower right, *Provenant des collections Crozat, Nourri, St. Maurice etc.* Inscribed on verso of mount in graphite in an old hand, *Lit. R.*; in pen and brown ink at lower center, *Nᵒ. 45. [95?] P. P. Rubens*; in pen and a different brown ink at lower right, *pierre paul Rubens Nᵒ 5 / des collections Crozat, Nourri / et Sᵗ Maurice*; at lower left in pen and red ink in the same hand as on recto of mount, *180 florins.*

The drawing shows an affluent young woman of the bourgeoisie, seated to the left on a chair and wearing a broad-brimmed hat, her gaze directed towards the spectator. In the background at the left are the shaft and base of a column resting on a wall or pedestal, and sweeping diagonally across the right corner behind the young woman is a heavy drapery. This architectural element and the drapery constitute the kind of setting in which Jordaens customarily placed his bourgeois subjects in order to give them a suitable dignity. The sitter has yet to be identified.

This splendid sheet, formerly ascribed to Rubens, was first attributed to Jordaens by Frits Lugt. (Opposite the description of the drawing in his copy of the sale catalogue of the Marquis de Biron [9–11 June 1914, lot 56], where the sheet is listed under Rubens' name, Lugt wrote in Dutch: "is Jordaens. Eerst aan Cossiers gedacht." [It] is Jordaens. First thought of Cossiers.) Though the drawing is clearly a study and not a finished, independent work, no painted portrait based on it is known. Style and technique as well as costume indicate that the sheet was executed c. 1635–40. It is best compared with the *Portrait of a Young Man* in the Boymans–van Beuningen Museum at Rotterdam, a drawing likewise begun in black and red chalk and heightened with white chalk (d'Hulst, *Jordaens*, 1974, I, no. A132; III, pl. 145). The costumes of the two sitters also present certain similarities. They have in common the full, slashed sleeves

and the large collars with scalloped edges. Similar details of costume can be found, as a matter of fact, in other works by Jordaens, namely, in the tapestry *Lady and Gentleman in an Arbor* (no. 5 in the series Scenes from Country Life, dated c. 1635) and some tapestries in the later series The Riding School.

<div align="right">Text by R.-A. d'Hulst</div>

BIBLIOGRAPHY: Morgan Library, *Eighteenth Report to the Fellows, 1975–1977*, 1978, pp. 243, 271.

<div align="right">Acc. no. 1977.42</div>

Gift of the Fellows with the special assistance of a number of Fellows and Trustees in honor of Miss Felice Stampfle

23. *The Satyr and the Peasant*

Watercolor and tempera in blue, red, green, brown, and yellow, over black chalk; squared for enlargement in black chalk.
12 × 9⅝ inches (303 × 245 mm.); sheet extended at top and bottom by the artist.
Watermark: none.

When Jordaens was received as a master in the Guild of St. Luke in Antwerp in 1615, it was as a *waterschilder*, a painter working in watercolor and tempera who on occasion produced large-scale works on canvas that were an inexpensive substitute for tapestry. Though none of Jordaens' works in this category survives, his attractive use of watercolor and tempera is demonstrated in such sheets as the present one. It was used in preparation for an actual tapestry in his suite of eight pieces, each illustrating a Flemish proverb. It was not used, however, without alteration. The scene as shown here illustrates one of the fables of Aesop (Ben Edwin Perry, *Aesopica*, Urbana, Illinois, 1952, p. 335, no. 35). The satyr, astounded that the peasant first blows on his hands to warm them and then on his spoonful of porridge to cool it, is used to point the moral that those who blow first hot and then cold are not to be trusted. In the seventh tapestry of Jordaens' series of eight, the replacement of the satyr with two children, one eating grapes and one placing a wreath around the neck of a goat, transforms the scene into an illustration of the proverb *De natuur is met weinig tevreden (Nature is content with little)*. As in the Morgan drawing, the scenes illustrated in the tapestries are represented as themselves being on hangings suspended from an architectural support, a tapestry within a tapestry, so to speak, an illusionistic device which had as precedent Rubens' cycle of Eucharist tapestries. The same figures appear in little more than half-length in a painting in the Musées Royaux des Beaux-Arts de Belgique at Brussels (*Catalogue de la peinture ancienne*, 1959, p. 70, no. 238). D'Hulst (1974, under I, A38) cites the sketch on the verso of a drawing in the Louvre (Inv. no. 20.028) as one of Jordaens' earliest versions of this popular theme.

Two sets of the tapestries, for the cartoons of which Jordaens signed an agreement on 22 September 1644, are known: one is in the former Schwarzenberg palace at Hluboká, Czechoslovakia, and the other, an enlarged suite, is in the Museo Diocesano, Tarragona, Spain. Two cartoons at the Musée des Arts Décoratifs and at least five other drawings relating to the tapestry project are listed by d'Hulst (1974, II, cat. nos. A416–17; and I, nos. A188, A190–92). The Proverbs tapestry suite was only one of Jordaens' commissions in this area, which included designs for the cycles The History of Alexander the Great, Scenes from Country Life, The Story of Ulysses, and The History of Charlemagne.

PROVENANCE: Charles Fairfax Murray; J. Pierpont Morgan (no mark; see Lugt 1509).

BIBLIOGRAPHY: Max Rooses, *Jacob Jordaens*, London, 1908, pp. 58–60, 186, and 292, repr.; Fairfax Murray, I, no. 236, repr.; Leo van Puyvelde, *Jordaens*, Paris, 1953, pp. 180, note 141, and 231; d'Hulst, *Jordaens*, 1956, pp. 236, 365, no. 107, fig. 155; Michael Jaffé, "Reflections on the Jordaens Exhibition," *National Gallery of Canada Bulletin*, no. 13, 1969, p. 33; d'Hulst, *Jordaens*, 1974, I, pp. 276 and 286–87, no. A200, III, pl. 215.

EXHIBITIONS: Antwerp, Koninklijk Museum voor Schone Kunsten, *Tentoonstelling Jacob Jordaens*, 1905, no. 123; Hartford, *The Pierpont Morgan Treasures*, 1960, no. 73; Antwerp, Rubenshuis, and Rotterdam, Museum Boymans–van Beuningen, *Tekeningen van Jacob Jordaens*, catalogue by R.-A. d'Hulst, 1966–67, no. 78, repr.; Ottawa, National Gallery of Canada, *Jacob Jordaens 1593–1678*, catalogue by Michael Jaffé, 1968–69, p. 199, no. 220, repr., p. 364; Stockholm, *Morgan Library gästar Nationalmuseum*, 1970, no. 61.

Acc. no. I, 236

24. *Vanitas*

Black chalk, point of brush and black tempera, with brown and yellow washes, some pen and brown ink, heightened with white tempera.

9¹¹⁄₁₆ × 13⅛ inches (246 × 334 mm.).

Watermark: none visible through lining.

Inscribed at lower right of old blue mount in pen and brown ink, *Jordaens*. Inscribed on verso of old mount at lower right in graphite, presumably by three different hands, *A true Drawing W / very fine M / D° Ph* (for other drawings commented on by the same three individuals, see Nos. 34 and 40); in graphite in another hand, *Jordaens from Calonnes Sale / 3. 13. 6*; in graphite in Fairfax Murray's hand, *Engraved – the print is / with Plantin Moretus / No. 13.*

The key to the subject of this drawing is given by the related drawing in the Ashmolean Museum, Oxford, which carries the words of the proverb KENT. U. SELVEN (Know thyself) inscribed in the cartouche (d'Hulst, 1974, I, no. A203; III, pl. 218). This proverb, as d'Hulst noted, would have been familiar to Jordaens through such a book as that of the Dutch poet Jacob Cats, *Spiegel van den Ouden ende Nieuwen Tijdt* (The Hague, 1632), where, in fact, most of the sayings Jordaens illustrated in his tapestry series of Proverbs are found (see No. 23). In both the Oxford and Morgan drawings, the young woman holds her comb in the left hand, an indication that the composition was designed for translation into another medium where it would appear in reverse and the figures consequently right-handed.

The Oxford drawing was possibly connected with the project of the Proverbs tapestries; the larger and highly finished Morgan drawing, however, appears to have served as the model for a contemporaneous engraving where the title was translated into Latin, *Nosce te ipsum*, and four lines of verse added: *Stulta, quid ad speculum fastus assumis inanes: / Atquè tibi formâ, quae peritura, places? / Hic cernis quod eris, quodque es, quid credere cessas? / Quâ loquor, haec forsan iam dabit hora fidem; Iac. Iordans pinxit, A. Bloteling Excudit Cum Privilegio* (see R. Hecquet, *Catalogue d'estampes gravées d'après Rubens, auquel on a joint l'oeuvre de J. Jordaens et celle de C. De Visscher*, Paris, 1751, no. 27; Hollstein, XIV, p. 138, no. 27; Jaffé, no. 314, impression in Bibliothèque Royale de Belgique, Brussels, repr.). According to Rooses (pp. 179–80), the *Nosce te ipsum* print was a copy of an engraving by Jacob Neefs (1610 – after 1660; Le Blanc, III, p. 95, no. 33). Hollstein, however, lists the *Nosce te ipsum* print as that by Neefs; d'Hulst and Jaffé describe it as anonymous. There is a copy of the Morgan drawing in the Louvre (d'Hulst, 1974, II, no. c62; III, pl. 219); of the Oxford drawing, at the Hessisches Landesmuseum, Darmstadt (d'Hulst, 1974, II, no. c37; IV, pl. 515). Three paintings of the subject, with some variations, are known, but none has a claim to being the original. According to d'Hulst (1974, I, p. 290 under no. A203), the best is in the museum at Saint-Brieuc, Brittany; a second at the museum of Saint-Lô, Normandy; and a third was auctioned in Vienna on 4 December 1962 as lot 50.

The identity of the three individuals whose comments on this drawing are recorded on the verso of the old mount has yet to be ascertained. While it is probably debatable as to whether the inscriptions are by the same hand or three different ones, it is clear that three different opinions are cited. Several scholars have made the tentative suggestion that "W" may refer to the dealer Samuel Woodburn (1786–1853) and

"Ph" possibly to the expert Thomas Philipe (died c. 1817).

PROVENANCE: James Hazard (no mark; see Lugt 1322); his sale, Brussels, Deroy, 15 April 1789, lot 82; Charles Alexandre de Calonne; his sale, London, Skinner & Dyke, 23–28 March 1795, probably lot 41, "Two by Van Dyck and Jordaens" or lot 42, "One Ditto, by Jordaens, fine"; Henry Temple, second Viscount Palmerston (1739–1802); Hon. Evelyn Ashley (by bequest from Lord Palmerston); his sale, London, Christie's, 24 April 1891, one of four in lot 120; Charles Fairfax Murray; J. Pierpont Morgan (no mark; see Lugt 1509).

BIBLIOGRAPHY: Fairfax Murray, I, no. 237, repr.; Max Rooses, *Jacob Jordaens*, London, 1908, pp. 180, 182, 262, repr. p. 179; K. T. Parker, *Catalogue of the Collection of Drawings in the Ashmolean Museum*, I, Oxford, 1938, p. 63, under no. 147; Lugt, *École flamande, Louvre*, 1949, I, p. 76, under no. 745; L. van Puyvelde, *Jordaens*, Paris, 1953, p. 156; d'Hulst, *Jordaens*, 1956, p. 367, under no. 112 and p. 410, no. 219 (as workshop copy); Julius S. Held, "Jordaens at Ottawa," review in *Burlington Magazine*, CXI, 1969, p. 267 (as Jordaens); R.-A. d'Hulst, "Jordaens," review in *Art Bulletin*, LI, 1969, p. 383 (uncertain as to Jordaens' authorship); J. Michalkowa, "Jordaens w Ottawie," review in *Biuletyn Historii Sztuki*, XXXIV, 1969, pp. 306 and 315; d'Hulst, *Jordaens*, 1974, I, pp. 290–91, no. A204, III, pl. 219 (as Jordaens); Antwerp, Plantin-Moretus Museum, *Jacob Jordaens: Tekeningen en grafiek*, exhibition catalogue by R.-A. d'Hulst, 1978, pp. 143–44, under no. 95.

EXHIBITIONS: Ottawa, National Gallery of Canada, *Jacob Jordaens 1593–1678*, catalogue by Michael Jaffé, 1968–69, p. 206, no. 233, repr. p. 370; Milwaukee, University of Wisconsin, *Rubens*, 1977, p. 7, no. 12, repr.

Acc. no. I, 237

25. *"Except ye be . . . as little children . . ."*
Matthew 18:3

Pen and brown ink, red chalk, with some preliminary indications in black chalk, brown wash; touches of white heightening on Christ's robe and hand.
7¼ × 6⅚ inches (185 × 160 mm.).
Watermark: none visible through lining.

Inscribed by the artist in pen and brown ink at lower edge, [Ma]tt 18/2 – Het En sy dat ghy het Rycke der Hemelen ontfa[nkt] / als Een Kindeken soo en suldt ghy daer niet In Comen (a free rendering of Matthew 18:3, "Verily I say unto you, Except ye be converted and become as little children, ye shall not enter into the kingdom of heaven"); at lower left in another hand in black chalk, partially traced over with brown ink, *Jordans*.

Such drawings as this illustration of a New Testament text perhaps are a reflection of the art-

ist's conversion to the Protestant faith which he openly embraced in the 1650's. He produced a small group of similar sheets, each bearing his written transcription of the biblical verses he was illustrating. There are examples in Brussels, Stockholm, Leningrad, Moscow, and Warsaw (d'Hulst, 1974, II, nos. A349, 351, 352–54). None of the group seems to relate to any known project. Another comparable drawing in the Morgan Library with a biblical text in Jordaens' hand (Acc. no. III, 168; d'Hulst, 1974, II, no. A326), a larger but less fresh sheet than the present one, may possibly have been intended as a tapestry design.

PROVENANCE: Charles Sackville Bale (no mark; see Lugt 640); his sale, London, Christie's, 9 June 1881, lot 2332 (to Butler); Charles Fairfax Murray; J. Pierpont Morgan (no mark; see Lugt 1509).

BIBLIOGRAPHY: Max Rooses, *Jacob Jordaens*, London, 1908, pp. 220 and 269, repr.; Fairfax Murray, I, no. 238, repr.; d'Hulst, *Jordaens*, 1956, p. 398, no. 188; Walther Bernt, *Die niederländischen Zeichner des 17. Jahrhunderts*, Munich, 1957, I, no. 322, repr.; Eduard Trautscholdt, review of Bernt, *Kunstchronik*, XI, 1958, p. 369; d'Hulst, *Jordaens*, 1974, II, no. A355, IV, pl. 373.

EXHIBITION: Antwerp, Koninklijk Museum voor Schone Kunsten, *Tentoonstelling Jacob Jordaens*, 1905, no. 100.

Acc. no. I, 238

26. *Christ among the Doctors*
Luke 2:46

Watercolor and tempera in blue, red, yellow, and green, with pen and brown ink, over red and black chalk. Slight sketch of half-length figure in red chalk, at upper center, in opposite direction.
17⁵⁄₁₆ × 13¹⁄₁₆ inches (440 × 332 mm.); sheet extended on both sides with vertical strips between 32 and 40 mm. in width; extended sheet has been lined.
Watermark: none visible through lining.

Inscribed in black chalk at lower right corner, *2*; in graphite on verso at lower left, *Philipes Sale June 1807 / 3 day Lot 69 £2.17.6*.

This study, together with another equally well-worked design in Antwerp, shows the attention Jordaens gave to the development of the composition of his large painting executed in 1663 for the high altar of the church of St. Walpurgis

at Furnes, Belgium, and now in the museum at Mainz, Germany. Neither model was followed explicitly in the painting but, in many respects, the Morgan sheet, especially the right half, is nearer to the finished work than the drawing in Antwerp, which is presumed to be the earlier study. The bespectacled scribes seated at the table in the right foreground are closer to those of the altarpiece and the same is true of the doctor who stands behind them, speculatively fingering his beard. The ornamental winged female creatures with serpentine tails which appear on the added side strips of the Morgan sheet, but are not found in the Antwerp version, are present in the altarpiece. On the other hand, in the Antwerp study the central figure of the twelve-year-old Christ stands (rather than sits) by the lectern as he does in the painting. Curiously, in the Morgan drawing there is a very summary red chalk notation of the upper half of this figure of the standing Christ in the area of the large candelabrum but oriented in the opposite direction and apparently drawn over the finished design. (The sketch is hard to discern in reproduction but is clearly visible in the original.) The lightly sketched figure raises the right arm and reaches across the body with the left in the attitude of the Antwerp Christ. This might be interpreted as evidence that the Morgan study came first and that the Antwerp study was then developed as an alternative solution but eventually discarded except for the figure of the standing Christ. Possibly, however, it is an indication of the artist's decision to return to his first idea of showing the boy Christ standing and to eliminate the candelabrum which is given decided prominence in the Morgan design. In this connection the numeral "2" inscribed in the lower right corner of the present sheet may or may not be significant. A third drawing connected with the painting, but not with either the Morgan or Antwerp drawing, is the study at Besançon of the doctor represented picking up a book in the left foreground of the picture (d'Hulst, 1974, II, no. A397; IV, pl. 418). D'Hulst under his no. A395 also mentions a

second picture in the Alte Pinakothek, Munich, similar in composition but altered "with studio help" to a horizontal format.

The enlargement of the sheet of paper by the addition of two vertical strips on either side is a typical practice, even idiosyncrasy, of Jordaens who very often pieced out the sheet of paper on which he drew. Whether the piece at hand was large or small, he seems to have more often than not found its given surface inadequate to carry his ideas which spilled over at the margin and required the accommodation of additional paper.

PROVENANCE: Thomas Philipe (no mark; see Lugt 2451); sale, London, Christie's, 3–5 June 1807, lot 69; Henry Temple, second Viscount Palmerston (1739–1802); Hon. Evelyn Ashley (by bequest from Lord Palmerston); his sale, London, Christie's, 24 April 1891, one of three in lot 177; Charles Fairfax Murray; J. Pierpont Morgan (no mark; see Lugt 1509).

BIBLIOGRAPHY: Max Rooses, *Jacob Jordaens*, London, 1908, p. 212, repr.; Fairfax Murray, III, no. 170, repr.; Hans Kauffmann, "Die Wandlung des Jacob Jordaens," *Festschrift Max J. Friedländer*, Leipzig, 1927, p. 200; Leo van Puyvelde, *Jordaens*, Paris, 1953, p. 190, fig. 45; d'Hulst, *Jordaens*, 1956, pp. 299 and 401–02, no. 195, pl. 196; d'Hulst, *Jordaens*, 1974, II, no. A396, IV, pl. 417; James Byam Shaw, *Drawings by Old Masters at Christ Church, Oxford*, Oxford, 1976, I, p. 336, under no. 1382; Antwerp, Plantin-Moretus Museum, *Jacob Jordaens: Tekeningen en grafiek*, exhibition catalogue by R.-A. d'Hulst, 1978, pp. 130–31, under no. 79.

EXHIBITIONS: Antwerp, Koninklijk Museum voor Schone Kunsten, *Tentoonstelling Jacob Jordaens*, 1905, no. 96; Minneapolis, Minneapolis Institute of Arts, *Watercolors by the Old Masters*, 1952, no. 12; Brussels, Musées Royaux des Beaux-Arts de Belgique, *Le Siècle de Rubens*, 1965, p. 305, no. 330, repr.; Ottawa, National Gallery of Canada, *Jacob Jordaens 1593–1678*, catalogue by Michael Jaffé, 1968–69, pp. 221–22, no. 263, repr. p. 383.

Acc. no. III, 170

Lucas van Uden

Antwerp 1595 – 1672 Antwerp

27. *Woodland with Monastic Buildings*

Pen and brown ink, gray wash, and watercolor in red, blue, and yellow over faint indications in graphite. Water staining in sky with later touches of white tempera; several slight losses at lower right.
8¾ × 12¼ inches (222 × 311 mm.).

Watermark: none visible through old lining which appears to be an engraving.
Numbered on verso at lower left in pen and brown ink, N° 379.

This view of a quiet woodland where a monastery is half-hidden away was used with very little change in Van Uden's panel painting in the Oeffentliche Kunstsammlung in Basle (Inv. no. 1145). The painting, however, does include a number of figures of fishermen, probably the work of David Teniers who sometimes supplied the staffage in Van Uden's landscapes. Three of the fishermen are depicted seining for fish in the pond and four others sharing their catch with a hooded monk. The latter's habit with its peaked hood at once identifies him, and consequently the monastery, as belonging to the Order of the Capuchins, a branch of the Franciscans. The drawing can also be associated with Van Uden's etching of a Capuchin monastery (Bartsch, no. 56; Le Blanc, IV, p. 66, no. 44) where the building that is seen in the center distance of the drawing appears to be represented from a somewhat different viewpoint and where again the presence of two friars wearing the distinctive pointed capuche marks the building as a Capuchin property. The building is, in fact, identified as the monastery of the Capuchins in the Forest of Soignes at Tervueren, southeast of Brussels, which was suppressed in 1796 and no longer exists.

Van Uden's etching does not show the four small edifices grouped around a central fifth in a rectangular complex that occupies the right corner of both the drawing and the painting. This unusual architectural feature, however, is to be seen in the left corner of the engraving showing a bird's-eye view of the monastery and its extensive grounds in Antonius Sanderus' *Flandria illustrata* . . . [Cologne], 1641–44 (repr. Alphonse Wauters, *Histoire des environs de Bruxelles*, 1973, IX B, p. 292, no. 521). The cluster of little buildings sheltered in the drawing by three ash trees—the site was known as Essenbosch (Flemish for ash wood)—constituted the infirmary of the monastery, the central structure crowned

with a small lantern being the chapel. (This information is owed to the helpfulness of M. Willy Laureyssens of the Musées Royaux des Beaux-Arts de Belgique, Brussels. See Sander Pierron, *Histoire illustrée de la forêt de Soignes*, Brussels, 1905, III, p. 402.) The pious Archduchess Isabella, who gave the ground for the monastery in the Forest of Soignes, laid the cornerstone in 1626 and was herself accustomed to retire to the monastery for meditation in a special little hermitage which she had had built at the end of the gardens (see Eugène de Seyn, *Dictionnaire historique et géographique des communes belges*, Turnhout, 3rd ed. [1950], II, p. 1296).

Van Uden must have spent some time in the neighborhood of the monastery for he represented it from several vantage points in two other drawings in the same muted watercolors. In that now in a private collection in Augsburg (formerly in the collection of E. Cichorius, Leipzig, and later O. Huldschinsky and E. J. Otto, both of Berlin), he depicted the complex of small pavilions reflected in a pond with a fisherman in the right foreground (*Zeichnungen alter Meister aus deutschem Privatbesitz*, exhibition catalogue, Hamburg, 1965, cat. no. 125, fig. 58; pen and watercolor, 215×345 mm.). In a drawing of comparable scale in the Courtauld Institute of Art, Witt Bequest, London (Inv. no. 2175), the artist viewed the pavilions from the "land side," as it were, with a glimpse of the monastery wall on the far right. Since this drawing is signed with the artist's initials and dated 1640, it provides a date for the related New York and Berlin sheets as well, and probably also for the print which must have been done about the same time.

One might reasonably conclude that the Basle painting was likewise not too distant in date. When it was exhibited at the retrospective exhibition of Flemish landscape held at the Musée Royal des Beaux-Arts de Belgique, Brussels, in the autumn of 1926, the painting was shown with a pendant, both under the title *L'Abbaye des Capucins dans la forêt de Soignes* and both then the property of Léon Rotthier of Brussels

(nos. 324 and 325 of the exhibition catalogue by Fierens Gevaert, not repr.). The pendant with a shepherd and shepherdess in the company of their flocks, probably also by Teniers, shows the monastery from a point not unlike that of the prints but the whole in reverse.

PROVENANCE: Unidentified collector (his *No. 379*; see Lugt S. 2986b); Charles Fairfax Murray; J. Pierpont Morgan (no mark; see Lugt 1509).

BIBLIOGRAPHY: Fairfax Murray, I, no. 239, repr.; *Great Drawings of All Time*, 1962, II, no. 561, repr.; Eisler, *Flemish and Dutch Drawings*, 1963, pl. 50.

EXHIBITION: Morgan Library, *Landscape Drawings* 1953, p. 24, no. 57, repr.

<div align="right">Acc. no. I, 239</div>

Anthony van Dyck

Antwerp 1599 – 1641 London

28. *The Martyrdom of St. Lawrence*

Pen and brown ink, point of brush and brown and gray washes.
9⅞ × 6¹¹⁄₁₆ inches (240 × 170 mm.).
Watermark: illegible fragment. See watermark no. 54.
Inscribed in pen and black ink at lower right, *3*[?]; on verso in graphite at lower edge and in opposite direction, fragmentary computations and *Antony van | Dyck*; inscribed on the old mount, in pen and black ink, by Roupell, *RPR | Van Dyck | Martyrdom of St Lawrence | from the Norblen Collection (Paris) | One of the 50 drawings selected for | Exhibition by Messrs. Woodburn in the | Lawrence Gallery in July 1835.*

Van Dyck's point of departure for this composition was Rubens' painting of the subject. That picture, which is now in the Bayerische Staatsgemäldesammlungen, Munich (Oldenbourg, *Rubens*, Klassiker der Kunst, 1921, p. 109; H. Vlieghe, *Saints II*, Corpus Rubenianum Ludwig Burchard, VIII, Brussels, 1973, pp. 107–08, no. 126, fig. 71), is usually dated about 1615–16, and it is assumed that the Morgan drawing was created several years later. The sheet provides a striking demonstration of the way in which the young draughtsman studied and radically adapted the older artist's composition. He retained the central diagonal of the saint's body,

the pointing finger of the old man—pointlessly, it might be said, because he does not show the statue of Jupiter which is the reason for the gesture in Rubens' painting—the plumed helm, the hands holding the body of the saint, but throughout there is heightened agitation and evidence of movement, noticeable especially in the extreme torsion of the saint's body and the impossible *contrapposto* of the executioner at the left. Van Dyck first sketched with a fine-pointed pen in brown ink and applied some gray wash and then, perhaps even on a later occasion, boldly shaded and reworked outlines with the brush, almost as if he had "corrected" his own work and to very dramatic effect. No related painting by Van Dyck is known although George Vertue, the eighteenth-century English artist and writer on art, mentioned in his *Notebooks* that a *Martyrdom of St. Lawrence* by Van Dyck brought 65 guineas at Lord Radnor's sale ("George Vertue, Notebooks," *Walpole Society*, XVIII, 1929–30, p. 132). It may well be that the drawing was only an exercise which was never carried further. The drawing was engraved, in the reverse direction with some variations, by Anton van der Does (1609–1680; Hollstein, VII, p. 113, no. 168).

PROVENANCE: Possibly Samuel van Huls, former burgomaster of The Hague; his sale, The Hague, Swart, 14 May 1736, Portfolio M, lot 549, "St. Laurent & 2 autres"; Jean-Pierre Norblin de la Gourdaine (1745–1830), Paris; Sir Thomas Lawrence (no mark; see Lugt 2445–46); Robert Prioleau Roupell (no mark; see Lugt 2234); his sale, London, Christie's, 12–14 July 1887, lot 1182; also sale (Roupell), Frankfurt, F. A. C. Prestel, 6 December 1888, p. 13, lot 47, ". . . Eine der 50 von Woodburn gewählten Zeichnungen, die 1835 in der Lawrence Gallery ausgestellt wurden"; George Edward Habich (Lugt 862); sale, Edward Habich, Stuttgart, H. G. Gutekunst, 27–29 April 1899, lot 246; Charles Fairfax Murray; J. Pierpont Morgan (no mark; see Lugt 1509).

BIBLIOGRAPHY: J. Guiffrey, *Antoine van Dyck: Sa vie et son oeuvre*, Paris, 1882, p. 251, no. 197; O. Eisenmann, *Ausgewählte Handzeichnungen älterer Meister aus der Sammlung Edward Habich zu Cassel*, Lübeck, 1890, III, no. 10, repr. (2nd ed., Leipzig, 189[?], no. 33, repr.); *25 Handzeichnungen alter Meister aus der Sammlung Habich*, Kassel [n.d.], no. 7, repr.; Fairfax Murray, III, no. 177, repr.; Vey, *Van Dyck*, 1962, I, no. 71, II, pl. 97.

EXHIBITION: London, *The Lawrence Gallery: Second Exhi-*

bition, 1835, p. 14, no. 43, "The Martyrdom of St. Lawrence – a spirited study: free pen, and bistre wash. Size, 7 inches by 9½ inches. From the Collection of M. Norblin, Paris."

Acc. no. III, 177

29. *The Mystic Marriage of St. Catherine*

Pen and brown ink, brown wash. Verso: Study in pen and brown ink of the back of a male torso seen from above.

6³⁄₁₆ × 9¼ inches (158 × 235 mm.).

Watermark: none.

Illegibly inscribed in Flemish in pen and brown ink and black chalk by the artist in lower left corner, in opposite direction; inscribed at lower right in graphite by a later hand, *Vandick*. Inscribed on verso by Roupell in graphite, *357 Lawrence | Woodburn 18 | Bot by me at Morants 1862*; numbered at lower right corner, *10*. Inscribed by Roupell on the mount in graphite, *A. van Dyck | "Marriage of St. Catherine." | no 6 In the Lawrence Gallery exhib. 1835. | Norblin Coll. Morant* (in another hand) *bought by Mr. Roupell at Morant's Sale*.

In his earlier years, Van Dyck seems to have made a great many compositional studies when preparing to execute a painting, sometimes as many as ten or eleven drawings being devoted to the evolution of a satisfactory scheme. The present drawing is one of a long sequence in which he experimented with possible solutions for the composition of his painting now in the Museo del Prado, Madrid, a picture probably executed in his first Antwerp period before he went briefly to England in 1620 (Glück, *Van Dyck*, Klassiker der Kunst, 1931, p. 60). Vey lists six compositional studies in pen and wash plus a black chalk study from the model for the figure of the Virgin, probably unjustly rejecting the sheet of the two variant pen sketches of the Child in the Jaffé collection as a copy (Vey, I, no. 58; Justus Müller Hofstede, "New Drawings by Van Dyck," *Master Drawings*, XI, 1973, p. 156, no. 3, pl. 20, as Van Dyck). In what was perhaps Van Dyck's first essay, the drawing in the Lugt Collection at the Institut Néerlandais, Paris (Vey, I, no. 52, II, pl. 70), the group of the Virgin and Child are seen frontally and occupy the relative center of the scene. In a sketch in Berlin (Vey, I, no. 59, II, pls. 79, 80) the Virgin ap-

pears in profile to the right and St. Catherine to the left; in the Bremen drawing that was destroyed in 1945 (Vey, I, no. 53, II, pl. 72), the group of Mother and Child is shifted very much to the left although the Virgin is still seen primarily from the front. In a rough abbreviated sketch on the verso of a drawing in the Courtauld Institute, London (Vey, I, no. 44, II, pls. 58, 60), for the *Worship of the Brazen Serpent* (a painting also from the first Antwerp period, now in the Prado), the Virgin is still on the left but is now viewed in profile. From then on Van Dyck seems to have adhered to this arrangement but experimented further with the position of the Child and eventually eliminated some of the saintly spectators. Apparently content with the composition arrived at in terms of the slashing pen lines of the Morgan sheet, he repeated it in more finished form in the drawing at Chatsworth (Vey, I, no. 55, II, pl. 75). (There is a copy of the Chatsworth drawing in the Louvre [Lugt, *École flamande, Louvre*, 1949, I, p. 56, no. 605].) But it was only in the drawing formerly belonging to the Rump Collection, Copenhagen, which was lost sight of after its sale as lot 167 at Amsler & Ruthhardt, Berlin, in May 1908 (Vey, I, no. 56, II, pl. 76), that Van Dyck finally settled on the compact composition he followed in the Madrid painting though he deleted the Rump drawing's central figure of St. George[?] which had been retained up to this point. The figure of Joseph seen behind the Virgin in the present sheet also was banished in the Rump drawing and in the painting, an angel with a palm standing directly behind the child was introduced, and the saints behind St. Catherine limited to two.

The strongly modeled study of a male torso prostrate on the ground, on the verso of the Morgan drawing, was perhaps done after an antique sculpture.

Since Roupell acquired the Morgan drawing at the Morant sale in 1862, it could not have been the same as a drawing of the subject listed in the J. C. Robinson sale in the Hôtel Drouot at Paris, 7–8 May 1868, as lot 61, although the measurements of the Robinson drawing are

nearer to the Morgan sheet than to any of the other drawings of the subject listed by Vey.

PROVENANCE: Jean-Pierre Norblin de la Gourdaine (1745–1830); Sir Thomas Lawrence (Lugt 2445, scarcely visible in lower left corner); George J. Morant (no mark; see Lugt 1823); his sale, London, Foster, *A Catalogue of an Important Collection of Works of Art of a Well Known Amateur*, 9–16 April 1862, lot 226 (to Roupell); Robert Prioleau Roupell (no mark; see Lugt 2234); his sale, London, Christie's, 12–14 July 1887, p. 98, lot 1198; Charles Fairfax Murray; J. Pierpont Morgan (no mark; see Lugt 1509).

BIBLIOGRAPHY: Lugt, *École flamande, Louvre*, 1949, I, under no. 605; Horst Vey, *Van Dyck–Studien*, Cologne, 1958 (dissertation, Cologne, 1955), pp. 83ff.; *Great Drawings of All Time*, 1962, II, no. 546, repr.; Vey, *Van Dyck*, 1962, I, no. 54, II, pls. 73, 74; Julius Held, review of Vey, *Art Bulletin*, XLVI, 1964, p. 567; Washington, D.C., National Gallery of Art, and elsewhere, *Old Master Drawings from Chatsworth*, II, exhibition circulated by International Exhibitions Foundation with catalogue by James Byam Shaw, 1969–70, under no. 81; London and elsewhere, *Flemish Drawings . . . Collection of Frits Lugt*, 1972, under no. 27; Princeton, New Jersey, The Art Museum, Princeton University, *Van Dyck as Religious Artist*, exhibition catalogue by John Rupert Martin and Gail Feigenbaum, 1979, p. 85, fig. 22, p. 88 under no. 20.

EXHIBITIONS: London, *The Lawrence Gallery: Second Exhibition*, 1835, p. 8, no. 6; Antwerp, Rubenshuis, and Rotterdam, Museum Boymans–van Beuningen, *Antoon Van Dyck: Tekeningen en olieverfschetsen*, catalogue by R.-A. d'Hulst and Horst Vey, 1960, no. 28, pl. xv.

Acc. no. I, 245a

30. *Diana and Endymion*

Pen and point of brush, brown ink and brown wash, heightened with white tempera on gray-blue paper. 7½ × 9 inches (190 × 228 mm.).

Watermark: none visible through lining.

Inscribed on old mount, in the hand of the collector Jacob de Vos Jbzn, in pencil, *K Dec 65* (date, 1865, of one of the art historical conferences in *Arti et Amicitiae* at Amsterdam where the collector showed his drawings); in red ink, /r[?].t.e.

Within the swirling pattern of pen and brush strokes in this interesting study sheet, two designs for a composition of Diana and Endymion can be discerned, one above the other. It is not too difficult to retrace the artist's course of action. There is little doubt that he first quickly

and lightly sketched in the lower group with his pen, showing the moon goddess kissing the cheek of the sleeping shepherd whose beauty had drawn her to earth. He then tried a variant pose above; there Diana, clearly identified by the crescent diadem, only watches the youth as he sleeps, his body now more definitely relaxed in a reclining position and his legs shown crossed. Alternate positions for Diana's left arm were considered, but in the end the artist turned again to the first sketch and carried it further with rapid applications of wash. With the point of his brush he drew another cherub at the left and emphasized the fluttering draperies that suggest the *glissando* movement of the goddess "sliding from her sphere." The white highlighting in the upper sketch is perhaps suggestive of the moonlight appropriate to the scene and the cupid with the smoking torch is a further indication of the night setting. The drawing, if not from Van Dyck's Italian years 1621–27, must have been executed soon after his return to Antwerp.

It is difficult to understand Vey's statement that the upper group was added by another hand; ink and execution are unquestionably identical throughout. (This was also pointed out by Held in his review of Vey's monograph in the *Art Bulletin*.) Equally misguided is his identification of the sleeping figure in the lower sketch as Diana, a misconception probably deriving from confusion with the Madrid painting where the goddess is seen sleeping. In earlier years the subject of the Morgan sheet was wrongly identified as Venus and Adonis. Fairfax Murray noted this error on page 96 of his autograph manuscript notebooks, University of Texas, Austin, after he had acquired the drawing in 1891 from Seymour Haden's sale where it was so catalogued.

No related picture is known; the very different version of the theme in Madrid (Glück, *Van Dyck*, Klassiker der Kunst, 1931, p. 141) is thought to be a much earlier work than this drawing.

PROVENANCE: William Young Ottley (no mark; see Lugt 2662–65); Samuel Woodburn (no mark; see Lugt 2584); Sir Thomas Lawrence (Lugt 2445; not in *Law-*

rence Gallery: Second Exhibition, 1835); Jacob de Vos Jbzn (Lugt 1450); his sale, Amsterdam, Roos, Muller . . . , 22–24 May 1883, lot 145 (to Thibaudeau for 510 florins); Sir Francis Seymour Haden (Lugt 1227); his sale, London, Sotheby's, 15–19 June 1891, lot 546 (to Murray for £4.4); Charles Fairfax Murray; J. Pierpont Morgan (no mark; see Lugt 1509).

BIBLIOGRAPHY: Fairfax Murray, I, no. 240, repr.; Tietze, European Master Drawings, 1947, p. 124, under no. 62; Great Drawings of All Time, 1962, II, no. 548, repr.; Vey, Van Dyck, 1962, I, no. 132, II, pl. 173; Eisler, Flemish and Dutch Drawings, 1963, pl. 43; Julius S. Held, review of Vey, Art Bulletin, XLVI, 1964, p. 566.

EXHIBITIONS: New London, Connecticut, Lyman Allen Museum, Fourth Anniversary Exhibition: Drawings, 1936, no. 71; Morgan Library, An Exhibition Held on the Occasion of the New York World's Fair, 1939, no. 79 (1940 ed., no. 96); New York, M. Knoedler and Company, Great Master Drawings of Seven Centuries, 1959, no. 45, pl. XXXI; New York, Wildenstein and Company, Gods and Heroes: Baroque Images of Antiquity, 1968–69, no. 56, repr.

Acc. no. I, 240

31. *Study for a Portrait of a Woman and Her Daughter*

Black chalk; a few strokes in pen and brown ink on the sitter's left sleeve.
12½ × 10 5/16 inches (317 × 262 mm.).
Watermark: hunting horn within a coat of arms; illegible countermark. See watermark no. 45.
Inscribed in pen and brown ink at lower right, *P. P. Rubens.*

The Flemish woman depicted here with her small daughter is a study for the painting in the Alte Pinakothek, Munich (Glück, *Van Dyck*, Klassiker der Kunst, 1931, p. 289). The painted portrait was at one time thought to represent the wife and child of the Flemish sculptor Andreas Colyns de Nole (before 1590 – 1638) on the supposition that the presumed companion portrait of a man represented the sculptor himself. That idea, however, has been discarded in view of the lack of resemblance between the man in the portrait and the engraved likeness of De Nole by P. de Jode the Younger and the fact that there also is some doubt that the two portraits constitute a pair because of differences in format. The woman and her child thus remain in anonymity.

Glück noted that a drawing by Juriaen Ovens in the Kunsthalle, Hamburg, which is a copy after the painted portrait in Munich, is inscribed *by myn Heer Leers tot Antwerp* and that accordingly the woman might have been a member of the Leerse family. Van Dyck portrayed Sebastian Leerse with his wife and son in a painting in Kassel (Klassiker der Kunst, p. 303).

Van Dyck characterized the woman's countenance more incisively than might have been expected in a drawing made primarily for the purpose of establishing the pose and setting, and one wonders if her likeness was not truer in this quick study than in the painting where her face is much longer. Vey suggests that the left eye was retouched, but it may well have been the artist himself who attempted to sharpen the woman's gaze. The fact that the placement of the child is somewhat ambiguous and the draughtsman experienced some difficulty in this area, namely in rendering the slashed sleeve, suggests that the small girl may have been a recalcitrant sitter. In the painting, strangely enough, she appears a trifle older and is shown standing beside her mother, her left arm encircling her mother's right arm, but still looking out of the picture as she does in the drawing. Like Rubens (see No. 10), the artist did not bother to indicate decorative details of dress and jewelry at this stage; neither the rings nor the elaborate embroidery of the stomacher shown in the painting are even hinted at in the drawing. Drawing and painting are works from the artist's second Antwerp period (1627–32).

By way of a footnote on the history of the ownership of this drawing and the record of one collector's generosity to another, Frits Lugt penciled a note in his copy of the Fairfax Murray catalogue, now in the Rijksbureau voor Kunsthistorische Documentatie at The Hague, that this drawing, which was sold as Rubens in the De Vos sale, was given to Lord Leighton by J. P. H[eseltine]. He owed his information to his ownership of J. P. Heseltine's copy of the De Vos sale catalogue where the English collector had noted his gift to Lord Leighton.

PROVENANCE: Jonathan Richardson, Sr. (Lugt 2183); Sir Thomas Lawrence (Lugt 2445); Jacob de Vos Jbzn (no mark; see Lugt 1450); his sale, Amsterdam, Roos, Muller . . . , 22–24 May 1883, lot 452, under Rubens but with the notation "Croquis magistral à la pierre noire qui nous paraît plutôt être de van Dyck, savoir une première idée pour le tableau du Maître au Musée de Dresde. Hauteur 32, largeur 27 cent." (to Thibaudeau for Heseltine for 305 florins); J. P. Heseltine (no mark; see Lugt 1507–08); given by him to Sir Frederick Leighton; Frederick, Lord Leighton (Lugt S.1741a); Charles Fairfax Murray; J. Pierpont Morgan (no mark; see Lugt 1509).

BIBLIOGRAPHY: Fairfax Murray, I, no. 244, repr.; Glück, *Van Dyck*, Klassiker der Kunst, 1931, under nos. 288–89; Vey, *Van Dyck*, 1962, I, no. 185, II, pl. 229.

EXHIBITION: Hartford, *The Pierpont Morgan Treasures*, 1960, no. 75.

Acc. no. I, 244

32. *View of Rye from the Northeast*

Pen and brown ink.
7 15/16 × 11 9/16 inches (201 × 294 mm.).
Watermark: none visible through lining.
Inscribed and signed by the artist in brown ink at lower right, *Rie del naturale li 27 d'Aug^to 1633 A^o vand[yck]*.

While Van Dyck seems to have painted no landscapes—at least none can be traced today although they are sometimes mentioned in old sources—he did turn to landscape in his drawings, sketching in *plein air*, probably for his own pleasure when he was at leisure. Interestingly enough, he took pains to sign a number of these landscape sheets. Only one example is unquestionably a souvenir of his Italian sojourn (1621–27), Windsor Castle's pure landscape which he inscribed *fuori de Genua quarto* (Vey, I, no. 282, II, pl. 334); but there are a number of drawings that can be associated with both the Flemish and English countryside. Some of the drawings are definitely topographical, including the 1632 view of his native city of Antwerp (Vey, I, no. 287, II, pl. 339) now in the Royal Library at Brussels (Amsterdam, Sotheby Mak van Waay, 3 April 1978, lot 109), and this view of Rye in Sussex. Thanks to the artist's explicit inscription that he made the present drawing on the spot on 27 August 1633, the sheet provided the key

for the identification of three other sketches of different aspects of Rye, one of the towns added to the original Cinque Ports, the ancient association of seaports in Kent and Sussex formed for the defense of the English coast. Rye today retains much of its original character since its thriving seventeenth-century trade came to an end when the harbor silted up early in the nineteenth century, leaving the town three miles from the sea.

The Morgan drawing gives a full view of the picturesque town, rising steeply on a sharp eminence above the sea and crowned by the mediaeval church of St. Mary's. Below and slightly to the left of the church in the midst of the houses mounting the hillside, one can see the Landgate built in 1329, the only surviving city gate from the time of Edward III; to the right of the gate is the chapel of the Austin Friars; very much to the left, on the edge of the hill just before it slopes down to the water, is the Ypres Tower, one of the oldest surviving fortifications of the Cinque Ports. Van Dyck made two separate drawings of the Tower on the sheets now in the Boymans–van Beuningen Museum, Rotterdam (Vey, I, no. 291, II, pl. 342) and the Fitzwilliam Museum, Cambridge (Vey, I, no. 290, II, pl. 343), as well as a nearer view of St. Mary's from the southeast in the drawing in the Uffizi (Vey, I, no. 289, II, pl. 341). Since the Uffizi and Fitzwilliam drawings record aspects of the town as seen from the sea, it is assumed that Van Dyck drew them aboard ship, possibly a three-masted vessel such as that seen in the left distance in the Morgan sheet or that sketched from a closer vantage point in the drawing in the possession of Michael Kroyer, London (Vey, I, no. 292, II, pl. 344). With the exception of the Fitzwilliam drawing of the Ypres Tower, which appears in the background of Van Dyck's portrait of Eberhard Jabach in the Hermitage at Leningrad, none of the landscape drawings was utilized in paintings (Glück, *Van Dyck*, Klassiker der Kunst, 1931, p. 355).

Van Dyck was apparently in Rye on two different occasions since the Morgan drawing is

dated in the summer of 1633, and the Uffizi example and another in the British Museum (Vey, I, no. 294, II, pl. 346) in 1634. Rye, lying directly across the English channel opposite Boulogne, was an important harbor for travelers between England and the Continent, and Van Dyck, while waiting to cross the Channel—or for transport to London—may have passed the time in sketching the historic points of interest of the town that is still attractive to tourists and artists. The placement of the windswept grasses and vines on the left in the foreground of the Morgan sheet effectively establishes the considerable distance from which the artist viewed the English hill town, as does the small scale of the horseman and another figure on the road at the center of the foreground. It was perhaps about the same time, if not on the same occasion, that Van Dyck produced the studies of plants in the Lugt Collection, Institut Néerlandais, Paris, (Vey, I, no. 297, II, pl. 349) and the British Museum (Vey, I, no. 296, II, pl. 348). In these drawings of town and country Van Dyck skillfully continues the landscape tradition of his great sixteenth-century Flemish antecedent Pieter Bruegel.

The Morgan drawing served as a model for Wenzel Hollar's washed silverpoint drawing formerly in the collection of Sir Bruce S. Ingram and now in the Huntington Library and Art Gallery, San Marino, California (see F. Sprinzels, *Hollar Handzeichnungen*, Vienna, 1938, no. 367, fig. 234). When Hollar etched the composition in 1659 at the upper left of his *Map of Kent*, he acknowledged his debt in the inscription: *Sir Anthony Van Dyck Delineavit* (see further, G. Parthey, *Wenzel Hollar: Beschreibendes Verzeichniss seiner Kupferstiche*, Berlin, 1853, no. 665c).

It is interesting to note that at least a dozen of Van Dyck's landscapes bear the mark of the eighteenth-century English artist and collector Jonathan Richardson, Sr. It might be remarked in passing that the Library also owns a wooded landscape view in watercolor and gouache of the type which English tradition long linked with Van Dyck; his authorship of these, however, was ultimately questioned by Hind and explicitly rejected by Vey in his monograph (I, pp. 56–57) as well as by Held in 1959 in a paper read at the meeting of the College Art Association in Detroit and in his review of Vey's work (*Art Bulletin*, XLVI, 1964, p. 566).

PROVENANCE: Jonathan Richardson, Sr. (Lugt 2183; Richardson's pressmarks inscribed in brown ink on verso of the mount, *P97. | Tk. 13. | L.8 | G.*; above this, perhaps in another hand, *A1F* [Lugt 2983–84]); Jan van Rijmsdijk (Lugt 2167); Charles Fairfax Murray; J. Pierpont Morgan (no mark; see Lugt 1509).

BIBLIOGRAPHY: Fairfax Murray, III, no. 178, repr.; A. M. Hind, "Van Dyck and English Landscape," *Burlington Magazine*, LI, 1927, p. 297; G. Vertue, "Vertue Note Books, IV," *Walpole Society*, XXIV, 1936, p. 114, and V, XXVI, 1938, p. 60; A. M. Hind, in *The London Illustrated News*, 20 March 1937, pp. 484–85, fig. 2; Ludwig Burchard, "A View of Rye by Anthonie Van Dyck," *Old Master Drawings*, XII, March 1938, pp. 47–48, fig. 51; Paul Wescher, *Alte Städte in Meisterzeichnungen aus fünf Jahrhunderten*, Frankfurt am Main, 1938, no. 27, repr.; Paul Oppé, "Sir Anthony van Dyck in England," *Burlington Magazine*, LXXIX, 1941, p. 190; Horst Vey, "De tekeningen van Anthonie van Dyck in het Museums Boymans," *Bulletin Museum Boymans*, 1956, p. 88 and note 7; Cambridge, Fitzwilliam Museum, *Seventeenth Century Flemish Drawings and Oil Sketches*, exhibition catalogue by Carlos van Hasselt, 1958, under no. 15; *Great Drawings of All Time*, 1962, II, no. 556, repr.; Vey, *Van Dyck*, 1962, I, p. 56, no. 288, II, pl. 340; Eisler, *Flemish and Dutch Drawings*, 1963, pl. 44; Martin Hardie, *Water-colour Painting in Britain*, I, 1966, p. 57; London and elsewhere, *Flemish Drawings . . . Collection of Frits Lugt*, 1972, under nos. 34 and 35; Morgan Library, and elsewhere, *European Drawings from the Fitzwilliam*, exhibition catalogue by Michael Jaffé, Duncan Robinson, and Malcolm Cormack, 1976–77, under no. 69.

EXHIBITIONS: Morgan Library, *An Exhibition Held on the Occasion of the New York World's Fair*, 1939, no. 78 (1940 ed., no. 97); Baltimore, Maryland, Johns Hopkins University, *Landscape Painting from Patinir to Hubert Robert*, catalogue by Georges de Batz, 1941, no. 23; Worcester, Massachusetts, Worcester Art Museum, *Art of Europe during the XVIth–XVIIth Centuries*, 1948, no. 43, repr.; Morgan Library, *Landscape Drawings*, 1953, no. 58; Morgan Library and elsewhere, *Treasures from the Pierpont Morgan Library*, 1957, no. 92, pl. 59; Antwerp, Rubenshuis, and Rotterdam, Museum Boymans–van Beuningen, *Antoon van Dyck: Tekeningen en olieverfschetsen*, catalogue by R.-A. d'Hulst and Horst Vey, 1960, no. 100, pl. LXI; Stockholm, *Morgan Library gästar Nationalmuseum*, 1970, no. 63, repr.; London, The Tate Gallery, *The Age of Charles I*, catalogue by Oliver Millar, 1972, no. 122.

Acc. no. III, 178

33. *Study for the Dead Christ*

Black chalk heightened with white chalk on gray-blue paper.

10⅞ × 15⁷⁄₁₆ inches (276 × 393 mm.).

Watermark: none visible through lining.

After Van Dyck removed to England in 1632 as Chief Court Painter to Charles I, he made several trips back to his native Flanders. On an extended visit in 1634–35 he appears to have been busy with commissions for the diplomat Abbot Cesare Alessandro Scaglia, then a rich man and connoisseur living in Brussels, his career as ambassador of the House of Savoy to the major courts of Europe having ended in disfavor. In addition to the full-length painted portrait of the Abbot in Viscount Camrose's collection (Glück, *Van Dyck*, Klassiker der Kunst, 1931, p. 426) and a portrait drawing in the collection of Frits Lugt, Institut Néerlandais, Paris (repr. in the exhibition catalogue *Flemish Drawings of the Seventeenth Century* . . . , 1972, no. 32, pl. 54), Van Dyck executed two religious paintings for the Abbot: the *Virgin and Child Adored by the Abbot Scaglia*, the oval painting in the National Gallery, London (Glück, p. 366; Gregory Martin, *National Gallery Catalogues: The Flemish School, circa 1600 – circa 1900*, London, 1970, pp. 48–52, no. 4889), and the *Lamentation* (Glück, p. 367), which Scaglia commissioned and presented to the monastery of the Friars Minor or Recollects of the Franciscan order in Antwerp where he was to retire shortly after September 1637, and to be buried in 1641. The sensitive, moving representation of the dead Christ in the Morgan drawing is a study for this last painting, long since removed from the Recollects' chapel of Our Lady of the Seven Sorrows and now in the Koninklijk Museum voor Schone Kunsten at Antwerp. In the catalogue of the recent Princeton exhibition (p. 172), it is suggested that the painting was executed in England in 1636 or 1637 and shipped to Antwerp for installation in the altarpiece.

Van Dyck's style finds very personal expression in this luminous study from a slender model although not without strong Venetian overtones

in the harmony of the soft chalks and blue paper. There is no likelihood of confusing it with Rubens' manner as sometimes happens in the earlier pen sketches. The slightly angular quality of Van Dyck's line is very different from the broad sweeping rhythms of the chalk drawings of the older artist (see No. 12). Van Dyck tried two positions for the left arm, which, in the painting St. John lifts to point out the wound to a pair of mourning angels, but in the end Van Dyck chose his first solution of the lower position. The diagonal of the upper position was clearly an afterthought for its black chalk outlines cross the white heightening. There is also a partial indication of a still higher placement of the arm that was not pursued. The head, only partially indicated in the drawing, is heavily bearded in the painting and rests on the Virgin's lap. There is another larger painting of the subject of the Lamentation in the Antwerp Museum, and another of the theme in Berlin (Glück, pp. 223, 244), both vertical compositions in contrast to the horizontal of the Scaglia picture; there is a figure study of the Christ for the Berlin picture in the British Museum (Vey, I, no. 130, II, pl. 169).

PROVENANCE: Possibly Samuel van Huls, former burgomaster of The Hague; his sale, The Hague, Swart, 14 May 1736, Album M, lot 535, "Antoine van Dyck. Un Christ mort et un St. Jérôme"; William Young Ottley (no mark; see Lugt 2662–65); possibly sale, [Ottley], London, T. Philipe, 11–14 April 1804, one of three in lot 429, "Three. Dead Christ, black chalk, on blue paper, heightened; St. John Preaching, free pen, Indian ink, and bistre, sketches on the back; and another"; George William Reid (no mark; see Lugt 1210); his sale, George William Reid, Esq. F.S.A., Late Keeper of the Prints and Drawings at the British Museum, London, Sotheby's, 26 February – 1 March 1890, lot 585, "A. van Dyck. Study for a Dead Christ, black and white chalk, on grey paper" (to Murray for 6 shillings); Charles Fairfax Murray; J. Pierpont Morgan (no mark; see Lugt 1509).

BIBLIOGRAPHY: Fairfax Murray, I, no. 243, repr.; Vey, *Van Dyck*, 1962, I, no. 141, II, pl. 179; A. Monballieu, "Cesare Alesandro Scaglia en de 'Bewening van Christus' door A. Van Dijck," *Jaarboek van het Koninklijk Museum voor Schone Kunsten Antwerpen*, 1973, p. 263, fig. 10.

EXHIBITIONS: Morgan Library and elsewhere, *Treasures from The Pierpont Morgan Library*, 1957, no. 93; Princeton, New Jersey, The Art Museum, Princeton University, *Van Dyck as Religious Artist*, catalogue by John Rupert Martin

69

and Gail Feigenbaum, 1979, no. 50, repr. (represented in the exhibition by a photographic facsimile).

<div align="right">Acc. no. I, 243</div>

Jan Cossiers

Antwerp 1600 – 1671 Antwerp

34. *Portrait of the Artist's Son Guilliellemus*

Black and red chalk, a few touches of white chalk; some lines strengthened with pen and brown ink.
10⅞ × 7³⁄₁₆ inches (268 × 183 mm.).
Watermark: none visible through lining.

Numbered and inscribed in pen and brown ink, probably in the artist's hand, at upper left, *21*; at upper right, *Guilliellemus Cossiers*. Inscribed on old mount at center, in pen and brown ink, *Cossiers*; at lower right corner in graphite, *129*. Variously inscribed on verso of the mount, in brown ink at upper right, *P N⁰ 84*; in pencil at lower right, *No. 3*; still lower in graphite in three different old hands, the first line partly erased, *Four heads by Cossiers done with great Freedom and | Spirit allmost equal to Rubens W. Something French in them A little like Greuze. M. | All very fine Ph.* (for other drawings commented on by the same three individuals, see Nos. 24 and 40); further below, in pencil, in the hand of Fairfax Murray, *given me by JCR.*

The small boy portrayed here was one of the six sons of Cossiers by his second wife, Marie van der Willigen, whom he married 26 July 1640. Curly-haired Guilliellemus, that is, William, in whose face the soft roundness of infancy still lingers, was most likely the youngest. Companion portraits of three of his older brothers exist today and there is mention of a fourth likeness in the 1810 catalogue of the Paignon Dijonval collection (no. 1527). Jan Frans Cossiers, his father's namesake as befits the eldest son, is represented at age sixteen in the portrait dated 1658 in the collection of Frits Lugt, Institut Néerlandais, Paris (*Flemish Drawings of the Seventeenth Century . . .* , 1972, no. 20, pl. 74); Jacobus is seen in the British Museum's portrait (one of the two mentioned in the Paignon Dijonval catalogue), also dated 1658 (Hind, *Flemish Drawings*, 1923, II, p. 98, no. 1, pl. XLIX); Cornelis in the drawing in the collection of Professor J. Q. van Regteren Altena, Amsterdam, again dated 1658 (Rotterdam and elsewhere, *Kabinet van tekeningen . . . uit een Amsterdamse verzameling*, exhibition catalogue, 1976–77, no. 43, pl. 106). Ge-

rardus was the subject of the presumably lost Paignon Dijonval sheet. This handsome sequence of sibling portraits all depict the sitters more or less three-quarters to the left with their names inscribed—in all likelihood by their father—at the upper right, and probably they were all done at the same time. Understandably, given the artist's interest in his models, they show Cossiers at his best; he is, in fact, generally more highly regarded as a draughtsman than a painter.

When the five portraits were last together is difficult to ascertain. Certainly there were five portraits in the collection of Viscount Palmerston, which was formed between 1770 and 1801 according to the much later sale catalogue of 1891, but these five could not have included the two portraits which, in 1810, were described in the catalogue of the Paignon Dijonval collection. The explanation for such discrepancies may lie in the possibility that further drawings existed in the form of copies or replicas as in the case of the drawing in the Louvre (Inv. no. 21.918) which is a repetition of the Lugt portrait. The three unknown critics whose opinions are inscribed on the verso of the old mount of the Morgan sheet mention four drawings if the half-obliterated inscription has been correctly read. Sir John Charles Robinson later owned at least two of the drawings as is indicated by Fairfax Murray's notes on the mounts of both the Morgan and Lugt sheets. (His initials on the recto of the latter sheet were effaced sometime after the drawing was in Fairfax Murray's possession as it appears with the initials intact in the lower right corner in the reproduction in the unpublished fifth volume of plates of the Murray catalogue. These plates are unlabeled reproductions of drawings, which, with one or two exceptions, were not acquired by Pierpont Morgan in 1910.)

Cossiers recorded his own features in the small drawing now in the Ashmolean Museum, Oxford, and it is not beyond the realm of possibility that the artist also portrayed his five daughters, whose likenesses might some day come to light. For a listing of other works by Cossiers, see the discussion by Carlos van Hasselt in the exhibi-

tion catalogue *Flemish Drawings . . . Collection of Frits Lugt*, 1972, under no. 20.

PROVENANCE: Salomon Gautier (inscription on verso of mount; see Lugt 2977); Henry Temple, second Viscount Palmerston (1739–1802); Hon. Evelyn Ashley (by bequest from Lord Palmerston); his sale, London, Christie's, 24 April 1891, one of five in lot 129; Sir John Charles Robinson (no mark; see Lugt 1433); Charles Fairfax Murray; J. Pierpont Morgan (no mark; see Lugt 1509).

BIBLIOGRAPHY: Fairfax Murray, I, no. 248, repr.; London, Royal Academy of Art, *Exhibition of Flemish and Belgian Art 1300–1900, Organized by the Anglo-Belgian Union* (hand catalogue), 1927, p. 181, under no. 634; London, Royal Academy of London, *Catalogue of the Loan Exhibition of Flemish and Belgian Art: A Memorial Volume Edited by Sir Martin Conway, M.P.*, 1927, p. 220, under no. 634; Lugt, *École flamande, Louvre*, 1949, I, under no. 544; Walther Bernt, *Die niederländischen Zeichner des 17. Jahrhunderts*, Munich, 1957, I, no. 159, repr.; London, P. & D. Colnaghi, *Old Master Drawings: A Loan Exhibition from the National Gallery of Scotland*, exhibition catalogue by Keith Andrews, 1966, under no. 63; Michael Jaffé, "Figure Drawings Attributed to Rubens, Jordaens, and Cossiers in the Hamburg Kunsthalle," *Jahrbuch der Hamburger Kunstsammlungen*, XVI, 1971, p. 48; Rotterdam, Museum Boymans–van Beuningen and elsewhere, *Kabinet van tekeningen: 16e en 17e eeuwse Hollandse en Vlaamse tekeningen uit een Amsterdamse verzameling*, 1976–77, under no. 43.

EXHIBITION: Brussels, Musées Royaux des Beaux-Arts de Belgique, *Le Siècle de Rubens*, 1965, p. 297, no. 313.

Acc. no. I, 248

David Teniers the Younger
Antwerp 1610 – 1690 Brussels

35. *Village Street with Three Figures*

Black chalk.
7½ × 10¾ inches (191 × 273 mm.).
Watermark: foolscap with five points (cf. Churchill 341; Heawood 1964). See watermark no. 34.
Signed at lower edge left of center with monogram, *T* within a *D*, *F* (fecit). Numbered on verso at lower right in pen and brown ink, · *8* · *8*.

Such village scenes are often found in the background of Teniers' paintings of genre subjects, frequently oriented on the diagonal as is the case in this typical black chalk drawing. While the artist does not seem to have used this composition in its entirety in a painted work, he did utilize a part of it. The two houses at the left of the sheet, together with the single tree and the church steeple, are surely recalled in the painting *The Archers*, formerly in the collection of Baron Albert Oppenheim and more recently in the possession of the Krupp family (exhibition catalogue, Essen, Villa Hügel, 1965, no. 93), although there are slight changes in detail, half-timber construction, for instance, instead of the thatched gable of the foremost cottage. Since the Krupp painting is signed and dated 1645, the year the artist became Dean of the Antwerp Guild of St. Luke, it is probable that the drawing was executed not too long before.

Teniers' hasty, somewhat haphazard though distinctive style of drawing changed little during his career. His use of areas of close parallel hatching, usually on the diagonal and sometimes joined in a lightning-like zigzag to indicate foliage, is almost a hallmark. This sheet is one of a considerable group of landscapes and village scenes, some of them very probably actual views; these rapid sketches were obviously valued by the artist who signed some of them with his monogram composed of a small "T" enclosed within a large "D", usually in conjunction with an "F" for *Fecit*. Other examples are to be found in the British Museum, and the Courtauld Institute of Art in London, the Louvre in Paris, and the Kupferstichkabinett in Berlin. The present drawing is the only landscape in the Morgan Library; that illustrated in Volume V of the Fairfax Murray catalogue did not come to the Library as stated under no. 109 in the 1972 catalogue of the Flemish drawings from the Lugt Collection, Institut Néerlandais.

PROVENANCE: Jean-Denis Lempereur (Lugt 1740); William Esdaile (Lugt 2617); his sale, London, Christie's, 18–25 June 1840, one of three in lot 1163, "a cavalier and a gypsey—a pair; and a landscape; black chalk" (to Mayor for 12 shillings); William Mayor (Lugt 2799); Charles Fairfax Murray; J. Pierpont Morgan (no mark; see Lugt 1509).

BIBLIOGRAPHY: *A Brief Chronological Description of a Collection of Original Drawings and Sketches, by the Most Celebrated Masters of the Different Schools of Europe, From the Revival of Art in Italy in the XIIIth to the Middle of the XVIIIth Century; Formed by and Belonging to Mr. Mayor, the Result of Upwards of Forty Years Experience and Research*, London, 1871, no. 259; *A Brief Chronological Description of a Collection of Original Drawings and Sketches by the Old Masters . . . Formed by the Late Mr. William Mayor of Bayswater Hill*, London, 1875, no. 444.

Acc. no. I, 124b

DUTCH DRAWINGS

Hendrick Goltzius

Mühlbracht (Limburg)
1558 – 1617 Haarlem

36. *The Judgment of Midas*

Pen and brown ink, red-violet, brown, and gray watercolor, green tempera, with some heightening in white tempera.
15¾ × 26¹⁵⁄₁₆ inches (400 × 681 mm.).
Watermark: none visible through lining.
Signed with monogram and dated at right, *HG.* (interlaced) / *Fecit* / *A⁰ 1590.*

The most famous member of the group of Mannerist artists flourishing in Haarlem in the 1580's was the young draughtsman and engraver Hendrick Goltzius. In the last years of that decade and the first year of the following (1588–90), he was much occupied with the designs for three series of engravings illustrating the *Metamorphoses* of Ovid. He produced the preparatory drawings for two series of twenty illustrations each and one of twelve, all engraved anonymously; only a handful of his drawings for these projects survive (Reznicek, I, nos. 99–104, II, pls. 119–24; I, 100a, II, pl. 451). Quite independent of these series though, perhaps the culmination of his interest in the *Metamorphoses*, is the present large, elaborate drawing of 1590. With its mood of elegant artifice, it stands at the end of the early phase of his activity when the inspiration of the art of Bartholomaeus Spranger had not completely disappeared.

It represents Apollo and his strings victorious over Pan in the musical contest in which the oak-wreathed Tmolus and King Midas were judges. Midas is identified by the ass's ears which were bestowed upon him when he voted against Apollo (Ovid, *Metamorphoses*, XI, 156ff.). Grouped in a semi-oval in the right half of the scene are the Muses. Seated in the foreground is a figure holding a sphere and compasses, whom one would ordinarily identify as Urania (Muse of astronomy), but Goltzius, as Ann Lowenthal kindly pointed out, in his engraved series of the individual figures of the nine Muses executed in 1592 labels the figure with these same attributes as Erato. Usually, the attribute of Erato as Muse of lyric and love poetry is a musical instrument like a lyre or tambourine. What the artist's authority was for such a departure from traditional iconography remains to be ascertained. On Erato's right are Terpsichore (dancing and song), holding her lute face down, and Thalia (comedy, pastoral poetry), identified by the fool's baton and bladder beside her foot. Standing at the right is Euterpe (music, lyric poetry), with her flute, in the company of Urania (astronomy), the figure with an armillary sphere at her feet. In the middle ground are the goddess Athena with her owl, and Clio (history) with a book; further to the left, behind Apollo, are the remaining Muses, Calliope (epic poetry) with a scroll, Melpomene (tragedy), and Polyhymnia (sacred song and rhetoric) holding a caduceus, which, since it sometimes signifies Eloquence and Reason, is an attribute that is not inappropriate though again a departure from the tradition that assigns an organ or other musical instrument to this Muse. Ovid in his account of the contest between Apollo and Pan in the *Metamorphoses* makes no mention of the presence of Athena and the Muses, but the goddess and her nymphs were present at the contest between Apollo and Marsyas in Ovid's account

72

in the *Fasti*, VI, 697ff. In such details as Apollo's head "wreathed with laurel of Parnassus and his mantle dipped in Tyrian dye [which] swept the ground," Goltzius closely adhered to the text of the *Metamorphoses* though he took the liberty of giving the god a viol rather than a lyre "inlaid with gems and Indian ivory."

Goltzius translated this drawing into an engraving of equally impressive measurements, dedicating it to Floris van Schoterbosch, an art patron of The Hague who had just returned from a trip to Constantinople. Shortly thereafter, in October 1590, Goltzius himself left for a trip to Italy, which was to alter the course of his development. The drawing which is in reverse of the engraving (Bartsch, no. 140), is, in its painterly quality, an unusual preparation for an engraving; it might be said to forecast the interest Goltzius was to take in painting for a period after 1600. The artist seldom created two more beautiful figures than the graceful pair of Muses standing at the right, Euterpe in her red-violet gown and her companion in green.

Goltzius' composition, known, of course, through the master print, was much copied and imitated in its entirety and in its details. Even Spranger whose work was so influential in the shaping of Goltzius' early style (Goltzius had engraved many of his drawings) paid the younger artist the tribute of copying the engraving in a signed painting on marble preserved as a fragment in the Kunsthistorisches Museum, Vienna (repr. *Jahrbuch des A.H. Kaiserhauses Wien*, XXVIII, 1909–10, p. 129, pl. 23; also *Gazette des Beaux-Arts*, LXIII, 1964, p. 138, fig. 11). To the list of copies and variations of the composition listed by Reznicek (p. 274) may be added a signed painting by Raphael Sadeler dated 1646 in the museum at Baden, Switzerland (*Zeitschrift für schweizerische Archäologie und Kunstgeschichte*, XXXI, no. 3, 1974, p. 181, fig. 4).

PROVENANCE: John MacGowan (no mark; see Lugt 1496); his sale, London, T. Philipe, 26 January – 1 February 1804, no. 266, ". . . a capital design. . . " (to Ottley for 11 shillings); William Young Ottley (no mark; see Lugt 2662–65); Sir Thomas Lawrence (no mark; see Lugt 2445–46); Samuel Woodburn (no mark; see Lugt 2584); Lawrence-Woodburn sale, London, Christie's, 4–8 June 1860, lot 435 (13 shillings); Dr. John Percy (Lugt 1504); his sale, London, Christie's, 15–18 and 22–24 April 1890, lot 1462; Charles Fairfax Murray; J. Pierpont Morgan (no mark; see Lugt 1509).

BIBLIOGRAPHY: Fairfax Murray, I, no. 228, repr.; K. T. Parker, *Catalogue of the Collection of Drawings in the Ashmolean Museum*, Oxford, I, 1938, p. 23, under no. 54; Reznicek, *Goltzius*, 1961, I, pp. 19, 74–75, 273–74, no. 107, II, pls. 127, 129–30; Warsaw, University of Warsaw, *Rysunki z Kręgu Manierystów Niderlandzkich XVI i Początku XVII Wieku, ze zbiorów Gabinetu Rycin, Biblioteki Uniwersyteckiej w Warszawie, Muzeum Pomorskiego w Gdańsku i Muzeum Narodowego w Poznaniu*, exhibition catalogue by Stanisława Sawicka, 1967, p. 29, under no. 13; John Shearman, *Mannerism*, Harmondsworth, 1967, p. 192, under no. 7; J. R. Judson, *Dirck Barendsz*, 1970, pp. 92–93, fig. 103; Walter Strauss, ed., *Hendrick Goltzius, 1558–1617: The Complete Engravings and Woodcuts*, New York, 1977, II, p. 504, under no. 285; Geneva, Cabinet des Estampes, Musée d'art et d'histoire, *Dieux et héros*, 1978, p. 104, under no. 103.

EXHIBITIONS: Morgan Library and elsewhere, *Treasures from the Pierpont Morgan Library*, 1957, no. 88, pl. 55; Rotterdam, Museum Boymans, and Haarlem, Teylers Museum, *Hendrick Goltzius als Tekenaar*, 1958, no. 12, repr.

Acc. no. I, 228

37. *Mountainous Coastal Landscape*

Pen and brown ink over faint preliminary indications in black chalk.
9¼ × 15⅛ inches (235 × 383 mm.).
Watermark: monogram *FMO* within a shield (close to Heawood 3196). See watermark no. 51.
Inscribed in an old hand in pen and brown ink at lower left corner, *P. Bril*; numbered on verso in pen and brown ink at lower left, *8*.

Late in October 1590, Goltzius left Haarlem for a trip to Rome; he was back in Holland by the end of 1591. The experience affected various aspects of his artistic life, including the practice of landscape draughtsmanship, in which until then, as far as is known, he had displayed no interest. Traveling first by ship to Hamburg and then overland on foot through Germany and North Italy, he, like Pieter Bruegel about forty years before him, was impressed by the majesty of the mountains and rivers. After his

return, he produced a small group of heroic mountain landscape drawings inspired by the Alpine scene, among them the Morgan sheet which is perhaps one of the later works in the sequence. It lends itself to comparison with the landscapes in Haarlem, Dresden, and Besançon, respectively dated 1594, 1595, 1596 (Reznicek, I, nos. 396, 395, 393; II, pls. 239, 242, 252), but also shows some affinity to the later mountain-and-river scene of 1608, known only through the print engraved after it by Simon Frisius (Hollstein, VII, p. 29, no. 106). Reznicek, who suggested a date for the sheet around 1596–97, aptly pointed out that Goltzius here combines the landscape traditions of Bruegel and Titian, the latter most obviously apparent in the rhythmic vertical systems of strong parallel hatching. Around 1600 Goltzius began to turn his observing eye on the Dutch countryside and produced some of the earliest drawings of the landscape of Holland.

The landscape that Goltzius presents in the Morgan drawing is obviously not one he traversed in reality, although the small figure with alpenstock and backpack, who is seen tramping —once understandably resting in the Besançon landscape (Reznicek, II, pl. 252)—along the rocky mountain paths of the various landscapes, could well be a reminiscence of the manner in which the artist himself had traveled. He must have actually known the carefully described stone house, perhaps an inn, with timbered entrance and smoking chimney, sheltering among the pine trees at the left—perhaps even stood in the spot where he shows two figures leaning against the retaining wall watching the watermill churning up the water below. The picturesque motive of a stream rushing through a stony defile is one he used more than once. It can also be found in the compositions of Paul Bril, whose name understandably occurred to a former owner as the author of the present drawing.

As one remarks the spatial control of the composition and the virtuosity of the line, evenly bold in the foreground, delicately light and fine

in the middle distance and background, they seem all the more extraordinary when it is recalled that Goltzius drew with a crippled hand, maimed by fire in a childhood accident.

PROVENANCE: Count Karl Lanckoronski, Vienna; Countess Adelheid Lanckoronska; sale, London, Christie's, 30 March 1971, lot 97.

BIBLIOGRAPHY: Josef Schönbrunner and Josef Meder, *Handzeichnungen aus der Albertina und anderen Sammlungen*, 1893–1908, no. 666; J. G. van Gelder, *Jan van de Velde*, The Hague, 1933, p. 20; J. Q. van Regteren Altena, *The Drawings of Jacques de Gheyn*, Amsterdam, 1936, p. 88; J. G. van Gelder and N. F. van Gelder-Schrijver, "De zestiende eeuw," *Kunstgeschiedenis der Nederlanden* (H. E. van Gelder, ed.), Utrecht, 1936, p. 181, fig. 21; Reznicek, *Goltzius*, 1961, I, pp. 110, 433, no. 408, II, pl. 253; Wolfgang Stechow, *Dutch Landscape Painting of the Seventeenth Century*, London, 1966, p. 133; Morgan Library, *Sixteenth Report to the Fellows, 1969–1971*, 1973, pp. 94–95, 114, pl. 20; Egbert Haverkamp-Begemann, *Hercules Segers*, Amsterdam, 1973, p. 32, note 15.

EXHIBITION: Morgan Library, *Major Acquisitions, 1924–1974*, 1974, no. 38, repr.; Los Angeles, *Old Master Drawings from American Collections*, catalogue by Ebria Feinblatt, 1976, no. 184, repr.

Acc. no. 1971.3

Gift of the Fellows with the special assistance of the Lore and Rudolf Heinemann Foundation

38. *Lucretia as the Sense of Touch*

Black chalk, heightened with white tempera.
12⁹⁄₁₆ × 8¹⁄₁₆ inches (319 × 205 mm.).
Watermark: none.

The theme of the Five Senses was a popular one in the Netherlands, especially for series of engravings, and during Goltzius' career he produced a number of drawings that were designed for this purpose. For one series, that engraved by Jan Saenredam (Bartsch, nos. 95–99), all five of the drawings have survived, four in Rotterdam (Reznicek, I, nos. 167–70, II, pls. 305–08) and one belonging to P. and N. de Boer, Amsterdam (Reznicek, I, no. 171, II, pl. 309), the group dating c. 1595–96; for the series engraved by Nicolaes Clock and Cornelis Drebbel (Bartsch, nos. 1–5) in 1596, three drawings in Berlin, Frankfurt, and the New York art market

(1954) are known (Reznicek, I, nos. 172, 174, 177, II, pls. 63, 62, 61). Beyond these two series, Reznicek also cites three drawings for which no engravings are known, those representing Hearing in Rotterdam (Reznicek, I, no. 175, II, pl. 233) and Vienna (I, no. 176, II, pl. 422), and a third representing Sight, the sheet from the Sir Bruce Ingram collection now in the Fitzwilliam Museum (Reznicek, I, no. 173, II, pl. 346).

The present drawing is yet another of Goltzius' representations of one of The Senses. Before its acquisition by the Morgan Library in 1974, it had long been in a private collection quite unknown to scholars. It is clearly a companion to the Fitzwilliam drawing, sharing the same format and medium, and one assumes that both must have been designed as part of yet another series of the Five Senses. In each drawing a superbly modeled, lightly draped female figure is seen nearly full-length, seated against a tree trunk. Where the Fitzwilliam figure personifying the Sense of Sight is shown gazing into a mirror, with an eagle at her side, the Morgan personification of the Sense of Touch presses a dagger to her breast—surely the ultimate expression of touch—and is accompanied by a turtle, with a spider web in the right background. Both the turtle and the spider as creatures of tactile sensitivity are symbols of touch, the turtle, in particular, being known for its ability to retract head and limbs into its shell on the slightest contact. The Morgan figure might be interpreted as Lucretia representing the Sense of Touch, a concept which, if not original with Goltzius, is not usual. The animal in the De Boer drawing of Touch in the series engraved by Jan Saenredam (Reznicek, I, no. 171, II, pl. 309) has been identified as a Greek land turtle (Testudo Graeca) by H. E. van Gelder ("Twee Braziliaanse schildpadden door Albert Eeckhout," Oud Holland, LXXV, 1960, p. 11), and the Morgan chelonian is undoubtedly of the same variety. The Fitzwilliam and Morgan drawings, for neither of which an engraving is known, are the largest and most likely the latest of Goltzius drawings of The Senses. Reznicek notes, in connection with the Fitzwilliam drawing, that the relatively realistic conception of the figure and the freedom of execution suggest a date around 1600.

PROVENANCE: Pierre Lorillard; Hon. F. W. Pearson.

BIBLIOGRAPHY: Morgan Library, *Seventeenth Report to the Fellows, 1972–1974*, 1976, pp. 147, 167.

Acc. no. 1974.5

Purchased as the gift of Mrs. G. P. Van de Bovenkamp (Sue Erpf Van de Bovenkamp) in memory of Armand G. Erpf

39. *Young Man Holding a Skull and a Tulip*

Pen and brown ink.
18⅛ × 13¹⁵⁄₁₆ inches (460 × 354 mm.).
Watermark: none visible through lining.
Signed and dated at upper left, with monogram, *HG* (interlaced) / *1614*. Lettered in pen and brown ink, by the artist at right center, *QVIS EVADET / NEMO*.

Goltzius' virtuosity with the pen is spectacularly demonstrated by this drawing executed in the manner of an engraving at a period when he had long ceased to work with the graver on copper, in part because of the deterioration of his eyesight. (He engraved only occasionally after he had begun to paint around 1600.) The artist's virtuosity in the production of these *federkunststücke* is again all the more remarkable when one remembers that he could not spread the fingers of the crippled hand that guided his pen. This life-size "fantasy portrait," together with the *Portrait of Jan Govertsen as St. Luke*, in Coburg, drawn in the same year (Reznicek, I, no. 70, II, pl. 442), is the last of these large showpieces which he had produced throughout his career. The series began in 1586 with the *Marcus Curtius* in Copenhagen (Reznicek, I, no. 142, II, pl. 74) and found its most celebrated expression in the *"Sine Cerere et Baccho friget Venus"* of 1593 in the British Museum, London (Reznicek, I, no. 129, II, pls. 224–26), with which, as Reznicek remarked (p. 130), the Mor-

gan sheet is on a par in artistic quality and, above all, in technique; likewise similar in style and extraordinary in its size is the *Bacchus, Venus, and Ceres* of 1604 in the Hermitage, Leningrad (Reznicek, I, no. 128, II, pl. 387). It might also be said that in the rendering of the feathers and hair of the young man in the Morgan example, Goltzius rivals the expertness of Dürer, whose engraved work he had earlier copied and imitated to the point of deception as related by Van Mander (p. 365).

As the Latin inscription (*Who escapes? No man*) and the symbols of the hourglass, the skull, and the tulip show, the drawing is a *memento mori*, a reminder of the transience of existence. Even the vital richly-dressed young man will not escape the fate of him whose skull he holds, and with the passing of time, marked by the hourglass, he, too, will fade and decay like the short-lived flower. The drawing was prophetic of the artist's death just two years later on 29 December 1616 or perhaps on 1 January 1617.

An engraving of 1594 (Bartsch, no. 10) designed by Goltzius also carries the motto *Quis evadet*; it represents a putto, seated against a skull, blowing bubbles. (See H. W. Janson, "The Putto with the Death's Head," *Art Bulletin*, XIX, 1937, pp. 446–47, fig. 21.)

PROVENANCE: John MacGowan (Lugt 1496); his sale, London, T. Philipe, 26 January – 2 February 1804, lot 267, ". . . masterly pen" (£1); William Mayor (Lugt 2799); Robert Prioleau Roupell (no mark; see Lugt 2234); his anonymous sale, Frankfurt, Prestel, 6 December 1888, lot 55 (440 marks); Jeffrey Whitehead (see under Lugt 2799); his sale, Munich, Helbing, 19 June 1897, lot 340, repr.; sale [unnamed but including some drawings from the collection of the late William Mayor], London, Christie's, 19 April 1909, one of four in lot 5 (the lot to Agnew for £25); Charles Fairfax Murray; J. Pierpont Morgan (no mark; see Lugt 1509).

BIBLIOGRAPHY: *A Brief Chronological Description of a Collection of Original Drawings and Sketches, by the Most Celebrated Masters of the Different Schools of Europe, From the Revival of Art in Italy in the XIIIth to the Middle of the XVIIIth Century; Formed by and Belonging to Mr. Mayor, the Result of Upwards of Forty Years Experience and Research*, London, 1871, no. 341; *A Brief Chronological Description of a Collection of Original Drawings and Sketches by the Old Masters . . . Formed by the Late Mr. William Mayor of Bayswater Hill*, London, 1875, no. 599; Fairfax Murray, III, no. 145, repr.; Reznicek, *Goltzius*, 1961, I, pp. 130, 389, no. 332, II, pl. 443; Christopher Brown, *Dutch and Flemish Painting*, Oxford, 1977, no. 3, repr.

EXHIBITIONS: Montreal, Montreal Museum of Fine Arts, *Five Centuries of Drawings*, 1953, no. 119; New York, Wildenstein and Company, *Masterpieces*, 1963, no. 65, repr.; Stockholm, *Morgan Library gästar Nationalmuseum*, 1970, no. 57.

Acc. no. III, 145

Abraham Bloemaert
Dordrecht 1564 – 1651 Utrecht

40. *The Holy Family at the Foot of a Tree*

Pen and brown ink over black chalk, olive-green wash, heightened with white tempera, on paper tinted light pinkish tan; lightly traced with the stylus.
9½ × 7 3⁄16 inches (241 × 182 mm.).
Watermark: none visible through lining.
Numbered in pencil at upper left of old mount, *168*. Inscribed on verso of old mount in pencil, in three different hands: *A true drawing and very good W | Bloemaert has been called the German Baroccio | True. has been engraved Ph* (for other drawings commented on by the same three individuals, see Nos. 24 and 34).

As its prominent use of schematized hatching might suggest, the appealing group of the Holy Family was designed with a print in view. It was reproduced in reverse in a three-block chiaroscuro woodcut by the German painter and wood engraver Ludolph Büsinck (c. 1590–1669; Hollstein [G], V, p. 179, no. 4). Büsinck did not follow Bloemaert's effective color scheme of contrasting green and brown but printed the two tone-blocks of the woodcut in different shades of brown; the third block, the line-block, he printed in black. The print is apparently the German engraver's only certain work after a design by the Dutch artist and the question arises as to how even this limited association of their work came about. Both Bloemaert and Büsinck spent some time in Paris but Bloemaert was there from about 1580 until 1583, much earlier than the sojourn of the younger Büsinck. Apparently Büsinck's only known connection with Utrecht, where Bloemaert spent most of his long life, was through his son Wilhelm who was there many years later. Wolfgang Stechow

in his article on Büsinck was of the opinion that the *Holy Family* was the engraver's earliest chiaroscuro since it is executed in the technique of Goltzius' chiaroscuros unlike the German's prints after the French artist Lallemand ("Ludolph Buesinck, a German Chiaroscuro Master of the Seventeenth Century," *Print Collector's Quarterly*, XXV, 1938, p. 413). Apropos Goltzius, one wonders if Bloemaert knew Goltzius' print *The Holy Family under the Cherry Tree*, 1589 (Hollstein, VIII, no. 18), since the placement and scale of the main elements of the two compositions are similar, particularly the triangular form of the cloaked figure of the Virgin presented against a great tree trunk.

There is another almost identical but inferior drawing at Amsterdam in the Rijksmuseum (Inv. no. A242; pen and brown ink, gray wash, heightened with white; 237 × 170 mm. Boon, no. 34), which is executed in the same direction as the Morgan sheet. There are only slight differences in detail in the Amsterdam example: Mary, for example, wears her cloak fastened and a hat at her back; Joseph's hands are lightly clasped rather than engaged in holding his hat and staff; and the Child is less animated. A drawing from the collection of Colonel J. Weld, Lulworth Manor, Dorset, may well be a copy after Büsinck's chiaroscuro as it is in the same direction (pen and brown ink, brown wash, heightened with white; 242 × 178 mm.; photograph at Witt Library, London).

The three connoisseurs whose comments are inscribed on the mount of the drawing are the same as those who also gave their opinion of other drawings in the present exhibition (see Nos. 24 and 34). The comment "Bloemaert has been called the German Baroccio" is especially apt in connection with the gentle mood of this particular drawing.

PROVENANCE: Unidentified English collector; Charles Fairfax Murray; J. Pierpont Morgan (no mark; see Lugt 1509).

BIBLIOGRAPHY: Fairfax Murray, I, no. 229, repr.; K. G. Boon, *Netherlandish Drawings of the Fifteenth and Sixteenth Centuries*, The Hague, 1978, I, under no. 34.

EXHIBITIONS: New York Public Library, *Drawings for Prints and the Prints Themselves, 1933–34* (checklist by Frank Weitenkampf in *Bulletin of the New York Public Library*, New York, XXXVIII, no. 2, 1934, p. 101); New York, *Bloemaert*, 1973, no. 22.

Acc. no. I, 229

41. *St. Roch*

Red tempera over faint traces of black chalk, heightened with white tempera.
11⅜ × 8½ inches (290 × 215 mm.).
Watermark: partly visible through lining but illegible (horn?).

St. Roch, an historical figure, was born in Montpellier, France, about 1350 and died in Angera, Lombardy, around 1378 or 1379. Orphaned early, he traveled to Italy as a pilgrim in 1367 and became known for his care and healing of the sick, especially those afflicted with the plague. In the following century when the dread disease was still prevalent, its arrest in Ferrara in 1439 was attributed to his intercession and led to his veneration as the patron saint of sufferers of the plague. He himself is said to have been one of its victims. Usually he is represented as Bloemaert shows him, dressed as a pilgrim with staff and wallet, and lifting his tunic to display the plague spot on his thigh. At his side is the faithful dog who brought him bread when he retreated to the wilderness to die; above is the angel who watched over him until he recovered.

Only a few monochrome works such as this one are known in Bloemaert's *oeuvre*. *The Wedding of Peleus and Thetis* in the Mauritshuis in The Hague, signed and dated 159[4?], is executed in red and white oil on canvas (*Mauritshuis*, 1977, p. 43, no. 1046, repr.), and Marilyn Aronberg Lavin in *Oud Holland* (LXXX, Part 2, 1965, pp. 123–35) mentions two small tondo paintings attributed to Bloemaert, *Apollo and Daphne* in the Busch-Reisinger Museum, Harvard University, Cambridge, Massachusetts, and *Arachne* in the collection of Dr. Giulio Bilancioni in Mexico, both done in "pinkish-purple gri-

saille." At the time Mrs. Lavin wrote, *The Wedding of Peleus and Thetis* at The Hague was in the collection of Dr. H. Becker of Dortmund from whom it was acquired by the Mauritshuis in 1973. The purpose of such monochrome works is unknown. In the case of the highly polished Morgan example, it is not inconceivable that it was made as an independent work of art—perhaps a devotional piece—to be enjoyed as an end in itself.

PROVENANCE: Sir Charles Greville (Lugt 549); George Guy, fourth Earl of Warwick (Lugt 2600); his sale, Christie's, London, 20–21 May 1896, one of two in lot 33; Charles Fairfax Murray; J. Pierpont Morgan (no mark; see Lugt 1509).

EXHIBITION: New York, *Bloemaert*, 1973, no. 21.

Acc. no. I, 229b

by adding small amounts of watercolors, he produces unusual effects" (pp. 415–16).

The same subject is represented in a drawing of more or less identical measurements at the National Gallery of Scotland (Inv. no. 1084; 147×230 mm.). Since that drawing is much looser in execution and its outlines have been incised, it seems clear, as Keith Andrews suggested when he learned of the existence of the Morgan landscape, that the Edinburgh version was the working sketch that preceded the more detailed and finished New York version.

PROVENANCE: Charles Fairfax Murray; J. Pierpont Morgan (no mark; see Lugt 1509).

EXHIBITION: New York, *Bloemaert*, 1973, no. 17.

Acc. no. I, 229a

42. *Landscape with Farm Buildings*

Pen and brown ink, gray-green wash, over traces of graphite.
5¹³⁄₁₆×9 inches (147×228 mm.).
Watermark: none visible through lining.

This drawing of a complex of thatched farm buildings is typical of the artist's many sketches of houses and rural buildings, often as not in a state of picturesque dilapidation. Some of these were engraved by his second son, Frederick, who produced two suites of landscapes with farmhouses, dovecotes, sheds, hay stacks, etc. (Hollstein, II, nos. 269–78 and 279–93). The Morgan sheet, as far as could be ascertained, was not engraved. Undoubtedly such scenes were popular with collectors. Carel van Mander testifies to this in his *Schilderboeck*, first published in 1604, the year in which, as he took the trouble to note, Bloemaert was thirty-seven years old: "Certain art collectors have some interesting landscapes by Bloemaert. Most of these pictures are farm scenes with farm implements, peasants, trees and fields—sights to be seen often and in variety near Utrecht. Bloemaert works mostly from nature; he did these farm scenes from life. He has a clever way of drawing with a pen, and,

43. *A Clump of Three Trees*

Pen and brown ink over black chalk, gray wash, watercolor in green, yellow, and brown, with touches of white, on paper tinted pale pink.
11¼×7½ inches (285×190 mm.).
Watermark: double-headed eagle, surmounted by single crown, with initials *FB* (close to Heawood 1300). See watermark no. 12.
Inscribed on verso in pen and brown ink in an old calligraphic hand, *Roeland Savery f.*; above this in graphite, *R. SAVERY.*

To the modern eye, Bloemaert's studies after nature are among the most pleasing of his drawings. Here, he focused on a clump of three trees, attracted mainly, one feels, by the mossy tangle of exposed roots that seem always to have intrigued Mannerist artists, north and south (see No. 2). It is difficult to say what season is represented; the predominance of bare branches with only a few clusters of leaves, here and there, suggests an autumnal scene.

The artist first set down a few faint guidelines in black chalk and then brushed in the main forms in gray wash, eventually giving them firm definition with his pen, but leaving the upper reaches of the branches in the soft gray. Along with the sensitive application of various water-

78

color tints, he may have returned to a slightly darker gray wash to model the tree trunks in circular strokes. The stippling technique, notable especially in the leaves, is characteristic of the artist. There are other examples of these delicately worked woodland studies in the Albertina (II, 1928, p. 41, nos. 452–53, pl. 114) and the Metropolitan Museum of Art (Inv. no. 1970.242.3).

PROVENANCE: Possibly Dr. E. Peart (no mark; see Lugt 891–92); P. & D. Colnaghi and Co., London.

BIBLIOGRAPHY: Morgan Library, *Seventeenth Report to the Fellows, 1972–1974*, 1976, pp. 153–54.

EXHIBITIONS: London, P. & D. Colnaghi and Co., *Drawings by Old Masters*, 1972, no. 22, repr.; New York, *Bloemaert*, 1973, no. 18.

Acc. no. 1972.9

Gift of the Fellows

Jacques de Gheyn II

Antwerp 1576 – 1632 The Hague

44. *Mountain Landscape*

Pen and brown ink, over very faint indications in black chalk. Vertical fold through center.
11½ × 15⅝ inches (292 × 389 mm.).
Watermark: none.
An inscription on verso in pen and brown ink at lower right margin trimmed to illegibility.

This extraordinary drawing, made perhaps four to five decades after Pieter Bruegel's Alpine landscapes of the 1550's, encompasses a wide sweeping view over a tremendous expanse of rugged mountainous terrain. Off to the right, hills and valleys stretch in almost infinite peregrination, merging finally at the horizon in a wide, populated plain. Meandering rivers and streams course the valleys of their creation, and here and there in this successor to the "world landscapes" of Patinir are farms, towns, a castle, a convent, and an arched bridge. Beyond the prominent fortified town—so crystalline and sharp in its delineation that one can trace its streets and chart its ramparts—is a range of

ancient, worn peaks. In the immediate foreground, in an effect of bold repoussoir, the draughtsman records his appreciation of the eroded forms of rock and earth, ornamentally tufted with grasses and leafy growths. The pen stroke, rich and varied in accent in this area, modulates with infinite finesse until it fades out in the mist of the distance. The draughtsman, one realizes, must have paused many times to sharpen or renew his crowquill pen before the final filament of golden line dropped from its point.

The attribution of this panoramic landscape is not without some question and the problem is complicated by the existence of an extraordinarily close version, inscribed *de Gheÿn*, in the Nationalmuseum at Stockholm. Ever since the Morgan drawing was first exhibited seventy-one years ago at the galleries of Messrs. Obach in London, however, it has been associated with the name of De Gheyn. It was first published as such by Campbell Dodgson in the *Burlington Magazine* of 1912 when it was in the possession of Mrs. Murray Baillie. In 1932, Professor J. Q. van Regteren Altena, writing in *Oud Holland*, discussed its relationship with the forgotten artist Jan van Stinemolen (1518 – after 1582) and with the version in Stockholm; he proposed among other possibilities that both drawings were copies of a lost drawing by Stinemolen, the Library's by De Gheyn, the Stockholm sheet by Goltzius. Stinemolen's signed and dated panoramic view of Naples (1582) in the Albertina presents a sufficient number of affinities with the two drawings to have led the late Otto Benesch to suggest that all the drawings were by the same hand. In 1936, Professor Altena included the Morgan landscape in his book on De Gheyn's drawings (p. 55), and in a more recent letter he remarked that it "can hardly be anything else than a genuine De Gheyn drawing." The catalogue of the Royal Academy's 1953 exhibition, in which the Morgan drawing—then owned by James Murray Usher—was shown as no. 265, records Mr. A. E. Popham's preference for the attribution to De Gheyn; it was also

79

observed there that "the style of the two signed drawings by Jan van Stinemolen at Edinburgh and in the Albertina which have been connected with it [i.e., the Library's drawing] by J. Q. van Regteren Altena, seems slightly more archaic and less pictorial."

In the Nationalmuseum's catalogue of its 1953 exhibition of Dutch and Flemish drawings, Nils Lindhagen and Per Bjurström noted that "the Stockholm drawing (no. 24) is in certain respects inferior in quality to the English one [the Morgan drawing], e.g., in regard to the accuracy of form, the omission of some details, etc. On the other hand, the details, etc., are in a higher degree fused into a painterly whole, with a certain accentuation of the atmospheric perspective by the aid of a slight wash. . . ." Visitors to the important exhibition *Drawings from Stockholm*, on view at the Library early in 1969, had a unique opportunity to test this statement in the presence of the two drawings themselves. Most critics felt that the confrontation favored the Morgan landscape.

It is debatable whether this landscape had its origin in reality. If the draughtsman was working from nature, it has been suggested that his model might have been in the locale of the volcanic hills of central Italy. A town like La Civita, near Bagnoregio, for example, a small settlement cresting an isolated tufa plateau (repr. Italian Touring Club volume on Lazio, Milan, 1943, p. 141), could have been in the draughtsman's recollection, if not within his actual range of vision, when he created the mountain town of the drawing.

PROVENANCE: Mrs. Murray Baillie, Ilston Grange, near Leicester; James Murray Usher; sale (Alexandrine de Rothschild, and others [including James Murray Usher]), London, Sotheby's, 6 July 1967, lot 6, repr.; R. M. Light & Co., Boston.

BIBLIOGRAPHY: Campbell Dodgson, "Staynemer: An Unknown Landscape Artist," *Burlington Magazine*, XXI, 1912, p. 35; J. Q. van Regteren Altena, "Vergeten Namen: III. Staynemer of Stinemolen," *Oud Holland*, XLIX, 1932, pp. 91ff.; J. Q. van Regteren Altena, *The Drawings of Jacques de Gheyn*, Amsterdam, 1936, p. 55; Nils Lindhagen and Per Bjurström, *Dutch and Flemish Drawings in the Nationalmuseum and Other Swedish Collections*, Stockholm,

1953, under no. 24; London, P. & D. Colnaghi, *Old Master Drawings: A Loan Exhibition from the National Gallery of Scotland*, exhibition catalogue by Keith Andrews, 1966, under no. 13; Morgan Library, *Fifteenth Report to the Fellows, 1967–1968*, 1969, pp. 95–98, repr.; Morgan Library and elsewhere, *Drawings from Stockholm: A Loan Exhibition from the Nationalmuseum*, 1969, under no. 47; Morgan Library, *Review of Acquisitions 1949–1968*, 1969, p. 147, pl. 39.

EXHIBITIONS: London, Messrs. Obach, 1908 (apparently without catalogue); London, Royal Academy of Arts, *Drawings by Old Masters*, 1953, no. 265; Rome, Académie de France à Rome, Villa Medici, *Il Paesaggio nel disegno del cinquecento europeo*, catalogue by Françoise Viatte, Roseline Bacou, and Giuseppina delle Piane Perugini, 1972–73, no. 131, repr.; Morgan Library, *Major Acquisitions, 1924–1974*, 1974, p. xxv, no. 39, repr.; Berlin, *Pieter Bruegel*, 1975, no. 163, fig. 302.

Acc. no. 1967.12

Gift of the Fellows

45. *Design for a Garden Grotto*

Pen and brown ink, gray wash, over slight indications in black chalk.
7⅛ × 11⅞ inches (181 × 302 mm.).
Watermark: cockatrice with little house (similar to Heawood 842). See watermark no. 7.

Jacques de Gheyn II, the most gifted member of the family that for three generations produced an artist bearing this name (see No. 60), is usually thought of as engraver and painter, but towards the end of his life he was also employed as a landscape architect. He worked in this capacity in the court garden of the palace at The Hague, first for Prince Maurits of Nassau, who died in 1625, and then for Prince Frederik Hendrik, the younger brother of Maurits. This we know on the authority of his friend and neighbor, the Dutch statesman and poet Constantijn Huygens who was secretary to Frederik Hendrik. Huygens in his *Autobiography* praises De Gheyn's design for the garden pavilion and his "introduction of ornaments such as hedges, flower beds, fountains, and other such decorations," and then remarks that De Gheyn "left unfinished the work on which he had begun, of imitating in the Italian manner high rocks standing in water, and transferred both the work and the

reward to his only son" (quoted from J. Q. van Regteren Altena, *The Drawings of Jacques de Gheyn*, Amsterdam, 1936, pp. 18–19). Conceivably, such a remark might have applied to a rocky grotto like that represented in the Library's drawing which in its ultimate inspiration must go back to gardens of the previous century in Italy.

The design is a blend of the fantastic and weird, something in the spirit of drawings like the *Witches' Sabbaths* at Berlin and Oxford (Judson, *De Gheyn II*, 1973, pls. 101 and 96). But the fantasy is carried a step further in that the whole design is a double-image conceit. The composition when viewed in a certain way resolves itself into one monstrous visage, of which the lateral caverns form the eye-sockets, and the curled tails of the long-nosed beasts, its nostrils, while the bearded central figure is seen to be engulfed within its rocky jaws. A similar face on a lesser scale manifests itself when the curled tails of the small monsters are interpreted as eyes.

De Gheyn's design owes a debt to the work of a fellow artist of Antwerp, Cornelis Floris II (1514–1575), who had spent some time in Italy in the late 1530's and 1540's, and on his return to Antwerp produced designs for several books of engravings that helped to introduce the Roman *opera grottesca* to the Netherlands. The first series of engravings, *Veelderleij veranderinghe van grotissen ende compertimenten . . . Libro primo*, appeared in 1556 and was quickly followed by *Veelderleij niewe inventien van antijcksche sepultueren diemen nou zeere ghebruijkende is met noch zeer fraeije grotissen ea compertimenten zeer beqwame voer beeltsniders, antijcksniders schilders en alle constenaers ghedruckt bij mij Ieronijmus Cock, C. Floris Invent., Libro secundo*, 1557. It was one of the eight plates devoted to "grotesques" and "compartments" in the 1557 publication that furnished the starting point for the Morgan drawing, namely the plate showing in the lower center the figure of a nude man ensconced in shell draperies and seated astride the head of a sea monster.

De Gheyn made something quite different of the rigid central figure of the engraving when he adopted it as the focal point of his watery grotto. His skillful pen quickened and enlivened with free fancy, creating forms that are at once close to nature and ornamental. The device of the double-image is his own contribution. That he had the full series of Cornelis Floris' *Veelderleij niewe inventien* at hand is suggested by the fact that the placement of the arms of the old man in the drawing is similar to that of those of the figure on the title page of the engraved series, and the drawing's variety of sea creatures is not unlike that found in the engraved plate showing Neptune. The free, loose style of the drawing is quite in keeping with the lateness of the period in the artist's life at which it must have been executed, possibly sometime in the early or middle 1620's. De Gheyn carried his design a step further in a very large, elaborately colored drawing in the British Museum (Sloane, Inv. no. 54.5237), where he made a number of changes and introduced various other creatures, both real and fanciful, denizens of the land as well as of the sea.

When translated into three dimensions and enhanced by the play of water and light over moss-covered surfaces, one can imagine that the grotto presided over by the old sea deity, presumably Neptune, would have been startlingly effective, particularly in the illusionism of the double-images. Whether or not De Gheyn's design was ever executed is not known. Hendrik Hondius' view of the garden at The Hague, published in 1622 in his *Institutio artis perspectivae*, shows no grotto although the text mentions "une grotte faicte fort artificeusement." Possibly Professor van Regteren Altena will provide further information on these grotto drawings in his long awaited *catalogue raisonné* of De Gheyn's drawings.

PROVENANCE: Dr. Edmund Schilling, London; H. M. Calmann, London.

BIBLIOGRAPHY: Morgan Library, *Fifth Annual Report to the Fellows*, 1954, pp. 68–70, repr.; Felice Stampfle, "A Design for a Garden Grotto by Jacques de Gheyn II," *Master Drawings*, III, 1965, pp. 381–83, pl. 27; J. Q. van Regteren Altena, "Grotten in de tuinen der Oranjes," *Oud Holland*, LXXXV, 1970, no. 1, p. 34, fig. 2; J. Richard Judson, *The Drawings of Jacob de Gheyn II*, New York, 1973, p. 12, pl. 111.

EXHIBITION: Los Angeles, *Old Master Drawings from American Collections*, catalogue by Ebria Feinblatt, 1976, no. 188, repr.

Acc. no. 1954.3

Purchased as the gift of Mr. Walter C. Baker

46. *A Soldier Preparing to Load His Caliver*

Pen and brown ink, gray wash, and some work with point of brush and gray wash.

10¼ × 7⅛ inches (261 × 180 mm.).

Watermark: none.

Inscribed in pen and brown ink at lower right, *22*; on verso, in graphite at upper left, *26656* (crossed out) / $\frac{70}{28}$; in pen and brown ink at lower left, *1659* (crossed out); in graphite at lower right, *DeGheyn | 10 . 6.*

This precise drawing is preparatory for one of the plates in an important early military manual for the Dutch army, commissioned by Johan II of Nassau and published in three parts in The Hague in 1607 under the title *Wapenhandelinghe / van Roers – Mvsqvetten / ende Spiessen / Achtervolgende de ordre van / Sÿn Excellentie Maurits Prince van / Orangie Graue van Nassau . . . Figvirlyck Vutgebeelt, door / Jacob de Gheÿn.* The three parts respectively illustrate the proper handling of calivers (42 plates), muskets (43 plates), and pikes (32 plates). French and English editions were published in The Hague in 1608, and the first of several German editions was issued in 1609. There was also an early edition in Danish. It is thought that the plates were probably engraved by De Gheyn's pupil Robert de Baudous.

The Morgan drawing was engraved as plate 22 in the first section of the manual which is devoted to the use of the caliver, a variety of harquebus, also known as the small shot. The instruction reads: "Now he shall open the charge of the flaske, or als if he doe weare a bandolier, he shall doe like as is shewed by the Musquetiers." The command for this position reads: "Open your charges."

More than half the drawings for the 117 illustrations are known. The following, however, is probably only a partial census: Rijksprenten-kabinet, Amsterdam (25); National Maritime Museum, Greenwich (20); Fitzwilliam Museum, Cambridge (6); Gemeentemusea (Fodor Collection), Amsterdam (3); Yale University Art Gallery, New Haven (2); J. Q. van Regteren Altena, Amsterdam (2); and one each in a number of other collections (Ashmolean Museum, Oxford; Boymans–van Beuningen Museum, Rotterdam; British Museum, London; Gemeente Museum, The Hague; Prentenkabinet, Rijksuniversiteit, Leyden; Maida and George Abrams Collection, Boston (the former C. R. Rudolf drawing); and Teylers Museum, Haarlem). No doubt some of the above drawings were among the group of thirty-two sold in Amsterdam at Frederik Muller & Company in the sale of Comte de Robiano and others, 15–16 June 1926, lot 373, when they were sold to Colnaghi's for 825 florins. The drawings were apparently resold by Colnaghi's in another sale since they reappear in Anton W. M. Mensing's sale, Amsterdam, Frederik Muller, 27–29 April 1937, lot 208, when Colnaghi's again bought them, this time for 525 florins. K. G. Boon noted that all of the drawings for the manual were still together in the collection of Jan Pietersz. Zomer (1641–1724)—they are described in the catalogue of the collection probably printed between 1720 and 1724—and the full series appeared in the Jan Goeree sale of 1731, after which the drawings were variously dispersed (*Netherlandish Drawings of the Fifteenth and Sixteenth Centuries in the Rijksmuseum*, The Hague, 1978, I, p. 74, under no. 212). The copy of the rare catalogue of Zomer's important collection acquired by the Rijksbureau voor Kunsthistorische Documentatie, The Hague, in 1946 from the collection of A. Mensing of Amsterdam, will be published in the next year or so by J. G. van Gelder and S. A. C. Dudok van Heel.

Whenever it has been possible to check, the preparatory drawing is executed in the same direction as the engraved illustration; some of the drawings are traced for transfer with the stylus and some not, as is the case here. There must have been another step in the process of

transferring the design to the plate; otherwise the weapons would have been shown in the wrong hand in the engraving.

The drawings were probably made well in advance of their publication in 1607. Johan II of Nassau in a letter of 10 December 1608 refers to the book made by De Gheyn about ten or twelve years earlier (*Jacob de Gheyn: The Exercise of Armes*, commentary by J. B. Kist, New York, 1971, pp. 13–14). The delay in publication may have been occasioned by reasons of military security pending the signing of the armistice with Spain as suggested by Van Regteren Altena (Judson, *De Gheyn II*, 1973, pp. 12, 39) or, as Kist mentioned (p. 15), possibly by the initial skepticism of Maurits and Willem Lodewijk of Nassau as to the value of the manual. There appears to have been another series of the drawings for the section on the musketeers in the Königliche Bibliothek, Berlin, presumably from the estate of Johan of Nassau, but the series was destroyed in World War II (Boon, p. 74).

Haverkamp-Begemann has advanced the hypothesis that this series of drawings may not have been the work of De Gheyn's own hand. He cites as evidence a refined drawing of a musketeer from the Fodor Collection which differs somewhat in technique from the others as it is largely executed with the brush and heightened with white. While it is not directly preparatory for any single print, it bears ⸢De Gheyn's signature and "it should, therefore, perhaps be considered the model for the whole series, and, even if it cannot be answered, the question nevertheless should be asked whether Jacques de Gheyn employed an assistant for these numerous drawings" (E. Haverkamp-Begemann and Anne-Marie S. Logan, *European Drawings . . . in the Yale University Art Gallery 1500–1900*, New Haven, 1970, pp. 203–04; see also Marijn Schapelhouman, *Tekeningen van Noord-en Zuidnederlandse kunstenaars geboren voor 1600: Oude tekeningen in het bezit van de Gemeentemusea van Amsterdam, waaronder de collectie Fodor*, Amsterdam, 1979, II, p. 50 under no. 24, p. 52 under no. 26). If an assistant were involved in the project, he could be said to have been a credit to his master. It might be added that Boon found Haverkamp-Begemann's hypothesis "not improbable" though he rejected De Gheyn's authorship of the Fodor drawing and likewise doubted the inscription as a signature.

PROVENANCE: Jonkheer Johann Goll van Franckenstein the Elder (1722–1785; his *No. 1180* in brown ink on verso, Lugt 2987; acquired about 1758, does not figure in the Pieter Hendrik Goll van Franckenstein sale, 1 July 1833, and was probably sold by the owner before the end of the eighteenth century); Paignon Dijonval (1708–1792), Paris; Charles-Gilbert, Vicomte Morel de Vindé (no mark; see Lugt 2520); sold in 1816 to Samuel Woodburn (no mark; see Lugt 2584); sale, London, Christie's, 29 November 1977, lot 156 (to Thaw); Mr. and Mrs. Eugene V. Thaw, New York.

BIBLIOGRAPHY: Bénard, *Cabinet de M. Paignon Dijonval*, 1810, p. 65, one of six under no. 1302, "Six dessins, étude de soldats en diverses attitudes et mouvemens d'exercises; d. à la plume lavés d'encre sur papier blanc; h. 10 po. sur 7 po."; John Herbert, ed., *Christie's Review of the Season 1978*, London, 1978, p. 104, repr.

Acc. no. 1979.1

Gift of Mr. and Mrs. Eugene V. Thaw

Claes Jansz. Visscher
Amsterdam 1586 – 1652 Amsterdam

47. *View of Enkhuizen*

Pen and brown ink.
7⅛ × 11⅛ inches (181 × 283 mm.).
Watermark: ewer with initials *DS*. See watermark no. 15.
Inscribed by the artist in pen and brown ink, across center, *Enckelhuisen*; at the upper right is the key to the ten numbers above the buildings, *1 valbrug, 2 mainerttruls brug, 3 t'klockhŭijs, 4 de kraen, 5 De suyder kerck, 6 De ton op de keten, 7 peeper toorn, 8 Denieŭwe pack tŭynen, 9 De ckaep, 10 t' stathŭis*; to the right of center, over houses, *wat te hoochg*; under church, *langs heen vol boomen*; at upper right near margin, *65*.

Visscher was one of the first interpreters of the Dutch landscape *per se*. That he worked in direct contact with his subject is obvious in this annotated view of the town of Enkhuizen, a port in the province of North Holland, less than thirty miles from Amsterdam. In the upper right corner he provided a key to the numbers placed above points of interest in the city's skyline, the drawbridge (1), the crane (4), the South Church

83

(5), the salt factories (6), the pepper tower (7), the town hall (10). His concern for topographical accuracy is witnessed by his notation *wat te hoochg* written above a group of rooftops to the right of the tower of the South Church, indicating that he had shown the houses a little too high at this point. Below the church, in the area paralleling the water's edge, he wrote *langs heen vol boomen* to remind himself that there were trees all along there.

Enkhuizen was the birthplace of the artist Paul Potter (1625–1654) who knew the town as Visscher drew it, a thriving commercial and fishing center, much larger than it is today; the painter and engraver Jan van de Velde II died there in 1641.

Miss Lieneke Frerichs of the Rijksprentenkabinet, Amsterdam, reports that our subject is not among the views that the draughtsman etched and issued as a series. The large ornamental script in which the town's name is written, and which is so vital to the composition of the page, suggests nevertheless that the drawing may have been made with such a purpose in mind. Transcription and translation of the inscriptions are owed to Egbert Haverkamp-Begemann and S. A. C. Dudok van Heel.

PROVENANCE: H.M. (Lugt 1343); E. J. Otto (Lugt S. 873b); Margery Baker Davis; her son, Richard S. Davis.

BIBLIOGRAPHY: Morgan Library, *Fifteenth Report to the Fellows 1967–1968*, 1969, p. 100; Morgan Library, *Review of Acquisitions 1949–1968*, 1969, p. 175.

Acc. no. 1967.2

Gift of Mr. Richard S. Davis and Mrs. Marianna Davis Larsen in memory of Hollis S. Davis and Margery Baker Davis.

H. B. Blockhauer

Active 1621

48. *Country Village with Two Men Conversing*

Pen and brown ink.
5⅜ × 7 1/16 inches (136 × 179 mm.).
Watermark: none.

84

Signed with initials at lower right edge, *HB* (interlaced)

This drawing and No. 49 appear to have been together as a pair since the middle of the eighteenth century. Their history in the auction rooms of Amsterdam can be traced consecutively from 1754 when they were sold in the sale of Henri Tersmitten to 1810 when they appeared in the sale of Johannes van Heijnen and Jacob Helmolt. Exactly one hundred years later they were acquired by Pierpont Morgan from Fairfax Murray, but where they were before the latter acquired them, probably around 1900, is unknown. It is not only their later provenance that remains a problem but the draughtsman himself is something of a mystery. As far as could be ascertained at this time, these are the only examples of his work that are known although a third drawing ascribed to "H. Blockhauwer" appeared in the sale of the Vicomte Marmontel in Paris on 25–26 January 1883, lot 23, where it brought 50 francs. It is described as a pen drawing entitled "*Sous bois; cerf aux écoutes.*" While the artist's name would seem to be German, his style of drawing and his subject matter are surely Netherlandish. Could he perhaps have been an amateur draughtsman? Certainly his work is not without charm and competence, and it is to be hoped that its inclusion in this catalogue may elicit further information.

PROVENANCE: Henri Tersmitten, Amsterdam; his sale, Amsterdam, 23 September 1754, Album N, p. 69, lot 637, "H. B. Blockhouwer. Deux Païsages, ornés de Figures, à la plume" (4 florins 15); Pieter Testas de Jonge, Amsterdam; his sale, Amsterdam, 29 March 1757, Album L, p. 48, lots 633–34, "Een Landschap met de pen geteekent, door B. Blockhouer, zeer raar," "Een dito, door denzelven"; Hendrik Busserus, Amsterdam; his sale, Amsterdam, 21 October 1782, Album 9, lot 571, "Twee dito dito [stuks Landschappen], met de Pen geteekend, door Blockhouwe" (sold with lot 570 for 1 florin 10); Johannes Ulriens van Heijnen and Jacob Helmolt, Amsterdam; their sale, 11 April 1810, Album F, lot 30, "Twee rijk gestoffeerde Landschappen. Meesterlijk met de pen geteekend, door H. B. Blokhauwer" (to Gruiter for 2 florins); Charles Fairfax Murray; J. Pierpont Morgan (no mark; see Lugt 1509).

Acc. no. III, 247c

49. *Landscape with Figures on a Winding River Road*

Pen and brown ink.
$5\frac{3}{8} \times 7\frac{1}{16}$ inches (136×179 mm.).
Watermark: none.
Signed and dated by the artist in pen and brown ink at lower left corner, *hermen · Bertholoniez · Blockhauwer / ANNO 1621*.

See the text for No. 48.

PROVENANCE: see No. 48.

Acc. no. III, 247d

Esaias van de Velde

Amsterdam 1591 – 1630 The Hague

50. *Landscape with a Goatherd*

Pen and brown ink, over faint traces of graphite, brown wash and a touch of gray (right corner).
$6\frac{1}{4} \times 7\frac{5}{8}$ inches (160×194 mm.).
Watermark: none.
Signed by the artist in brown ink at lower left, *E. VV* (interlaced)*ELDE*. Inscribed on verso at lower right in graphite in an old hand, *4 – 6*.

This is a relatively early drawing by the artist, the eldest of an illustrious artistic family, who played an important role in the development of realism in seventeenth-century Dutch landscape art. Most likely it was executed before he moved from Haarlem to The Hague in 1618. In its mannered ornamentalism it is close to the drawn and etched landscapes of Willem Buytewech, with whom Esaias and also Hercules Segers entered the painters' guild at Haarlem in 1612. At the same time its subject matter is realistic, perhaps what Haverkamp-Begemann termed "realistic imaginary," though the artist could well have known the houses of the hamlet situated at the fork of a road and enjoyed the patterning of the trees along the distant horizon, all of which he renders with calligraphic neatness. One admires especially the skill with which the draughtsman controls the spatial effects of his composition on its several levels. Another landscape, very similar in style and format, in

the Library's collection (Acc. no. I, 117) is dated 1616, perhaps also an appropriate date for the present sheet. There is a signed and dated black chalk drawing of this year, *Winter Scene*, in the Yale University Art Gallery, New Haven (Egbert Haverkamp-Begemann and Anne-Marie Logan, *European Drawings and Watercolors in the Yale University Art Gallery 1500–1900*, New Haven, 1970, I, no. 430, II, pl. 203) and a pen drawing in the Städelsches Kunstinstitut, Frankfurt am Main (Inv. no. 2805).

PROVENANCE: Charles Fairfax Murray; J. Pierpont Morgan (no mark; see Lugt 1509).

Acc. no. I, 117a

Jacob Pynas

Alkmaar c. 1585 – after 1656 Amsterdam(?)

51. *St. Francis Receiving the Stigmata*

Brush and thin brown oil paint over slight indications in red chalk. Verso: offset in brown oil of composition with a camel.
$11\frac{1}{16} \times 7\frac{3}{16}$ inches (280×183 mm.).
Watermark: fleur-de-lis within a shield, surmounted by crown (cf. Heawood 1663 et seq.). See watermark no. 18.
Signed with the brush at lower left, *Jac. Pynas f.* Inscribed on verso in graphite at lower right, *Lot 3 / B. White*.

This sheet is one of three signed drawings representing St. Francis, each a kind of devotional image on more or less the same scale. The drawing in the Boymans–van Beuningen Museum, Rotterdam (*The Pre-Rembrandtists*, fig. 44), which is in the same monochrome brown as the present one, shows the saint kneeling in prayer before a rude cross and holding a crucifix, his rosary looped over his wrist. The *St. Francis* in the Albertina, Vienna, described as being in red chalk and showing the saint in a slightly different kneeling posture without the crucifix and book of the Rotterdam version, bears, in addition to the usual signature, a calligraphic Latin inscription reading: *Jacob Pinus In Amsterdam fecit* (*The Pre-Rembrandtists*, fig. 43). All three versions include the small church on a hillside at the right.

Possibly the reference in the Latin inscription to Jacob Pynas in association with Amsterdam gives a clue for the dating of these three works, which are as similar in style as in subject matter. Since the artist, who is known to have been in Italy in 1605, is mentioned in 1608 as being in Amsterdam, it could be that these drawings are a more or less immediate reflection of his experience in the South; it might be pointed out that a church of much the same character as those in the background of the St. Francis compositions is found in the Italianate landscape, dated 1608, in Berlin (repr. Kurt Bauch, "Beiträge zum Werk der Vorläufer Rembrandts, IV: Handzeichnungen von Jakob Pynas," *Oud Holland*, LIV, 1937, p. 241, fig. 1). Of course, as is known, Pynas is also mentioned as being in Amsterdam in 1641 and 1643, but the drawings are surely earlier rather than later works of the artist, as Bauch indicated when he placed the Albertina drawing in the beginning years of the seventeenth century (p. 250). Astrid Tümpel, on the other hand, suggests that all three drawings "probably were done as preliminary studies for Pynas' signed painting *The Stigmatization of St. Francis* which she dated in the late 1630's (p. 31, fig. 38; the location of the painting which was sold at Christie's, 2 May 1930, lot 87 is not known). In the painting, the setting, including the church, is much the same as in the drawings but the saint kneels in three-quarter view to the right. The Morgan drawing perhaps should be regarded more in the nature of an independent work than as a study for the painting as Astrid Tümpel proposed, and the same is probably true of the Rotterdam and Vienna drawings.

PROVENANCE: B. White (according to inscription; possibly William Benoni White; Lugt 2592); Charles Fairfax Murray; J. Pierpont Morgan (no mark; see Lugt 1509).

BIBLIOGRAPHY: Wolfgang Wegner, *Kataloge der Staatlichen Graphischen Sammlung München, I: Die niederländischen Handzeichnungen des 15.–18. Jahrhunderts*, Berlin, 1973, p. 118, under no. 840.

EXHIBITION: Sacramento, California, E. B. Crocker Art Gallery, *The Pre-Rembrandtists*, catalogue by Astrid and Christian Tümpel, 1974, p. 31, no. 13, repr.

Acc. no. I, 170a

Willem Pietersz. Buytewech
Rotterdam 1591/92 – 1624 Rotterdam

52. *The Mussel Seller*

Pen and point of brush, black ink and gray wash. 3$\frac{15}{16}$ × 6$\frac{13}{16}$ inches (100 × 173 mm.).
Watermark: fragment of eagle with three circles below (cf. Briquet 1370). See watermark no. 14.
Inscribed on verso, in graphite, in different hands, *299* corrected to *289*; *The Dutch Hawker*; *Paulus | Joachim | Uytewael | 1560–1640*.

With a sharp eye for attitude and gesture, Buytewech sketches a group of animated women bargaining with a harried fishmonger who dispenses his wares from a wheelbarrow; two small urchins watch the seller as he is about to scoop up a bowlful of the barrow's contents—probably mussels, as Haverkamp-Begemann pointed out —for transfer to the pail of the foremost woman. Such a market scene was no doubt done directly from nature, and in the depiction of these scenes from daily life Buytewech noticeably anticipates Rembrandt who was still a boy when this drawing was made. Haverkamp-Begemann in his monograph associated the Morgan sheet with other genre sketches like the *Pancake Woman* in Leipzig (his no. 40, pl. 60) and the *Sperm Whale* in Berlin (his no. 35, pl. 59), the latter specifically dated 21 January 1617, but he, as well as the authors of the catalogue of the Buytewech exhibition of 1974–75, remark on the difficulty of dating the drawing precisely. 1617 was the year Buytewech returned to his native Rotterdam after a sojourn of some years in Haarlem, and it may be that this drawing and the *Pancake Woman* with which it shows decided affinity in style and similar horizontal format were executed not long afterwards. Although no prints after them are known, these drawings would have lent themselves as delightful illustrations for a series portraying the daily life of the time.

PROVENANCE: Colonel Gould Weston, London; P. & D. Colnaghi and Co., London.

BIBLIOGRAPHY: E. Haverkamp-Begemann, *Willem Buytewech*, Amsterdam, 1959, pp. 23, 29, 33, no. 40, pl. 145; Morgan Library, *Tenth Report to the Fellows*, 1960, pp.

52–53; Morgan Library, *Review of Acquisitions 1949–1968,* 1969, p. 135.

EXHIBITIONS: London, P. & D. Colnaghi and Co., *Exhibition of Old Master Drawings,* 1959, no. 28, pl. IV; Rotterdam, Museum Boymans–van Beuningen, and Paris, Institut Néerlandais, *Willem Buytewech, 1591–1624,* catalogue by A.W.F.M. Meij, Jeroen Giltay, Mària van Berge, and Carlos van Hasselt, 1974–75, no. 40, pl. 59.

Acc. no. 1959.5

Gift of the Fellows

53. *A Peasant Woman of De Zijpe*

Pen and brown ink, over black chalk, pale blue watercolor; outlines incised with the stylus.
7¹³⁄₁₆ × 5½ inches (198 × 139 mm.).
Watermark: none visible through lining.

In Buytewech's drawn *oeuvre* there are a number of sets of individual figure studies of men and women. Some depict the elegant world of fashion, not without an element of light mockery; others like the series to which this drawing belongs are straightforward representations of rustic life and costume. The young woman of De Zijpe belongs to a series of eight studies of Dutch country women from different parts of the province of North Holland, all engraved in reverse by Gillis van Scheyndel (active in Haarlem between 1620 and 1654). Buytewech's pleasingly composed drawing of the young peasant in the company of her rooster and hen, with their chicks, was faithfully transcribed by Van Scheyndel as the first of the sequence of eight numbered prints; he omitted only the church spire across the water in the distance and the vegetation of the foreground. The Latin inscription at the lower margin of the engraving identifies and describes the subject: "The robust girl of De Zijpe, her uncovered head bound with braids, her step light, is proud of countenance and bearing" (*Zipensis nudata caput, Cvisposque* [read *levipesque*] *virago / Subnectens Crines, vultu ingressuque superbit*). Unlike some of the others of the series, she was not given a classical name. The drawing for *Galatea of Alkmaar* is in the collection of J. Q. van Regteren Altena, Amsterdam (Rotterdam-

Paris catalogue of the Buytewech exhibition of 1974–75, no. 87, pl. 107); *Phyllis of Edam,* in the museum at Rennes (no. 88, pl. 96); the *North Sea Fisherman's Wife* in the Albertina, Vienna (no. 89, pl. 104); the *Peasant Woman of the Rhineland,* also in the museum at Rennes (no. 90, pl. 98). The drawings for the engravings *Nisa of Edam,* the *Woman of the Land of Hoorn,* and *Thestylis of the Land of Hoorn* are not known. All the Van Scheyndel engravings as well as the drawings are conveniently reproduced in the Rotterdam-Paris catalogue; according to the same work (p. 129) the eight Van Scheyndel prints are probably to be dated about 1621 on the basis of an engraving bearing that date in another series of prints after a sequence of four Buytewech drawings that have not survived. Only the Morgan sheet and that in the Albertina have been washed with blue watercolor, and it may be that this is the addition of a later hand. The blue wash covers the entire area of the sky in the present drawing.

PROVENANCE: Possibly Samuel van Huls, former burgomaster of The Hague; his sale, The Hague, Swart, 14 May 1736, part of lot 1914; P. & D. Colnaghi and Co., London.

BIBLIOGRAPHY: Morgan Library, *Seventeenth Report to the Fellows, 1972–1974,* 1976, p. 155.

EXHIBITIONS: London, P. & D. Colnaghi and Co., *Exhibition of Old Master Drawings,* 1972, no. 19, repr.; Rotterdam, Museum Boymans–van Beuningen, and Paris, Institut Néerlandais, *Willem Buytewech, 1591–1624,* catalogue by A.W.F.M. Meij, Jeroen Giltay, Mària van Berge, and Carlos van Hasselt, 1974–75, no. 86, pl. 105.

Acc. no. 1972.10

Purchased as the gift of Mr. Frits Markus

Pieter Molijn
London 1595 – 1661 Haarlem

54. *Herdsmen around a Fire at Night*

Black chalk, gray wash, heightened with white tempera.
5¹³⁄₁₆ × 7¹¹⁄₁₆ inches (148 × 196 mm.).
Watermark: fragment of fleur-de-lis within a shield. See watermark no. 27.

Signed and dated by the artist in black chalk at upper right, *PM*(interlaced)*olyn | 1655*. Inscribed on old mount, in brown ink, *uyt het Cabinet van de H*ʳ*: Bernardus Hagelis N*º *31*.

Molijn, one of the main masters of early seventeenth-century Dutch landscape painting, was also active as a draughtsman, particularly in his later period. Like the examples shown here, a great many of his drawings are dated in the 1650's, although there are sheets dated as early as the 1620's in Berlin (Bock-Rosenberg, 1930, I, p. 192, nos. 4329–30, II, pl. 129) and Brussels (De Grez Collection; De Grez catalogue, 1913, nos. 2568–70). The earliest dated drawing of the group of ten in the Morgan Library (Acc. no. III, 167c) bears the date 1634. Almost invariably the artist's drawings are signed and usually they are also dated. As early as 1625, Molijn produced a painting of a night scene, the *Nocturnal Street Scene* in the Musées Royaux des Beaux-Arts de Belgique, Brussels (repr. Wolfgang Stechow, *Dutch Landscape Painting of the Seventeenth Century*, London, 1966, fig. 349) but night subjects are very rarely represented in the drawings. Here he depicts a pastoral nocturne, experimenting with two sources of illumination. The light of the flames from the campfire around which the herdsmen gather (two of their cattle may be distinguished in the middle distance at the left), effectively picks out the forms of the half-ruined masonry arches while the light of the full moon, half obscured by clouds, streaks the dark sky.

Information concerning the collector Hagelis and his sale is owed to Dr. Hans-Ulrich Beck.

PROVENANCE: Bernardus Hagelis; his sale, Amsterdam, 8 March 1762, lot 808, "ein Maanligje"; Charles Fairfax Murray; J. Pierpont Morgan (no mark; see Lugt 1509).

Acc. no. III, 167g

55. *Winter Landscape*

Black chalk, gray wash.
5¾ × 7⅝ inches (147 × 194 mm.).
Watermark: fragment of foolscap (close to Churchill 337). See watermark no. 30.

Signed and dated by the artist in black chalk, in lower left corner, *PM*(interlaced)*olyn | 1656*.

Winter landscapes were a favorite theme of Molijn for his drawings. The present one is a fresh and carefully composed example; characteristically the figures peopling the scene are featureless and anonymous. There are two other winter scenes in the Library's collection, both dated 1655. In the instance of a winter landscape illustrating the month of December in the De Grez Collection in the Musées Royaux des Beaux-Arts de Belgique, Brussels, the artist was preparing his design for an engraved series of The Months, but as far as is known the Morgan winter landscapes are independent works and not connected with any project. The De Grez Collection possesses the full sequence of preparatory drawings, dated 1655, for all twelve months and the engravings as well (De Grez catalogue, 1913, nos. 2582–93). There is another sequence of drawings of The Months dating from 1658 at Teylers Museum, Haarlem (H. J. Scholten, *Musée Teyler: Catalogue raisonné des dessins des écoles françaises et hollandaises*, Haarlem, 1904, pp. 81–85, port. O, nos. 60–71).

PROVENANCE: Charles Fairfax Murray; J. Pierpont Morgan (no mark; see Lugt 1509).

Acc. no. III, 167a

Jan den Uyl
Amsterdam 1595 – 1640 Amsterdam

56. *Canal with a Sluice Gate*

Black chalk, blue, green, and gray watercolor washes.
3⅞ × 6½ inches (100 × 165 mm.).
Watermark: illegible fragment.

It was Frits Lugt, who, many years ago on the occasion of an early visit to the Morgan Library, rescued this drawing from anonymity and restored it to its proper author, the modestly charming but little-known artist Jan den Uyl. Presumably it is the work of the first of this

name, who signed his paintings with the owl that "Uyl" signifies, rather than his son. Eduard Trautscholdt in his articles on the two artists in Thieme-Becker (XXXIV, 1940) pointed out that drawings of this kind displaying the minute dot-like touches of the chalk—almost a *pointillisme*—and faintly reminiscent of the manner of Buytewech, are most probably to be assigned to the father. Whether or not the portfolio of eighty-three drawings listed in the inventory of the estate of the painter Jan van de Cappelle (A. Bredius, "De Schilder Johannes van de Cappelle," *Oud Holland*, X, 1892, p. 38, no. 41; also Margarita Russell, *Jan van de Cappelle*, Leigh-on-Sea, 1975, p. 56) were by the father or the son will probably never be known. A second drawing by the artist in the Library's collection is a pretty woodland scene, more extensively washed than the one shown here (Acc. no. I, 169a). Examples are also found in the collections at Berlin (Bock-Rosenberg, 1930, I, p. 290, nos. 4339, 14061–62, 14682) and at Rotterdam, and in the Institut Néerlandais, Paris (Brussels, Bibliothèque Albert Ier, and elsewhere, *Dessins de paysagistes hollandais du XVIIe siècle*, 1968–69, nos. 151–52). None of the known drawings, as far as could be ascertained, appears to be related to the paintings of still-life subjects published by P. de Boer (*Oud Holland*, LVII, 1940, pp. 49–64).

PROVENANCE: Charles Fairfax Murray; J. Pierpont Morgan (no mark; see Lugt 1509).

Acc. no. I, 169

Jan van Goyen

Leyden 1596 – 1656 The Hague

57. *Rider Inquiring the Way to The Hague*

Black chalk.
4¹¹⁄₁₆ × 6⅝ inches (119 × 169 mm.).
Watermark: none.

The horseman in this drawing appears to be inquiring the way from two countrymen, one of whom points to the silhouette of the city of The Hague on the horizon where the lofty tower of the Grote Kerk, or Church of St. James, is clearly distinguishable as seen from the south. The high building to the right of the tower is the choir of the church which has a much lower nave. Van Goyen apparently allowed himself some liberty in depicting the high choir; the small tower on the choir, a so-called "dakruiter," seems to be placed in the middle of the roof; in reality it is at the left side. (This information is owed to the kindness of Dr. An Zwollo and Mr. A. van der Weel.) By the early 1640's when this sketch was most likely made, such a view must have been a familiar sight to the draughtsman who had settled in The Hague in 1631 and, although he traveled much, maintained his headquarters there until his death. Many of his paintings and drawings record views of the city. As Beck noted, the present drawing appears to be part of a sketchbook, of which there is another leaf in the Library (Acc. no. III, 175d); both were once in the collection of W. Y. Ottley, an early nineteenth-century keeper of the British Museum's Print Room. Beck also listed four related leaves in Berlin, three in the print room of the Staatliche Museen, Berlin, and one in a private collection (his nos. 576, 583, 586, and 146); two in Teylers Museum, Haarlem (nos. 581, 588); one in the Louvre, Paris (no. 582); and one in the collection of Julius Held, formerly of New York and now of Old Bennington, Vermont (no. 587). Curiously, the two Morgan leaves are the only ones of the group that are not signed although there may be the remains of a signature on Acc. no. III, 175d. The date of the group is established by the fact that one of the Berlin drawings (no. 146) is signed and dated 1642, and several others of the group bear partially illegible or fragmentary dates in the 1640's. In addition to Beck's compilation of the considerable number of drawings where The Hague appears, mention might be made of a quick notation on leaf 26 of a dismembered Van Goyen album, now on the London art market; it also shows at the right the distant outlines of

The Hague and a lone rider at the left. Miss Shaunagh FitzGerald reports that Dr. Beck dates the drawings of the album, presumably from a sketchbook that was broken up in the eighteenth century, about 1630.

PROVENANCE: William Young Ottley (Lugt 2665); possibly his sale, London, T. Philipe, 14–21 April 1803, as part of one of the Van Goyen lots 936–39; Charles Fairfax Murray; J. Pierpont Morgan (no mark; see Lugt 1509).

BIBLIOGRAPHY: Hans-Ulrich Beck, *Jan van Goyen*, Amsterdam, 1972, I, no. 591, repr.

Acc. no. III, 175c

58. *Fishermen and Market Women on the Beach at Egmond aan Zee*

Black chalk, gray wash.
6¹¹⁄₁₆ × 10¾ inches (170 × 272 mm.).
Watermark: monogram *LR* (see Heawood 3073; Beck, I, p. 345, fig. 77). See watermark no. 48.
Signed with monogram and dated by the artist in black chalk at lower right, *VG 1653*.

Van Goyen is sometimes cited as the most prolific and best-documented painter and draughtsman of the seventeenth century in Holland, producing around fifteen hundred paintings and more than eighteen hundred drawings. A surprising number of the drawings were made in the first half of the decade of the 1650's, especially in 1653, the date of the present sheet. Beck's numbers from 332 through 557e in his recent monograph on the artist are all signed and dated examples from this one year. These black chalk drawings washed in gray or brown seem to be almost exclusively independent works.

It is the squat, square church tower at the right which identifies the locale of this drawing as the beach at Egmond aan Zee, today a resort village though still occupied with fishing. The ruined choir of the church is only slightly suggested at the right of the tower in this drawing, but there is an interesting close view of the church in the drawing at the Bibliothèque Nationale, Paris (Beck, I, no. 803) which was used for a painting that was on the London art market in 1956 (Beck, II, no. 935). Interestingly enough, one of Van Goyen's few dated paintings of the year 1653 (Beck, II, no. 963) is a view of the beach at Egmond, rather similar in its general configuration to the Morgan drawing but not in any of the details, with the possible exception of the wagon and its occupant bending over to lift a cask. The Egmond beach seems to have attracted Van Goyen—or his clients—since he produced a painting of the subject as early as 1633 and then at least one annually from 1641 through the year 1646 (Beck, II, nos. 925, 933–34, 943, 949, 951, 954, 956). Drawing no. 35 in the recently dismembered album on the London market (see previous entry) may represent the Egmond tower and the rooftops of the village houses on the dune above the beach.

PROVENANCE: Charles Fairfax Murray; J. Pierpont Morgan (no mark; see Lugt 1509).

BIBLIOGRAPHY: Fairfax Murray, III, no. 172, repr.; Hans-Ulrich Beck, *Jan van Goyen*, Amsterdam, 1972, I, no. 367, repr.

Acc. no. III, 172

59. *The Horse Market at Valkenburg near Leyden*

Black chalk, gray wash.
6⅝ × 10¾ inches (168 × 273 mm.).
Watermark: monogram *LR* (see Heawood 3073; Beck, I, p. 345, fig. 77). See watermark no. 49.
Signed with monogram and dated by the artist in black chalk at lower right, *VG 1653*. Inscribed on verso in graphite in lower left corner, *Mer | d 2.L oox . . . | f 36 | n⁰ 600* with *Gg* written in black ink over the number 600; in lower center, *8*.

The clue to the identity of the scene Van Goyen depicts here is the presence of the horses in the background and the slender pointed spire of the church at Valkenburg between Leyden and The Hague. His contemporaries perhaps would have recognized the scene of the horse fair held in this village since mediaeval times around 17 September, St. Lambert's day. The fair was

a favorite subject among seventeenth-century Dutch painters, including Adriaen van de Venne, Salomon van Ruysdael, Jan Steen, and Philips Wouverman. In 1665, a dozen years after Van Goyen made this drawing, the tower of the church was struck by lightning and later representations like those of Cornelis Pronk (1691–1759) and Paulus Constantijn la Fargue (1732–1782) show the church without its gothic spire. In the course of the nineteenth century the open space of the market as seen by Van Goyen was given over to houses but the memory of the "Marktveld" is preserved in the name of a street in the area. (Information on the horse fair is owed to the kindness of Dr. An Zwollo who supplied the following references: W. Stechow, "Het vroegst bekende werk van Salomon van Ruysdael," *Kunsthistorische Mededelingen van het R.K.D.*, II, 1947, pp. 36ff., p. 39, addition by Annet Hoogendoorn; E. Pelinck, "De Paardenmarkt te Valkenburg," *Leids Jaarboekje*, L, 1958, pp. 8off.)

Van Goyen chose to emphasize the human interest of the fair—the casual family group of onlookers in the left foreground, and, at the right, the visitors arriving by wagon and those patronizing the pancake woman before the tent pitched adjacent to the inn marked by the banner. Earlier, Van Goyen had represented a similar scene in the background of his painting of 1644 which was sold at Sotheby's in 1963 (Beck, II, no. 1025, repr.), and there is also a leaf from the sketchbook in Dresden (Beck, I, no. 846/89, repr.) showing very much the same scene. The lively stenographic notation at Dresden, clearly made on the spot, would appear to be the genesis of the other representations of the subject, including the Morgan drawing which was made considerably later, undoubtedly with a view to its sale. Beck cites a copy of the Library's drawing formerly in the collection of Prince Reuss.

PROVENANCE: Sir Joseph Hawley; possibly sale, M. de Salicis . . . and property of a Baronet [Sir Henry Hawley], London, Christie's, 16 July 1891, lot 201; Charles Fairfax Murray; J. Pierpont Morgan (no mark; see Lugt 1509).

BIBLIOGRAPHY: Fairfax Murray, III, no. 173, repr.; Hans-Ulrich Beck, *Jan van Goyen*, Amsterdam, 1972, I, no. 380, repr.

EXHIBITION: Amsterdam, Stedelijk Museum, *Jan van Goyen: Tekeningen*, catalogue by Frits Lugt, 1903, no. 51.

Acc. no. III, 173

Jacques de Gheyn III

The Hague c. 1596 – 1641 Utrecht

60. *Three Groups of Grotesque Heads in Rocks; Head of an Old Woman*

Pen and brown ink, gray-brown wash.
$7\frac{5}{8} \times 6\frac{11}{16}$ inches (193 × 169 mm.).
Watermark: fragment of fleur-de-lis within a shield (cf. Heawood 1769). See watermark no. 26.

This sheet of multiple-image fantasies and two related drawings in the Lugt Collection at the Institut Néerlandais, Paris (Inv. no. 5094), and the Witt Collection at the Courtauld Institute of Art, London (Inv. no. 1473 as J. Wonderlyn), might be regarded as the son's continuation of his famous father's interest in such subjects as the witches' kitchens he represented in drawings in the Kupferstichkabinett, Berlin, the Ashmolean Museum, Oxford, and the Metropolitan Museum, New York. Furthermore, the multiple-image concept finds a direct precedent in the faces that emerge amid roots and vegetation from the earthy roof of the cavern in the British Museum's extraordinary representation of a grotto by Jacques de Gheyn II that is an elaboration of the Morgan drawing (see No. 45).

Of the three rare prints of similar groups of heads (Hollstein, III, p. 212, nos. 26–28), two show elements based directly on the Morgan sheet. The three human heads and the fierce, bewhiskered visage (of an owl?) at the upper right of the sheet were etched in reverse on the lower part of Hollstein, no. 26; the group of heads above a segment of a root in the center of the sheet appear in reverse in the right half of Hollstein, no. 28. The left half of the etching shows the heads of old men at the upper right of the Witt drawing. The prints have for many

years been assigned to Bartholomeus Breenbergh, Bartsch apparently being the source of this attribution. Van Regteren Altena, however, at one time suggested that these prints as well as the three drawings are by De Gheyn himself, a logical assumption in view of the fact that each print bears De Gheyn's name and the date 1638. In recent correspondence, the same scholar reports that he considers "the multiple-image drawings to be late products of De Gheyn II and the small etchings of 1638 to be by Stefano della Bella when visiting Holland before settling in Paris." Apropos the attribution of the Witt drawing to Wonderlyn, Van Regteren Altena suggests that "Wonderlyn" may have been a misreading of an old comment "*wonderlijk*" (wonderful or strange).

PROVENANCE: William Mayor (Lugt 2799); sale, W. N. Lantsheer and Jeronimo de Vries, Amsterdam, Frederik Muller & Co., 3–4 June 1884, lot 104; Charles Fairfax Murray; J. Pierpont Morgan (no mark; see Lugt 1509).

BIBLIOGRAPHY: Fairfax Murray, III, no. 158, repr., as De Gheyn II; J. Q. van Regteren Altena, *The Drawings of Jacques de Gheyn*, Amsterdam, 1936, p. 108, footnote 1, as De Gheyn III; Hans Möhle, "Drawings by Jacques de Gheyn III," *Master Drawings*, I, no. 2, 1963, p. 4.

Acc. no. III, 158

Salomon de Bray

Amsterdam 1597 – 1664 Haarlem

61. *The Twins Clara and Albert de Bray*

Red chalk over faint indications in black chalk. 6¼ × 6 inches (160 × 152 mm.).

Watermark: fleur-de-lis within a shield (close to Heawood 1667). See watermark no. 20.

Inscribed and dated by the artist in red chalk at lower right, *1646 $\frac{8}{12}$ Neef Simon de Braÿ Symon*[szoon] / *2 lingen* $\begin{cases} Clara \\ Albert \end{cases}$ *en.*

Salomon de Bray and Jan, his son and pupil, were both excellent portraitists and appear to have been especially successful in depicting children, on occasion as here, members of their own family. The sleeping infants, as the inscription states, are the twins Clara and Albert, the children of the artist's nephew Simon, as they appeared in their crib on the twelfth of August in the year 1646. The order of the names in the inscription must mean that the child at the left is Clara, and there is something of the feminine in the small, round countenance that seems to bear this out.

The intimate red chalk sketch, most appealing in its human interest, was used for a more formal presentation of the two infants in the artist's painting now in a private collection in Scotland. The painting, reproduced as the work of Jacob Jordaens in the Arundel Club Portfolio (1906, III, no. IX), and also exhibited as such when it was shown in Brussels in 1910 (*Trésors de l'art belge*, Brussels and Paris, I, 1912, p. 218, no. CII [240], pl. 89), was restored to Salomon de Bray by Von Moltke in his article in the Marburg yearbook. In the painting, the twins are shown awake. Now elaborately clothed in starched robes and headdresses, and wearing lockets or medals beneath their dimpled chins, they are tucked beneath a lace-bordered sheet and velvet coverlet. Instead of the simple wicker (note the handle) crib of the drawing, they occupy a richly carved and gilded baroque cradle.

It was suggested by Robinson in the 1977 exhibition catalogue that the elaborate setting of the painting may indicate that the children are dead and the picture thus commemorative. It might, however, be argued that the painting rather marked the happier occasion of the baptism of the twins. The medals which the infants wear could be those presented by the godparents, the so-called *pillegifts* (see G. D. J. Schotel, *Het Oud-Hollandsch huisgesin dez zeventiende eeuw*, Amsterdam[?], 1903, pp. 54–61; reference owed to the courtesy of Egbert Haverkamp-Begemann). The shell ornamenting the headboard of the cradle might also be interpreted as having reference to baptism. Apropos the elaborate setting, it might be added that a taste for similar rich display was later reflected in Jan de Bray's portrayal of himself and his wife—in the com-

92

pany of their several children—as Antony and Cleopatra in the painting of 1669 formerly in the Germanisches Nationalmuseum at Nuremberg (Bernt, *Maler*, 1948, I, no. 135, repr.) and now in the Currier Gallery of Art in Manchester, New Hampshire (Franklin W. Robinson, "*The Banquet of Antony and Cleopatra* by Jan de Bray," *The Currier Gallery of Art Bulletin*, October-December 1969, n.p.). If one cannot rule out the possibility that the infants in the Edinburgh painting may have been dead when it was executed—the sobriety of Clara's expression and Albert's upward gaze might be thought to support such a supposition—there is nothing in the drawing to suggest that the infants were anything but normally asleep at the time the artist, who was their great-uncle, looked down on them in their crib and was inspired to sketch their likeness. "Nephew Simon," father of the twins and son of the artist's brother Simon, was a lawyer (*procureur*) at Haarlem. This biographical information is owed to the kindness of G. Th. M. Lemmens of the Kunsthistorisch Instituut der Universiteit of Nijmegen.

PROVENANCE: Charles Fairfax Murray; J. Pierpont Morgan (no mark; see Lugt 1509).

BIBLIOGRAPHY: Fairfax Murray, III, no. 176, repr.; Joachim Wolfgang von Moltke, "Salomon de Bray," *Marburger Jahrbuch für Kunstwissenschaft*, XI–XII, 1938–39, no. 104, pl. 89; Tietze, *European Master Drawings*, 1947, no. 78, repr.

EXHIBITION: Washington, D.C., and elsewhere, *Seventeenth Century Dutch Drawings*, 1977, no. 25, repr.

Acc. no. III, 176

Bartholomeus Breenbergh

Deventer 1598 or 1600 – 1657 Amsterdam

62. *The Temple of the Sibyl at Tivoli*

Pen and brown ink, brown wash, over indications in black chalk. Extraneous spots of brown and green oil paint. Verso: Ponte Nomentano, and barren landscape with half-ruined building (two separate views oriented vertically).
15¾ × 18⅞ inches (399 × 480 mm.).
Watermark: illegible.

Few foreign artists sojourning in Rome and its environs have, in any period, failed to pay graphic homage to the beautiful circular temple picturesquely situated on a high cliff above the gorge of the Aniene River at Tivoli, the Tibur of antiquity, about twenty miles northeast of Rome. The temple, which dates from the beginning of the first century B.C., and still preserves ten of its original eighteen Corinthian columns, is variously referred to as the Temple of the Sibyl or the Temple of Vesta. Breenbergh's imposing view with its play of brilliant light and shadow was drawn sometime during his long stay in Italy from 1619 to 1629. Although he made a number of drawings of scenes in and around Tivoli, he failed, with the one exception noted below, to date them. Roethlisberger plausibly suggested a date of around 1625 for most of these Tivoli views, including the Morgan sheet. Van Regteren Altena proposed a date before 1624 for the Morgan drawing, that is, prior to the earliest known dated drawing by the artist, the *Torre di Chia*, in Leningrad, which comes from the year 1624 (Roethlisberger, no. 13, repr.). Breenbergh, on his return to Holland, sometimes turned to the stock of drawings he had accumulated in his Italian years for the subjects of his prints or for details in the backgrounds of his religious and mythological pictures, but one cannot point to any direct use of the Morgan drawing although the famous temple appears in such paintings as the *Arcadian Landscape* in the Los Angeles County Museum (repr., *Art Quarterly*, XII, 1949, p. 270, fig. 1). A view of the temple very similar in scope to the Morgan drawing occurs in a painting from the collection of William V in The Hague, *Mercury Falls in Love with Herse near Athens* (repr., *Mauritshuis*, 1977, p. 182, no. 134) once attributed to Breenbergh but recently restored to Cornelis van Poelenburgh whose monogram it actually bears. The resemblance is, no doubt, owed to parallel observation of the temple and its site from what must have been a favored vantage point for artists.

There can be little doubt that the draughts-

man has taken pains to record faithfully all aspects of the temple and its setting. He indicates the Corinthian capitals of the colonnade, the diagonal patterns of the *opus reticulatum*, the frieze of bucranes and swags, and even such transient elements of the local scene as the three carpets hanging over the wall somewhat to the right of the temple. The drawing thus has a certain archaeological interest in documenting the state of the temple and its surroundings at the end of the first quarter of the seventeenth century. The drawing by Jan Brueghel in the Institut Néerlandais, Paris, which shows the condition of the temple in 1593, affords an interesting comparison with the present sheet; see the exhibition catalogue *Flemish Drawings of the Seventeenth Century*, London, Victoria and Albert Museum, and elsewhere, 1972, no. 11, pl. 20.

Breenbergh also devoted a drawing to the temple from a different, much closer vantage point, the sheet in the E. B. Crocker Art Gallery at Sacramento, California (Roethlisberger, no. 88, repr.), which is signed and dated 1627. Roethlisberger regards the Crocker drawing as a copy of a somewhat more detailed one in Dresden that he attributes to Van Poelenburgh with a query (Roethlisberger, no. 87, repr.); in Dresden, the drawing is catalogued as by Breenbergh, who may well have done both drawings. Both record a less usual view of the round temple, showing a glimpse through the door (visible at the left in the Morgan drawing) of the cella to the relief[?] of the Virgin and Child in a niche, a reminder that during the Middle Ages the temple was transformed into the church of S. Maria della Rotonda. Similarly, the building with the tile roof adjoining the round temple on the right in the present drawing, was also originally a temple, a rectangular building with Ionic columns likewise of the first century B.C., that was converted into the church of S. Giorgio and so used until 1884. A full view of S. Giorgio is preserved in Piranesi's etching (Henry Focillon, *Giovanni Battista Piranesi*, ed. by Maurizio Calvesi and Augusta Monferini, Bologna, 1967, p. 341, no. 764, pl. 167). What remains today are a portion of the wall and the Ionic columns. If one looks closely at the drawing, one finds that Breenbergh lightly indicated these columns imbedded in the wall of S. Giorgio. In passing, it might be added that Piranesi's two other etchings of the temple (Focillon, nos. 765–66) afford interesting views of the 'Tempio della Sibilla' as it appeared in 1761. The most obvious change in the intervening years is the disappearance of the projecting piece of masonry to the left above the doorway in Breenbergh's drawing. It is still present in the Library's small drawing of the temple by Claude (Acc. no. III, 78; repr. M. Roethlisberger, *Claude Lorrain: The Drawings*, Berkeley and Los Angeles, 1968, II, fig. 39), probably made within ten years after Breenbergh's.

The verso of this sheet was employed by Breenbergh for two separate, carefully finished views oriented vertically, though in opposite directions, and the sheet was once folded to set them apart. The brown wash of these drawings on the verso shows through to the recto, detracting somewhat from the original brilliance of the paper in the area of the sky of the Tivoli view; the old fold is also visible on the recto. The most interesting scene is a precisely rendered view of the Ponte Nomentano, the ancient fortified bridge across the Aniene River on the Via Nomentano by which the artist must have traveled en route to or from Tivoli. The papal arms visible at the top of the bridge are probably those of Nicholas V (1447–55) under whom it was restored. At the upper edge of the view is a tiny sketch of a small building resting on a barrel-vaulted substructure, perhaps a wayside chapel or hermitage, which became the subject of the second view on the verso. Breenbergh represented the Ponte Nomentano again in a small drawing in Hamburg (Roethlisberger, no. 144, repr.), which was used for one of the etchings (Hollstein, III, no. 11, as 'Ponte Mamole') in the series of Roman ruins.

PROVENANCE: Adolphus Frederick, Duke of Cambridge (according to Fairfax Murray; no mark; see Lugt 118); possibly his sale, London, Sotheby's, 28 November 1904,

part of lot 161, "Drawings by Old Masters. A very extensive and valuable collection of drawings by masters of the Italian, Dutch, French, Flemish and other Schools, including many ascribed to masters of the first importance, alphabetically arranged under the names of the artists, in two large folio volumes; together with a third volume containing a collection of drawings by anonymous masters; three vol. half bound russia together 601" (to Headley for £148); Charles Fairfax Murray; J. Pierpont Morgan (no mark; see Lugt 1509).

BIBLIOGRAPHY: Fairfax Murray, III, nos. 212–14, repr.; Sacramento, California, E. B. Crocker Art Gallery, *Three Centuries of Landscape Drawings*, exhibition catalogue, 1940, under no. 25; Janet Ayer Scott, "Gods and Heroes: Baroque Images of Antiquity," *Archaeology*, October 1968, p. 306, repr.; Marcel Roethlisberger, *Claude Lorrain: The Drawings*, Berkeley and Los Angeles, 1968, no. 1203, repr. and under no. 39; Marcel Roethlisberger, *Bartholomäus Breenbergh Handzeichnungen*, Berlin, 1969, nos. 18–19, repr.; J. Q. van Regteren Altena, review of Roethlisberger in *Art Bulletin*, LIII, 1971, p. 537.

EXHIBITIONS: Morgan Library, *Landscape Drawings*, 1953, no. 62; Philadelphia, University Museum, University of Pennsylvania, *The Ruins of Rome*, 1960–61, no. 11; Ann Arbor, Michigan, *Italy through Dutch Eyes*, 1964, no. 25, repr.; New York, Wildenstein and Company, *Gods and Heroes: Baroque Images of Antiquity*, 1968–69, no. 2, pl. 46.

Acc. nos. III, 212–14

Herman van Swanevelt

Woerden c. 1600 – 1655 Paris

63. *Joseph Recounting His Dreams to His Brethren*
Genesis 37:5–10

Pen and brown ink, brown wash, over faint traces of black chalk. Some losses throughout the sheet.
$7\frac{5}{8} \times 10\frac{9}{16}$ inches (195 × 269 mm.).
Watermark: anchor (cf. Heawood 5–7). See watermark no. 1.

Van Swanevelt, like Breenbergh, spent a number of years in Rome, arriving there about the time the latter left in 1629 and remaining until 1638; he later settled in Paris. Again like Breenbergh, he made use of his Italian experience in devising backgrounds for his compositions of religious and mythological subjects as is obvious in the suggestion of an Italian town clinging to the slope of the mountains in the present drawing. Equally obvious is the influence of Claude

Lorrain to which he was exposed in Rome although he in turn appears to have exerted some influence on the French artist. The Morgan drawing was, in fact, attributed to Claude until Frits Lugt on an early visit to the Library penciled the name of Van Swanevelt on the mount of the drawing; later in 1956 Gerson associated it, along with the drawing now in the Leyden Print Room, with the pair of paintings by Van Swanevelt illustrating episodes in the story of Joseph in the Fitzwilliam Museum, Cambridge. The two drawings appear to have been together and properly attributed to Van Swanevelt until after the sale of William Esdaile in 1840. The Leyden drawing apparently was for a time in the Mayor collection (*A Brief Chronological Description of a Collection of Original Drawings and Sketches by the Old Masters . . . Formed by the Late Mr. William Mayor of Bayswater Hill*, London, 1875, no. 736) and then made its way to Holland; the collection of W. N. Lantsheer or Jeronimo de Vries (sale, Amsterdam, Frederik Muller & Co., 3–4 June 1884, lot 312) may be added to the provenance listed by Gerson, 1956, p. 115, footnote 2.

Young Joseph is represented encircled by his numerous older brothers, pointing upward to two medallions in the sky where his dreams are illustrated. To the left is the illustration of the text of Genesis 37:7: "For, behold, we were binding sheaves in the field, and, lo, my sheaf arose, and also stood upright; and behold, your sheaves stood round about, and made obeisance to my sheaf." The right medallion is a diagrammatic indication of Genesis 37:9: "And he dreamed yet another dream, and told it to his brethren, and said . . . behold the sun and the moon and the eleven stars made obeisance to me." These symbols Van Swanevelt wisely dispensed with in the painting as he did a cow or two. In general he adhered to the structure of the drawing's composition, but altered the background in the picture, opening up the middle distance in a Claudian effect and shifting the mountains to the right. If the two summarily indicated figures at the far left are included,

Joseph's brothers can be made to tally eleven and so correspond with the eleven stars of the right medallion. Both drawings and paintings are generally thought to be works of the 1640's. It might be significant for the date that the composition of the Morgan drawing and related Fitzwilliam painting corresponds in surprising degree to Swanevelt's signed painting sometimes identified as *The Departure of Jacob*, in the Bredius Collection, The Hague, which is dated 1630 (Albert Blankert, *Museum Bredius: Catalogus van de schilderijen en tekeningen*, The Hague, 1978, p. 113, no. 163, repr.); this subject, of course, is also related as a prelude to the story of Jacob's son Joseph. Another picture illustrating an episode in the history of Jacob, *Jacob and Laban*, in the Art Institute, Zanesville, Ohio, is cited by Waddingham as incorporating cattle and figures similar to those of the Bredius picture ("Herman van Swanevelt in Rome," *Paragone*, XI, no. 121, 1960, p. 48, footnote 4).

PROVENANCE: William Esdaile (no mark; see Lugt 2617); his sale, London, Christie's, 23 June 1840, one of two in lot 935, "Swanevelt. A pair with the history of Joseph and his brethren in bistre (£5.5)"; Sir William Drake (Lugt 736); his sale, London, Christie's, 24–25 May 1892, lot 406, "Claude. A landscape, with Joseph and his brethren"; Charles Fairfax Murray; J. Pierpont Morgan (no mark; see Lugt 1509).

BIBLIOGRAPHY: Fairfax Murray, I, no. 270 (as Claude), repr.; Horst Gerson, "Twee tekeningen van Herman van Swanevelt," *Oud Holland*, LXXI, 1956, pp. 113–15, fig. 1; Fitzwilliam Museum, *Catalogue of Paintings, I: Dutch and Flemish* (by Horst Gerson and J. W. Goodison), Cambridge, 1960, under no. 202.

EXHIBITIONS: Morgan Library, *An Exhibition Held on the Occasion of the New York World's Fair*, 1939, p. 26, no. 92 (as Claude); Ann Arbor, Michigan, *Italy through Dutch Eyes*, 1964, no. 56, pl. xv.

Acc. no. I, 270

64. *A Clump of Trees*

Pen and brown ink, point of brush, black and some brown washes, over black chalk.
9⅜ × 7⅛ inches (238 × 182 mm.).
Watermark: none.
Inscribed on verso in pen and brown ink, at bottom, *Swaenvelt del*; upside down at bottom, *N⁰ 48* (effaced). On old mount in pen and brown ink, in center, *T* – [or

F] *25*; at upper left, *1072* (crossed out in graphite in another hand and changed to *1657*); and at upper right, *3N / L83*.

In this tree study Van Swanevelt reveals a sensitive, direct response to nature. Such studies were recalled in his prints and his numerous paintings of landscapes where biblical or mythological staffage moves against a setting of fine trees and distant mountain vistas. There is nothing of the stereotype in the pairing of the sturdy oaks with the slender trunks and the lighter foliage of the trees at the right, and one can imagine that the artist known in the Schildersbent, the Dutch painters' informal society in Rome, as "the Hermit," enjoyed sketching these trees in solitude from a vantage point in nearby shade. Mariette in his *Abecedario* (*Archives de l'art français*, XII, 1959–60, p. 10) wrote: "[Il] fut surnommé l'Hermite, parce qu'on le trouvoit continuellement dans les ruines et les lieux les moins fréquentés de Rome et des environs, dessinant d'après le naturel, ce qui le rendit très habile dans le talent de peindre des ruines et des paysages, et luy acquit de la réputation." Van Swanevelt frequently favored the combination of brown ink and gray washes in his drawings although the washes are not always of the rich darkness that is effective here in conveying the density and fullness of the foliage. Claude Lorrain made similar studies of isolated clusters of trees, for example, the drawing in the former Ingram Collection, and that of the late Count Seilern (Roethlisberger, nos. 57 and 681, repr.).

PROVENANCE: George Knapton; General George Morrison (by bequest from Knapton); Knapton-Morrison sale, London, T. Philipe, 25 May – 3 June 1807, lot 1072 (to Miss Georgina Morrison for £12.12, according to her own notations in the copy of the sale catalogue at Colnaghi's); Sir Joseph Hawley; possibly sale, M. de Salicis . . . and property of a Baronet [Sir Henry Hawley], London, Christie's, 16 July 1891, one of four in lot 204; Charles Fairfax Murray; J. Pierpont Morgan (no mark; see Lugt 1509).

BIBLIOGRAPHY: Marcel Roethlisberger, *Claude Lorrain: The Drawings*, Berkeley and Los Angeles, 1968, under no. 57.

Acc. no. III, 228e

Simon de Vlieger

Rotterdam 1601 – 1653 Weesp

65. *Village on the Bank of a Canal*

Black chalk heightened with white chalk, gray wash, on blue paper.
10½ × 16¹¹⁄₁₆ inches (266 × 424 mm.).
Watermark: none.
Remains of inscription in pen and brown ink at lower left corner, *V. . . .* [?]. Inscribed on old mount in pen and brown ink, in center, *P 24*; at upper left, *June 5 – 1807 | Lot 1033*; and at upper right, *6 N | L 3*.

This "capital and desirable morceau," as this drawing was characterized in the Knapton sale in 1807, was at that time attributed to Waterloo, and it was so catalogued by Charles Fairfax Murray when he acquired it in 1891. The attribution to Simon de Vlieger, under whose name it has been filed for some years, is owed to Professor Jakob Rosenberg. The drawings of Waterloo (see No. 93) and De Vlieger, particularly in this type of landscape and the woodland scenes, are difficult to distinguish and frequently are found under one name with the other as an alternate. The same is not true of De Vlieger's marine scenes, which present little or no difficulty of attribution, though as has been pointed out, they are less numerous than the landscapes. In style and the combined medium of chalk and wash on blue paper, this peaceful village view may be compared to four large woodland scenes (400 × 530 mm.) catalogued under the name of Simon de Vlieger in the Rijksprentenkabinet in Amsterdam (Inv. nos. A2366, one unnumbered, A35, and A389). The sloping terrain of the village—in contrast to the usual flatness of Dutch towns—may hold the clue to its identity. In the last four years of his life following work in the centers of Delft, Amsterdam, and Rotterdam, De Vlieger retired to Weesp, a small town on the Vecht River, eight miles southeast of Amsterdam.

PROVENANCE: George Knapton; General George Morrison (by bequest from Knapton); Knapton-Morrison sale, London, T. Philipe, 25 May – 3 June 1807, lot 1033, "(A. Waterloo) One – a landschape – a village on the bank of a canal, surrounded with trees; near a bridge are two figures, and a woman is passing another bridge of planks, on the left – black chalk, and Ind. ink, on blue paper, heightened – a capital and desirable morceau" (to Mr. Peters for £6.6, according to Georgina Morrison's notations in the copy of the sale catalogue at Colnaghi's); Sir Joseph Hawley; possibly sale, M. de Salicis . . . and property of a Baronet [Sir Henry Hawley], London, Christie's, 16 July 1891, one of four in lot 204; Charles Fairfax Murray; J. Pierpont Morgan (no mark; ee Lugt 1509).

EXHIBITION: New York Public Library, *Morgan Drawings*, 1919, n.p. (as Waterloo).

Acc. no. III, 184a

Rembrandt Harmensz. van Rijn

Leyden 1606 – 1669 Amsterdam

66. *Head of a Man in a High Fur Hat; Self-Portrait*

Pen and brown ink.
4⅛ × 3¹³⁄₁₆ inches (105 × 96 mm.).
Watermark: none visible through lining.

The head of the old man in the ornate fur hat is found towering above those of his two companions in the center foreground of the *Preaching of John the Baptist*, the painting in the Staatliche Museen Preussischer Kulturbesitz, Berlin (Bredius-Gerson, no. 555), which is usually dated about 1634–36. Probably the old man of the painting is the High Priest and his companions, two Pharisees. Three other pen studies for the painting are preserved in the Kupferstichkabinett, Berlin (Benesch, 1954–57, I, no. 140, fig. 151, and no. 141, fig. 155 [1973, figs. 167–68]), and at Chatsworth (Benesch, 1954–57, I, no. 142, figs. 152–53 [1973, figs. 169–70]). There is a fifth preparatory drawing executed in red chalk in the collection of the late Count Antoine Seilern, which contains two studies for the figure of the Baptist (no. 182, pl. VII, in his 1961 catalogue; Benesch, 1973, I, no. 142A, fig. 171). In their rhythmic repetition the curving calligraphic pen strokes of the Morgan head render the bulk and texture of the high hat and beard with supreme authority; the trial outlines of the great hat on the verso of the Chatsworth sheet

97

must have preceded the effective image that finally evolved here.

The small, lightly frowning portrait at the left is a fleeting but lively instance of Rembrandt's self-scrutiny. Benesch suggested that it is to be compared with the painted portrait formerly belonging to Arthur Heywood-Lonsdale, Drayton, Shropshire, and now owned by Norton Simon (Bredius-Gerson, no. 32); perhaps more closely comparable is the earlier self-portrait in the Mauritshuis, The Hague (Bredius-Gerson, no. 24). The eye the artist drew at the upper left must have been his own. The few pen strokes at the lower edge of the sheet probably indicate that it was once part of a larger whole.

PROVENANCE: Charles Fairfax Murray; J. Pierpont Morgan (no mark; see Lugt 1509).

BIBLIOGRAPHY: Benesch, 1954–57, II, no. 336, fig. 380 (1973, fig. 406); Count Antoine Seilern, *Paintings and Drawings of Continental Schools Other Than Flemish and Italian at 56 Princes Gate, London S.W.7*, London, 1961, p. 16, under no. 182; Fritz Erpel, *Die Selbsbildnisse Rembrandts*, Berlin, 1967, p. 166, no. 61, p. 43, repr.

EXHIBITIONS: Paris, *Rembrandt*, 1908, no. 496 (1); New York Public Library, *Morgan Drawings*, 1919, n.p.; San Francisco, *Rembrandt from Morgan Collection*, 1920, no. 365; New York–Cambridge, *Rembrandt*, 1960, no. 59, pl. 52; Minneapolis, *Fiftieth Anniversary*, 1965–66, n.p.

Acc. no. I, 174a

67. *Three Studies of Women, Each Holding a Child; Head of a Man*

Pen and brown ink on paper darkened to a brown tone through exposure to light.

7⅜ × 5¹³⁄₁₆ inches (188 × 147 mm.).

Watermark: chapelet (close to Churchill 544). See watermark no. 2.

Inscribed on verso in pen and brown ink, in Esdaile's hand, *1835 WE, Rembrandt*.

The drawing is one of the numerous studies of women and children which Rembrandt made, particularly during the 1630's when, following his marriage to Saskia van Uylenburgh on 8 June 1633, he was involved in the domestic scene. Such drawings of the "Life of Women with Children" were at one time gathered together in a portfolio that was owned by Rembrandt's friend and fellow artist, the marine painter Jan van de Cappelle (c. 1624–1679). In the 1680 inventory of the great Van de Cappelle collection, which included more than five hundred drawings by Rembrandt, the portfolio is listed as "No. 17. Een dito [portfolio] daerin sijn 135 tekeningen sijnde het vrouwenleven met kinderen van Rembrandt" (A. Bredius, "De Schilder Johannes van de Cappelle," *Oud Holland*, X, 1892, p. 37; also Margarita Russell, *Jan van de Cappelle*, Leigh-on-Sea, 1975, p. 55). All of the drawings in Van de Cappelle's collection were later in the sale of his son Jan van de Cappelle (1657–1709) in Amsterdam, 7–8 November 1709, but no copy of the catalogue has come to light (see Dudok van Heel in *Jaarboek Genootschap Amstelodamum*, LXVII, 1975, p. 171, no. 133).

Rembrandt sketched directly with a fast-moving pen, perhaps first setting down at the center the transient pose of the pretty young mother and the baby who waves his hand but is not yet old enough to sit fully erect. Benesch remarked the resemblance of this young woman with that on the verso of his catalogue no. 246, who also wears a small cap on the back of her head. The more substantial figure of the woman at the lower edge of the paper, perhaps a nurse with her charge, was studied at greater length, once vigorously in three-quarter view as the infant sucked its fingers and again in back view, with a lighter touch, as the woman left the scene, the child looking back over her shoulder at the artist. The sad-faced man in the fur hat at the top of the sheet is one of the street types Rembrandt often sketched; the artist depicted himself in similar shaggy headgear, perhaps made of sheepskin, in the etching of 1630 (Bartsch, no. 24). This drawing happily escaped the fate of many of Rembrandt's study sheets which were cut apart so that each individual motif on the sheet became a small separate entity (see the preceding entry). Even so, it might once have been somewhat larger; at the upper left

98

corner there is the tiny trace of a line that appears to be consistent with the ink of the drawing and may be the remnant of an additional sketch.

PROVENANCE: Sir Thomas Lawrence (Lugt 2445); William Esdaile (Lugt 2617); sale, Samuel Woodburn, London, Christie's, 4–8 June 1860, lot 757 (to Money for £1.18.0); Charles Fairfax Murray; J. Pierpont Morgan (no mark; see Lugt 1509).

BIBLIOGRAPHY: Fairfax Murray, I, no. 190, repr.; Benesch, *Werk und Forschung*, 1935, p. 24; Benesch, 1954–57, II, no. 226, fig. 249 (1973, fig. 264); J. Q. van Regteren Altena, review of Benesch, *Oud Holland*, LXX, 1955, pp. 118–20; Willi Drost, *Adam Elsheimer als Zeichner*, Stuttgart, 1957, pp. 160 and 172, no. 178; Doris Vogel-Köhn, *Rembrandts Kinderzeichnungen*, dissertation, Würzburg, 1974, pp. 159–60, no. 3.

EXHIBITIONS: Paris, *Rembrandt*, 1908, no. 427; New York Public Library, *Morgan Drawings*, 1919, n.p.; San Francisco, *Rembrandt from Morgan Collection*, 1920, no. 375; Toronto, The Art Gallery of Toronto, *Rembrandt*, 1951, Drawings, no. 2; New York–Cambridge, *Rembrandt*, 1960, no. 20, pl. 16; Hartford, *The Pierpont Morgan Treasures*, 1960, no. 77.

Acc. no. I, 190

68. *Woman Carrying a Child Downstairs*

Pen and brown ink, brown wash.
7⅜×5³⁄₁₆ inches (187×132 mm.).
Watermark: none.
Inscribed at lower right corner in pen and brown ink, W̅T̅

This vital observation of a young mother swiftly descending a stair with a heavy, fretful child in her arms might well have graced Jan van de Cappelle's portfolio of 135 Rembrandt drawings entitled "The Life of Women with Children" (see the preceding entry). Its air of tender family intimacy is strong enough to have led scholars to identify the subject as the artist's wife, Saskia, and her first child, Rumbartus, who was baptized 15 December 1635, and the drawing has universally been dated towards the end of the following year on the basis of the apparent age of the child. The archival research of I. H. van Eeghen in the register of funerals of the Zuiderkerk, Amsterdam, however, showed that one of Rembrandt's children was buried on 15 February 1636, and though no name was given in the register, it is assumed that this child was Rumbartus ("De Kinderen van Rembrandt en Saskia," *Amstelodamum*, XLIII, 1956, pp. 144ff.). Saskia's two daughters, Cornelia I (baptized 22 July 1638 – buried 14 August 1638) and Cornelia II (baptized 29 July 1640 – buried 12 August 1640), each lived for just a few weeks; only Titus, who was baptized 22 September 1641, survived to maturity (d. 1668). Saskia herself died in June 1642, when Titus was only nine months old. The image of her wasted features in certain of the drawings and etchings indicates that she was ill for some months prior to her death, eliminating the possibility that the drawing could represent her with Titus.

Were it not for these facts, one might be tempted to see a resemblance to Rembrandt himself in the child's broad countenance. Certainly the child and the mother, too, in their facial types bear some resemblance to their counterparts in *The Naughty Boy*, the drawing in the Berlin Kupferstichkabinett (Benesch, 1954–57, II, no. 401, fig. 459 [1973, fig. 485]) and perhaps also that in Budapest, *Woman with a Child, Frightened by a Dog* (Benesch, 1954–57, II, no. 411, fig. 460 [1973, fig. 494]). Benesch, when he included the Morgan drawing in his *Rembrandt as a Draughtsman* (no. 21), was aware of Van Eeghen's researches, but maintained the association of the drawing with Saskia though he queried the identity of the child as Rumbartus. In all these drawings there is a sense of personal engagement on the part of the artist. This suggests that he was not just an objective observer of the scene and that the participants may in some way have been associated with his family circle.

In connection with the paraph or letter inscribed at the lower right corner of the sheet, it might be noted that it also occurs on the following drawings: *The Virgin and Child Seated near a Window*, British Museum, London (Benesch, 1954–57, I, no. 113, fig. 128 [1973, fig. 131]); *Poor Woman Nursing Her Child*, Museum Boymans–van Beuningen, Rotterdam (Benesch,

1954–57, I, no. 186, fig. 195 [1973, fig. 214]); *Nurse Holding a Child, Seen from Behind* (Benesch, 1954–57, II, no. 228, fig. 244 [1973, fig. 266]), also Rotterdam; *Woman with a Child on Her Lap*, Louvre, Paris (Benesch, 1954–57, II, no. 275, fig. 302 [1973, fig. 325]); *A Woman Scolding*, Count Antoine Seilern, London (Benesch, 1954–57, II, no. 279, fig. 325 [1973, fig. 329]), and *An Artist in His Studio*, Springell Collection, Portinscale, Keswick (Benesch, 1954–57, II, no. 390, fig. 442 [1973, fig. 470]). Since these drawings, with one exception, depict *vrouwenleven*, the mark or letter might be thought to have had some connection with the Van de Cappelle album; it has also been suggested that this may have been the mark of a collector or possibly, as Jeroen Giltay believes, simply an "R" for Rembrandt.

Fairfax Murray gives no clue as to the provenance of this beautiful drawing or where or when he acquired it. There is a remote possibility that it might have come from the sale of the Earl of Gainsborough *et al.* (Christie's, 2 June 1902) where lot 102 is described as "Rembrandt. A Woman Carrying a Child—pen-and-ink; and another." Fairfax Murray was active at this sale as he acquired a drawing by Andrea del Sarto, now in the Library (Acc. no. I, 30) from the section of the sale devoted to drawings from the collection of E. A. Leatham. There are, of course, a number of other Rembrandt drawings where a woman is represented carrying a child. According to the Gainsborough sale catalogue, the Earl's drawings were "from the collection of Sir Horace Mann, by whom they were purchased at Florence in the Eighteenth Century," an intriguing provenance.

The kind of steep spiral Dutch staircase that Rembrandt indicates here with a few diagonal strokes of the pen supplemented by strong wash can be seen in more detail in the drawing *Study of an Interior with a Winding Staircase* in Copenhagen (Benesch, 1954–57, II, no. 392, fig. 450 [1973, fig. 472]), also on the verso of the *Virgin and Child Seated near a Window* in the British Museum (see above).

From a stylistic point of view, the drawing conforms to the accepted norm of Rembrandt's manner of about 1636.

PROVENANCE: Charles Fairfax Murray; J. Pierpont Morgan (no mark; see Lugt 1509).

BIBLIOGRAPHY: Fairfax Murray, I, no. 191, repr.; W. R. Valentiner, *Rembrandt und seine Umgebung, zur Kunstgeschichte des Auslandes*, Strassburg, 1905, XXIX, p. 29; Richard Graul, *Rembrandts Zeichnungen*, Leipzig, 1906 (2nd ed., 1924), no. 14; Wilhelm Bode and W. R. Valentiner, *Handzeichnungen altholländischer Genremaler*, Berlin, 1907, no. 1, repr.; F. Schmidt-Degener, "Tentoonstelling van Rembrandts teekeningen in de Bibliothèque Nationale te Parijs," review of Paris 1908 exhibition, *Onze Kunst*, XIV, 1908, p. 101; A. M. Hind, *Rembrandt* (Charles Eliot Norton Lectures), Cambridge, Massachusetts, 1932, p. 36, pl. XIV; Valentiner, 1934, II, no. 675, repr.; Benesch, *Werk und Forschung*, 1935, p. 22; Regina Shoolman and Charles E. Slatkin, *The Enjoyment of Art in America*, New York, 1942, pl. 395; Otto Benesch, *A Catalogue of Rembrandt's Selected Drawings*, London, 1947, p. 24, no. 79; Tietze, *European Master Drawings*, 1947, no. 64, repr.; Paul J. Sachs, *The Pocket Book of Great Drawings*, New York, 1951, p. 71, pl. 45; Theodore Rousseau, "Rembrandt," *Metropolitan Museum of Art Bulletin*, IX, no. 3, 1952, p. 89, repr.; Ludwig Goldscheider, "A Rembrandt Self Portrait," *Connoisseur*, CXXXII, 1953, p. 158; Benesch, 1954–57, II, no. 313, fig. 347 (1973, fig. 378), and I, under no. 117; Jakob Rosenberg, "Rembrandt the Draughtsman with Consideration of the Problem of Authenticity," *Daedalus*, LXXXVI, 1956, p. 128; Willi Drost, *Adam Elsheimer als Zeichner*, Stuttgart, 1957, p. 172, no. 179; J. G. van Gelder, *Dutch Drawings and Prints*, New York, 1959, no. 60, repr.; Jakob Rosenberg, *Great Draughtsmen from Pisanello to Picasso*, Cambridge, Massachusetts, 1959, p. 76, fig. 140; Otto Benesch, *Rembrandt as a Draughtsman*, London, 1960, no. 21, pl. 21; Claude Roger Marx, *Rembrandt*, Paris, 1960, p. 152, repr.; J. G. van Gelder, "The Drawings of Rembrandt," review of Benesch, *Burlington Magazine*, CIII, 1961, p. 150; Walther Scheidig, *Rembrandt als Zeichner*, Leipzig, 1962, pp. 41, 77, pl. 29; J. E. Schuler, ed., *Cento capolavori: L'arte del disegno da Pisanello a Picasso*, Milan, 1962, p. 148, repr.; *Great Drawings of All Time*, 1962, II, no. 575, repr.; Nigel Lambourne, *Rembrandt van Rijn: Paintings, Drawings, and Etchings*, London, 1963, pl. 34; David M. Robb and J. J. Garrison, *Art in the Western World*, New York, 1963, p. 543, fig. 465; Eisler, *Flemish and Dutch Drawings*, 1963, pl. 72; Robert Beverly Hale, *Drawing Lessons from the Great Masters*, New York, 1964, pp. 252–53, repr.; Roberta M. Capers and Jerrold Maddox, *Images and Imagination*, New York, 1965, p. 261, fig. 10–8; Marcel Brion *et al.*, *Rembrandt*, Paris, 1965, fig. 51; Robert Wallace, *The World of Rembrandt*, New York, 1968, pl. 53; Henry Bonnier, *L'Univers de Rembrandt*, Paris, 1969, p. 13, repr.; Werner Sumowski, "Beiträge zu Willem Drost," *Pantheon*, XXVII, no. 6, 1969, p. 374, fig. 5; Doris Vogel-Köhn, *Rembrandts Kinderzeichnungen*, dissertation, Würzburg, 1974, pp. 192–93, no. 38, repr.; B. Haak, *Rembrandt*

Zeichnungen, Cologne, 1974, pl. 18; Bernhard, *Rembrandt*, 1976, II, p. 187, repr.; Kenneth Clark, *An Introduction to Rembrandt*, London, 1978, p. 76, fig. 73.

EXHIBITIONS: Paris, *Rembrandt*, 1908, no. 400; New York, Metropolitan Museum, *Rembrandt*, 1918, no. 24; Buffalo, New York, Albright Art Gallery, *Master Drawings*, 1935, no. 48, repr.; Chicago, *Rembrandt*, 1935–36, no. 26, repr.; Worcester, *Rembrandt*, 1936, no. 25, repr.; Morgan Library, *An Exhibition Held on the Occasion of the New York World's Fair*, 1939, no. 88; Worcester, Massachusetts, Worcester Art Museum, *Art of Europe during the XVIth–XVIIth Centuries*, 1948, no. 50; New York, Wildenstein and Co., *Rembrandt*, 1950, no. 30, pl. 25; Philadelphia, Philadelphia Museum of Art, *Masterpieces of Drawing*, 1950–51, no. 52, repr.; Morgan Library, *Treasures from the Pierpont Morgan Library*, 1957, no. 95; New York–Cambridge, *Rembrandt*, 1960, no. 23, pl. 19; Amsterdam, Rijksmuseum, *Rembrandt 1669–1969*, 1969, no. 44, repr.

Acc. no. I, 191

69. *Two Studies of Saskia Asleep*

Pen and brown ink, brown wash.
5⅛ × 6¾ inches (130 × 171 mm.).
Watermark: fragment with letters *WR* (cf. Briquet 7211–12). See watermark no. 25.
Inscribed in pen and brown ink, at lower left, by Jan van Rijmsdijk, *Rijmsdijk's M.*; on verso of mount, at upper center, possibly also by Rijmsdijk, *BXI ⅜ ⅹ / BXI ⅹ B / Rijmsdijk.*

Rembrandt's interest is concentrated on the physical phenomenon of sleep rather than a likeness of his wife, Saskia, who is, nevertheless, recognizable in the upper sketch. It was apparently made first. The lower sketch was added as the sleeper, now sunk more deeply into her pillows, shifted her hand, opened her mouth, and most likely began gently to snore.

The drawing is one of a sizable group of studies representing Saskia in bed, done very probably during an illness or one of her four confinements between 1635 and 1641. It seems to be among the earlier studies of the group and is best dated about 1635–37 since Saskia shows little sign of the ravages of the ill health that prematurely aged her. It is perhaps closest stylistically to the drawing in Groningen where Saskia is seen sitting up in bed (Benesch, 1954–57, II, no. 282, fig. 315 [1973, fig. 338]).

PROVENANCE: Jan van Rijmsdijk (Lugt 2167); Tighe (according to Fairfax Murray); Charles Fairfax Murray; J. Pierpont Morgan (no mark; see Lugt 1509).

BIBLIOGRAPHY: Fairfax Murray, I, no. 180, repr.; F. Schmidt-Degener, "Tentoonstelling van Rembrandts teekeningen in de Bibliothèque Nationale te Parijs," review of Paris 1908 exhibition, *Onze Kunst*, XIV, 1908, p. 108; Valentiner, 1934, II, no. 690, repr.; A. M. Hind, *Rembrandt* (Charles Eliot Norton Lectures), Cambridge, Massachusetts, 1932, pp. 49, 125, pl. XXVI; Benesch, *Werk und Forschung*, 1935, p. 22; Charles de Tolnay, *History and Technique of Old Master Drawings*, New York, 1943, no. 195, repr.; Tietze, *European Master Drawings*, 1947, no. 65, repr.; Benesch, 1954–57, II, no. 289, fig. 319 (1973, fig. 347); Jakob Rosenberg, "Rembrandt the Draughtsman with Consideration of the Problem of Authenticity," *Daedalus*, LXXXVI, 1956, p. 127, fig. 17; Jakob Rosenberg, *Great Draughtsmen from Pisanello to Picasso*, Cambridge, Massachusetts, 1959, pp. 75–76, fig. 139b; *Great Drawings of All Time*, 1962, II, no. 580, repr.; Walther Scheidig, *Rembrandt als Zeichner*, Leipzig, 1962, p. 41, no. 26, repr.; Claude Marks, *From the Sketchbooks of the Great Artists*, New York, 1972, pp. 114–15, pl. 79; Nathan Goldstein, *The Art of Responsive Drawing*, Englewood Cliffs, New Jersey, 1973, p. 3, pl. 11; Bernhard, *Rembrandt*, 1976, II, p. 117, repr.

EXHIBITIONS: Paris, *Rembrandt*, 1908, no. 415, repr.; New York, Metropolitan Museum, *Rembrandt*, 1918, no. 27; New York Public Library, *Morgan Drawings*, 1919, n.p.; San Francisco, *Rembrandt from Morgan Collection*, 1920, no. 367; Toronto, The Art Gallery of Toronto, *Inaugural Exhibition*, 1926, no. 41; Buffalo, New York, Albright Art Gallery, *Master Drawings*, 1935, no. 50, repr.; Chicago, *Rembrandt*, 1935–36, no. 31; Worcester, *Rembrandt*, 1936, no. 30; Morgan Library, *An Exhibition Held on the Occasion of the New York World's Fair*, 1939, no. 86; Toronto, The Art Gallery of Toronto, *Rembrandt*, 1951, Drawings, no. 1; Rotterdam, Museum Boymans and Amsterdam, Rijksmuseum, *Rembrandt : Tekeningen*, 1956, no. 51; New York–Cambridge, *Rembrandt*, 1960, no. 24, pl. 20; Chicago, *Rembrandt after Three Hundred Years*, 1969, no. 107, repr.; Stockholm, *Morgan Library gästar Nationalmuseum*, 1970, no. 64.

Acc. no. I, 180

70. *Actor (?) in the Role of Badeloch*

Pen and brown ink, brown wash, corrected with lead white; additions in pen and gray ink.
9 × 5½ inches (228 × 140 mm.).
Watermark: none visible through lining.
Inscribed in pen and brown ink, at lower right, by Jan van Rijmsdijk, *Rijmsdijk's Museum*; on verso of mount, at upper center, possibly also by Rijmsdijk, *BXI ⅹ / Rijmsdijk*; at lower right, in graphite, *LSD / 3.3.0.*

101

In the catalogue of the great Rembrandt exhibition held at the Bibliothèque Nationale, Paris, in 1908, this drawing, following the opinion of the day, was identified as "The Jewish Bride." More recent scholarship has demonstrated that it and a sizable group of other drawings represent characters of Dutch classical tragedy as opposed to the various drawings depicting comic characters to which Valentiner drew attention some fifty years ago ("Komödiantendarstellungen Rembrandts," *Zeitschrift für bildende Kunst*, L, 1925–26, pp. 265–77), and which Volskaya in 1961 connected with personages of the Commedia dell'Arte.

The Morgan drawing and similar full-length studies of richly costumed women (Benesch, 1954–57, II, nos. 316–21, figs. 350, 358, 360–64 [1973, figs. 384–85, 388–91]) are related in style and execution to a sequence of drawings focusing on the figure of a bishop (Benesch, 1954–57, I, nos. 120–23, figs. 132–36 [1973, figs. 140–44]). Formerly the bishop was described as St. Augustine but he was conclusively identified, by Van de Waal, as Bishop Gozewijn, the character who figures in the fourth act of the drama *Gijsbrecht van Aemstel* (1638), the best-known play of Holland's great seventeenth-century poet, Joost van den Vondel. Given this connection, it is assumed that the stylistically similar drawings of women probably also represent characters in the same drama (or possibly others) of the period.

Volskaya generously associates all of the drawings of women, except one, with Badeloch, the wife of Amsterdam's hero Gijsbrecht, although the variations in their costumes might be thought to indicate different roles. The Morgan drawing is as close as any to the drawings of Bishop Gozewijn and so perhaps the woman is properly cast as Badeloch. The figure may best be compared with that of the bishop in the drawing *Gijsbrecht van Aemstel and His Men Kneeling before Bishop Gozewijn*, in the Herzog Anton Ulrich Museum in Brunswick (Benesch, 1954–57, I, no. 122, fig. 134 [1973, fig. 144]). The masterful treatment of the sumptuous brocaded robes, ma-

jestic in the fall of the heavy folds, is especially comparable. Both drawings in turn bring to mind the similar treatment of the rich stuffs in the gown of the young woman in the etching *The Spanish Gypsy* (Bartsch, no. 120), which, Gersaint stated, was intended to illustrate a Dutch tragedy that was still being played in Amsterdam in the eighteenth century. It might further be noted that the awkward rendering of the arms in the Morgan figure is also present in the Brunswick bishop.

Vondel's drama, of which the first printed edition bears the date 1637, was written for the inauguration of Amsterdam's new theatre, the "Schouburg." The opening was scheduled for 26 December 1637, but delayed until 3 January 1638, after which the play ran for thirteen performances and was not repeated again until 1641. If Rembrandt were present on the occasion of the opening, the series of drawings of the bishop and the richly gowned women would be dated 1637–38 at the earliest, assuming he might also have had entrée to rehearsals.

Although the subjects of Rembrandt's "Badeloch" drawings appear to be women, they must also be considered in the light of the date of the first appearance of women on the Amsterdam stage. According to one authority, before 1655 all female roles were acted by men (see C. N. Wybrands, *Het Amsterdamsche tooneel van 1617–1772*, Utrecht, 1873, p. 85). If this is correct, the Morgan drawing and the others would presumably represent an actor in female costume. For a further discussion of the question of the connection of these drawings with the theatre, see W. M. H. Hummelen, "Rembrandt und Gijsbrecht: Bemerkungen zu den Thesen von Hellinga, Volskaja und Van de Waal," *Neue Beiträge zur Rembrandt-Forschung*, Berlin, 1973, pp. 151–61.

Jan van Rijmsdijk, a Dutch painter and engraver who lived in England in the mid-eighteenth century, copied the Morgan drawing when it was in his collection. The copy, which also includes two other motifs that seem to be derived from Rembrandt, is now in the Lugt

Collection, Institut Néerlandais, Paris (Inv. no. 8548). Rijmsdijk's copy includes the gray ink passages in the woman's veil and elsewhere in the Morgan drawing which appear to be additions by a hand other than Rembrandt's.

PROVENANCE: Jan van Rijmsdijk (Lugt 2167); Tighe (according to Fairfax Murray); Charles Fairfax Murray; J. Pierpont Morgan (no mark; see Lugt 1509).

BIBLIOGRAPHY: Fairfax Murray, I, no. 177, repr.; Bock-Rosenberg, 1930, I, p. 233, under no. 2685; W. R. Valentiner, "Carel and Barent Fabritius," *Art Bulletin*, XIV, 1932, p. 211, fig. 4; Benesch, *Werk und Forschung*, 1935, p. 23; Benesch, 1954-57, II, no. 318, fig. 358 (1973, fig. 384); H. van de Waal, "Rembrandt, 1956," *Museum*, LXI, 1956, p. 204; Egbert Haverkamp-Begemann, "Otto Benesch, *The Drawings of Rembrandt*," review in *Kunstchronik*, XIV, 1961, p. 25, under no. B316; V. Volskaya, "Teatral'nye Personazhi v Risunkakh Rembrandta," *Iskusstvo*, XXIV, no. 4, 1961, p. 59, repr.; Seymour Slive, *Drawings of Rembrandt*, New York, 1965, under no. 261; H. van de Waal, "Rembrandt at Vondel's Tragedy Gijsbreght van Aemstel," *Miscellanea I. Q. van Regteren Altena*, Amsterdam, 1969, pp. 146, 147, fig. 4 (this important article is also accessible in H. van de Waal, *Steps towards Rembrandt: Collected Articles 1937–1972*, R. H. Fuchs, ed., Amsterdam-London, 1974, p. 76, fig. 4); Julius S. Held in *De Kronik van het Rembrandthuis*, XXVI, 1972, no. 1, pp. 3ff., fig. 4; Bernhard, *Handzeichnungen*, 1976, II, p. 193, repr.

EXHIBITIONS: Paris, *Rembrandt*, 1908, no. 410, repr.; New York, Metropolitan Museum, *Rembrandt*, 1918, no. 26; Minneapolis, *Fiftieth Anniversary*, 1965-66, n.p.; New York–Cambridge, *Rembrandt*, 1960, no. 32, pl. 27.

Acc. no. I, 177

71. *Two Mummers on Horseback*

Pen and brown ink, brown wash, with yellow and red chalks; white tempera on ruffs.
$8\frac{3}{8} \times 6\frac{1}{16}$ inches (212 × 153 mm.).
Watermark: none visible through lining.
Inscribed on mount, at upper left in graphite, *81*; on verso of mount at upper center, in pen and brown ink, *6*; at lower center, in pen and black ink, in Robinson's hand, *J C Robinson | July 18 1893 | from Lrd Aylesford Coll^n*.

The costumes of the two horsemen, particularly the high cylindrical hat and cartwheel ruff of the fiercely moustachioed cavalier on the left, are typical of the first two decades of the seventeenth century. Hyatt Mayor once spoke of

them as being Spanish. It is therefore supposed that this drawing and the three related sketches, one representing another horseman (British Museum; Benesch, 1954-57, II, no. 367, fig. 415 [1973, fig. 443]) and the two others, negro drummers and trumpeters (British Museum; Benesch, 1954-57, II, no. 365, fig. 412 [1973, fig. 442]. Feilchenfeldt, Zürich; Benesch, 1954-57, II, no. 366, fig. 413 [1973, fig. 441]), record figures from a festival or pageant which Rembrandt witnessed. Van Regteren Altena cited the tournament and other festivities attendant on the wedding of Wolfert van Brederode with Louise Christine van Solms, a sister of the Princess of Orange, at The Hague in February 1638, as a possible source of Rembrandt's colorful personages of an earlier time (J. Q. van Regteren Altena, "Retouches to our Conception of Rembrandt: The Concord of State II," *Oud Holland*, LXVII, 1952, pp. 59–63). Rembrandt views the pompous make-believe of the mounted mummers of the Morgan drawing with a pointed humor not manifested in the other drawings of the group. All four drawings were once together in the collection of Jonathan Richardson, Sr.

Technically, the drawing is an interesting example of the complex range of drawing materials the artist used in a single drawing. Watrous analyzed it as follows: "Rembrandt . . . introduced natural red chalk strokes into the plume of a hat and applied moistened red chalk to the boots and along the slits in one of the costumes while the remainder of the drawing was completed with quill pen and bistre ink, bistre washes, yellow ochre fabricated chalk, and semi-opaque whites applied with a brush." The artist's use of this particular combination of pen and wash with colored chalks appears to be confined to this group of drawings and to the copies after Indian miniatures (see Nos. 75–76), making them as unusual in technique as in subject.

PROVENANCE: Jonathan Richardson, Sr. (Lugt 2184); Thomas Hudson (Lugt 2432); possibly his sale, London, Messrs. Langford, 15-26 March 1779, one of three in

lot 52 (according to manuscript note in British Museum copy, "The Drummers etc. to Mr. Willett for £6.15.0"); Heneage Finch, fifth Earl of Aylesford (Lugt 58); his sale, London, Christie's, 17–18 July 1893, lot 265 (to Sir Charles Robinson for £6 according to priced copy at R.K.D.); Sir John Charles Robinson (according to inscription on verso of mount); his sale ["Well-Known Amateur"], London, Christie's, 12–14 May 1902, lot 355 (£42); Charles Fairfax Murray; J. Pierpont Morgan (no mark; see Lugt 1509).

BIBLIOGRAPHY: Fairfax Murray, I, no. 201, repr.; Hofstede de Groot, *Rembrandt*, 1906, no. 1109; Valentiner, 1934, II, no. 790, repr.; Benesch, *Werk und Forschung*, 1935, p. 41; Benesch, 1954–57, II, no. 368, fig. 414 (1973, fig. 444); James Watrous, *The Craft of Old-Master Drawings*, Madison, Wisconsin, 1957, pp. 96, 152, repr.; Walther Scheidig, *Rembrandt als Zeichner*, Leipzig, 1962, pp. 44, 79, fig. 47; B. Haak, *Rembrandt Zeichnungen*, Cologne, 1974, pl. 3; Bernhard, *Rembrandt*, 1976, II, p. 230, repr.; Nigel Konstam, "Over het gebruik van modellen en spiegels bij Rembrandt," *De Kroniek van het Rembrandthuis*, 1978, no. 1, p. 27, fig. 8 (the substance of this article originally appeared in *Burlington Magazine*, CXIX, 1977, pp. 94–98).

EXHIBITIONS: London, Guildhall, 1895, no. 45; London, Royal Academy, *Old Masters*, 1899, no. 110; Paris, *Rembrandt*, 1908, no. 433; Rotterdam, Museum Boymans, and Amsterdam, Rijksmuseum, *Rembrandt: Tekeningen*, 1956, no. 74, fig. 22; New York–Cambridge, *Rembrandt*, 1960, no. 31, pl. 26; Chicago, *Rembrandt after Three Hundred Years*, 1969, no. 112, pp. 165–66, 212, repr.; Stockholm, *Morgan Library gästar Nationalmuseum*, 1970, no. 65.

Acc. no. I, 201

72. *Three Studies for a "Descent from the Cross"*

Mark 15:42–46

Quill and reed pen, and brown ink. Repair along upper margin.
7½ × 8⅟₁₆ inches (190 × 205 mm.).
Watermark: none.

Throughout his life, Rembrandt was concerned with the illustration of scenes from the Life and Passion of Christ, but he was particularly preoccupied with these themes in his drawings and etchings of the first half of the 1650's, the period to which this remarkably expressive sheet of studies is assigned. As in the instance of the Thaw *Descent from the Cross* by Rubens (see No. 14), it is possible here to trace the artist's development and refinement of his ideas, both formally and psychologically. He appears to have first drawn the right group of the Christ and the compassionate supporter of His dead body, which is still suspended from the Cross by one hand; then he seems to have revised the original position of Christ's left forearm and back, pressing heavily on the broad nibs of his reed pen to produce the bold outlines. In the smaller sketch at the upper left he incorporated the new position of the forearm and clarified that of the shoulder, at the same time altering the relationship of the two heads so that Christ's head no longer overlaps the other. Finally, moving his pen to the lower left, he studied the new juxtaposition of the heads on a larger scale. As befits the nocturnal setting of the event, the sensitive face of the Christ is now effectively illumined against the shadowed countenance of the young man, perhaps intended as St. John and possibly bearing a faint reminiscence of the features of Rembrandt's son Titus. (Compare the portrait *Titus Reading* in the Kunsthistorisches Museum, Vienna [Bredius-Gerson, no. 122].) The other lightly indicated heads may have been first thoughts for spectators at the scene of the Deposition, the upper two possibly extraneous notations that were already on the sheet when Rembrandt began these moving studies of the dead Christ and His sorrowing young disciple who performs his poignant task with infinite tenderness. Campbell's assertion that Rembrandt in the Thaw drawing was inspired by Marcantonio Raimondi's print after Raphael's *Deposition* is not as convincing as his association of *The Standing Old Man and Seated Young Man* (Benesch, 1954–57, II, no. 348, fig. 400 [1973, fig. 421]) with Marcantonio's print after Raphael's *St. Paul Preaching in Athens*.

Critics have associated the Thaw drawing with the etching of 1654 (Bartsch, no. 83) and also with the painting in the National Gallery, Washington, D.C. (Bredius-Gerson, no. 584; Gerson refers to the painting as the work of a "pupil who based himself on Rembrandt"; Rosenberg has always maintained that the painting is a "highly important" work from Rembrandt's

own hand). It cannot be said that the Thaw drawing is directly connected with either work although compositionally it would seem nearer to the painting than to the etching with which Benesch related it.

PROVENANCE: George Guy, fourth Earl of Warwick (according to Benesch; no mark; see Lugt 2600); Thomas Halstead; Dr. A. Hamilton Rice, New York; Mr. and Mrs. Louis H. Silver, Chicago; Knoedler, New York; Robert Lehman, New York; Norton Simon Foundation, Los Angeles; R. M. Light & Co., Boston.

BIBLIOGRAPHY: Valentiner, 1934, II, no. 493, repr.; Benesch, *Werk und Forschung*, 1935, p. 55; Benesch, 1954–57, V, no. 934, fig. 1145 (1973, fig. 1211); Jakob Rosenberg, review of Benesch, 1954–57, *Art Bulletin*, XLI, 1959, p. 114; unsigned review of exhibition, "Rembrandt Drawings from American Collections," *Arts*, XXXIV, 1960, p. 29, repr.; Colin Campbell, "Raphael door Rembrandts pen herschapen," *De Kroniek van het Rembrandthuis*, XXVII, 1975, p. 28.

EXHIBITIONS: New York–Cambridge, *Rembrandt*, 1960, no. 68, pl. 57; Chicago, *Rembrandt after Three Hundred Years*, 1969, no. 133, repr.; Morgan Library and elsewhere, *Drawings from the Collection of Mr. and Mrs. Eugene V. Thaw*, catalogue by Felice Stampfle and Cara D. Denison, 1975, no. 30, repr.

Mr. and Mrs. Eugene V. Thaw
Promised gift to The Pierpont Morgan Library

73. *The Mocking of Christ*
Matthew 27:27–29

Pen and brown ink.
6⅛ × 8⁹⁄₁₆ inches (156 × 218 mm.).
Watermark: none visible through lining.

Nearly one hundred of the large body of Rembrandt's surviving drawings of biblical subjects represent events of the Passion. Drawings on this theme are particularly numerous in the years 1650–55, the period which also produced the master etchings, *The Three Crosses* of 1653 and *Christ Presented to the People* of 1655. *The Mocking of Christ* fits well in this period.

The immaculately preserved Morgan drawing illustrates Matthew 27:27–29: "Then the soldiers of the governor took Jesus into the common hall, and gathered unto him the whole band of soldiers. And they stripped him, and put on him a scarlet robe. And when they had platted a crown of thorns, they put it upon his head, and a reed in his right hand: and they bowed the knee before him, and mocked him, saying, Hail, King of the Jews!" The fact that Rembrandt shows the reed in the left hand of Jesus could be interpreted as an indication that he contemplated a print where, in the normal reversal process, the design would have appeared in the opposite direction. The sculptured lioness towering over the scene carries a recollection of the powerful life study in the British Museum (Benesch, 1954–57, IV, no. 775, fig. 922 [1973, fig. 978]). Haverkamp-Begemann and Logan in the catalogue of the Chicago exhibition pointed out that the semi-nude Christ is in the pictorial tradition of the northern representation of the "Man of Sorrows." While Rembrandt departed from the text in not showing Christ actually wearing the "scarlet robe," it appears draped over the pier at the back of the figure. The diversity of expression among the spectators is notable, and their pairing off in two's serves to emphasize the isolation of the principal figure.

Rembrandt conveys the drama of the scene with the utmost graphic brevity, dispensing entirely with wash, although he deliberately smudged with thumb or finger the hatching at the lower right edge to emphasize the form of the ledge. The broken, delicately vibrant strokes which make for the subtle effects of light and air are achieved through the use of a half-dry pen, a technical innovation of the middle period. A pen heavy with ink was used to emphasize the repoussoir figure at left and for accents here and there.

A less developed version of the same theme, similarly employing the device of composing on different levels, occurs in a drawing now in a private collection in the United States, but formerly in the Léon Bonnat collection, that was sold as lot 58 at Sotheby's, London, on 10 December 1968 (Benesch, 1954–57, V, no. 1024, fig. 1238 [1973, fig. 1308]); the Chatsworth drawing of the subject (Benesch, 1954–57, VI, no. A82, fig. 1674 [1973, fig. 1746]) was dis-

105

cerningly rejected by Benesch. In view of the absence of any wash, the Morgan drawing cannot be that in the Simon Fokke sale (Amsterdam, 6 December 1784, Album O, p. 145, lot 983, "De bespotting van Christus, met de pen en luchtig gewasschen met Oostind Inkt").

PROVENANCE: William Roscoe (according to the Muller sale catalogue of 1882 referred to below); his sale, Liverpool, Winstanley, 23–28 September 1816, lot 607, "six by or in the manner of Rembrandt" (to Stanley for 14 shillings); Sir John Charles Robinson (no mark; see Lugt 1433); sale, "deux amateurs connus" [J. C. Robinson and Marquis de Chennevières], Amsterdam, Frederik Muller and Co., 20–21 November 1882, lot 164, "Jésus-Christ outragé"; Charles Fairfax Murray; J. Pierpont Morgan (no mark; see Lugt 1509).

BIBLIOGRAPHY: Fairfax Murray, I, no. 189, repr.; Valentiner, 1934, II, no. 476, repr.; Benesch, *Werk und Forschung*, 1935, p. 51; Tietze, *European Master Drawings*, 1947, no. 68, pl. 36; Benesch, 1954–57, V, no. 920, fig. 1131 (1973, fig. 1199); Willi Drost, *Adam Elsheimer als Zeichner*, Stuttgart, 1957, p. 197, no. 225; Egbert Haverkamp-Begemann, review of Benesch, 1954–57, *Kunstchronik*, XIV, 1961, p. 86, under B.1000; Malcolm Vaughan, "Master Drawings: A Royal Occasion," review of Knoedler exhibition, 1959, *Connoisseur Yearbook*, 1961, p. 29, repr.; Hans-Martin Rotermund, *Rembrandts Handzeichnungen und Radierungen zur Bibel*, Stuttgart, 1963, no. 227, pp. 262–63, 315, repr.; Julius S. Held and Donald Posner, *Seventeenth- and Eighteenth-Century Art*, New York, 1972, p. 269, fig. 279.

EXHIBITIONS: London, Guildhall, 1895, no. 53; London, Royal Academy, *Old Masters*, 1899, no. 105; Paris, *Rembrandt*, 1908, no. 354, repr.; New York, Metropolitan Museum, *Rembrandt*, 1918, no. 55; New York Public Library, *Morgan Drawings*, 1919, n.p.; San Francisco, *Rembrandt from Morgan Collection*, 1920, no. 374; New York, Wildenstein and Co., *Rembrandt*, 1950, no. 36; Morgan Library, *Treasures from the Pierpont Morgan Library*, 1957, no. 96; New York, M. Knoedler and Co., *Great Master Drawings of Seven Centuries: A Benefit Exhibition of Columbia University*, 1959, no. 46, pl. XXVIII; New York–Cambridge, *Rembrandt*, 1960, no. 59, pl. 52; Minneapolis, *Fiftieth Anniversary*, 1965–66, n.p.; Chicago, *Rembrandt after Three Hundred Years*, 1969, no. 129, repr.

Acc. no. I, 189

74. *Canal and Bridge beside a Tall Tree, a Couple Seated on the Bank*

Pen and brown ink, brown wash, on paper darkened to a brown tone through exposure to light.
$5\frac{9}{16} \times 9\frac{9}{16}$ inches (141×243 mm.).
Watermark: none visible through lining.
Inscribed in pen and brown ink at upper right, C[?].

Rembrandt appears to have first set down this idyllic landscape motive of quiet water and bright boscage, and subsequently added the shorthand notation of the couple seated on the embankment as a counteraccent for the darks of the canal and bridge. One is reminded of similar pairs of lovers who appear less conspicuously in corners of such landscape etchings as the *Three Trees* (Bartsch, no. 212) and the *Omval* (Bartsch, no. 209). The little footbridge was almost as typical of the seventeenth-century Dutch scene as the windmill. Its reflection in the water adds another strong vertical to this balanced composition of upright and horizontal elements; though less obvious, the diagonals of the design formed by the canal and the path along the embankment converge effectively at the foot of the dominant tree. The device of a single tall tree as a central focal point was sometimes used by Rembrandt in his landscape paintings as well as his drawings. Compare the romantically composed painting *Stormy Landscape with an Arched Bridge*, in the Staatliche Museen Preussischer Kulturbesitz, Berlin (Bredius-Gerson, no. 445). The present drawing is a characteristic example of Rembrandt's landscapes of the first half of the 1650's where he achieves wonderful effects of vibrant light and airiness by delicate manipulation of a half-dry pen as noted in the preceding drawing, but here the pen work is combined with washes. Though many of the sites Rembrandt sketched were identified by Frits Lugt in his charming book *Mit Rembrandt in Amsterdam* (1920), this peaceful glimpse of Dutch countryside cannot be localized.

While Rembrandt appears occasionally to have used a drawing paper which he had himself tinted a light brown, just as he experimented with different papers for his etchings, the original white or cream paper here appears to have darkened through exposure to strong light during the centuries. Such exposure is in a way a sign of past owners' regard for the drawing since it must have been displayed on the wall, but the change such treatment has wrought in the paper can be judged by comparison with the

pristine paper of the preceding drawing. Fairfax Murray as a past owner of this sheet may well have contributed to its present appearance since, according to Frits Lugt, Murray's Rembrandt drawings were framed and hung along the stairway of his house in Kensington. It must be confessed that the effect of the paper darkened by age and exposure is not too different from that achieved with a brown tint applied with a brush. For another example of a paper darkened by exposure to light, compare No. 67. For a brief discussion of tinted papers by Haverkamp-Begemann, see *Drawings from the Clark Art Institute*, New Haven and London, 1964, p. 21 under no. 17. There are probably more examples than those listed there.

PROVENANCE: Heneage Finch, fifth Earl of Aylesford (no mark; see Lugt 58); his sale, London, Christie's, 17–18 July 1893, lot 260, "A Landscape with a slight bridge over a dyke" (to Salting for £12.10); George Salting (no mark; see Lugt 2260–61); Charles Fairfax Murray; J. Pierpont Morgan (no mark; see Lugt 1509).

BIBLIOGRAPHY: Fairfax Murray, I, no. 202, repr.; Hofstede de Groot, *Rembrandt*, 1906, no. 1094; Benesch, *Werk und Forschung*, 1935, p. 58; Otto Benesch, *A Catalogue of Rembrandt's Selected Drawings*, London, 1947, no. 226, repr.; Franz Winzinger, *Rembrandt Landschaftszeichnungen*, Baden-Baden, 1953, no. 32, repr.; Benesch, 1954–57, VI, no. 1343, fig. 1577 (1973, fig. 1655).

EXHIBITIONS: Paris, *Rembrandt*, 1908, no. 469; New York, Metropolitan Museum, *Rembrandt*, 1918, no. 34; New York, Wildenstein and Co., *Rembrandt*, 1950, no. 34; Morgan Library, *Landscape Drawings*, 1953, no. 65; Kansas City, Missouri, William Rockhill Nelson Gallery, *Twenty-fifth Anniversary Exhibition*, 1958, no. 15 (Patrick Kelleher in *Nelson Gallery and Atkins Museum Bulletin*, I, no. 2, 1958, p. 8); New York–Cambridge, *Rembrandt*, 1960, no. 54, pl. 46; Minneapolis, *Fiftieth Anniversary*, 1965–66, n.p.

Acc. no. I, 202

75. *Indian Warrior with a Shield*

Pen and brown ink, brown wash, and some red chalk wash, on Japanese paper. Narrow vertical strip added at right edge of sheet.
7 × 3¹⁵⁄₁₆ inches (178 × 100 mm.).
Watermark: none visible through lining.
Inscribed by Esdaile, in pen and brown ink, on mount at lower right, *WE*; at lower center, *Rembrandt.*; at lower

left corner, *105x 1831x*; at lower right corner, in graphite, in another hand, *10 17ᵈ/cd*; below this, in another hand, in pen and brown ink, *222*. On verso of mount, at upper left, in graphite, *N L59*; at upper center, numbered, probably by Esdaile, in pen and brown ink, *19*; at lower left, in graphite, *üf*[?]; in lower left corner, in pen and brown ink, by Esdaile, *1831 WE N105x*; below this, in pen and brown ink, in another hand, *№ 493* (see Lugt S.2986b); in lower right corner, in another hand, in graphite, *z:v/5*.

Among Rembrandt's copies after other works of art—and witness to the universality of his taste—is an extensive series of studies after miniatures by court painters of the Mughal School in India. The Indian artists whose works Rembrandt copied were more or less his contemporaries since personages like Jahangir (1569–1627), the Emperor of Hindustani, and Shah Jahan (1592–1666), his son and successor who built the Taj Mahal, are portrayed in the miniatures. Twenty-five of Rembrandt's studies were assembled in an album in the first half of the eighteenth century by the English painter and collector Jonathan Richardson, Sr. Today, nineteen of these Richardson drawings, including the present example and the following one, are known in the literature; all are identified by the stamp of the collector's monogram and all are executed on Japanese paper, the soft-surfaced paper, frequently light yellow or golden in tone, that Rembrandt sometimes used for printing his etchings. Yet another, an unrecorded drawing of two heads of women after an Indian miniature, also from the Richardson collection, is reported by Carlos van Hasselt to have been in a French private collection in the 1960's; he notes further that it was probably once mounted together with *Indian Lady in a Veil* (Benesch, 1954–57, V, no. 1206, fig. 1421 [1973, fig. 1506]). This brings the total of the known Richardson drawings to twenty with five remaining unaccounted for. In addition to the twenty drawings with the Richardson mark, there are three others after Indian subjects which come from different sources: those in the Nationalmuseum, Stockholm, the Rijksprentenkabinet, Amsterdam, and the Fogg Art Museum, Cambridge (Benesch,

107

1954–57, II, no. 450, fig. 509 [1973, fig. 539]; V, no. 1202, fig. 1427 [1973, fig. 1503] and no. 1198, fig. 1423 [1973, fig. 1498]). These three drawings are also set apart from the Richardson group in that they are executed on European papers rather than Japanese. There is thus a total of twenty-three drawings actually extant, and, if the two lost drawings Hofstede de Groot listed at Weimar (nos. 541–42; on Japanese paper; then privately owned), bearing inscriptions in Rembrandt's hand "na een oostindies poppetje geschets," were actually after miniatures, the total of traceable drawings of this kind is twenty-five.

Mughal miniatures were far from rare in seventeenth-century Holland where they were generally known as "Suratse Teeckeningen," that is, drawings from the city of Surate, the chief seaport of India under Jahangir and Shah Jahan, where the Dutch traded; they were also sometimes referred to as "Mogolse teeckeningen." It has been suggested that Rembrandt himself might have owned some of them and that "the [book] of curious miniature drawings," noted in the inventory of his collection made in 1656 prior to his bankruptcy, may have had reference to Mughal miniatures. It has further been proposed that Rembrandt's models were the miniatures which in the eighteenth century were trimmed and rearranged in rococo shapes for the decoration of the "Millionenzimmer" in Schönbrunn Palace, Vienna, where they can be seen today. Although these miniatures came from an album said to be of Dutch provenance (Constantinople has also been suggested as its source), they may not be the very models that Rembrandt copied but rather a series dependent on a common prototype since the subjects of Indian miniatures frequently were repeated over a long period with little variation. In any event, the warrior of the Morgan drawing is found in similar guise among the Schönbrunn miniatures though there he holds no stick but only folds his hands; on the other hand, the long ends of his girdle are omitted in the drawing and his turban appears to be of somewhat

different design than that of the miniature. Whether these differences are due to the copyist or whether they were present in the original he had before him cannot be ascertained. In the Schönbrunn miniature, the warrior is shown standing just beyond an arched doorway, which in the drawing is echoed in the curve of the dark ground at the upper right. Originally, there may have been another figure on the Library's sheet which has been trimmed at the right; note the small triangular shape at the center of the right edge of the paper of the drawing.

The drawings after Indian miniatures are usually dated about 1656, partly because the British Museum sheet *Four Orientals Seated beneath a Tree* (Benesch, 1954–57, V, no. 1187, fig. 1411 [1973, fig. 1486]) seems to have inspired the composition of *Abraham Entertaining the Angels*, the etching of 1656 (Bartsch, no. 29). Benesch proposed a date of 1654–56 for all of the series except the *Young Indian Woman* in the Nationalmuseum, Stockholm (Benesch, 1954–57, II, no. 450, fig. 509 [1973, fig. 539]) which he dated c. 1638.

PROVENANCE: Jonathan Richardson, Sr. (Lugt 2184); his sale, London, Mr. Cock, 22 January – 8 February (actually Wednesday, 11 February), 1746–47 [*sic*], lot 70, "A book of Indian drawings, by Rembrandt, 25 in number" (notation in British Museum copy, "Withdrawn"); unknown eighteenth-century collector (see Lugt S.2986b); William Esdaile (Lugt 2617); his sale, London, Christie's, 18–25 June 1840, lot 1030, "A Persian with a Shield; fine" (to Hodgson for 11 shillings); Charles Sackville Bale (no mark; see Lugt 640); his sale, London, Christie's, 9–13 June 1881, lot 2432, "a whole-length Figure in Eastern Costume. From the Esdaile Collection" (£2.12.6); Charles Fairfax Murray; J. Pierpont Morgan (no mark; see Lugt 1509).

BIBLIOGRAPHY: Fairfax Murray, I, no. 207, repr.; Hofstede de Groot, *Rembrandt*, 1906, no. 1088; F. Schmidt-Degener, "Tentoonstelling van Rembrandts teekeningen in de Bibliothèque Nationale te Parijs," review of Paris 1908 exhibition, *Onze Kunst*, XIV, 1908, p. 100; Valentiner, 1934, II, no. 649, repr.; Benesch, *Werk und Forschung*, 1935, p. 56; M. D. Henkel, *Catalogus van de Nederlandsche teekeningen in het Rijksmuseum te Amsterdam, I: Teekeningen van Rembrandt en zijn school*, The Hague, 1942, under no. 30; Benesch, 1954–57, V, no. 1201, fig. 1425 (1973, fig. 1501).

EXHIBITIONS: Paris, *Rembrandt*, 1908, no. 387; New York, Metropolitan Museum, *Rembrandt*, 1918, no. 28; Washington, D.C., National Gallery of Art, and else-

where, *Dutch Drawings: Masterpieces of Five Centuries*, 1958–59, no. 71a, repr.; New York–Cambridge, *Rembrandt*, 1960, no. 61, pl. 54.

Acc. no. I, 207

76. *Two Indian Noblemen*

Pen and brown ink, brown wash, with touches of red chalk wash, red and yellow chalk, some white tempera on turban and skirt of figure at right, on Japanese paper.
7½ × 9⁹⁄₁₆ inches (191 × 234 mm.).
Watermark: none visible through lining.
An inscription on verso, in pen and brown ink, at upper margin trimmed to illegibility.

The two figures Rembrandt brought together here on the same sheet, but clearly not *en rapport*, were copied from separate miniatures. Comparable models for each are found among the mutilated Schönbrunn miniatures. The imposing archer with the sharp-pointed white beard, who was probably drawn first, was identified by Dr. Richard Ettinghausen as Abd-al-Rahim Khan (1556–1627), known under the title Khan-i-Khanan. He was a famous general, statesman, and scholar at the Mughal Court, serving under the emperors Akbar the Great and Jahangir. The bow and the khattar or dagger in his girdle indicate that it is obviously in his capacity as a soldier that he was represented by the miniaturist whose work Rembrandt copied, but there is a certain distinctive refinement of feature—which must have attracted the copyist—that is consistent with the general's role as a poet and patron of the arts. His poetry, composed in four languages, was written under the pseudonym Rahim. The nobleman who holds a falcon in his gloved right hand and the lure in his left has not been identified.

It is interesting that for his copies after the exotic Mughal miniatures Rembrandt again employed the colorful blend of media he had used for the equally unusual group of drawings of the festival procession featuring a black drummer and trumpeters, and soldiers of an earlier era (see No. 71).

PROVENANCE: Jonathan Richardson, Sr. (Lugt 2184); his sale, London, Mr. Cock, 22 January – 8 February (actually Wednesday, 11 February), 1746–47 [*sic*], lot 70, "A book of Indian Drawings, by Rembrandt, 25 in number" (notation in British Museum copy, "Withdrawn"); Charles Rogers (no mark; see Lugt 624–26); his sale, London, T. Philipe, 15–23 April 1799, lot 57, "Asiatic figures, by Rembrandt—one of them is presenting an arrow to the other, who carries an hawk on his arm—pen and bistre, with a tinge of red chalk wash—very fine" (11 shillings); Jonkheer Johan Goll van Franckenstein the Younger (according to Hofstede de Groot); Heneage Finch, fifth Earl of Aylesford (Lugt 58); his sale, London, Christie's, 17–18 July 1893, lot 263, "Two Oriental Figures, in pen and ink, washed with colour. From the Richardson Coll." (to Fairfax Murray for £8, according to F. Lugt notes); Charles Fairfax Murray; J. Pierpont Morgan (no mark; see Lugt 1509).

BIBLIOGRAPHY: Fairfax Murray, I, no. 208, repr.; Hofstede de Groot, *Rembrandt*, 1906, no. 1087; F. Schmidt-Degener, "Tentoonstelling van Rembrandts teekeningen in de Bibliothèque Nationale te Parijs," review of Paris 1908 exhibition, *Onze Kunst*, XIV, 1908, p. 100; Valentiner, 1934, II, no. 651, repr.; Benesch, *Werk und Forschung*, 1935, p. 56; Benesch, 1954–57, V, no. 1203, fig. 1429 (1973, fig. 1502); Richard Ettinghausen, *Paintings of the Sultans and Emperors of India in American Collections*, Lalit Kalā Akademi, India, 1961, p. 6, repr.; Theodore Bowie *et al.*, *East-West in Art*, Bloomington, Indiana, 1966, p. 108, fig. 204.

EXHIBITIONS: Paris, *Rembrandt*, 1908, no. 428; New York, Metropolitan Museum, *Rembrandt*, 1918, no. 29; Toronto, The Art Gallery of Toronto, *Rembrandt*, 1951, Drawings, no. 3; New York–Cambridge, *Rembrandt*, 1960, no. 62, pl. 65; Chicago, *Rembrandt after Three Hundred Years*, 1969, no. 107, repr.

Acc. no. I, 208

77. *The Finding of Moses*

Quill and reed pen, and brown ink; corrected in white in the area of the hands of the figure at the far left and possibly in the area of the left foot of Pharaoh's daughter. Verso: Head of a woman in a plumed hat in pen and brown ink. Repairs at upper and lower left corners.
7⅜ × 9¼ inches (187 × 235 mm.).
Watermark: fleur-de-lis within a shield, surmounted by a crown (cf. Heawood 1717–45). See watermark no. 19.
Numbered in brown ink at lower right corner, *15*.

As far as is known, Rembrandt drew the Finding of Moses only in this important sheet of the mid-1650's and an earlier one in the Rijksprentenkabinet at Amsterdam (Benesch, 1954–57, II, no. 475, fig. 535 [1973, fig. 566]; Münz's attribution to Ferdinand Bol, which Benesch

accepted, is rejected by most scholars). In the lively but slight sketch in Amsterdam, Pharaoh's daughter and her two attendants are shown as bathers with little or no indication of the setting. Here, however, Rembrandt illustrates the biblical story with a full array of characters dramatically disposed at the water's edge, the great umbrella used to convey the royal and exotic nature of the event. Pharaoh's daughter, richly garbed and arms akimbo, dominates the scene. Her elaborate hat and the pose of her head as well bring to mind—in reverse—the striking Flora of the Metropolitan Museum's painting (Bredius-Gerson, no. 114), a work not too far removed in date. In this connection, it is interesting that the small sketch on the verso, which has not been noted previously, shows an alternate solution for the head of Pharaoh's daughter. She wears a long earring and a hat with two plumes, one erect at the back and one extending forward at the side. The cluster of her peering maids on the recto focuses with a telling variety of gaze on the two attendants lifting the Infant Moses from the water. Boldly set down with the broad, even crude strokes of the reed pen as repoussoir figures, the attendants are instinct with the energy and purpose of their task; a *pentimento* may be observed in the arm of the figure in the corner of the sheet. Equally intent is the visage of the Infant Moses' sister—somehow suggestive of concern even in the abbreviation of its notation—worriedly watching from behind the curving lines of the low chariot of Pharaoh's daughter.

Sumowski notes that a copy of the drawing sold at The Hague in 1912 shows that it has at some time been cut down on three sides. As Benesch remarked, the spokes of the chariot wheel, executed in a more golden brown ink than the rest of the drawing, appear to have been added later.

Another drawing of the subject attributed to Rembrandt—but surely not by him—passed through the auction rooms in Paris and London in the 1920's (Charles Haviland, sale, Paris, Hôtel Drouot, 14–15 December 1922, lot 24, as

"Rembrandt, attribué à"; Prince W. Argoutinsky-Dolgoroukow, sale, London, Sotheby's, 4 July 1923, lot 67, as Rembrandt; Pierre Geismar, sale, Paris, Hôtel Drouot, 15 November 1928, lot 108, repr., as Rembrandt and coming from the collections of Argoutinsky-Dolgoroukow and Marignane).

PROVENANCE: (Not, as previously recorded, H. Duval, according to Frits Lugt's annotated copy of the following sale); sale, Amsterdam, Frederik Muller, 22–23 June 1910, lot 302 (bought in at 700 guilders and returned to the owner, Dr. Schweizgut; Lugt, in his notes now at the R.K.D., questioned the attribution to Rembrandt); probably Maurice Marignane (but possibly Hubert Marignane); Dr. James Henry Lockhart, Jr., Rochester, New York; R. M. Light & Co., Boston.

BIBLIOGRAPHY: Valentiner, 1925, I, no. 124, repr.; Benesch, *Werk und Forschung*, 1935, p. 56; Benesch, 1954–57, V, no. 952, fig. 1163 (1973, fig. 1225); Werner Sumowski, *Bemerkungen zu Otto Beneschs Corpus der Rembrandtzeichnungen II*, Bad Pyrmont, 1961, p. 17, under no. B.952 ("Eine Kopie der Verst. C.O.C. Obreen, Den Haag, 18.12. 1912, Nr. 276 [Feder, 20:30 cm] erweist das Blatt als auf drei Seiten beschnitten."); Hans-Martin Rotermund, *Rembrandts Handzeichnungen und Radierungen zur Bibel*, Stuttgart, 1963, pp. 89, 109, 312, no. 70.

EXHIBITIONS: Pittsburgh, Carnegie Institute, *Exhibition of Prints and Drawings from the Collection of J. H. Lockhart, Jun.*, 1939, p. 111; Morgan Library and elsewhere, *Drawings from the Collection of Mr. and Mrs. Eugene V. Thaw*, catalogue by Felice Stampfle and Cara D. Denison, 1975, no. 29, repr.

Mr. and Mrs. Eugene V. Thaw
Promised gift to The Pierpont Morgan Library

78. *Old Scholar at His Writing Table*

Reed pen and brown ink, smudged rather than washed; corrected in white.
5⅛ × 4³⁄₁₆ inches (129 × 105 mm.).
Watermark: illegible fragment. See watermark no. 57.

In the last years of his life Rembrandt devoted himself in large part to painting and drew very little. The drawings of this last period of the 1660's, however, are powerful in execution and expression as the present composition bears witness. The bearded old scholar is seen seated, working at a table covered in the Dutch fashion with a heavy rug. Pausing in thought, he has

momentarily lifted his pen from the large folio in which he has been writing while holding his place in the smaller book he has been studying or copying. Were it not for the globe in front of the table at the left, he might well pass as St. Jerome at work on his translation of the Bible into Latin. The presence of the globe, however, which could be either terrestrial or celestial, indicates that Rembrandt was portraying either a geographer or an astronomer.

PROVENANCE: Friedrich August II of Saxony, Dresden (Lugt 971); A. & R. Ball, New York; L. V. Randall, Montreal; his sale, London, Sotheby's, 6 July 1967, lot 5, repr.

BIBLIOGRAPHY: Hofstede de Groot, *Rembrandt*, 1906, no. 305; Hans Wolfgang Singer, *Zeichnungen aus der Sammlung Friedrich August II . . .* , 1921, no. 46; K. Freise and H. Wichmann, *Rembrandts Handzeichnungen, III: Staatliches Kupferstichkabinett und Sammlung Friedrich August II zu Dresden*, Parchim a.M., 1925, no. 113; Hans Hell, "Die späten Handzeichnungen Rembrandts, II," *Repertorium für Kunstwissenschaft*, LI, 1930, p. 127; Benesch, *Werk und Forschung*, 1935, p. 67; Benesch, 1954–57, V, no. 1151, fig. 1373 (1973, fig. 1447).

EXHIBITIONS: New York, Wildenstein and Co., *Rembrandt*, 1950, no. 39; Rotterdam, Museum Boymans, and Amsterdam, Rijksmuseum, *Rembrandt: Tekeningen*, 1956, no. 252; New York–Cambridge, *Rembrandt*, 1960, no. 77, pl. 67.

Mr. and Mrs. Eugene V. Thaw
Promised gift to The Pierpont Morgan Library

Rembrandt Pupil

79. *St. Mark Preaching*

Pen and brown ink, brown wash, corrected with white tempera.
7⁵⁄₁₆ × 7⅛ inches (202 × 182 mm.).
Watermark: arms of Amsterdam. See watermark no. 10.

When this drawing was first published by Hofstede de Groot in 1894, it was unhesitatingly attributed to Rembrandt but in later years it has been questioned as a work of his own hand and classed as a drawing by a good but anonymous pupil of the master. The peculiar interest of the drawing attaches to the fact that it is freely copied from an Italian Renaissance drawing, as Hofstede de Groot recognized. The Italian model still exists today in the Devonshire Collection at Chatsworth and once belonged to Nicolaes Anthoni Flinck (1646–1723) and most likely also to his father, Govaert Flinck (1615–1660), who was a pupil of Rembrandt (repr. Valentiner, II, no. 622A). It could well be that earlier it had been owned by Rembrandt himself as a part of the group of Italian works of art in his collection which contained "the precious book of Mantegna" and "one book with drawings by the leading masters of the whole world" as well as numerous albums of prints after or by such artists as Michelangelo, Raphael, Titian, Barocci, and the Carracci (C. Hofstede de Groot, *Urkunden über Rembrandt*, The Hague, 1906, p. 190). The Chatsworth drawing, formerly attributed to Carpaccio, was more plausibly associated with another Venetian artist, Lattanzio da Rimini, pupil of Giovanni Bellini, by Detlev Baron von Hadeln (*Venezianische Zeichnungen des Quattrocento*, 1925, pp. 64, 65, and pl. 83).

The draughtsman, presumably a Rembrandt pupil of the 1650's, transformed the rather stiff schematic linearism of the Chatsworth drawing into a softer, more pictorial style; only in a few passages such as the figure of the standing woman on the left and that of the saint did he even suggest the pronounced horizontal hatching of his model, and then he directs it diagonally. He is careful to transcribe all twenty-five of the spectators, exclusive of the main figures of the saint and the woman at the left, and endows them with more expressive countenances and psychological interplay. Were one to judge only by such single elements as the domed church—much more convincing in space and form than the Italian artist's architecture—and the seated woman turning to look at the elegant young woman at the left, one might assign them to Rembrandt himself, but the curious figure of the seated woman on the far right and the difficulty in rendering the saint's feet and those of the figure at the far right explain the demotion of the drawing. Benesch brought together a group of ten other drawings which he regarded as the

work of the same hand as the Morgan sheet; the individual drawings of this not altogether cohesive group are listed in his volume VI under no. A83. All of them, with the exception of the Morgan sheet and *Joseph Telling His Dream* in Warsaw (no. A116), depict scenes from the Life of Christ, a subject which was of particular concern to Rembrandt in the decade of the fifties. Benesch cited as a characteristic of the draughtsman his practice of lightly rubbing the pen lines with the finger to create shadows, a device used by Rembrandt himself after 1650.

PROVENANCE: Possibly Hendrik Busserus sale, Amsterdam, 21 October 1782, Album 31, p. 221, lot 2116, "Twee stuks, een Predikenden Monnik, en een Historiëele Teekening, geteekend als boven, in de manier van dezelven (i.e. Rembrandt)" (with lots 2114 and 2115 for 2 florins 5); Charles Fairfax Murray; J. Pierpont Morgan (no mark; see Lugt 1509).

BIBLIOGRAPHY: C. Hofstede de Groot, "Entlehnungen Rembrandts," *Jahrbuch der Königlich Preussischen Kunstsammlungen*, XV, 1894, p. 177, repr.; Fairfax Murray, I, no. 206, repr.; Hofstede de Groot, *Rembrandt*, 1906, no. 1084 (as Rembrandt); J. F. Backer and Jans Veth, "Een missing link," *Oude Kunst*, II, 1916–17, p. 79, pl. 1 (as Rembrandt); Hans Hell, "Die späten Handzeichnungen Rembrandts," *Repertorium für Kunstwissenschaft*, LI, 1930, pp. 11, 27, and 36; Valentiner, 1934, II, no. 622B, repr.; Hans Tietze and Erika Tietze-Conrat, *Drawings of the Venetian Painters*, 1944, p. 181, under no. 749; Christopher White, "Rembrandt Exhibitions in Holland," *Burlington Magazine*, XCVIII, 1956, p. 323; Benesch, 1954–57, VI, no. A104, fig. 1672 (1973, fig. 1771); Jakob Rosenberg, review of Benesch, *The Art Bulletin*, XLI, no. 1, 1959, p. 118 (as school of Rembrandt); Willi Drost, "Eine Handzeichnungsgruppe aus der Rembrandt-Werkstatt um 1655: Zum Problem der Zusammenarbeit von Meister und Schüler," *Das Werk des Künstlers*, Stuttgart, 1960, p. 127 (as Rembrandt and pupils); Fritz Heinemann, *Giovanni Bellini e i Belliniani*, Venice, [1962], p. 114, under s.179; Joseph Gantner, *Rembrandt und die Verwandlung klassischer Formen*, Bern, 1964, p. 78, note 5 (as attributed to Rembrandt); Kenneth Clark, *Rembrandt and the Italian Renaissance*, London, 1966, pp. 161–63, and footnote 7, fig. 154; Bredius-Gerson, 1969, p. 486, note 4 (as school of Rembrandt); Washington, D.C., National Gallery of Art, and elsewhere, *Old Master Drawings from Chatsworth*, II, exhibition circulated by International Exhibitions Foundation, with catalogue by James Byam Shaw, 1969–70, p. 26 under no. 41.

EXHIBITIONS: Paris, *Rembrandt*, 1908, no. 368, repr.; Chicago, *Rembrandt*, 1935–36, no. 44; Worcester, *Rembrandt*, 1936, no. 44; Toronto, The Art Gallery of Toronto, *Rembrandt*, 1951, Drawings, no. 4; Rotterdam,

Museum Boymans, and Amsterdam, Rijksmuseum, *Rembrandt: Tekeningen*, 1956, no. 224.

Acc. no. I, 206

Rembrandt Pupil, with corrections by Rembrandt

80. *Lot Defending the Angels from the Men of Sodom*
Genesis 19:1–11

Pen and gray-black ink with gray and brown washes, with corrections in reed pen and brown ink, and some heightening in white tempera.
7¾ × 10³⁄₁₆ inches (197 × 259 mm.).
Watermark: foolscap with four visible points. See watermark no. 32.
Inscribed at lower right in brown ink, *Rembrand*.

This drawing, which came to light a little more than ten years ago, is an addition to the group of drawings which demonstrate Rembrandt's manner of instructing his pupils by directly reworking and amending their compositions with his authoritative pen, no doubt during the course of a pungent oral *critique*. The 1973 edition of Benesch's *catalogue raisonné* lists sixteen of these "corrected drawings" which are by a variety of hands (VI, nos. 1370–84, figs. 1683–98). The pupil most commonly mentioned as the possible author of several of these drawings is Constantijn Renesse (1626–1680), who was probably in Rembrandt's studio in 1649 and possibly later as well (see Benesch VI, no. 1379 and Trautscholdt in Thieme-Becker, XXVIII, p. 160).

The somewhat uncommon subject of the Morgan drawing, which the late Curtis O. Baer was the first to recognize, is drawn from Genesis 19:1–11. It represents Lot defending the two angels to whom he had extended hospitality for the night when a band of the men of Sodom demanded that he give them the visitors whom they intended to violate. Eventually the Lord intervened, the Sodomites were struck blind, and Lot, warned by the angels whom he had protected, fled the city before its destruction.

Since the timid composition which Rembrandt's pupil presented to him for criticism

was laid out with a hesitant, thin grayish pen line supplemented by some gray wash, the master's changes, forcefully made with the broad nibs of his reed pen in a rich brown ink, are clearly distinguishable; they are obvious even though the pupil later attempted to unify the composition with a brown wash of his own. Rembrandt perhaps began by strengthening the contours of the principal actors in the central foreground, immediately lending substance and weight to them. He pointed up the dramatic interest of the scene by adding several expressive figures of his own in the middle ground at the right. With a few bold lines, he firmed up the architecture of the doorway where Lot stands; another three or four geometric movements of the pen altered the position of the patriarch's arm and created the effective figure peering over his shoulder. The addition of this figure— perhaps one of Lot's daughters whom he offered to the Sodomites in lieu of the angels—heightened the tension of the action and increased the feeling of interior space within. A new position for the arm of the bowman approaching from the left carries the movement of the crowd forward towards the center of interest in the doorway. Even the alteration of the position of his foot quickens and invigorates. The pupil was surely awed—and very possibly depressed—by this almost ruthlessly brilliant transformation of his feeble invention.

Most of Rembrandt's corrections of his pupils' drawings appear to date from the decade of the fifties. Here, the centrally focused composition, with the main action taking place on a raised level, possibly reflects the design of *Christ Presented to the People*, Rembrandt's master etching of 1655 (Bartsch, no. 76), and the oriental costumes among the crowd of Sodomites recall that Rembrandt's copies after Indian miniatures were made about 1654–56.

Mrs. Eva Benesch reported that there is no record of this drawing in the files of her late husband so it was apparently unknown to him. She also kindly drew attention to the exact copy of the drawing, by an inferior hand, in the De Bruijn bequest to the Rijksmuseum, Amsterdam (see the Rijksmuseum's *Bulletin*, 1961, nos. 2–3, p. 87, no. 42). Sumowski noted that there is a second copy at Brunswick in the Herzog Anton Ulrich Museum (review of the Chicago Rembrandt exhibition catalogue of 1969, *Pantheon*, XXIX, 1971, p. 174).

PROVENANCE: Charles Rogers (Lugt 624); Chevalier Ignace-Joseph de Claussin (Lugt 485); Duke of Somerset at Bulstrode Park; his sale, London, Christie's, 28 June 1890, lot 7; Charles Sedelmeyer, New York (according to inscription on verso); Charles Stewart Smith, New York (in 1907, according to inscription on verso); Mr. and Mrs. Adolph I. Margolis, New York; their son, Stephen Margolis.

BIBLIOGRAPHY: Morgan Library, *Fifteenth Report to the Fellows, 1967–1968*, 1969, pp. 104–06; Benesch, 1973, I, p. xii.

EXHIBITION: Chicago, *Rembrandt after Three Hundred Years*, 1969, no. 145, repr.

Acc. no. 1967.24

Purchased as the gift of Mr. and Mrs. Arnold Whitridge

Jan Lievens the Elder
Leyden 1607 – 1674 Amsterdam

81. *Portrait of a Man*

Black chalk.
9⅝ × 7⅝ inches (244 × 195 mm.).
Watermark: foolscap with five points (close to Heawood 1921–22). See watermark no. 33.
Signed with monogram in black chalk at lower right, *IL*. Inscribed on verso in graphite at lower left, *N° 112*; below this in pen and brown ink, *N 4144*; further below, in another hand (possibly Engelbert Michael Engelberts, 1773–1843), in graphite, *3[?]L: HS ao-KP*.

Lievens' drawings, for the most part, fall into two main categories: the many portraits executed in black chalk, usually of an oily consistency, and the even more numerous landscapes drawn with the pen in brown ink. As a portrait draughtsman of the first rank, he captured the character and mood of his sitters without seeming effort. Usually his subjects are men of parts delineated with little or no indication of accessories or setting. In addition to his fellow artists, Lievens portrayed various Dutch patricians and

distinguished men of science and letters, among them René Descartes, the French philosopher (Groningen Museum, Groningen; Hans Schneider and R. E. O. Ekkart, *Jan Lievens: Sein Leben und seine Werke*, 2nd ed., 1973, no. z.56), the poet and dramatist Joost van den Vondel (Teylers Museum, Haarlem, no. z.76), and Constantijn Huygens, the diplomat and poet (British Museum, London, no. z.60). Somewhat more than half of his sitters, however, remain anonymous.

We have no clue to the identity of the open-faced man of the Morgan portrait who posed in easy relaxation as he turned the full force of his intelligent, half-amused gaze on the artist; he is portrayed with a spontaneity and sympathy that possibly betokened a bond of friendship. In this and Lievens' other black chalk portraits, unlike his early works of the Leyden period, there is no trace of the influence of Rembrandt, his friend and senior by one year, but rather an allegiance to the style of Van Dyck whom he knew in Antwerp. Van Dyck drew Lievens' portrait sometime during the Dutch artist's extended sojourn in Antwerp (1635–43). While some of Lievens' chalk portraits were preparatory for etchings, others were apparently independent works as this one seems to be. Its free but decisive execution would suggest that it is a work of the artist's full maturity, possibly around 1645–50.

PROVENANCE: Jonkheer Johan Goll van Franckenstein the Younger (1756–1821; his *No. 4144* in brown ink on verso, Lugt 2987); Jonkheer Pieter Hendrik Goll van Franckenstein (1787–1832); his sale, Amsterdam, 1 July 1833, Album K, p. 44, one of two in lot 29 (to Engelberts for 5 florins); possibly Engelbert Michael Engelberts (1773–1843); Baroness de Conantré; Baroness de Ruble; Mme de Witte; Marquise de Bryas; Cailleux, Paris; Benjamin Sonnenberg, New York.

BIBLIOGRAPHY: Morgan Library, *Eighteenth Report to the Fellows, 1975–1977*, 1978, pp. 243, 273.

EXHIBITIONS: Poughkeepsie, Vassar College Art Museum and New York, Wildenstein and Co., Inc., *Centennial Loan Exhibition: Drawings & Watercolors from Alumnae and Their Families*, 1961, no. 49, repr.

Acc. no. 1976.49

Gift of Mr. Benjamin Sonnenberg

82. *Farm Buildings behind a Fence, and Cows*

Pen and brown ink on Japanese paper.
8¹⁵⁄₁₆ × 14¾ inches (226 × 376 mm.).
Watermark: none.
Inscribed on verso at lower left in pen and brown ink, *de Maas.*

Of the nearly four hundred fifty drawings by Lievens that are listed by Schneider and Ekkart, slightly more than three hundred are landscapes. By contrast only a few paintings of landscape subjects are known. Most of the landscape drawings like the two illustrated here are finished and complete works in themselves, skillfully and quickly rendered, usually without benefit of any preliminary guide lines. The present example is notable in the pristine state of its preservation, offering an opportunity to observe the fine, silky quality of the Japanese paper which Lievens often used for his landscapes. In this instance, he used the quill rather than the reed pen with which he frequently drew. There are replicas or copies of this drawing in the De Grez Collection, Brussels (De Grez catalogue, 1913, no. 2317; Schneider-Ekkart, 1973, no. z.-355 and supplement p. 374) and also, as Professor Sumowski reports, in Turin (Gianni Carlo Sciolla, *I disegni di maestri stranieri della Biblioteca Reale di Torino*, Turin, 1974, no. 68, fig. 70). Ekkart cited the Brussels drawing as the original, but the Morgan drawing has a better claim to primacy on the basis of quality. In connection with the inscription *de Maas* on the verso, Mr. van Hasselt in correspondence suggested that it may refer to the river Maas or to the Maasland so that it is at least possible that the drawing was made in that region.

PROVENANCE: Charles Fairfax Murray; J. Pierpont Morgan (no mark; see Lugt 1509).

BIBLIOGRAPHY: Hans Schneider, with Supplement by R. E. O. Ekkart, *Jan Lievens: Sein Leben und seine Werke*, 2nd ed., 1973, p. 247, no. 1, and p. 374 under no. z.355 ("perhaps a copy of the drawing in Brussels").

Acc. no. III, 186b

83. *Pollard Willows and Two Cows*

Pen and brown ink on Japanese paper; accidental spots of brown wash in sky.

9⅜ × 14¹⁵⁄₁₆ inches (234 × 380 mm.).

Watermark: none.

Inscribed on verso in graphite at upper left, *A. 1046*; at lower left, *G . . [?]* / *Lievens.*

Lievens very often drew trees disposed like a great screen across his composition, with glimpses into the distance here and there between the trunks. The irregular group of aged pollard willows he drew on this sheet must have attracted his attention by reason of the contrast between the decaying ruggedness of the old trunks and the airy delicacy of the feathery foliage that is suggestive of the newness of spring. The Library owns five other landscapes in addition to the two shown here. All are executed on the relatively large scale which Lievens seems to have preferred for his landscapes as opposed to the smaller format his friend Rembrandt ordinarily used.

PROVENANCE: Charles Fairfax Murray; J. Pierpont Morgan (no mark; see Lugt 1509).

BIBLIOGRAPHY: Hans Schneider, with Supplement by R. E. O. Ekkart, *Jan Lievens: Sein Leben und seine Werke*, 2nd ed., 1973, p. 247, no. 2.

Acc. no. III, 186c

Cornelis Saftleven

Gorinchem 1607 – 1681 Rotterdam

84. *A Young Man Seated on a Stool, Seen from Behind*

Black chalk and gray wash.

11⅝ × 7¹⁵⁄₁₆ inches (295 × 201 mm.).

Watermark: none.

Signed with initials and dated at lower right in black chalk, *CSL / 1643*. Numbered on verso in graphite, *XI B14.*

Highly productive as a draughtsman, Saftleven depicted a wide range of subjects, from religious scenes to witches' sabbaths and satire, to low-life genre episodes and animals. Among the largest categories of his drawings is the extensive series of single figure studies, executed in black, and occasionally red, chalk. For the most part these drawings represent men and boys; they are seen smoking, drinking, reading, taking aim with their guns, playing the trombone, the sackbut, or cello, or just standing or sitting at their ease like the youth of the present drawing. He, one could imagine, might have been a youth listening to the tales of his elders in an inn or ale house, one leg twisted behind the other in a position that could, like the stool on which he sits, be described as three-cornered. According to Schulz, the same youth occurs in the drawings in the Museum der Bildenden Künste, Leipzig, and in the Rhode Island School of Design, Providence (Schulz, 1978, pp. 90–91, 98, nos. 89, 123).

Most of these figure studies are dated, beginning with the 1620's and continuing into the decade of the 1670's; one of the latest and one of the few devoted to a female subject appears to be the *Old Woman with Her Dog* in the École des Beaux-Arts, Paris, dated 1677 (Lugt, *École hollandaise*, I, 1950, no. 541, pl. LXIX). It is appropriate that there should be a lengthy series of these figures in the Museum Boymans–van Beuningen since the artist lived in Rotterdam for a long time. These range in date from 1636 to 1664, and include the subject of a young man in a cape, holding his gloves in his left hand (no. 10), dated 1659, a more elegant type than the ordinary men Saftleven usually drew.

PROVENANCE: Carl Robert Rudolf (Lugt S.2811b); his sale, Amsterdam, Sotheby Mak van Waay B.V., part I, 18 April 1977, lot 107, repr.

BIBLIOGRAPHY: Terence Mullaly, "The Sale of the Rudolf Collection of Old Master Drawings," *Art at Auction: The Year at Sotheby Parke Bernet 1976–77*, New York, 1977, p. 72, repr.; Morgan Library, *Eighteenth Report to the Fellows, 1975–1977*, 1978, pp. 242, 291; Wolfgang Schulz, *Cornelis Saftleven*, Berlin–New York, 1978, pp. 63, 91, 94, no. 105, p. 98.

EXHIBITION: London, Arts Council Gallery, and elsewhere, *Old Master Drawings from the Collection of Mr. C. R. Rudolf*, 1962, no. 135.

Acc. no. 1977.16

Gift of the Fellows

Herman Saftleven

Rotterdam 1609 – 1685 Utrecht

85. *Distant View of a Town on a River*

Black chalk and brown wash.
9⅛ × 13½ inches (232 × 343 mm.).
Watermark: fleur-de-lis within a shield, surmounted by a crown (cf. Heawood 1745). See watermark no. 22.
Signed at lower right in black chalk with monogram, *HSL*, and dated *164*[*o*?].

The character of the landscape suggests that this drawing may have been made during the course of travels along the Rhine and its tributaries. The draughtsman looked down on the broad panorama of the river and the distant town from a considerable height, commanding a view of the inlets of the spreading stream and the far mountains along the horizon. His swift notational system verges on the abstract, especially in the indication of the town on the opposite side of the river and the boats, but in sketching the nearer buildings on the point of land in the center ground, he paused long enough to indicate the half-timbered structure and the circular contours of what must have been a plowed field in the left foreground. The use of black chalk in combination with wash, either brown or gray and sometimes both, is characteristic of the artist. If the date has been properly read as 1640, the sheet is among the earlier dated drawings of the artist.

PROVENANCE: Dr. G. L. Laporte (Lugt 1170); Julius Weitzner, New York; Felice Stampfle.

BIBLIOGRAPHY: Morgan Library, *Eighteenth Report to the Fellows, 1975–1977*, 1978, p. 291.

Acc. no. 1975.59

Gift of Miss Felice Stampfle

86. *Farm Landscape*

Black chalk, point of brush, brown and black washes; a few touches of white tempera left of center, on paper tinted light brown.
17⅝ × 14⁵⁄₁₆ inches (447 × 364 mm.).
Watermark: fleur-de-lis within a shield, surmounted by a crown, with cross below, and countermark, cross with letters *IHS* and *IR* below (cf. Heawood 1785–90). See watermark no. 28.

Inscribed by the artist in pen and brown ink at upper center, *tot Heeyem*, partly cut off; at lower right edge, traces of his monogram in black chalk, partly cut off; in another hand at lower center, in pen and brown ink, *H. Sachtleben*; on verso at lower left in graphite, *D. 30 fl.*

Although the artist inscribed the name of the region where he saw the rolling farmland he depicted in this large drawing, it has not been possible to identify it at this time. Was it in his own country or was it in Germany where he is known to have traveled? The only place name that could be located that bears even a remote resemblance to *Heeyem* is Heeten, which is near Raalte in the province of Overijssel. This province in the northeast of the Netherlands borders on Germany on the east, and is characterized by its sandy soil and rolling heathland. The character of the country in the drawing is perhaps to be compared to that in a painting of a farm and vineyard dated 1649, formerly in Dresden (repr. J. Nieuwstraten, "De ontwikkeling van Herman Saftlevens kunst tot 1650," *Nederlands Kunsthistorisch Jaarboek*, XVI, 1965, p. 107, fig. 34). The drawing appears to carry the remnants of Saftleven's monogram at the lower right, most of his initials having disappeared when the sheet was trimmed along its lower edge.

After the French edition of this catalogue appeared, Dr. Hans-Ulrich Beck suggested that the inscription on this drawing is to be read as *Heelsom*, noting that there are drawings by Saftleven in Leyden and in a private collection in Augsburg representing that site.

PROVENANCE: Sir Charles Greville (Lugt 549); George Guy, fourth Earl of Warwick (Lugt 2600); his sale, London, Christie's, 20–21 May 1896, lot 359; Charles Fairfax Murray; J. Pierpont Morgan (no mark; see Lugt 1509).

BIBLIOGRAPHY: Fairfax Murray, III, no. 188, repr.; Wolfgang Stechow in Thieme-Becker, XXXIX, 1935, p. 310.

Acc. no. III, 188

87. *View in Montfoort*

Black chalk with some light gray wash.
13⅝ × 11 9⁄16 inches (345 × 293 mm.).
Watermark: foolscap with seven points, and countermark, letters *PC* (similar to Heawood 1989–2008). See watermark no. 38.
Signed at lower center edge in pen and black ink with monogram, *HSL*, partly cut off. Inscribed by the artist in black chalk at upper center, *te montfoort*; on verso, in an old hand, in pen and brown ink, now faded, *No 60.*

Except for a sojourn in the Rhineland, most of Saftleven's long life was passed in Utrecht where he married in May 1633, and many of his drawings record views of the city and its environs executed over a wide range of time. The present drawing must have been a souvenir of an excursion to Monfoort, a town on the Hollandsche IJssel River eight miles west-southwest of Utrecht. Saftleven was paid for topographical views of Utrecht around 1647–48 and 1669 (Stechow in Thieme-Becker, 1935, XXIX, p. 310). Possibly this sheet is to be placed at the end of the forties or the beginning of the fifties, rather than later when Saftleven's style becomes more of a formula. A view of the same buildings from the opposite direction is represented in a drawing entitled *The Ruins of the Castle Montfoort* in the 1965 catalogue of Bernard Houthakker, Amsterdam, no. 59; it was later sold at Sotheby's, London, 13 December 1973, lot 118, repr. Both drawings must have been made at the same time.

PROVENANCE: P. & D. Colnaghi and Co., London.

BIBLIOGRAPHY: Morgan Library, *Ninth Report to the Fellows, 1958–1959*, 1959, p. 98; Morgan Library, *Review of Acquisitions 1949–1968*, 1969, p. 167.

EXHIBITION: London, P. & D. Colnaghi and Co., *Exhibition of Old Master Drawings*, 1953, no. 52.

Acc. no. 1958.19

Adriaen van Ostade

Haarlem 1610 – 1685 Haarlem

88. *Four Peasants Smoking and Drinking*

Pen and brown ink, light brown wash, over preliminary drawing in graphite. Some later hatching in graphite at left center. Upper and lower left corners repaired.
7½ × 6¼ inches (190 × 159 mm.).
Watermark: fleur-de-lis within a shield, surmounted by a crown (cf. Heawood 1721A). See watermark no. 23.
Signed and dated, in pen and brown ink, at lower right, *Av*(interlaced) *ostade / 1636*. Inscribed on verso, at upper margin, in pen and brown ink, *...–:g:.*

Ostade had been a member of the guild of painters in his native Haarlem for two years when he signed and dated this diverting tavern scene. 1636 was important for him personally as the year of his first marriage. The drawing appears to be among the earliest of the dated examples of his draughtsmanship. Another dated drawing from the same year, *Peasants Dancing*, is found in the Teylers Museum, Haarlem (repr. in the exhibition catalogue, Washington, D.C., National Gallery of Art, and elsewhere, *Dutch Drawings, Masterpieces of Five Centuries*, 1958–59, no. 88). In subject and mood, both still show the influence of Adriaen Brouwer, with whom Ostade is said by Houbraken to have been a pupil in the studio of Frans Hals (*De groote schouburgh*, I, 1718, pp. 320 and 347). Later, the rowdy tavern types of the present drawing give way to more respectable personages in quieter, domestic pursuits and pastimes like those pictured in the other drawings in the exhibition. The amiable rogue in the high peaked cap, standing, pipe in hand, at the right, recurs in somewhat different pose in another early drawing at Rotterdam (repr. in the exhibition catalogue *Dessins hollandais du siècle d'or*, 1961, pl. XII). The animation of the scene is paralleled by the lively work of the pen which knowingly sharpens the fugitive outlines of the preliminary sketch in graphite. A sign of the artist's developing mastery is seen in the hasty, but deft, indication of the string of onions on the wall which serves admirably to define the space between the figures and the wall.

In early reproductions of this drawing, including that in the Fairfax Murray catalogue, one notes broadly brushed washes, chiefly to the left and right of the figures; when and how these were removed is not known as the drawing has

117

been in the present state for at least thirty-five years. One assumes that Trautscholdt must have made use of an old photograph in his article in the Winkler *Festschrift* of 1959.

PROVENANCE: Charles Fairfax Murray; J. Pierpont Morgan (no mark; see Lugt 1509).

BIBLIOGRAPHY: Fairfax Murray, I, no. 126, repr.; Egbert Haverkamp-Begemann, "Een vroege tekening van Adriaen van Ostade," *Bulletin Museum Boymans*, II, April 1951, p. 11; Eduard Trautschold, "Über Adriaen van Ostade als Zeichner," *Festschrift Friedrich Winkler*, Hans Möhle, ed., Berlin, 1959, pp. 283–84, 286, fig. 2; Brussels, Bibliothèque Albert Ie, *Dessins hollandais du siècle d'or*, 1961, under no. 83; Schnackenburg, *Van Ostade*, 1971, no. 10.

EXHIBITION: New York Public Library, *Morgan Drawings*, 1919, n.p.

Acc. no. I, 126

89. *The Family*

Pen and brown ink, gray and brown washes, over black chalk.
6⅞ × 6⅟₁₆ inches (174 × 154 mm.).
Watermark: none visible through lining.
Inscribed in black chalk at lower left, *AV* (interlaced). *O.* Inscribed on verso of lining: in graphite, upper center, *95*; in pen and black ink, in the hand of J. C. Robinson, *Design for the etching Known as 'Le Père de famille' | From the Greffier Fagel's Collection | sold at (Christies* [crossed out]) *Phillips' | May 27 – 1807 | acquired* [?] *from Lord Palmerston's Colln | sold by Mr Evelyn Ashley at Christie's Apl 24 1891 | the collection (sold* [crossed out]) *formed by the second Viscount Palmerston | 1770–1801 | J. C. Robinson.*

Of the fifty etchings Ostade executed during the course of his long career, the earliest dated examples are three from the year 1647: *The Hurdy-Gurdy Player*, *The Barn*, and *The Family* (Bartsch [also Godefroy], nos. 8, 23, and 46). The Morgan drawing is the preparatory study for the last of these etchings. Unlike other studies for the etchings, it is executed in the same direction as the print, but there is no question as to its authenticity and the artist must have had to reverse his design in another step in the process of transferring it to the copperplate. Drawing and print have the same dimensions, and there are only the slightest differences between them.

In the etching, for example, there is the addition of a spoon to accompany the saucepan, and such details as the child's stocking, on the floor near the basket of linen at the woman's side, and the andiron are made more legible. The following year (1648) Ostade executed a smaller etching of a similar subject entitled *Le Père de famille* by Bartsch (no. 33) and *Le Père de famille donnant la bouillie à son enfant* by Louis Godefroy in his *catalogue raisonné* of Ostade's etchings (1930); there the *pater familias* is seated tending the child while the mother stands warming the infant's linen before the fire. The English collector Sir John Charles Robinson obviously confused the two etched subjects in his inscription on the verso of the present drawing although certainly "The Father of the Family" is a title applicable to both domestic scenes. Here the father, stooping somewhat under the burden of his chores, cuts a loaf of bread for the two older children while the mother cares for the baby, amid the extraordinary clutter of the household. Understandably, the woman's swift or wool winder has been temporarily shelved above the cupboard; behind the infant's basket-crib one sees a dolly leaning with its wheels exposed, against the bed. The steep staircase behind the man is of the type one sees only summarily suggested in Rembrandt's drawing *Woman Carrying a Child Downstairs* (No. 68).

A painting of the subject is listed by Hofstede de Groot (III, p. 294, no. 480) as last having been in the sale of the collection of the "Comte de M[ornay]," Paris, 24 May 1852, lot 15. The painting like the etching is dated 1647.

Information concerning the ownership of this drawing by the early Dutch collector Hendrik Fagel the Elder is owed to Dr. J. Heringa of Assen who is working on the Fagel collection. He reports that in the manuscript catalogue of the collection of Hendrik Fagel the Elder compiled by François Fagel the Younger (Fagel Archives, Ms. no. 172, Algemeen Rijksarchief, The Hague), Portfolio E is described as containing eight drawings by Ostade ("Agt Ostades"); in the Fagel sale, London, Phillips, 27 May 1807,

however, lots 53–55 together contained only five drawings by Ostade. Possibly the Morgan drawing was one of the three that left the collection before the 1807 sale.

PROVENANCE: Hendrik Fagel the Elder; Henry Temple, second Viscount Palmerston (1739–1802); Hon. Evelyn Ashley (by bequest from Lord Palmerston); sale, London, Christie's, 24 April 1891, lot 167; Sir John Charles Robinson (Lugt 1433); his sale ["Well-Known Amateur"], London, Christie's, 12–14 May 1902, lot 244; Charles Fairfax Murray; J. Pierpont Morgan (no mark; see Lugt 1509).

BIBLIOGRAPHY: Fairfax Murray, III, no. 195, repr.; Schnackenburg, *Van Ostade*, 1971, no. 46a.

EXHIBITIONS: London, Guildhall, 1895, p. 7, no. 32; New York Public Library, *Drawings for Prints and the Prints Themselves, 1933–34* (checklist by Frank Weitenkampf, in *Bulletin of the New York Public Library*, XXXVIII, no. 2, 1934, p. 101).

Acc. no. III, 195

90. *Strolling Violinist at an Ale House Door*

Pen and brown ink, watercolor in varying tints of green, gray, violet, blue, brown, red, etc., and some tempera (in faces).

13⅞ × 12³⁄₁₆ inches (350 × 308 mm.).

Watermark: Strassburg lily (cf. Churchill 427). See watermark no. 21.

Signed and dated in pen and brown ink at lower left, *Av.*(interlaced)*Ostade. 1673*. Inscribed on verso at lower left corner in pen and brown ink, *C J Nieuwenhuys 1840*.

As a draughtsman Ostade has several manners, the rough, vigorous pen style in which he sketched his first ideas and compositional studies (see No. 89, *The Family*), and the gentler combination of refined pen outlines and restrained watercolors he employed for the drawings he made and sold as independent works of art. These watercolors are mainly a product of his later years, notably the decade of the seventies. The elaborate Morgan drawing is a prime example of its kind. Frits Lugt in conversation once remarked of this drawing that it is one of the most beautiful of Ostade's watercolors and one of which Charles Fairfax Murray was very proud. Its distinguished provenance goes back to Jonas

Witsen, burgomaster of Amsterdam, and possibly even earlier to the Amsterdam silk manufacturer and collector Constantijn Sennepart (1625–1703), who owned a number of Ostade watercolors later acquired by the burgomaster as reported by Houbraken (*De groote schouburgh der Nederlantsche konstschilders en schilderessen . . .*, Amsterdam, 1718–21, I, p. 347). It was engraved in the first quarter of the nineteenth century by Ploos van Amstel and then by Josi who explains in his text that the color of the former's plate was unsatisfactory. A comparison of the drawing and Josi's plate shows that he, too, failed to achieve complete success. At the time it was engraved it was owned by Goll van Franckenstein the Younger and later described as "de aller beste kwaliteit" in the 1833 sale of his collection where it fetched one of the highest prices.

As was his frequent practice, Ostade translated the subject of this watercolor to oils. The painting now hangs in the Mauritshuis in The Hague (Hofstede de Groot, III, p. 271, no. 429; *Mauritshuis*, 1977, p. 173, no. 129, repr.). Not too much larger than the drawing (18 × 16½ inches, 450 × 420 mm.), it is signed and dated the same year (1673) as the drawing.

The popularity of Ostade's watercolors led to imitations by his contemporaries and successors, among them the various members of the Chalon family. A collection of 106 drawings by Christina Chalon (1748–1808), beginning with a drawing made at age five, is preserved in an album from the collection of J. van Buuren, now in the Morgan Library.

PROVENANCE: Burgomaster Jonas Witsen, Amsterdam (to C. Ploos van Amstel for 126 louis, according to Josi); Cornelis Ploos van Amstel Jb Czn (no mark; see Lugt 2034; the drawing of this subject which was lot 9 in his sale, Amsterdam, 3 March 1800, Album M, which was bought by Versteegh for 35 florins, is apparently a copy after the Morgan drawing); Jonkheer Johan Goll van Franckenstein the Younger (1756–1821; his *No. 3954* in brown ink on verso, Lugt 2987); Jonkheer Pieter Hendrik Goll van Franckenstein (1787–1832); his sale, Amsterdam, 1 July 1833, Album A, lot 2 (to Van Idsinga for 1515 florins according to Lugt 2987); I. van Idsinga (the drawing was not in the I. van Idsinga sale, Amster-

dam, 2–6 November 1840); C. J. Nieuwenhuys, Brussels, Belgium, and Oxford Lodge, Wimbledon, England; Robert Stayner Holford (Lugt 2243); his sale, London, Christie's, 11–14 July 1893, lot 655 (to Salting for £255); George Salting (no mark; see Lugt 2260–61); Charles Fairfax Murray; J. Pierpont Morgan (no mark; see Lugt 1509).

BIBLIOGRAPHY: C. Ploos van Amstel and C. Josi, *Collection d'imitations de dessins d'après les principaux maîtres hollandais et flamands . . .* , Amsterdam and London, 1821–27; Rudolph Weigel, *Die Werke der Maler in ihren Handzeichnungen*, Leipzig, 1865, p. 445, no. 5290; Fairfax Murray, I, no. 134, repr.; Schnackenburg, *Van Ostade*, 1971, no. 171; *Mauritshuis*, 1977, p. 173, under no. 129.

EXHIBITIONS: Hartford, *The Pierpont Morgan Treasures*, 1960, no. 78; Stockholm, *Morgan Library gästar Nationalmuseum*, 1970, no. 68.

Acc. no. I, 134

91. *Ale House Interior with Nine Peasants*

Pen and brown ink, brown wash, watercolor in varying tints of gray, green, blue, yellow, and pink.
9$\frac{15}{16}$ × 9$\frac{1}{4}$ inches (255 × 235 mm.).
Watermark: arms of Amsterdam (cf. Heawood 344; Churchill 10–11). See watermark no. 4.
Signed and dated in pen and brown ink at lower right, *Av.*(interlaced)*Ostade.1673.*

As in the case of the previous drawing, this convivial scene of peasants enjoying themselves at cards or tric-trac before the fire in a public house is also the subject of a painting by Ostade. The painting, recorded in 1786 in the sale of the Comte de Vismes, Paris (Hofstede de Groot, III, p. 357, no. 691), then later in the A. de Rothschild collection, and now the property of the National Trust, Ascott, is signed and dated 1674, a year later than the drawing. Although the painting, measuring 14$\frac{1}{4}$ × 13 inches, is larger than the drawing, they correspond with the exception of a very few details. These details, however, are found in a former Heseltine drawing acquired by the Library in 1961 (Acc. no. 1961.2). That signed but undated drawing, though completely realized in all its details and in color, is clearly a working draught executed on a sheet of paper that has been pieced together; in the roughness of the pen lines, it re-

tains the immediacy of the artist's first shaping of his ideas.

The relation of the two drawings is instructive, as is their relation to the Ascott painting; the former Heseltine sheet is clearly preliminary to both the present sheet and the painting. Between the two drawings, a number of changes are to be remarked. In general, one sees that Ostade worked towards a clarification of the space, a lightening of the coloration, and an ordering, sometimes an elimination, of details. More obviously, he altered the verticality of the format for the more nearly square shape of the present drawing and eventually of the painting. In its first incarnation the more or less central figure, with the dog at his side, does not face the spectator and wears instead of his round cap a broad-brimmed hat that conceals his countenance; the change of the chamois color of his shirt to the pronounced pink seen here further enhances his prominence, and the spotting of the same rosy tint in the clay pot, the hose of the man standing by the fire, and the shirt and cap of the man standing at the window mark the progression of the composition into depth; a similar purpose is served by the change of the position of the spectator of the tric-trac game in the background so that he sits behind the bench rather than upon it, and his former place is taken by a jug, a small change which further strengthens the spatial differentiation. Missing here are details like the playing card on the floor and the ewer suspended by its handle from the wall shelf but their presence in the Heseltine drawing and the painting indicates that Ostade referred to both drawings when he executed the painting. Aside from its genre detail and the delicate counterplay of Ostade's watercolor tints, it is his skillful handling of the effect of pale sunlight filtering through the leaded panes of the window above the heads of the tric-trac players that gives this drawing its charm. A painting on panel (17$\frac{1}{4}$ × 14 inches) called *Inn Interior* and assigned to Cornelis Dusart (formerly in the collection of Lord Ellesmere, Bridgewater House) is a copy of this composition (Witt

Library photograph). A rough sketch of the scene was sold in the Peltzer sale, at Gutekunst, Stuttgart, 13–14 May 1914, lot 276, repr.

PROVENANCE: C. J. Nieuwenhuys, Brussels, Belgium, and Oxford Lodge, Wimbledon, England; his sale, London, Christie's, 15 July 1887, lot 30 (sold with lots 31 and 32 for £10.12); Charles Fairfax Murray; J. Pierpont Morgan (no mark; see Lugt 1509).

BIBLIOGRAPHY: Fairfax Murray, I, no. 133, repr.; Schnackenburg, *Van Ostade*, 1971, no. 184.

EXHIBITIONS: Minneapolis, Minneapolis Institute of Arts, *Watercolors by the Old Masters*, 1952, no. 17; Morgan Library and elsewhere, *Treasures from the Pierpont Morgan Library*, 1957, no. 97.

Acc. no. I, 133

Leendert van der Cooghen

Haarlem 1632 – 1681 Haarlem

92. *Standing Man in a Cloak*

Black chalk, heightened with white chalk, on brown paper.
14 × 8¾ inches (355 × 222 mm.).
Watermark: none.
Dated in black chalk at lower center, *1656*.

As a member of a patrician family and a man of means, Van der Cooghen practiced his art chiefly for his own pleasure. He studied under Jordaens at Antwerp and had been a member of the painters' guild of Haarlem for four years when he produced the present drawing. A strong, well-modeled study after life, it is a good example of his capability as a draughtsman. For the most part, he limited himself to the representation of single figures and studies of heads, very often of serious, contemplative mien. There are a number of these heads in the Rijksprentenkabinet, mostly dated in the 1650's. A black and red chalk drawing in the collection of Gatacre de Stuers of Vorden, also representing a single standing figure, described as an Israelite in his prayer shawl, seen from the back, is dated the same year as the Morgan sheet (D. Hannema, *Oude tekeningen uit der verzameling Victor de Stuers*, Almelo, 1961, no. 46, fig. 13). Josi writing in *Collection d'imitations de dessins . . .*, I, 1821, under Visscher, footnote 1, reported that

such figures sold for "5 à 10 louis" depending on the interest of the subject; he further commented somewhat gratuitously, "Van der Koogen avait des moeurs fort sages; il vécut dans le célibat jusqu'à sa mort." The portrait of the gifted Haarlem amateur was apparently painted by his famous fellow townsman Frans Hals, but the portrait has not been traced. (See Seymour Slive, *Frans Hals*, London, 1974, III, under no. 164.) Older dictionaries cite 1610 as Van der Cooghen's birth date, but he is now known to have been born on 9 May 1632 (C. A. van Hees, "Nadere gegevens omtrent de Haarlemse vrienden Leendert van der Cooghen en Cornelis Bega," *Oud Holland*, LXXI, 1956, pp. 243–44).

PROVENANCE: Justus Hiddes Halbertsma (Lugt 1473); Dr. J. A. van Dongen; R.M. Light & Co., Boston.

BIBLIOGRAPHY: Morgan Library, *Seventeenth Report to the Fellows, 1972–1974*, 1976, p. 158.

Acc. no. 1974.6

Purchased as the gift of Mr. Benjamin Sonnenberg

Anthonie Waterloo

Lille c. 1610 – 1690 Utrecht

93. *Woodland Scene with a Duck Hunter*

Black chalk, point of brush, and black and gray washes.
16⅟₁₆ × 25⅛ (408 × 640 mm.).
Watermark: none visible through lining.
Inscribed in pen and black ink on verso of lining at lower left, *Coll. J. Werneck Frankfurt a M.*

Probably self-taught, Waterloo was primarily a draughtsman and etcher rather than a painter. He was also in the art trade. Born in Lille, he lived in Utrecht, Amsterdam, and Leeuwarden when he was not traveling in Germany and Belgium. His inspiration for the present landscape, if not the rolling country of eastern Holland, was perhaps the forests near Brussels, but more specifically it was the great dying oak tree that supplied the impetus for this large-scale composition. The aged forest giant, riven and deformed by a monstrous growth, imparts an almost surrealist quality to the otherwise tranquil vista, and this effect is underscored by the mi-

nute scale of the hunter and fisherman moving unconcernedly amid the grandeur of the woodland. The anthropomorphic burl, growing out of the heart of the tree like some uncomely dryad, compels comparison with certain of the forms of twentieth-century sculpture. Waterloo, in other instances, drew trees deformed and ravaged by time and weather; compare, for example, the *Leaning Tree* in the British Museum (Hind, *Dutch Drawings*, IV, 1931, p. 104, no. 9, pl. LXI) or the *Tree Trunk and Roots* from the collection of Gustav Grünewald (sale, London, Sotheby's, 22 November 1974, lot 59). The Morgan drawing is notable for the variety and freshness with which the artist indicates the different kinds of foliage and vegetation, as well as the manner in which he suggests the subdued northern sunlight. The atmospheric softness and the full perfection of the foliage of the trees surrounding the dominant oak bespeak a landscape of spring or early summer.

PROVENANCE: J. Werneck (Lugt 2561); possibly sale, M.-A. J. van Eyndhoven and J. Werneck, Amsterdam, Frederik Muller & Co., 23–25 June 1885, lot 327, "A. Waterloo. Vue d'une forêt. Dessin capital à la pierre noire et à l'encre de Chine.—H. 44 L. 64 cent." (to Amsler and Ruthardt, Berlin, for 10 florins); C. G. Boerner, Düsseldorf; W. von Wenz; R. M. Light & Co., Boston.

BIBLIOGRAPHY: C. G. Boerner, *Handzeichnungen alter und neuerer Meister—Neue Lagerliste Nr. 34*, 1962, no. 187, repr.; Morgan Library, *Fourteenth Report to the Fellows, 1965–1966*, 1967, pp. 118–19; Morgan Library, *Review of Acquisitions 1949–1968*, 1969, p. 176.

Acc. no. 1964.5

Purchased as the gift of Miss Alice Tully

Jan Asselijn

Dieppe before 1615 – 1652 Amsterdam

94. *Aqueduct at Frascati*

Brush, gray and black washes, over preliminary indications in graphite; outlines incised with the stylus for transfer.
7⅜ × 10 inches (187 × 255 mm.).
Watermark: grapes (cf. Heawood 2099). See watermark no. 39.
Inscribed in an old hand, in pen and brown ink, on slip

of paper pasted on verso at upper left, *Vestiges des acqueducs de Frescati*; in graphite, at lower left, *AN*, and *Nº 844*; and at lower right, in an eighteenth-century hand, *Asselyn*.

Asselijn, one of the second generation of Italianate Dutch landscape painters, was active in Rome for a period of some four or five years, possibly longer, before he returned to Holland about 1645. A member of the Bentvueghels, he was known as Crabbetje (Little Crab) because of a deformed hand, though this is not obvious in the portrait Rembrandt etched of him after his return from Italy (Bartsch, no. 277). Witness to his diligence in recording the ruins of Roman antiquity—very likely on commission—is a sequence of eighteen etchings executed by the French engraver Gabriel Perelle (c. 1603–1677; Hollstein, I, p. 44, nos. 15–32) after Asselijn's designs. The Morgan drawing, a tranquil scene whose sober range of black and gray could easily be translated into a print, is the preparatory design, in the reverse, for the etching bearing the legend "Vestiges des Arcades ou Acqueducs de Friscati (vilage proche de Rome) qui emmenoient l'eau au Palais d'Auguste." The print, which measures 7⁵⁄₁₆ × 9⅞ inches (186 × 256 mm.), is faithful to the drawing down to the slightest detail. As far back as the Van Eyl Sluyter sale in 1814, the Morgan drawing was accompanied by the *Temple of Marcus Curtius*, another of Asselijn's preparatory drawings for the Perelle series; the two drawings were separated in 1969 after their acquisition by Colnaghi's when the Print Room of the Rijksmuseum acquired the *Temple of Marcus Curtius* and the Library, the present sheet. There are other drawings for the Perelle etchings in various European collections. They are listed here under the titles of the prints: *Veue du Tivoli avec le Temple de la Sibilla Tiburtine*, Gabinetto Nazionale delle Stampe, Rome; *Porte St. Paul* and *Pont des Sabines*, Museum Boymans-van Beuningen, Rotterdam; *Veue du Colisée*, Windsor Castle; *Colisée ou Amphithéâtre de Marcellus*, De Grez Collection, Musées Royaux des Beaux-Arts de Belgique, Brussels; and *Ruyne du Colisée* and *Une Fontaine proche de Loretto*, Teylers Museum, Haarlem.

PROVENANCE: Hendrik van Eyl Sluyter; his sale, Amsterdam, Van der Schley–De Vries, 26 September 1814, Album F, one of two (the other, *Temple of Marcus Curtius*, now Rijksprentenkabinet, Amsterdam, Inv. no. 1969:14) in lot 25 (to De Vries for 256 florins); Prestel(?) (according to catalogue record of Rijksprentenkabinet, Inv. no. 1969.14); Hendrick van Cranenburgh; his sale, Amsterdam, Roos-Engelberts, 26 October 1858, with the *Temple of Marcus Curtius* in lot 158 (to Gruyter for 31 florins); W. Pitcairn Knowles (Lugt 2643); his sale, Amsterdam, Frederik Muller & Co., 25–26 June 1895, lot 12 (sold with lot 13, *Temple of Marcus Curtius*, to Frederik Muller & Co. for 42 florins); Vischer Burckhardt, Basle (according to annotated copy of Pitcairn Knowles catalogue at R.K.D. and catalogue record of Rijksprentenkabinet, Inv. no. 1969:14); sale, Anton W. M. Mensing, Amsterdam, Frederik Muller & Co., 27–29 April 1937, lot 8 (to Van de Mandele for 40 florins); W. van de Mandele; Mrs. A. C. R. van de Mandele–Vermeer, Bloemendaal; her sale, Amsterdam, Mak van Waay, 18 December 1968, lot 238b (to Colnaghi together with lot 238a for 2,350 florins).

BIBLIOGRAPHY: Morgan Library, *Sixteenth Report to the Fellows, 1969–1971*, 1973, p. 108.

EXHIBITION: London, P. & D. Colnaghi, *Exhibition of Old Master and English Drawings*, 1969, no. 33.

Acc. no. 1969.8

Purchased as the gift of the Earl of Crawford and Balcarres

Thomas Wijck

Beverwijk 1616 – 1677 Haarlem

95. *View of an Italian Courtyard with Stairway on the Right*

Pen and brown ink, gray and brown washes, over preliminary indications in black chalk and graphite.
11⅞ × 15¹¹⁄₁₆ inches (302 × 399 mm.).
Watermark: arms of Basle. See watermark no. 6.
Number and code of dealer or collector inscribed in pencil on verso.

Wijck was another of the Dutch painters who traveled to Italy. Sunlit courtyards like the one seen here often attracted his eye, and some of the drawings he made of them were used for the setting of his etchings as well (see Hind, *Dutch Drawings*, 1931, IV, p. 117, no. 3). The Morgan drawing accurately records an actual rustic courtyard with its stone water trough, the windlass of the cistern or well, and beyond that probably a bake oven; the draughtsman, moreover, did not overlook the shrine and lamp on the wall of the stairway and the flower pots and trellis at its summit. Although this drawing was apparently not used for one of Wijck's etchings, it served as the basis for a somewhat smaller but more elaborate composition in the Rijksmuseum (Inv. no. A.1543; 154 × 234 mm.), no doubt worked up in the studio. In that drawing he extended the arch of which only the left portion is seen in a repoussoir effect in the Morgan drawing, and represented a lantern hanging from a pulley in the center, thereby anticipating similar effects in the work of Canaletto. He "furnished" the courtyard, as it were, with such various household appurtenances as barrels, buckets, shelves, and jugs, and also in the left foreground represented a man filling a vessel at a wellhead. At the center, he added a typically Dutch note in the motif of a figure leaning over the lower half of what is obviously a "Dutch door," where in the Morgan scene there is only an empty doorway. The Morgan and Amsterdam drawings provided points of departure for several paintings, one formerly with W. E. Duits, London (*Burlington Magazine*, LXXXVIII, no. 523, 1946, p. ii) and one in a sale in Berlin, R. Lepke, 29 October 1929, lot 96, pl. 11.

Towards the end of his career, Wijck traveled to England in the company of his son Jan, a painter chiefly of battle and hunting scenes, a number of whose drawings are in the Library.

PROVENANCE: Henry Temple, second Viscount Palmerston (1739–1802); Hon. Evelyn Ashley (by bequest from Lord Palmerston); possibly his sale, London, Christie's, 24 April 1891, part of lot 153, "Landscapes, by John Wyck; etc. 4."; Bernard Houthakker, Amsterdam.

BIBLIOGRAPHY: Morgan Library, *Twelfth Report to the Fellows, 1962*, 1963, p. 78; Morgan Library, *Review of Acquisitions 1949–1968*, 1969, p. 177.

EXHIBITIONS: Amsterdam, Bernard Houthakker, *Dessins*, 1954, no. 63; Ann Arbor, Michigan, *Italy through Dutch Eyes*, 1964, no. 70, pl. xx; Washington, D.C., and elsewhere, *Seventeenth Century Dutch Drawings*, 1977, no. 51, repr.

Acc. no. 1961.38

Gift of the Fellows

Philips Koninck

Amsterdam 1619 – 1688 Amsterdam

96. *The Visitation*

Luke 1:36–56

Pen and brown ink, gray wash, on light brown paper.
10⁷⁄₁₆ × 8 inches (265 × 203 mm.).
Watermark: fragment of foolscap with six points, visible through lining. See watermark no. 37.
Inscribed in pen and brown ink at lower left, *Rembrant*.

This is a thoroughly characteristic example of the artist's style, distinguished by its swift, if not scrawling, line and its patches of diagonal cross-hatching coupled with a certain ambiguity of spatial definition. The figure types, the faces in particular, are dependent on Rembrandt whom Koninck probably knew, perhaps in the capacity of the master's pupil as reported by Houbraken. The faces of Elizabeth and Mary are more genuinely expressive of the emotion of the event than is sometimes the case with Koninck. The Morgan sheet is to be grouped stylistically with such other religious drawings as the *Dismissal of Hagar* formerly in the collection of Friedrich August II, Dresden (Gerson, no. z.116, pl. 59) and the *St. Peter* formerly in the collection of Hofstede de Groot, The Hague (Gerson, no. z.217, pl. 52; sale, Berlin, G. Bassenge, 26–30 April 1977, lot 163, repr.). Gerson assigned the drawing to the mid-forties; Haverkamp-Begemann and Logan in the Chicago exhibition catalogue, more plausibly to the second half of the fifties, the period with which Gerson himself associated the *St. Peter* which is so similar to the Morgan figures. The small sketch of a man in broad-brimmed hat in the area of the lower half of the door jamb was obviously on the sheet before Koninck used it again for the representation of the Visitation; the figure was not, as Gerson stated, added by the later hand that inscribed the drawing at the lower left since the long vertical line defining the post to the right of the portly figure of Zacharias clearly overlies the tiny sketch.

PROVENANCE: Charles Fairfax Murray; J. Pierpont Morgan (no mark; see Lugt 1509).

BIBLIOGRAPHY: Gerson, *Koninck*, 1936, p. 76, no. z. 140, pl. 56.

EXHIBITIONS: Chicago, *Rembrandt after Three Hundred Years*, 1969, no. 186, repr.; Washington, D.C., and elsewhere, *Seventeenth Century Dutch Drawings*, 1977, no. 52, repr.

Acc. no. I, 213a

97. *A Fiddler and a Masquerader*

Pen and brown ink, brown wash, corrected in white.
7¼ × 5⅜ inches (184 × 137 mm.).
Watermark: none.
Inscribed in pen and brown ink at lower left margin, almost completely cut off, *P. Koninck*; possibly signed by the artist on verso, at lower right margin, also partially trimmed, *P Konin. . . .* Inscribed on old mount in pen and brown ink, in center, *W 36*; at upper left, *458*; and at upper right, *6N / L17*.

In contrast to the hasty compositional pen study of the *Visitation* (No. 96), this diverting sheet shows Koninck's more pictorial style for a relatively finished work. The jovial fiddler and the amusingly grotesque masker, wearing a high hat and holding a broom[?], perhaps have reference to the pre-Lenten carnival season of merrymaking and revelry beginning on Epiphany (6 January). Both figures would be at home in Koninck's painting of 1654, the rustic bacchanal in the Bredius Museum, The Hague (Gerson, no. 147, pl. 21; Albert Blankert, *Museum Bredius: Catalogus van de schilderijen en tekeningen*, The Hague, 1978, p. 75, no. 88, repr.). A similar figure of a fiddler, somewhat differently posed, occurs in a signed and dated (1649) painting by Koninck, *Peasants Merrymaking in an Interior*, sold at Christie's, London, on 27 June 1975, lot 98. There the fiddler wears a different hat, but face and expression are unmistakably the same. Gerson dated the Morgan drawing in the decade of the sixties on the basis of its presumed stylistic affinity with the *Three Nuns*, a signed and dated sheet of 1662, in the Teylers Museum, Haarlem. In view of the appearance of the fiddler in the painting sold in 1975, the drawing should perhaps be dated somewhat earlier. When Fairfax Murray acquired the drawing in 1891, he wrote in his notebook, "a drawing of

124

fine quality, inscribed at back *P. Koning* in writing of the time(?)." His assessment of the drawing still stands and the inscribed name of the artist on the verso is certainly of the time and almost surely a signature. The signed drawing of a fiddler in the Albertina, Vienna (Bernt, I, no. 345), may have been that in the Amsterdam sale of Dionis Muilman, 29 March 1773, Album Q, p. 197, lot 1265, "Een Boertje, zittende op een viol te speelen. . . ."

PROVENANCE: George Knapton; General George Morrison (by bequest from Knapton); Knapton-Morrison sale, London, T. Philipe, 25 May – 3 June 1807, one of two in lot 458 (to Miss Georgina Morrison for £1.50, according to her own notations in the copy of the sale catalogue at Colnaghi's); Georgina Morrison; Sir Joseph Hawley; possibly sale, M. de Salicis . . . and property of a Baronet [Sir Henry Hawley], London, Christie's, 16 July 1891, one of two in lot 200; Charles Fairfax Murray; J. Pierpont Morgan (no mark; see Lugt 1509).

BIBLIOGRAPHY: Fairfax Murray, I, no. 213, repr.; Lugt, *École hollandaise, Louvre*, III, 1933, p. 61, under no. 1319; Gerson, *Koninck*, 1936, p. 79, no. z.263, pl. 42; Richard Lewis, *In Praise of Music*, New York, 1963, p. 114.

EXHIBITION: Raleigh, North Carolina, North Carolina Museum of Art, *Rembrandt and His Pupils*, catalogue by W. R. Valentiner, 1956, no. 57.

Acc. no. I, 213

98. *View of the Buitenhof at The Hague*

Pen and brown ink, brown wash. Diagonal crease at upper center.
4¹¹⁄₁₆ × 11¼ inches (119 × 285 mm.).
Watermark: illegible fragment. See watermark no. 55.
Inscribed variously on verso, at lower center, in a contemporary hand, perhaps that of the artist, in pen and brown ink, *den 7 martij 1660*; at lower left in graphite, *A.S.*[?] / 7; below that, in another hand, *273*; in pen and black ink, the signature *J. C. Robinson*, written over inscription in graphite, *Het Hof te 's Gravenhage*.

Considerable interest attaches to this drawing topographically since it depicts the Buitenhof in The Hague, the outer court or open space before the western section of the irregular pile of buildings that in earlier times constituted the palace of the Counts of Holland. At the time the drawing was made the section of the building adjoining the square tower was known as the Stadtholders' Quarter, having been con-

structed in 1620–21 for Stadtholder Prince Maurits of Orange (1567–1625); the tower itself was built between 1568 and 1598. The site today still retains much of the same character and the complex is used for government purposes. Visitors and government workers today enter the Binnenhof or inner court through the same archway as that seen in the drawing to the left of the single tree by the crenellated wall; street cars now run in the area where the draughtsman saw fowls scratching. The trees at the far left border the ornamental rectangular lake, the Vijver, as do their twentieth-century successors, providing a pleasant walk for students of Dutch art today using the Rijksbureau voor Kunsthistorische Documentatie (R.K.D.), which is housed in the building at the far end of the Vijver that appears in the drawing as the white house to the rear and at the left of the square tower. It was built in 1634–36 by Arent Arentsz. Gravesande, pupil of Jacob van Campen, to serve as a meeting place for the members of the Militia Company of St. Sebastian. At the beginning of the present century it housed the Gemeentemuseum. (For earlier and more detailed views of this historic site by Buytewech, see Haverkamp-Begemann's monograph [no. 116, pl. 94] and the catalogue of the Buytewech exhibition at Rotterdam and Paris, 1974–75, nos. 104–05, pls. 116–17. Thanks are also due to Professor Haverkamp-Begemann for his assistance in the identification of the buildings in the present drawing.)

Because of the distinctive nature of the subject, it is possible to trace this drawing's progress through a long sequence of collections beginning with an anonymous Amsterdam sale in 1772. The attribution of the drawing has fluctuated between Philips Koninck and Rembrandt although the earliest reference that has been traced, the 1772 sale, ascribed it to Koninck working in the manner of Rembrandt. The possibility of Rembrandt's authorship was properly discarded after the middle of the nineteenth century. It was apparently Fairfax Murray who introduced the name of Jacob Koninck, the

125

older brother and teacher of Philips, but this was rejected by Byam Shaw and later by Gerson in his monograph in favor of Philips. More recently scholars have tended to discount the traditional attribution to Philips Koninck but it seems advisable to retain the drawing under his name until further light is shed on the individual style of the Rembrandt pupils and followers, for example, on that of Abraham Furnerius, who was Philips' brother-in-law.

PROVENANCE: Anonymous sale, Amsterdam, 20–28 January 1772, lot 555, "Gezigt van 't Buitenhof in 's Hage, met Roed gewassen, door Koning, in de manier van Rembrand" (to Busserus, with lot 556, for 0.10 florins, according to Gerson); Hendrik Busserus; his sale, Amsterdam, 21 October 1782, Album 11, p. 76, lot 686, "Gezigt van het Buitenhof in 's Hage, met Roet geteekent, door Rembrandt" (4 florins); Abraham Saportas, sale, Amsterdam, 14 May 1832, Album A, lot 37 (according to Gerson); sale, Gérard Leembruggen Jz., Amsterdam, 5 March 1866, lot 335 (as Philip de Koningh), "La résidence des Princes d'Orange à la Haye: à la plume et au bistre. Coll. Muller." (to De Vos for 21 florins); Jacob de Vos Jbzn (Lugt 1450); his sale, Amsterdam, 22–24 May 1883, lot 273 (as Philippe de Koning), "Vue de la cour extérieur ('Buitenhof') à La Haye. Dessin remarquable nous conservant quelques particularités des édifices de la Cour Intérieur [sic], que nous n'avons pas rencontrées ailleurs. Au revers, la date du dessin: Den 7 Martii 1660" (to Thibaudeau for 170 florins); Sir Francis Seymour Haden (Lugt 1227); his sale, London, Sotheby's, 15–19 June 1891, lot 563 (as Ph. de Koning.), "View of the 'Buitenhof' at The Hague, bistre washed, dated at the back, 17 [sic] March 1660. From the De Vos collection" (to Sir John Charles Robinson for £6); Sir John Charles Robinson (signature on verso; see Lugt 1433); Charles Fairfax Murray; J. Pierpont Morgan (no mark; see Lugt 1509).

BIBLIOGRAPHY: Fairfax Murray, I, no. 210, repr. (as Jakob Koninck); J. Byam Shaw, "Philips Koninck (1619–1688)," *Old Master Drawings*, V, September 1930, p. 41; Gerson, *Koninck*, 1936, pp. 65 and 145, no. z.70.

Acc. no. I, 210

Nicolaes Berchem

Haarlem 1620 – 1683 Amsterdam

99. *View of a River with Distant Mountains*

Black chalk and gray wash.
5⅛ × 7½ inches (148 × 190 mm.).
Watermark: fragment of foolscap with four (?) points (similar to Heawood 1921–2087). See watermark no. 31.

Signed and dated in black chalk at upper right, *CPB* (interlaced)*erghem f.* / *1654*; inscribed on verso in graphite and black ink, *No. 102*, similar but not identical to Goll van Franckenstein numbers; see Lugt 2987.

One of the best known and most productive of the Italianate Dutch landscapists of the seventeenth century, Berchem was active for a period of more than forty years. Paintings and drawings are both numerous, the former numbering more than eight hundred fifty, the latter some five hundred. Although no sojourn in Italy can be documented, he almost certainly visited there, if not in the early forties in the company of his cousin Jan Baptist Weenix, then probably in the early fifties. The panoramic landscape encompassed within the narrow confines of this small drawing was perhaps inspired by scenery that the artist could have seen along a great river like the Rhône, on a journey to or from the south. In its firm, fresh chalk work and the fine modulation of values in the wash, it shows the draughtsman at his best. In mood as well as in the character of the landscape, it may be compared with the painting, signed and dated 1652, in Buckingham Palace, London (Inv. no. 137; Bernt, *Maler*, 1948, no. 67, repr.), or to the painting in the Wallace Collection, London (Hofstede de Groot, IX, no. 498), which is signed and dated the same year as the Morgan drawing. A painting at Chatsworth (Hofstede de Groot, IX, no. 134) is also comparable although it is dated much later by Eckhard Schaar (*Studien zu Berchem*, dissertation, Cologne, 1958, p. 99, c. 1670–80).

PROVENANCE: Charles Fairfax Murray; J. Pierpont Morgan (no mark; see Lugt 1509).

BIBLIOGRAPHY: Von Sick, *Berchem*, 1930, p. 56, no. 79.

EXHIBITIONS: Morgan Library, *Landscape Drawings*, 1953, no. 73; Ann Arbor, Michigan, *Italy through Dutch Eyes*, 1964, no. 8, pl. XVII.

Acc. no. I, 137a

100. *Pack Mules Descending a Mountain Road*

Black chalk and touches of an oily black chalk.
11⅛ × 18⅛ inches (283 × 459 mm.).
Watermark: none.

Signed in black chalk at lower right, *CPB*(interlaced) *erchem f.*

Freely executed in two kinds of black chalk, this landscape displays the deft, light touch that is characteristic of Berchem's draughtsmanship. One notes that when the artist signed the drawing, he spelled his name "Berchem" rather than "Berghem" as he was wont to do in his earlier periods, as witness the signature of the previous drawing. It has been observed that the signature with the "ch" seems to predominate after the mid-point of the 1650's. (See Wolfgang Stechow, "Über das Verhältnis zwischen Signatur und Chronologie bei einigen holländischen Künstlern des 17. Jahrhunderts," *Festschrift Dr. L. C. Eduard Trautscholdt*, Hamburg, 1965, pp. 113–15.) It is probably reasonable to assume that the present drawing was made in the later fifties. The scene mirrors the kind of Alpine landscape with its boulders and spruce trees that the artist must have encountered in the course of his journey to Italy. No doubt, he would have traveled much in the same fashion as the two wayfarers and their well-laden mules which he drew here.

The mountainous terrain and especially the waterfall of the vista on the right of the drawing bring to mind the rocky landscape with a ring of four cascades represented in the drawing from the Koenigs collection in the Boymans–van Beuningen Museum, Rotterdam (Inv. no. H.79). It, too, is executed in two kinds of black chalk on a sheet of comparable scale (282 × 440 mm.), and it likewise was once in the Jacob de Vos collection. The Rotterdam sheet surely records an actual picturesque watering spot for herdsmen and their flocks, gathered on the edge of the pool at the base of the four falls, and the Morgan drawing also suggests the immediacy of observed reality. If Berchem did not see in nature what he depicts here, he skillfully created the illusion of reality from a mélange of images stored in memory. Two drawings in the British Museum also reflect similar mountainous country with spruce trees, rocks, and streams (Hind, *Dutch Drawings*, 1926, III, pp. 30–31, nos. 20–21). It is not impossible that the Rot-

terdam and Morgan sheets were drawn at the same time and in the same region. A mule train on a mountain road is also represented in an elaborately worked drawing in the Cleveland Museum (Ann Arbor, Michigan, *Italy through Dutch Eyes*, 1964, no. 7, repr.), and in the painting signed and dated 1658 in the National Gallery, London (MacLaren, *The Dutch School*, Plates, 1958, p. 18, Text, 1960, no. 1004).

PROVENANCE: Jacob de Vos (1735–1831; no mark; see under Lugt 1450); his sale, Amsterdam, 30 October 1833, Album P, lot 5, "Nicolaas Berghem /S. Eenige Landlieden op en bij beladen e zels. Luchtig en meesterlijk met zw. krijt geschetst" (to De Vries for 60 florins for Jacob de Vos Jbzn); Jacob de Vos Jbzn (Lugt 1450); his sale, Amsterdam, Roos, Muller . . . , 22–24 May 1883, probably one of three in lot 46, "Pâtres avec leurs troupeaux" (to Thibaudeau for 120 florins), or one of five in lot 47, "croquis divers" (to Amsler and Ruthardt for 30 florins); George Salting (according to Fairfax Murray; no mark; see Lugt 2260–61); Charles Fairfax Murray; J. Pierpont Morgan (no mark; see Lugt 1509).

BIBLIOGRAPHY: Fairfax Murray, III, no. 207, repr.; Von Sick, *Berchem*, 1930, p. 58, no. 130.

Acc. no. III, 207

101. *Shoeing the Mule*

Pen and brown ink, brown wash, over preliminary indications in black chalk; outlines incised with the stylus for transfer.
11 3⁄16 × 15 3⁄8 inches (284 × 390 mm.).
Watermark: foolscap with seven points (cf. Heawood 1996–2020). See watermark no. 36.
Signed and dated in brown ink at lower left margin, *Berchem fec 1657*. Inscribed on verso, in pen and brown ink, *C J Nieuwenhuys 1840*.

Berchem himself produced almost sixty etchings, but enormous numbers of his drawings and paintings were reproduced in prints by others. The finished Morgan drawing is a preparatory design, in the reverse, for one of a series of four prints etched by Jan de Visscher (c. 1636 – c. 1692) under the title *Diversa animalia Quadrupedia* (Hollstein, I, p. 279, nos. 374a–77). Two other drawings for the series are known, that for the title page in the Dutuit Collection, Paris (Lugt,

1927, p. 11, no. 6, repr.), and the one for the *Shepherd Driving His Flock* in the Petschek collection, New York (Bernt, *Zeichner*, I, no. 54, repr.). The drawing for the fourth print representing a woman drying the wash has not been located to date. The three known drawings are all carefully washed compositions in the same horizontal format with brilliant light effects and all are dated 1657. The four-footed animals represented are not too diverse, being limited to donkeys, cattle, sheep, and dogs. The muleteer with his broad-brimmed hat figures in all three drawings. The donkey at the right of the Morgan drawing, heavily burdened with two paniers and a bundle on its back, is equipped with feeding bag and large round blinkers as well as an ornamental whisk between the ears to ward off flies. It has been noted that Berchem repeated the central triangular group of figures in the drawing with very little change in a painting of the following year, the *Mountainous Landscape with Muleteers* in the National Gallery, London (MacLaren, *The Dutch School*, Plates, 1958, p. 18; Text, 1960, p. 22, no. 1004).

PROVENANCE: Valerius Röver, Delft (his number *23/48* in graphite on verso; the drawing occurs in Röver's Manuscript Inventory in the Amsterdam University Library as Portfolio 23, no. 48. Lugt S.2984a–c); his widow, Cornelia Röver–van der Dussen; sold in 1761 to Hendrick de Leth for Goll van Franckenstein; Jonkheer Johann Goll van Franckenstein the Elder (1722–1785; his *No. 2881* in red ink on verso; Lugt 2987); Jonkheer Johan Goll van Franckenstein the Younger (1756–1821); Jonkheer Pieter Hendrik Goll van Franckenstein (1787–1832); his sale, Amsterdam, 1 July 1833, Album C, lot 1 (to Van Idsinga for 501 florins); I. van Idsinga (not in his sale, Amsterdam, 2–6 November 1840); C. J. Nieuwenhuys, Brussels, Belgium, and Oxford Lodge, Wimbledon, England; Robert Stayner Holford (Lugt 2243); his sale, London, Christie's, 11–14 July 1893, lot 622 (to Davis); Charles Fairfax Murray; J. Pierpont Morgan (no mark; see Lugt 1509).

BIBLIOGRAPHY: Fairfax Murray, III, no. 208, repr.; Von Sick, *Berchem*, 1930, p. 62, no. 232.

EXHIBITION: Washington, D.C., and elsewhere, *Seventeenth Century Dutch Drawings*, 1977, no. 55, repr.

Acc. no. III, 208

102. *Landscape with Tobias and the Angel*

Red chalk.
7⅞ × 12⅚ inches (200 × 313 mm.).
Watermark: letters *CD*. See watermark no. 50.
Inscribed on verso in pen and brown ink at upper center, *Berchem / . . .* (illegible).

Religious pictures constitute only a small segment of Berchem's painted *oeuvre*, thirty-five or so of a total of over eight hundred fifty. The drawings of religious subjects likewise are not numerous. The Morgan drawing in its handling which is swift and loose but at the same time definitely assured, suggests that it is a work of the artist's later activity, perhaps as much as twenty years beyond the *Annunciation*, the black chalk drawing dated 1648 that is one of the extra-illustrations in the Kitto Bible in the Huntington Library (see the exhibition catalogue by Marcel Roethlisberger, *European Drawings from the Kitto Bible*, San Marino, California, 1969–70, no. 32). No painting of the subject of Tobias and the Angel is listed by Hofstede de Groot.

PROVENANCE: Charles Fairfax Murray; J. Pierpont Morgan (no mark; see Lugt 1509).

BIBLIOGRAPHY: Fairfax Murray, III, no. 206, repr.; Von Sick, *Berchem*, 1930, p. 53, no. 4.

EXHIBITION: New York Public Library, *Morgan Drawings*, 1919, n.p.

Acc. no. III, 206

Nicolaes Berchem, formerly attributed to

103. *Landscape with the Ruined Castle of Brederode*

Black and red chalk, with accents in oily black chalk.
12⅟₁₆ × 20⅛ inches (307 × 511 mm.).
Watermark: none.
Inscribed in black chalk, and partially trimmed, at lower left margin, *Berchem*; on verso, at upper left corner, in graphite, *Breederoode*; at lower center, in black chalk, in another hand, *Ruins of the Castle of Brederode*, and at right, *Berghem / Mʳ Peels is by Hobema*.

This drawing, which comes from the famous collections of Valerius Röver and the three gen-

erations of Goll van Franckensteins, has long figured in the literature as an impressive example of the artist's large-scale chalk drawings. However, two Dutch scholars, the late Horst Gerson and J. Q. van Regteren Altena, as well as an American specialist in Netherlandish art, the late Wolfgang Stechow, remarked on various occasions that it is very probably not by Berchem but more likely by Laurens Vincentsz. van der Vinne (1658–1729) who, according to Gerson's entry in Thieme-Becker, was Berchem's pupil.

While the drawing at first glance appears to be in Berchem's style, on closer examination definite weaknesses are apparent. One of the most obvious is the discrepancy in scale between the figures and the oversize ducks which also dwarf the dog. It will further be remarked that the legs of the second cow from the right are very much out of drawing, and that the foliage of the trees is indicated with the monotonous regularity of a formula. The evidence seems to suggest that the drawing is clearly a clever imitation of Berchem's draughtsmanship. There are two drawings by Van de Vinne of Brederode Castle, from slightly different and closer viewpoints, in the Rijksprentenkabinet, Amsterdam (Inv. nos. A1806 and A127), both recording the central portion of the ruins to the left of the archway. Another version of Inv. no. A1806 is to be seen in the École des Beaux-Arts, Paris; interestingly enough, it likewise was attributed to Berchem until Frits Lugt assigned it to Van der Vinne in his 1950 catalogue of that collection (p. 87, no. 710, pl. xci). The Beaux-Arts drawing, which appears to be somewhat drier than the Amsterdam drawing, also less detailed in the foreground and lacking the figure in the archway, is dated 1676 on the verso. There is another drawing dated 1676 and also associated with Brederode formerly owned by Dr. A. Welcker, Amsterdam, whose collection is now in the Prentenkabinet der Rijksuniversiteit, Leyden, but that drawing is assigned to Vincent Laurentsz. van der Vinne (1629–1702), the father of Laurens (Bernt, *Zeichner*, 1958, II, no.

641). The date 1676 is probably applicable to the Amsterdam and New York sheets as well; they accordingly would be very early works of Laurens. But perhaps also to be taken into account is the confusion between the works of the Van der Vinnes, father and son. See in this connection the article by Ellen van den Berg in *Miscellanea I. Q. van Regteren Altena*, 1969, pp. 162–63.

Brederode Castle, the seat of the powerful Counts of Brederode, was built in the thirteenth century and finally destroyed in 1573. Its red brick ruins and moat are still to be seen at the foot of the dunes at Santpoort three miles north of Haarlem, much as generations of Dutch artists have seen and recorded them. The point from which the castle is seen in the Morgan drawing was clearly that affording a view of the most ample expanse of the ruins. Almost exactly the same view of the ruins is depicted in a fine large drawing in black and white chalk on blue paper also in the Rijksprentenkabinet. Since the latter drawing is dated 1683 it cannot be that of Simon de Vlieger (d. 1653) to whom it has been assigned in the past. For an extraordinary bird's-eye view of the ruins of Brederode and the surrounding country, see Jan van Kessel's drawing in the Kupferstichkabinett, Berlin (repr. Bernt, *Zeichner*, 1958, no. 330).

If Berchem did not execute the Morgan drawing, he certainly made other drawings of Brederode Castle. Among the eighty drawings credited to him in the catalogue of the Tonneman sale at Amsterdam on 21 October 1754 are four views of the castle, all described as being in pen and ink (Album C, lots 5–8). There are pen drawings of the subject at Amsterdam, Groningen, Haarlem, and Frankfurt; chalk drawings at Copenhagen and Weimar. A drawing in the Witt Collection, Courtauld Institute, London, which seems to bear some resemblance to the Morgan sheet, may also represent the environs of Brederode. The picture by Hobbema formerly in the collection of Sir Robert Peel to which a nineteenth-century owner referred in the inscription on the verso of the Morgan sheet is now

129

in the National Gallery, London (MacLaren, *The Dutch School*, Plates, 1958, p. 137, Text, 1960, pp. 168–69, no. 831).

There is a problem in connection with the provenance of this sheet in that Charles Greville, whose mark the drawing bears, died in 1832, a year before the Goll van Franckenstein sale of 1833 where the drawing presumably figured. It has been suggested by Dr. Hans-Ulrich Beck who is studying the content and history of the Goll van Franckenstein collection that the drawing was acquired by the Earl of Warwick after the Goll van Franckenstein sale of 1833 and the Greville stamp affixed later. As is well known, the bulk of the collection formed by Greville was bequeathed to his nephew, the Earl of Warwick, and the marks of the two collectors are usually found together as they are here.

PROVENANCE: Valerius Röver, Delft (his number *23/45* in graphite on verso; the drawing occurs in Röver's Manuscript Inventory in the Amsterdam University Library as Portfolio 23, no. 45; Lugt S.2984a–c); his widow, Cornelia Röver–van der Dussen; sold in 1761 to Hendrick de Leth, for Goll van Franckenstein; Jonkheer Johann Goll van Franckenstein the Elder (1722–1785; his *No. 2884* in red ink on verso; Lugt 2987); Jonkheer Johan Goll van Franckenstein the Younger (1756–1821); Jonkheer Pieter Hendrik Goll van Franckenstein (1787–1832); his sale, Amsterdam, 1 July 1833, possibly part of Album L, lot 9; Sir Charles Greville (1763–1832; Lugt 549); George Guy, fourth Earl of Warwick (Lugt 2600); his sale, London, Christie's, 20–21 May 1896, lot 30; Charles Fairfax Murray; J. Pierpont Morgan (no mark; see Lugt 1509).

BIBLIOGRAPHY: Fairfax Murray, I, no. 140, repr.; Von Sick, *Berchem*, 1930, p. 54, no. 23; Berlin, Staatliche Museen Preussischer Kulturbesitz, *Die holländischen Landschaftszeichnungen 1600–1740*, 1974, exhibition catalogue by Wolfgang Schulz, under no. 16.

EXHIBITION: Ann Arbor, Michigan, *Italy through Dutch Eyes*, 1964, no. 10.

Acc. no. I, 140

Aelbert Cuyp

Dordrecht 1620 – 1691 Dordrecht

104. *Landscape with a Watermill*

Black chalk, heightened with white tempera, yellow wash

and some gray wash. Old vertical crease left of center. $7\frac{1}{4} \times 12\frac{1}{16}$ inches (184 × 306 mm.).
Watermark: fragment of fleur-de-lis within a shield (close to Heawood 1743). See watermark no. 24.
Inscribed in graphite in a later hand at upper right, *A. Cuyp*. Inscribed on verso, at center, in black chalk, *105*; at lower left, in graphite, *CUYP / 454*; and at lower left corner in another hand (Engelberts' ?), in graphite, *CJ120: / IS ls / dJ / RS⊕XLO*.

This drawing, focusing on an old watermill in a somewhat barren setting, would appear to be a transcript from nature. J. W. Niemeijer suggested that the artist may have made the drawing in the vicinity of Bentheim, in the northwest region of Germany near the Dutch border. Strangely enough, none of Cuyp's paintings, as far as could be checked, depict a subject of this kind. J. G. van Gelder feels the *Watermill* is near in time to the drawing of a building at the water's edge, possibly a toll house, in the Teylers Museum at Haarlem, which he places around 1642–44 (see the exhibition catalogue *Aelbert Cuyp en zijn familie: Schilders te Dordrecht*, Dordrecht, Dordrechts Museum, 1977–78, p. 134, no. 51, repr.). In such an early drawing the influence of Jan van Goyen is perhaps still to be discerned in the handling of the foliage. Josi appears to have been referring to this drawing when he wrote, "J'ai fourni en 1820 à M. de Roveray à Londres un des plus beaux dessins coloriés que je connaise d'*Albert Cuyp*; il représente un site avec un moulin à l'eau entouré d'arbres" (C. Ploos van Amstel and C. Josi, *Collection d'imitations de dessins d'après les principaux maitres hollandais et flamands . . .* , I, Amsterdam and London, 1821–27, p. 108). Cuyp's use of black chalk, heightened with white tempera in combination with a distinctive mustardy yellow wash, is almost a trademark for him.

PROVENANCE: Christian Josi (c. 1765–1828), London; M. de Roveray (according to Josi); possibly Engelbert Michael Engelberts (1773–1843); Charles Fairfax Murray; J. Pierpont Morgan (no mark; see Lugt 1509).

BIBLIOGRAPHY: Fairfax Murray, III, no. 185, repr.

Acc. no. III, 185

105. *Study of Cows and Milk Cans*

Black chalk and gray wash.
5⁹⁄₁₆ × 7½ inches (142 × 190 mm.).
Watermark: none.
Inscribed in pen and brown ink at lower right, in an old hand, *4*; in graphite at lower left, *ACuyp*.

The artist developed the staffage of his painted landscapes from studies of this kind made, as it were, after the bovine models in the meadows and the milkmaid at her task. One thinks in particular of *The Large Dort* in the National Gallery, London (MacLaren, *The Dutch School*, Plates, 1958, p. 71, and Text, 1960, p. 86, no. 961; Hofstede de Groot, 1909, no. 368), where cows and milkmaid are similarly posed, the standing animal, however, placed behind the reclining cow. The two brass milk cans, one with an earthenware funneling bowl and one closed with a lid, together with the yoke lying in front of them, are found with slight variations in the painting once in the Schaeffer Galleries, New York (Hofstede de Groot, no. 367). Similar individual studies of cows are to be found in the Kupferstichkabinett in Berlin, the British Museum, London, the Louvre, Paris, and elsewhere. The Morgan sheet is notably effective in the *mis-en-page* as well as its execution. The crisp, incisive stroke—on occasion the draughtsman exerted such pressure on the chalk that the paper was indented—is typical of the artist. So, too, is the use of a rich black chalk with which he achieved effects of sooty blackness, effects that could not be produced with graphite. He obviously came face to face with the white-faced animal staring somewhat belligerently from the page, and he paused long enough to note the bony ridges and rough coat of the resting cow.

PROVENANCE: Heneage Finch, fifth Earl of Aylesford (Lugt 58); probably his sale, London, Christie's, 17–18 July 1893, one of three in lot 235, "A large Bird's-eye View of a Town; and two Studies" (to Murray for £4.10); Charles Fairfax Murray; J. Pierpont Morgan (no mark; see Lugt 1509).

BIBLIOGRAPHY: Fairfax Murray, I, no. 123, repr.; James Watrous, *The Craft of Old-Master Drawings*, Madison, Wisconsin, 1957, pp. 144, 150 (wrongly described as executed in graphite).

Acc. no. I, 123

Gerbrand van den Eeckhout
Amsterdam 1621 – 1674 Amsterdam

106. *The Adoration of the Magi*
Matthew 2:1–11

Pen and brown ink, brown and black washes, some white wash, black and red chalks, and traces of graphite.
6³⁄₁₆ × 6 inches (157 × 152 mm.).
Watermark: none.
On verso, in pen and brown ink, at left side, four ruled vertical lines; ticket with printed number, *228*; numbered in graphite, *30*.

Among the more than fifty artists known to have studied with Rembrandt at one time or another, Eeckhout ranks as one of the most talented and versatile. A pupil of Rembrandt's middle period, he is reported to have entered the studio in Amsterdam at age fourteen and remained there for the five years between 1635 and 1640. Although the present drawing was executed many years after Eeckhout had left the studio, it still attests to the impact of his master, not only in style but in composition as well. The drawing is frankly dependent on the painting of the same subject, dated 1657, formerly thought to be a work by Rembrandt, which is in the royal collection at Buckingham Palace (Bredius-Gerson, no. 592); and, as Werner Sumowski has pointed out, the drawing is itself a study for Eeckhout's *Adoration of the Magi*, the painting of 1665 in the Pushkin Museum, Moscow. The drawing is striking in its rich, colorful blend of chalks, ink, and wash, and demonstrates an authoritative command of the Rembrandt idiom in its chiaroscuro effects and the variety of its pen line. As a small-scale compositional study, it is almost abstract in the brevity of the individual forms but at the same time explicit in its notation and remarkable in its brio.

PROVENANCE: Alfred Beurdeley (Lugt 421); his sixth sale, Paris, Galerie Georges Petit, 9 June 1920, no. 165;

131

André Beurdeley, Paris; sale, Paris, Palais Galliéra, 20 June 1961, lot 13, pl. F; Jacques Petit-Horry, Paris; R.M. Light & Co., Boston.

BIBLIOGRAPHY: John Charles Van Dyke, *The Rembrandt Drawings and Etchings*, New York–London, 1927, p. 120 (as Karel van der Pluym); Lugt, *École hollandaise, Louvre*, III, 1933, p. 41, under no. 1225; M. D. Henkel, *Catalogus van de Nederlandsche teekeningen in het Rijksmuseum te Amsterdam, I: Teekeningen van Rembrandt en zijn school*, The Hague, 1942, p. 75, under no. 6; Werner Sumowski, "Gerbrand van den Eeckhout als Zeichner," *Oud Holland*, LXXVII, 1962, pp. 19, fig. 26; Morgan Library, *Sixteenth Report to the Fellows, 1969–1971*, 1973, pp. 99–100; Wolfgang Wegner, *Kataloge der Staatlichen Graphischen Sammlung München, I: Die niederländischen Handzeichnungen des 15.–18. Jahrhunderts*, Berlin, 1973, p. 78, under no. 547, p. 166, under no. 1144.

Acc. no. 1970.1

Gift of the Fellows

tercolor, were as highly valued as those of Jacob van Ruisdael. Cornelis Ploos van Amstel, to whom the Morgan sheet once belonged, owned more than one hundred of them as is known by their listing in the catalogue of the sale of his collection on 3 March 1800. The artist almost invariably signed his sheets with his monogram as he did here, though he seldom dated them.

PROVENANCE: Cornelis Ploos van Amstel Jb Czn (Lugt 3002–03); Charles Fairfax Murray; J. Pierpont Morgan (no mark; see Lugt 1509).

BIBLIOGRAPHY: Fairfax Murray, I, no. 135, repr.

Acc. no. I, 135

Allaert van Everdingen
Alkmaar 1621 – 1675 Amsterdam

107. *Farm Landscape with Sheep*

Pen and point of brush and brown ink, brown wash.
7 × 11¾ inches (177 × 300 mm.).
Watermark: letters *IHS* surmounted by a cross and *LM* below (similar to Heawood 1795). See watermark no. 46.
Signed with initials at lower left, *AVE*. Inscribed on verso at left, in graphite, by Ploos van Amstel, *A v Everdingen | hoog 7 | bred 12 dm*; at lower center, in another hand, *et.*

This drawing obviously has nothing to do with the artist's records of his famed visit to Sweden and Norway in the first half of the 1640's which first introduced the mountain scenery of Scandinavia to the Netherlands. If the Morgan landscape had any bearing on a specific locale, it might well have been the vicinity of Haarlem where Van Everdingen was a pupil of Pieter Molijn after earlier studies with Roelant Savery at Utrecht; it is possibly the silhouette of Haarlem's Groote Kerk, St. Bavo, that is mistily suggested on the horizon to the right of center. The presence of spruce trees at the right of the Morgan composition is proof that it was made sometime after the Scandinavian journey.

In the eighteenth century Van Everdingen's drawings, especially those enlivened with wa-

Isaac van Ostade
Haarlem 1621 – 1649 Haarlem

108. *Eight Boors Drinking*

Pen and brown ink, brown and some gray washes, over black chalk.
4¼ × 5⅚ inches (107 × 150 mm.).
Watermark: none visible through lining.
Signed in pen and brown ink at lower left, *I. v. Ostade*. Inscribed on verso of lining, in pen and brown ink, *P. N⁰ 59*; below that in pen and black ink in J. C. Robinson's hand, *Adrian van Ostade | from Lord Palmerston's Colln*; numbered in graphite below, *10/2*.

This composition of two groups of gnome-like peasants enjoying a moment of infectious, boisterous jollity over their beer and pipes is proof of the gifts of observation and humor that the artist shared with his older brother Adriaen. The short-lived Isaac was active for only about a decade and this drawing, still very much under the influence of his brother, was probably executed early in his brief career, about 1642–43, Schnackenburg suggests. He also is of the opinion that the wash, presumably the brown wash, and the inscription of the artist's name are probably additions by Cornelis Dusart, who is known to have completed some of the paintings of Adriaen van Ostade who was his master. It must be remarked, however, that there is no

perceptible difference in the color of the ink of the background and the signature, and if the drawing was worked on by Dusart, he worked in admirable harmony with Isaac's purpose.

PROVENANCE: Henry Temple, second Viscount Palmerston (1739–1802; according to inscription on mount); Hon. Evelyn Ashley (by bequest from Lord Palmerston); possibly his sale, London, Christie's, 24 April 1891, one of two in lot 126, "A. Ostade. A Party of Boors Drinking – pen washed; another of a Man and a Woman"; Sir John Charles Robinson (Lugt 1433); his sale ["Well-Known Amateur"], 12–14 May 1902, lot 246, "Ostade (Isaac van). Party of Eight Boors, at a table in pen and bistre. From Lord Palmerston's Collection"; Charles Fairfax Murray; J. Pierpont Morgan (no mark; see Lugt 1509).

BIBLIOGRAPHY: Fairfax Murray, I, no. 136, repr.; Schnackenburg, *Van Ostade*, 1971, no. 415.

Acc. no. I, 136

Karel Dujardin

Amsterdam 1626 – 1678 Venice

109. *Study of a Long-Haired Young Man*

Red chalk. Small repairs at upper left and right corners; small stain at upper right.
12⅟₁₆ × 8⅟₁₆ inches (307 × 206 mm.).
Watermark: letters *IHS* surmounted by a cross (cf. Heawood 2957). See watermark no. 47.
Inscribed at lower left, in graphite, partially cut off, *. . . d V. deVelde*. On verso, in graphite at upper left, *X57:F.*; in another hand, also in graphite, *Schelling = ¼ 041F =*; in pen and brown ink, *Hs2*[?]; at lower center in graphite, *23*.

Once attributed to Adriaen van de Velde, this portrait of a pensive young man was recognized as the work of Dujardin by Nils Lindhagen of the Nationalmuseum, Stockholm, in the exhibition catalogue of 1953. As he pointed out, it coincides in style and conception with the red chalk *Self-Portrait* in the British Museum, a signed likeness dated 1658 (Bernt, *Zeichner*, 1957–58, no. 464, repr.). Given the similarities of the two sheets, one would assume that the Morgan portrait is most likely of the same period. Belonging to the second generation of Italianate Dutch painters and apparently a pupil of Nicolaes Ber-

chem, Dujardin made two trips to Italy where, indeed, he died. Though Houbraken states that he was not a member of the Schildersbent, he acquired the Bent name Bokkebaart or Goatsbeard (Houbraken, II, 1719, p. 352, and III, pp. 56 and 218). (Houbraken's remark that he did not know if the name were given to Dujardin because he shaved irregularly or out of anger is interesting in the context of the British Museum portrait where he shows himself beardless.) The artist's portrait drawings, almost invariably in red chalk, are encountered less frequently than his landscapes and animal studies, but there are examples at Berlin, Weimar, and Stockholm. In connection with the portraits at the Nationalmuseum (Inv. nos. 113/1866 and 115/1866) it may be remarked that they are executed on paper with the same watermark as the present sheet. The awkward rendering of the sitter's right hand in the Morgan sheet almost suggests that he might have had a crippled arm but the same fault occurs in the Stockholm drawing of a woman (Inv. no. 115/1866).

PROVENANCE: Charles Fairfax Murray; J. Pierpont Morgan (no mark; see Lugt 1509).

BIBLIOGRAPHY: Fairfax Murray, III, no. 227, repr.; Hind, *Dutch Drawings*, 1926, III, p. 123, under no. 1; Frits Lugt, "Beiträge zu dem Katalog der niederländischen Handzeichnungen in Berlin," *Jahrbuch der Preussischen Kunstsammlungen*, LII, 1931, p. 52, under no. s.186; Stockholm, Nationalmuseum, *Dutch and Flemish Drawings*, 1953, under no. 242.

Acc. no. III, 227

110. *Muleteer and Shepherdess with Animals at a Stream*

Point of brush, black and gray washes, over slight indications in black chalk. Repairs at upper left corner.
5⅞₁₆ × 7¾ inches (137 × 197 mm.).
Watermark: horn (compare Heawood 2680–2700). See watermark no. 43.
Signed in brush and black ink at lower left corner, *K. DV. IARDIN*. Inscribed on verso, in pen and brown ink, at lower left, *K du Jardin / behoorende aan / J. Chalon*.

Such pastoral landscapes, quiet in mood and delicately drawn—here almost entirely with the

brush—are typical of Dujardin. Though the landscape is probably idealized, the care with which the aqueduct is rendered suggests the previous inspection of actual ruins which the artist no doubt saw on his first Italian trip sometime during the 1640's. The composition does not appear in any of Dujardin's etchings although an animal very similar in almost every respect to the larger of the two mules is found in the etching *Two Mules* (Bartsch, I, 1920, p. 109, no. 2; Hollstein, VI, p. 29, no. 2, repr.). Dujardin also devoted a drawing to two of these small sturdy beasts of burden so quaintly yet practically accoutered (Rijksprentenkabinet, Amsterdam, Inv. no. A102; repr. Bernt, *Zeichner*, 1957–58, no. 196).

PROVENANCE: Jan Chalon (Lugt 439); William Benoni White (according to Roupell; no mark; see Lugt 2592); Robert Prioleau Roupell (Lugt 2234); his sale, London, Christie's, 12 July 1887, p. 85, no. 1002, "An Italian Landscape with peasants, cattle, and ruins. Exhibited Burlington Fine Arts Club, 1883" (to Salting); Charles Fairfax Murray; J. Pierpont Morgan (no mark; see Lugt 1509).

BIBLIOGRAPHY: Fairfax Murray, I, no. 142, repr.

EXHIBITIONS: London, Burlington Fine Arts Club, *Exhibition of Etchings by Renier Zeemon and Karel Du Jardin with Illustrative Drawings*, 1883, no. 177; Ann Arbor, Michigan, *Italy through Dutch Eyes*, 1964, no. 33, pl. XVIII.

Acc. no. I, 142

Willem Romeijn

Haarlem c. 1622 – after 1695 Haarlem

111. *Cattle, Goats, and Sheep in a Stream*

Point of brush, black and gray washes, over faint indications in black chalk; accents throughout in black chalk. Some losses and traces of old vertical creases at lower center, and some foxing.
$11\frac{3}{4} \times 15\frac{1}{4}$ inches (298 × 388 mm.).
Watermark: none.
Signed in black chalk at lower right, partially cut off, *WR*(interlaced)*OMEY* Inscribed on verso, in an old hand, in pen and brown ink, at upper right corner, *45ᵖ[ˀ]*.

Romeijn, mentioned as a pupil of Nicolaes Berchem in 1642, was yet another of the seventeenth-century Dutch landscapists who traveled to Italy. He is known to have been in Rome in 1650–51, and it was probably not too long after his Italian experience that he made this drawing. Like the signed painting in the Institut Néerlandais (Inv. no. 1975-S.3) with which it coincides in most respects, it is one of his more successful compositions. (The painting, formerly belonging to F. C. Butôt, is reproduced in color in the exhibition catalogue *Hollandse en Vlaamse kunst uit de 17ᵉ eeuw: Schilderijen en tekeningen uit de verzameling F. C. Butôt*, Rotterdam, Boymans–van Beuningen Museum, 1973, pp. 110–11.) Though characteristically the animal staffage dominates the scene, the background preserves a graceful recollection of Italian landscape. The quiet pool overlooked by the umbrella pine and the twin cypresses is almost eighteenth-century in feeling. The shepherd at the right surely owes a debt to the figures of Berchem, and the influence of Dujardin as well is manifested in both the style and subject.

The drawing no doubt preceded the painting. Although the two works are very close, there are small differences that rule out the possibility of the drawing's being a copy after the painting. Such details as the tree with a broken branch in the distance beyond the shepherd are missing in the painting as is the foliage sprouting from the tree trunk at the extreme left of the Morgan sheet. The configuration of the trees in the painting also differs somewhat as a third cypress, of which only the very top is seen in the drawing, is given full prominence. Possibly, the artist after finishing the drawing, which stands as an independent work, went on to translate the subject into oil. The painting, which measures $13\frac{7}{8} \times 16$ inches, is only slightly larger than the drawing.

PROVENANCE: Charles Fairfax Murray; J. Pierpont Morgan (no mark; see Lugt 1509).

BIBLIOGRAPHY: Fairfax Murray, III, no. 216, repr.

Acc. no. III, 216

Lambert Doomer

Amsterdam 1624 – 1700 Amsterdam

112. *The Spring at Cleves*

Pen and brown ink, brown, gray, and ochre washes, over faint indications in black chalk, very slight corrections in white tempera. Verso: Small sketch, in pen and brown ink, at left center, of the Swan Tower of Schwanenburg Castle at Cleves.

8⅞ × 14¼ inches (226 × 363 mm.).

Watermark: none.

Inscribed by the artist on verso in pen and brown ink, *aen de Springh te Kleef*. Inscribed on verso of old mount at lower right corner, in graphite, in three different hands, *Doomer | Domer | From Lord Palmerston's colln*; at right center, in pen and black ink, in J. C. Robinson's hand, *Jan doomer | From Lord Palmerston's colln | formed 1770–1801 | sold at Christie's Apl 24 1891 | J. C. Robinson*.

Like so many of his fellow artists of the period, Doomer traveled extensively. Unlike most of them, however, he did not go south to Italy but journeyed instead to France and Germany. In France where he visited his two brothers at Nantes in 1646, he was accompanied on the return journey by the painter Willem Schellinks (c. 1627–1678), the two young artists traveling via the Loire valley and Paris. Schellinks' diary of their tour is preserved in the Royal Library at Copenhagen (Ny Kgl s.370). In Germany, Doomer traveled—possibly on more than one occasion—in the region of the Lower and Middle Rhine, visiting at one point the birthplace of his father in the village of Anrath near Mönchen-Gladbach. His Rhine journey has been variously placed between 1648 and 1670; the most recent proposal is 1663, the date advanced with cogent arguments by Schulz in his recent monograph on the artist's drawings (pp. 24–25).

Doomer was in the main a topographical draughtsman and he recorded his journeys in numerous drawings made en route, annotating but seldom dating them. Doomer probably reached Cleves early in the course of his travels along the Rhine which took him as far south as Bingen; he paused there at least long enough to make four drawings. He drew a panoramic view of the city now in the British Museum; a view of the castle square in the collection of N.

Henriot-Schweitzer, Louveciennes; a view of the amphitheatre in the British Museum (of which he later executed the replica in the Gemeentemuseum at Arnhem); and the present drawing of a woodland path above the amphitheatre (Schulz, 1974, nos. 192–96, figs. 98–101). Without the view of the amphitheatre in the British Museum and one of Doomer's usual inscriptions on the verso of the Morgan drawing, it would be difficult to place its locale. The amphitheatre, part of a large park project and still in existence today, was relatively new when Doomer visited it. Built in 1658 under Johan Maurits of Nassau-Siegen, the semicircular arcaded structure rises above a pond with a fountain, overlooked by a marble sculpture of Minerva Tritonis by Artus Quellinus, a gift of the city of Amsterdam to Cleves in 1660 and so furnishing a *terminus post quem* for Doomer's visit. The Morgan drawing shows only the uppermost tip of the arcaded amphitheatre and the small structure housing the chalybeate spring supplying the water for the fountain and pond. Doomer's curiosity apparently led him to investigate and record this unusual view of one of the sights of Cleves. Characteristically he shows himself or another artist, sketchbook in hand, standing before the "spring house," just as in the British Museum view of the amphitheatre he showed himself seated sketching in one corner. Although Doomer produced a great many replicas of his drawings, especially after 1680, no other version of the Morgan landscape is known. Its pristine condition makes it possible to enjoy the colorful effects Doomer achieved with his blended washes, ranging from brown to olive to gray and contrasting with the creamy whiteness of the paper which has retained its original freshness.

On the verso there is a small sketch of the top of the famous Swan Tower of the Schwanenburg, the Cleves castle associated with the Lohengrin legend.

PROVENANCE: Henry Temple, second Viscount Palmerston (1739–1802; according to inscription on mount); Hon. Evelyn Ashley (by bequest from Lord Palmerston); possibly his sale, London, Christie's, 24 April 1891, one

of four in lot 157, "Landscapes by Doomer"; Sir John Charles Robinson (according to inscription on verso of mount; Lugt 1433); his sale ["Well-Known Amateur"], London, Christie's, 12–14 May 1902, lot 100, "Landscape with man on a road in foreground, and building to right – pen and bistre, and indian ink wash. From Lord Palmerston's Collection. Exhibited at the Guildhall, 1895"; Charles Fairfax Murray; J. Pierpont Morgan (no mark; see Lugt 1509).

BIBLIOGRAPHY: Fairfax Murray, I, no. 218, repr.; Friedrich Gorissen, *Conspectus Cliviae: Die klevische Residenz in der Kunst des 17. Jahrhunderts*, Cleves, 1964, no. 172, repr., no. 147 (verso), repr.; H. Dattenberg, *Niederrhein-ansichten holländischer Künstler des 17. Jahrhunderts*, Düsseldorf, 1967, no. 106, repr., no. 107 (verso), repr.; Wolfgang Schulz, *Lambert Doomer, 1624–1700: Leben und Werk*, dissertation, Berlin, 1972, I, p. 54, and II, no. 280; Wilhelm Diedenhofen, "Trophäen im Park," *Bulletin van het Rijksmuseum*, XXI, 1973, p. 122, note 25, fig. 7; Wolfgang Schulz, *Lambert Doomer: Sämtliche Zeichnungen*, Berlin, 1974, no. 196, pl. 100.

EXHIBITIONS: London, Guildhall, 1895, no. 57; Raleigh, North Carolina, North Carolina Museum of Art, *Rembrandt and His Pupils*, catalogue by W. R. Valentiner, 1956, p. 116, no. 16; Stockholm, *Morgan Library gästar Nationalmuseum*, 1970, no. 69; Poughkeepsie, Vassar, *Seventeenth Century Dutch Landscapes*, 1976, no. 38, repr.

Acc. no. I, 218

113. *Well and Fortress at Ehrenbreitstein*

Pen and brown ink, brown, gray and ochre washes; very slight corrections in white tempera in foliage.
9⅛ × 14¼ inches (233 × 362 mm.).
Watermark: none.

Inscribed on verso in pen and brown ink, *de tide bron toe Kobelens*. Inscribed on old mount, at lower right corner, in graphite, in three different hands, *Domer* / *Scholar of Rembrandt* / *From Lord Palmerston's Colln* / *Doomer*; on verso, at lower center, in pen and black ink, in J. C. Robinson's hand, *L. doomer* / *From Lord Palmerston's colln* / *formed 1770–1801* / *Sold at Christie's Apl 24 1891* / *J. C. Robinson*.

Doomer obviously was fortunate in the fine day on which he visited Ehrenbreitstein to the end that he was eminently successful in rendering the light that warms the wall behind the wellhead and glances off the towers of the great fortress crowning the hill lined with vineyards. The fortress, once the most impregnable in Europe, dates back to the twelfth century and has been restored and rebuilt at various intervals.

In Doomer's time it housed the Holy Garment of Trier, supposedly the seamless robe of Christ woven by the Virgin and discovered by St. Helena (see the *New Catholic Encyclopedia*, XIV, 1967, p. 289). Ehrenbreitstein is a town on the right bank of the Rhine opposite Coblenz and since 1937 a part of that city. Wenzel Hollar and J. M. W. Turner are among the artists who also drew and painted Ehrenbreitstein, representing it as seen from the river, a much more dramatic view as the fortress is situated on a precipitous rock rising 385 feet above the river (see Franz Sprinzels, *Hollar Handzeichnungen*, Vienna, 1938, p. 85, no. 190, pl. 29; and Martin Butlin and Evelyn Joll, *The Paintings of J. M. W. Turner*, New Haven and London, 1977, I, no. 361, repr.). Conceivably Doomer might have made a drawing from this point but none is known today.

In the figure style and the free pen work of the foliage, in the Morgan drawing one still finds the influence of Rembrandt with whom Doomer had studied, probably about twenty years earlier. The family's association with the great artist most likely began in 1640 when Rembrandt painted the portraits of Lambert's father, Herman, a prosperous framemaker and ebony worker, and his mother; the son inherited these portraits which are now divided between the Metropolitan Museum, New York, and the Hermitage, Leningrad (Bredius-Gerson, nos. 217 and 357). Doomer repeated the Morgan drawing in the highly finished but less fresh version now in the Boymans–van Beuningen Museum in Rotterdam (Cornelis Hofstede de Groot and Wilhelm Spies, "Die Rheinlandschaften von Lambert Doomer," *Wallraf Richartz Jahrbuch*, III–IV, 1926–27, p. 189, fig. 12; H. R. Hoetink, *Tekeningen van Rembrandt en zijn school . . . Museum Boymans–van Beuningen*, Rotterdam, 1969, I, pl. 90; Schulz, 1974, no. 226). In the Rotterdam replica, probably made in the 1670's according to Schulz, he amused himself by inserting additional staffage. The donkey seen peering around the pillar at the far left of the Morgan sheet is prominently placed to the left of the wellhead

136

and attended by a muleteer and a woman loading the paniers with the flasks of mineral water. A man seated in the right corner is sampling the water on the spot, no doubt very much as the artist himself recalled having done years before. The mineral well still exists today.

PROVENANCE: Reynier Assueri (according to Schulz); perhaps his sale, Amsterdam, 10 January 1777, Album E, lot 19 (according to Schulz); Henry Temple, second Viscount Palmerston (1739–1802; according to inscription on mount); Hon. Evelyn Ashley (by bequest from Lord Palmerston); possibly his sale, London, Christie's, 24 April 1891, one of four in lot 157, "Landscapes by Doomer"; Sir John Charles Robinson (according to inscription on verso of mount; Lugt 1433); his sale ["Well-Known Amateur"], London, Christie's, 12–14 May 1902, lot 101, "Landscape, with two women and a dog by a well in foreground, walled town on a hill beyond in pen and bistre, and india ink wash. From Lord Palmerston's Collection"; Charles Fairfax Murray; J. Pierpont Morgan (no mark; see Lugt 1509).

BIBLIOGRAPHY: Wolfgang Schulz, *Lambert Doomer, 1624–1700: Leben und Werk*, Berlin, 1972, I, p. 54, and II, no. 323; Wolfgang Schulz, "Rheinische Burgen in 17. Jahrhundert," *Burgen und Schlösser*, XIV, 1973, p. 70, fig. 7; Wolfgang Schulz, *Lambert Doomer: Sämtliche Zeichnungen*, Berlin, 1974, no. 225.

EXHIBITIONS: Morgan Library, *Landscape Drawings*, 1953, no. 76; Raleigh, North Carolina, North Carolina Museum of Art, *Rembrandt and His Pupils*, catalogue by W. R. Valentiner, 1956, p. 116, no. 15; Chicago, *Rembrandt after Three Hundred Years*, 1969, no. 162, repr. p. 256.

Acc. no. I, 220a

Samuel van Hoogstraten
Dordrecht 1627 – 1678 Dordrecht

114. *Christ Sinking beneath the Cross*
John 19:17

Pen and brown ink, brown wash, red and black chalks; corrections in white tempera; gilded border.
9⁵⁄₁₆ × 14⁹⁄₁₆ inches (236 × 370 mm.).
Watermark: none.
Inscribed on verso in faint black chalk, at upper right, */12*; at lower right, *Werff Ex . . .* ; in graphite, at lower left, *AO hos–:*.

Van Hoogstraten entered Rembrandt's atelier at some point after the death of his father, his first teacher, in December 1640, and the influence of the master long lingered in his work, especially in his drawings. Many of them, like the present example, are devoted to biblical subjects. The artist's interest in such themes has been associated with his affiliation with the *Doopsgezinden* or Mennonites, and H.-M. Rotermund remarked that "he was one of the few among Rembrandt's pupils who had a personal attitude to Biblical subjects, and who remained true to those subjects even after having outgrown Rembrandt's School" ("The Motif of Radiance in Rembrandt's Biblical Drawings," *Journal of the Warburg and Courtauld Institutes*, XV, 1952, p. 116, note 3). In the elaborate Morgan composition Van Hoogstraten shows Christ carrying His own cross as reported in John 19:17 but also represents Simon being pressed into service in accordance with the accounts in the synoptic gospels where, in the version of Mark 15:21, ". . . they compel one Simon of Cyrene, who passed by, coming out of the country, the father of Alexander and Rufus, to bear his cross." The female figure kneeling in the foreground is Veronica, the woman who, according to legend, came forward to wipe the sweat from the face of Christ with her veil; it lies on the ground beside her.

The drawing's execution in a mixture of black and red chalk, generously supplemented by pen and brush in brown ink, is typical of a great number of the biblical sheets. In this instance, the artist emulated Rembrandt's practice of using a white bodycolor or tempera for purposes of correction in such areas as the face of the reluctant Simon, the hand of Christ, and the *pentimento* in the head of the foremost horse. Van Hoogstraten undoubtedly relied for inspiration on various works of Rembrandt's in the 1640's. The prominent horseman is a combination of the archer in the *Baptism of the Eunuch*, the dated etching of 1641 (Bartsch, no. 98), and the figure of Mordecai and his mount (in mirror image) in the etching of c. 1641 (Bartsch, no. 40). The woman holding the baby, a little to the right of center has an affinity with the

drawings in the Boymans–van Beuningen Museum, Rotterdam, and the Fogg Museum of Art, Cambridge, Massachusetts (Benesch, 1954–57, I, nos. 186–87, figs. 195–96 [1973, figs. 214–15]) and so perhaps in turn with the comparable figure to the left of the Hundred Guilder Print (Bartsch, no. 74).

PROVENANCE: Heneage Finch, fifth Earl of Aylesford (Lugt 58); his sale, London, Christie's, 17–18 July 1893, one of two in lot 252, "A Dutch Barn by Rembrandt; and the Carrying of the Cross, by Van den Eeckhout." (to Murray for £4.10); Charles Fairfax Murray; J. Pierpont Morgan (no mark; see Lugt 1509).

BIBLIOGRAPHY: Fairfax Murray, I, no. 217, repr. (as Van Hoogstraten); K. Lilienfeld, *Arent de Gelder: Sein Leben und seine Kunst*, The Hague, 1914, p. 163, under no. 91 (as possibly by Arent de Gelder); K. Lilienfeld, "Neues über Leben und Werke A. de Gelders," *Kunstchronik und Kunstmarkt*, XXX, 1918, p. 135 (as Arent de Gelder); J. Byam Shaw, "Arent de Gelder," *Old Master Drawings*, IV, 1929, p. 11 (as Van Hoogstraten); Valentiner, 1934, II, p. xxii, fig. 22; Wolfgang Wegner, *Kataloge der Staatlichen Graphischen Sammlung München, I: Die niederländischen Handzeichnungen des 15.–18. Jahrhunderts*, Berlin, 1973, p. 177, under no. 1212; Gianni Carlo Sciolla, *I disegni di maestri stranieri della Biblioteca Reale di Torino*, Turin, 1974, p. 47, under no. 60.

EXHIBITION: Washington, D.C., and elsewhere, *Seventeenth Century Dutch Drawings*, 1977, no. 68, repr.

Acc. no. I, 217

Samuel van Hoogstraten, attributed to

115. *Camel Seen from the Front*

Pen and brown ink, brown wash. Verso: Black chalk outline of the camel on the recto.
4⅟₁₆ × 6⅝ inches (103 × 160 mm.).
Watermark: coat of arms surmounted by a crown, partially trimmed (cf. Heawood 1833). See watermark no. 9.
Inscribed on verso, in upper right corner, in graphite, dealer's code, *GVN/2/o.S · OOC-VOX*.

There are at least a half dozen drawings of camels which have been variously assigned to Rembrandt and his school. Two of these are exhibited here. Fairfax Murray catalogued the present study and that following as the work of Rembrandt, and both were so listed by Hofstede de Groot in 1906. Frits Lugt in his cata-

logue of the Louvre's Dutch drawings also referred to No. 116 as by Rembrandt in connection with the sheet of two studies in the Louvre, the uppermost of which is plainly a copy of it. The Morgan drawings were not, however, included by Benesch in his corpus. He did include the two drawings of camels formerly in Bremen but lost since World War II (Benesch, 1954–57, II, nos. 453–54, figs. 511–12 [1973, figs. 542–43]), one of which bore the inscription *Drommedaris Rembrandt fecit. 1633. Amsterdam*. The attribution of that drawing has not been universally accepted in the past; Haverkamp-Begemann in his review of Benesch's corpus in *Kunstchronik* (1961, p. 27) expressed his agreement with Benesch's attribution and Van Gelder in his review speaks of the "marvellous dromedaries" (*Burlington Magazine*, XCII, 1955, p. 396, note 5). The former also suggested as a possible model for the draughtsman one of the two animals which Sir William Brereton saw on 4 June 1634 between The Hague and Loosduinen and noted in his *Travels in Holland . . .* (Edward Hawkins, ed., Manchester [Chetham Society, Remains Historical and Literary . . . I], 1844, p. 35). In the Warwick sale at Sotheby's on 17 June 1936, one of the two pen-and-wash drawings in lot 100 represented a camel, and yet another, sold as lot 77 at Sotheby's on 7 December 1967 and exhibited at Colnaghi's in 1968 (no. 28), is now in the Institut Néerlandais (Inv. no. 9027), Paris. The latter is very near the Library's sheets, possibly by the same hand, and all three are now acceptably attributed to Van Hoogstraten, a name apparently first proposed by Byam Shaw. Carlos van Hasselt reports that the Institut Néerlandais drawing once formed a pair with the Louvre drawing, and both came from the Ploos van Amstel sale, where they figured as Rembrandt (Amsterdam, 3 March 1800, Album VV, lot 44, to Van der Schley for 3 florins together with lot 45). Two sheets with camels, attributed to Rembrandt, figured in the sale of Sybrand Feitama (Amsterdam, 16 October 1758, p. 118, lot 72, to Calkoen for 10 florins), but there is no way of knowing whether these were the Mor-

gan drawings, the two divided between the Institut Néerlandais and the Louvre, or the lost Bremen ones, all the more since, as Schatborn noted (*De Kroniek van het Rembrandthuis*, Amsterdam, 1977, p. 18), it was not until the end of the eighteenth century in Holland that camels and dromedaries were distinguished.

The Morgan studies, certainly drawn in the presence of the animal—today it would be described as a Bactrian camel rather than a dromedary, which has only one hump—are notably successful in the rendering of the animal's visage and the proportions of the body, much more so, it might be said, than on the Bremen sheet (Benesch, no. 453)where the humps of the animal are not properly placed anatomically and the body is extraordinarily elongated. These faults might be used as an argument against the acceptance of the sheet as a work by Rembrandt who when drawing from a model, human or animal, invariably seized upon salient characteristics, whether of form or movement. If the Morgan drawings are properly attributed to Van Hoogstraten, his model probably was not one of those reported by Sir William Brereton in 1634, or, if so, he would have to have seen it at least ten years or so later since he was born in 1627. Camels are represented in Van Hoogstraten's drawing in the British Museum *Meeting of Jacob and Esau* (Hind, *Rembrandt*, 1915, I, p. 80, no. 2, pl. XLVI); that in the foreground, while poorly drawn, as a partial back view perhaps bears some reminiscence of No. 116, but one cannot help thinking that the draughtsman would have done well to refresh his memory by referring directly to his study.

PROVENANCE: Heneage Finch, fifth Earl of Aylesford (no mark; see Lugt 58); possibly his sale, London, Christie's, 17–18 July 1893, part of lot 254 (as Rembrandt), "Various Sketches in pen and ink. 5"; Charles Fairfax Murray; J. Pierpont Morgan (no mark; see Lugt 1509).

BIBLIOGRAPHY: Fairfax Murray, I, no. 204, repr.; Hofstede de Groot, *Rembrandt*, 1906, nos. 1090–91; Richard Graul, *Fünfzig Zeichnungen von Rembrandt*, Leipzig, 1906, p. 11, no. 37 (2nd ed., 1924, p. 8, no. 28); F. Schmidt-Degener, "Tentoonstelling van Rembrandts teekeningen in de Bibliothèque Nationale te Parijs," review of Paris, *Rembrandt*, 1908 exhibition, *Onze Kunst*,

XIV, 1908, p. 104 (as Rembrandt); Thieme-Becker, XVII, 1924, p. 464; Kurt Freise and Heinrich Wichmann, *Rembrandts Handzeichnungen, III: Staatliches Kupferstichkabinett und Sammlung Friedrich August II zu Dresden*, Parchim a.M., 1925, under no. 84 (Acc. no. I, 204a only); Lugt, *École hollandaise, Louvre*, III, 1933, p. 65, under no. 1335 (Acc. no. I, 204b only); Anna Maria Cetto, *Animal Drawings of Eight Centuries*, New York, 1950, no. 45, repr. (Acc. no. I, 204b only); London, Sotheby's, *Old Master Drawings*, 7 December 1967, under no. 77 (Acc. no. I, 204a only); London, P. & D. Colnaghi and Co., *Exhibition of Old Master Drawings*, June 1968, under no. 28.

EXHIBITIONS: Paris, *Rembrandt*, 1908, no. 447 (Acc. no. I, 204a), no. 448 (Acc. no. I, 204b); New York, Metropolitan Museum, *Rembrandt*, 1918, no. 30; New York Public Library, *Morgan Drawings*, 1919, n.p.; San Francisco, *Rembrandt from Morgan Collection*, 1920, no. 401; Iowa City, State University of Iowa, *Six Centuries of Master Drawings*, 1951, nos. 86a and b.

Acc. no. I, 204a

116. *Camel Seen from the Rear*

Pen and brown ink, brown wash, with very slight corrections in white.
$4\frac{1}{2} \times 6\frac{5}{16}$ (114×160 mm.).
Watermark: none.
Dealer's code in graphite, on verso, in upper right corner, *GVN/2/1:S OOC.*

See the text for No. 115.

PROVENANCE: see No. 115.
BIBLIOGRAPHY: see No. 115.

Acc. no. I, 204b

Jacob Isaacsz. van Ruisdael
Haarlem c. 1628/29 – 1682 Amsterdam

117. *Sun-Dappled Trees on a Stream*

Point of brush, black and gray washes, over slight indications in black chalk.
$10\frac{3}{8} \times 7\frac{11}{16}$ inches (264×196 mm.).
Watermark: none.
Signed in brush and black ink, at lower right with monogram, *JVR* (interlaced). Inscribed on verso in pen and brown ink, at upper center at left margin, *Ruydael*; at lower left corner, in another hand (Engelberts'?), in graphite, *a | mk $\frac{n}{k}$ | SL: AS⊕ COV:.*

139

Van Ruisdael, the forest painter *par excellence*, in the course of his career produced around one hundred and forty wooded landscapes, beginning with this theme in his very earliest works. These, as Stechow aptly remarked, "led him first to the edge of the forest and then afterwards into the thicket" (Stechow, *Dutch Landscape Painting*, 1966, p. 71). It is at the edge of the forest that he paused to make this early drawing, a straightforward reflection of the flat countryside near his native Haarlem.

Aside from a few skimming outlines in black chalk, the drawing is worked entirely in brush. The cool washes of Chinese ink, which Van Ruisdael consistently employed, modulate from light transparent grays to the strong blacks of the accents. The subject is simple, a corner of sunwashed woodland, edged by a placid pond and dominated by a sturdy, weathered oak twisting skyward. Van Ruisdael composes in terms of pure landscape—tree forms, foliage, grasses, clouds, water, and light. He is fascinated by the patterning of thorny branch and leaf against the sky. The silhouettes of the airy foliage masses are distinguished in an alternation of the irregular and the rounded outlines of the different kinds of trees. Clouds, which figure so magnificently in the later paintings, are an essential element of the design, and the luminous gray washes which give them form are important in the scale of values. The interlacing grasses in the sandy soil at the foot of the big tree are rendered with delicate calligraphic brush strokes, and among them the artist camouflaged his monogram. The mood is one of sun and solitude, undisturbed by any movement. There is no stir of human figures, and even the flight of birds high in the sky is too distant to affect the summer stillness.

Van Ruisdael's drawings—scanty in number, fewer than a hundred being known—seldom relate directly to his pictures, and the Morgan drawing is no exception. It may be compared, however, with the early paintings of woodland subjects now in Copenhagen, Vienna, and Budapest, all from the decade of the 1640's (Jakob Rosenberg, *Jacob van Ruisdael*, Berlin, 1928, no. 311, fig. 15, no. 386, fig. 14, no. 279a, fig. 13). Also comparable is *Willow Trees*, a small painting dated 1645 (Stechow, fig. 135) that is no larger than the Morgan drawing. All these early paintings like the drawing are vertical in format; Stechow (p. 46) notes that this upright shape was also frequently employed by Van Ruisdael for his later wood landscapes as well. The Morgan drawing probably belongs to the late forties, the years between 1646 and 1649 before the artist traveled to Germany. It is devoid of the faintly primitive quality that characterizes Berlin's *Hunter with Three Hounds in a Forest Clearing*, a drawing dated 1646 (Bock-Rosenberg, 1930, I, p. 256, no. 2618, II, pl. 187), and is closer in style and handling to the British Museum's *Landscape with Three Anglers* of 1648 (Hind, *Dutch Drawings*, III, 1931, p. 40, no. 1, pl. XXIII).

PROVENANCE: Possibly Engelbert Michael Engelberts (1773–1843); John, Earl of Northwick (no mark; see Lugt 2445), by descent to Captain E. Spencer-Churchill, Northwick Park; his sale, London, Sotheby's, 1–4 November 1920, lot 201 (to Sabin for £26); Martin B. Asscher, London.

BIBLIOGRAPHY: Morgan Library, *Eighth Report to the Fellows*, 1958, pp. 72–73, repr.; Felice Stampfle, "An Early Drawing by Jacob van Ruisdael," *The Art Quarterly*, XXII, no. 2, 1959, pp. 160–63, repr.; Morgan Library, *Review of Acquisitions 1949–1968*, 1969, p. 166.

EXHIBITIONS: Oberlin, Ohio, Allen Memorial Art Museum, *Youthful Works by Great Artists*, 1963 (catalogue in *Allen Memorial Art Museum Bulletin*, XX, no. 3, no. 14, repr.); Morgan Library, *Major Acquisitions, 1924–1974*, 1974, no. 42, repr.; Poughkeepsie, Vassar, *Seventeenth Century Dutch Landscapes*, 1976, no. 39, repr.

Acc. no. 1957.2

Gift of the Fellows with the special assistance of Mr. and Mrs. H. Nelson Slater

Jan de Bisschop
Amsterdam 1628 – 1671 The Hague

118. *View of Rome*

Pen and brown ink, brown, reddish-brown, and blue-gray washes, over preliminary indications in black chalk. Originally the drawing was executed on two sheets of

paper joined together; the join is evident to the left of center. Some time in the eighteenth century or earlier the drawing was cut to the right of this join and divided into two equal parts. It is exhibited here as a whole, although it is normally mounted in two parts.

Watermark on each sheet: fleur-de-lis within a shield, surmounted by a crown; countermark, cross with letters *IHS* (Heawood 1785). See watermark no. 29.

Part 1: 14 × 19⅝ inches (355 × 500 mm.). Traces of old vertical fold to left of center.

Inscribed by the artist on verso, in pen and brown ink across lower half, reading in the order of the monuments represented on the recto, *Horti Medicei*; *S. Trinità de' Monti*; *Palatium Pontifi / cis in Quirinali*; *Mons Pincius olim Collis hortulorum*; *Capitolium*; *Columna Antonini*; *Aventinus*; *il Giesù*; *Pantheon / hod. La Rotonda*; *S. Andrea della Valle*; *S. Agnese*; *S. Maria del' Anima*. Inscribed at upper center edge of verso, in an old hand, in graphite, *Nº 789*; on mount, in another hand, at lower right corner, in pen and brown ink, *nº 24*.

Part 2: 13¹³⁄₁₆ × 19¾ inches (352 × 502 mm.). Traces of old vertical fold slightly to left of center.

Inscribed by the artist on verso, in pen and brown ink at upper right, *Gesicht van Romen buyten Porta del popolo*; in another hand in black chalk just below preceding inscription, *Door Joan De Bisschop*. Further inscribed by the artist in pen and brown ink, across lower half, *Monte Mario*; *S. Maria in Valli / cella vulgo La Chiesa Nova*; *Palatium / Sfortiaᵉ*; *S. Maria del popolo*; *Porta del popolo seu Flaminia*; *Montes . . . Vaticani*; *S. Gio. Battᵃ de' Fiorentini*; *Castel S. Agnolo seu / Moles Adriani*; *S. Spirito in Sassia*; *Palatium Columnensium*; *Santo Officio*; *Tiberis*; *S. Pietro in Vaticano*; *Prata Quintia vulgo sed rectius Neroniana*; *Belvedere*. At lower left center, in black chalk, possibly in Ploos van Amstel's hand, *h. 13d / b. 40d*. Inscribed in another hand on mount, at lower right within border, in graphite, *Lᶜₐ:ao:-*; and in lower right corner, outside border, in pen and brown ink, *nº 24*.

Jan de Bisschop, a lawyer by profession who lived chiefly in The Hague, was, like his friend Constantijn Huygens the Younger, a highly talented amateur draughtsman. Eventually devoting himself almost exclusively to his art, he produced two handbooks for artists and amateurs containing his etchings after classical sculpture and works principally by Italian masters under the titles *Signorum veterum Icones*, which appeared in two parts in 1668 and then in 1669, and *Paradigmata graphices variorum artificum*, 1671.

This sunlit panorama of Rome, viewed from the Porta del Popolo, is of a quality and freedom to suggest that it was drawn on the spot, or at least compiled from sketches made from nature,

and certainly the quantity of De Bisschop's drawings devoted to Italian subjects argues that he must have visited Italy. (Van Gelder [p. 209] states that about seventy-five are known.) It has been proposed that he traveled to Italy some time before his marriage in 1653 or shortly thereafter in 1654–55, or perhaps 1657. On the verso of the drawing, the artist in his fastidious calligraphy carefully annotated the procession of majestic monuments that punctuate the long horizon line of the drawing. Beginning at the left, one sees in the distance, beyond the sun-tipped foliage and occasional ruin of the foreground, the enclosure of the Medici gardens and the twin towers of S. Trinità de' Monti; the Palazzo del Senatore, the Column of Marcus Aurelius, and Il Gesù; the low-lying dome of the Pantheon and the churches of S. Andrea della Valle and S. Agnese; the larger shape of S. Maria del Popolo (which was closer to the draughtsman), the Tiber, and the Castel S. Angelo with the girandole; and then at the far right St. Peter's and the Vatican. Curiously, St. Peter's is shown with Bernini's ill-fated south tower still in place, and, since it was pulled down in 1646, its inclusion by De Bisschop poses a problem as to the date of his Italian visit. Could he at eighteen—his probable age in 1646—have produced such an accomplished work? Could he have worked on the spot in Rome in the fifties and then completed certain individual details like the façade of St. Peter's from an engraving of earlier date still showing the tower? Or could he have miraculously transformed an engraved model into this lovely *plein-air* vista?

There are two other drawings of the same view, one in the Louvre (Lugt, *École hollandaise, Louvre*, II, 1931, p. 38, no. 767, pl. LI) and one in the De Grez Collection, Musées Royaux des Beaux-Arts de Belgique, Brussels (*Catalogue*, 1913, no. 3681); both were apparently copied after de Bisschop's drawing by Jan van der Ulft (1621–1689), who seems to have made a practice of repeating De Bisschop's drawings. It is to be remarked that Bernini's tower does not appear in either of these repetitions.

141

In the late eighteenth century the Morgan drawing was owned by the Edinburgh collector John MacGowan, who had at least one other Italian view by De Bisschop, the *Walls of Rome* now in the Lugt Collection, Institut Néerlandais, Paris (Inv. no. 4976; Florence, Istituto Universitario Olandese, *Artisti olandesi e fiamminghi in Italia*, 1966, no. 8, pl. XXXIII); it, too, was copied by Van der Ulft (Inv. no. 6481, folio 39), the copy likewise being in the same collection. The Library's drawing had already been divided into parts when it was in MacGowan's possession as each section bears his stamp. The provenance of the drawing which appears below was worked out with the assistance of J. Q. van Regteren Altena, J. G. van Gelder, and Carlos van Hasselt.

The Library also owns two typical examples of De Bisschop's drawings copied after other artists' work, both of them portraits after Van Dyck, one signed with the latinized form of his name, J. Episcopius.

PROVENANCE: Sale, Jeronimus Tonneman, Amsterdam, 21 October 1754, Album B, p. 19, lot 10, "Une Vue de Rome du côté de la Porte del Populo . . ." (to Kok for 19 florins); Gerrit Braamcamp (according to partially obliterated inscription in black chalk[?] on verso of part 2, beginning *N.21 komt uit Gerrit Braamkamps Verk . . .*); his sale, Amsterdam, 31 July 1771, Album A, p. 137, lot 21, "Een Gezicht van een hoogte over de Stad Romen te zien; zeer uitvoerig getekend door J. Bisscop. Hoog. 14, en breed 39 duim"; Johan van der Marck AEgzn (the inscription in graphite on verso of part 2 reading *Door Joan De Bisschop* is in his hand; Lugt 3001); his sale, Amsterdam, 29 November 1773, lot 1999 (to C. Smitt); sale, Coenraad Smitt, Amsterdam, 4 December 1780, Album K, lot 713, " 't Gezigt van de Stad Romen, buiten Porto del Popolo, naar 't Leeven, met de pen en roet geteekend, h. 13, br. 40 duim." (to "Metijer" [Metayer]); Louis Metayer (not identifiable among the summarily described Roman views by De Bisschop in his sale, Amsterdam, 17 February 1799); Cornelis Ploos van Amstel Jb Czn (according to J. Q. van Regteren Altena; possibly on his mount; Lugt 3004); possibly his sale, Amsterdam, 3 March and days following, 1800, II, p. 300, Album NNN, containing 170 drawings "door den grooten Kunstenaar JOANNES DE BISSCHOP" including views of Rome, statues, bas-reliefs, medallions, etc.; John MacGowan (Lugt 1496); his sale, London, T. Philipe, 26 January – 4 February 1804, lot 57, "A long view of Rome, on two sheets, representing the whole extent of that renowned city, as it was about 170 years ago; freely executed with an exqui-

site light pen. The foreground is mostly covered with trees, which are shaded with bistre, and the city and distant ground are in fine keeping, skilfully and lightly tinged with indigo, the whole in perfect harmony. The names of the principal edifices are marked on the back. A curious and rare design." (to Williams for £1.1); Sir William Forbes; presumably descendants of Sir William Forbes, including Mrs. Peter Somervell, Fettercairn House, Kincardineshire; sale, London, Sotheby's, 28 March 1968, lot 89, repr.

BIBLIOGRAPHY: Ekhart Berckenhagen, "Zeichnungen von Nicolas Poussin und seinem Kreis in der Kunstbibliothek Berlin," *Berliner Museen*, N.F. XIX, no. 1, 1969, p. 26, detail illus. p. 25; Morgan Library, *Review of Acquisitions 1949–1968*, 1969, p. 131; J. G. van Gelder, "Jan de Bisschop 1628–1671," *Oud Holland*, LXXXVI, no. 4, 1971, p. 209, fig. 32 (detail); Morgan Library, *Sixteenth Report to the Fellows, 1969–1971*, 1973, pp. 100–01, 109; Berlin, Staatliche Museen Preussischer Kulturbesitz, *Die holländischen Landschaftszeichnungen 1600–1740*, exhibition catalogue by Wolfgang Schulz, 1974, p. 9, under no. 19.

EXHIBITIONS: Morgan Library, *Major Acquisitions, 1924–1974*, 1974, no. 43, repr.; Poughkeepsie, Vassar, *Seventeenth Century Dutch Landscapes*, 1976, no. 43, repr.; New York, Metropolitan Museum of Art, *Roman Artists of the Seventeenth Century: Drawings and Prints* [checklist by Jacob Bean and Mary L. Myers], 1976–77, n.p.

Acc. no. 1968.6

Gift of the Fellows

Ludolf Backhuyzen

Emden 1631 – 1708 Amsterdam

119. *The "Amsterdam" under Sail off a Port*

Point of brush and black ink and gray wash, over faint indications in graphite. Faint traces of old vertical crease at center; foxing.

10⁹⁄₁₆ × 14¼ inches (268 × 362 mm.).

Watermark: arms of Amsterdam with letters *AJ*; countermark, letters *PR*. See watermark no. 3.

Signed with initials in brush and black ink, at lower left, on floating barrel, *LB*; dated on the "Amsterdam's" flag, *1688*. Inscribed on verso, by Ploos van Amstel, in pen and brown ink, at lower left, *L: Bakhuizen f | h: 10 ½ dᵐ | b:14 ½ dᵐ*; in another hand, in lower left corner, in graphite, over dry stamp of Ploos van Amstel, *L:N5 | fLhu | N⁰505*; in still another hand, above that, in graphite, *14*.

With the departure of the Van de Veldes for England late in 1672 or early 1673, Backhuyzen became the leading marine painter in the Netherlands, the last representative of a tradition

that reached its high point under Jan van de Cappelle and Willem van de Velde the Younger (see No. 120). He was a fertile draughtsman whose drawings commanded high prices in his day and were often copied. Mr. M. S. Robinson, the British authority on marine draughtsmanship, kindly supplied the following information concerning the Morgan sheet. "In view of the date 1688 inscribed on the flag, there can be little doubt that this ship is intended as the *Amsterdam,* a vessel of sixty-four guns built in 1688 and belonging to the Admiralty at Amsterdam; it was sold in 1712. It is not the same ship, likewise displaying the Amsterdam arms on the stern, which is shown in plate one of Backhuyzen's set of ten etchings of 1701 (Hollstein, I, 1949, p. 54, no. 1; Dutuit 1); but it is the same *Amsterdam* that is shown in the etching *Seaport with a Rock* (Hollstein, p. 59, no. 11; Dutuit 11) where the ship is seen in a gale. There was a painting by Backhuyzen related to this etching with Brian Koetser, London, about 1975; it shows the *Amsterdam* of 1688 in great detail." Given the size of the present drawing, one might add that the artist as was his wont also depicted considerable detail here. The precision with which the numerals of the date on the flag are drawn is in keeping with the artist's early role as an instructor in calligraphy. The date on the flag may well be that of the drawing as well as that of the ship.

PROVENANCE: Cornelis Ploos van Amstel Jb Czn (Lugt 2034, 3003-04); his sale, Amsterdam, 3 March 1800, Album P, lot 1 (to Yver for 305 florins); Robert Stayner Holford (Lugt 2243); his sale, London, Christie's, 11–14 July 1893, lot 616 (to Davis for £10); Charles Fairfax Murray; J. Pierpont Morgan (no mark; see Lugt 1509).

BIBLIOGRAPHY: Fairfax Murray, III, no. 220, repr.

Acc. no. III, 220

Willem van de Velde the Younger
Leyden 1633 – 1707 London

120. *Ships in a Heavy Sea*

Pen and brown ink (probably iron gall ink which has eaten through the paper in a few areas), over preliminary indications in black chalk, touches of white chalk, on blue paper.
9¾ × 15⅜ inches (248 × 385 mm.).
Watermark: none visible through lining.
Signed in pen and brown ink, with initials and dated[?] at lower right margin, *W.V.V J 170. . . .*

Most of the drawings on blue paper by Willem van de Velde the Younger, the foremost Dutch marine painter of the seventeenth century, are regarded as late works dating around 1700. They were thus executed in England where the artist and his father of the same name had lived since 1672–73 in the service of Charles II and James II, although they visited Holland from time to time. In recent correspondence, Mr. M. S. Robinson, the cataloguer of the collection of more than fourteen hundred drawings by the two Willem van de Veldes in the National Maritime Museum, Greenwich, wrote that the Morgan drawing, like various others made toward the end of the younger Van de Velde's life, was no doubt intended to be carried out in oils. Some of these later sketches deal with shipwrecks or ships in a gale, perhaps inspired by the Great Storm of November 1703, which affected the whole of the south of England and the Channel and resulted in the loss of twelve or thirteen ships of the British navy (see the contemporary account of "the Hurecan & Tempest" by John Evelyn [*The Diary of John Evelyn*, E. H. de Beer, ed., Oxford, 1955, V, pp. 550–52]). Assuming that the first three numerals of the date on the present sheet have been properly read, one can at least speculate that the missing numeral was possibly a three or a four, and the drawing may thus reflect the draughtsman's concern with the impact of the Great Storm. He had, of course, long observed the action of ships in a stormy sea as witness such a picture as *Three Ships in a Gale* in the National Gallery, London, which is dated London, 1673 (MacLaren, *The Dutch School*, Plates, 1958, p. 358, Text, 1960, no. 981). The manner in which the present sheet is signed with the initials *W.V.V J* with no period after the second "V" is typical. The "J", of course, stands for "(de) Jonge" (younger).

143

One cannot quarrel with Fairfax Murray's assessment of this sheet when he first acquired it in 1891, "a fine free drawing—like a Guardi" (recorded in autograph Manuscript Notebooks, University of Texas, Austin). And, one might add, it is executed with the remarkable accuracy for which the draughtsman is noted in the rendering of ships, even in such a swift compositional study.

PROVENANCE: Charles Fairfax Murray; J. Pierpont Morgan (no mark; see Lugt 1509).

Acc. no. I, 148a

Nicolaes Maes, attributed to

Dordrecht 1634 – 1693 Amsterdam

121. *Woman Asleep in a Chair*

Pen and brown ink, brown wash; slight corrections in white tempera.
7¹³⁄₁₆ × 6¹⁄₁₆ inches (200 × 153 mm.).
Watermark: none.
Inscribed on mount, in graphite, in Robinson's hand, *J C Robinson / From Lord Palmerston's Coll^n*.

This sympathetic rendering of a sleeping maidservant, drawn from life, has been variously assigned to Rembrandt and to several of his pupils. When it appeared in the Palmerston sale in 1891 it was listed as the work of Eeckhout but Hofstede de Groot classed it as Rembrandt in his 1906 catalogue and it was originally so accepted by various scholars, including Lugt (R.K.D. Rembrandt card file, no. 2470) and Benesch. The latter, however, eventually rejected that attribution in favor of Eeckhout according to his penciled note on the mount, although this name is not mentioned in his entry on the drawing in his Rembrandt Corpus where it is listed under the section headed Attributions. Valentiner included the drawing in his monograph on Maes, and the evidence that can be adduced in support of such an attribution seems to warrant retention of the sheet under that name, at least for the time being.

The most significant comparison is offered by two drawings representing a woman scraping a parsnip, both formerly in the collection of the Earl of Dalhousie (Valentiner, pp. 38–39, figs. 42–43); one of these is now in the Lugt Collection, Institut Néerlandais (Valentiner, fig. 43; Chicago, *Rembrandt after Three Hundred Years*, 1969, p. 199, no. 199, repr. p. 258). According to Sumowski, the other drawing was some years ago in the possession of L'Art Ancien at Zurich as School of Rembrandt. One is tempted to speculate that these two studies represent the same young woman as the Morgan one, only seen awake and working, posed slightly less frontally, and, in the case of the Lugt drawing, displaying the same high, well-lighted forehead and similar shadowed downcast countenance. The other Dalhousie drawing is more analogous technically in that it is executed with the pen and some wash whereas the Lugt sheet is drawn with the brush; one remarks the broad brush strokes defining the shadow at the right of the figure and the similar use of diagonal pen strokes in conjunction with wash in the shadows. Some of the same effects are also evident in *The Lace-maker* at Rotterdam (H. R. Hoetink, *Tekeningen van Rembrandt en zijn school . . . Museum Boymans-van Beuningen*, Rotterdam, 1969, pl. 126); while executed in red chalk, that drawing is comparable in the frontal concept of the figure, the head likewise characterized by the large, highlighted forehead and downward gaze, and the same use of diagonal parallel hatching in the shadows. The former Dalhousie drawings are preparatory for the painting *A Woman Scraping a Parsnip* in the National Gallery, London, which is signed and dated 1655 (MacLaren, *The Dutch School*, Plates, 1958, p. 186, Text, 1960, p. 228, no. 159) and the Boymans study is connected with the painting likewise signed and dated 1655, formerly in the Liechtenstein Gallery, Vienna, and now in the National Gallery of Canada at Ottawa (R. H. Hubbard, ed., *The National Gallery of Canada: Catalogue of Paintings and Sculpture, I, Older Schools*, Ottawa, 1961, p. 86, repr.). Such a date is compatible with the style of the Morgan drawing, reflecting as it does

Rembrandt's manner of the period when Maes was in his studio, presumably very late in the 1640's and early in the 1650's.

PROVENANCE: Henry Temple, second Viscount Palmerston (1739–1802); Hon. Evelyn Ashley (by bequest from Lord Palmerston); his sale, London, Christie's, 24 April 1891, one of five in lot 147, "Eeckhout. The Nativity; and a Young Woman Sleeping"; Sir John Charles Robinson; possibly his sale ["Well-Known Amateur"], London, Christie's, 12–14 May 1902, lot 199, "Maes (Nicholas). Woman Asleep – red chalk and bistre"; Charles Fairfax Murray; J. Pierpont Morgan (no mark; see Lugt 1509).

BIBLIOGRAPHY: Fairfax Murray, I, no. 199, repr. (as Rembrandt); Hofstede de Groot, *Rembrandt*, 1906, no. 1107 (as Rembrandt); F. Schmidt-Degener, "Tentoonstelling van Rembrandts teekeningen in de Bibliothèque Nationale te Parijs," review of Paris, *Rembrandt*, 1908 exhibition, *Onze Kunst*, XIV, 1908, p. 104 (as Rembrandt); W. R. Valentiner, *Nicolaes Maes*, Stuttgart, Berlin, Leipzig, 1924, fig. 49 (as Maes); Benesch, *Werk und Forschung*, 1935, p. 61 (as Rembrandt); M. D. Henkel, *Catalogus van de Nederlandsche teekeningen in het Rijksmuseum te Amsterdam, I: Teekeningen van Rembrandt en zijn school*, The Hague, 1942, p. 97, under no. 9 (as Rembrandt); Benesch, 1954–57, VI, no. A105, fig. 1704 (1973, fig. 1772; not by Rembrandt or Maes); L. C. J. Frerichs, "Nieuw licht op een oud opschrift," *De Kroniek van het Rembrandthuis*, XXIV, no. 2, 1970, pp. 37–40, fig. 2 (as Rembrandt School).

EXHIBITIONS: London, Royal Academy, *Rembrandt*, 1899, no. 107; Paris, *Rembrandt*, 1908, no. 397, repr.; New York Public Library, *Morgan Drawings*, 1919, n.p.; San Francisco, *Rembrandt from Morgan Collection*, 1920, no. 400; Chicago, *Rembrandt*, 1935–36, no. 57; Worcester, *Rembrandt*, 1936, no. 56.

Acc. no. I, 199

Abraham van Dyck, attributed to

Active c. 1640 – 1670

122. *Old Woman Seated, Holding a Book*

Pen and brown ink, brown and gray washes, some red chalk, over preliminary indications in black chalk. 5⅚₆ × 5⅜ inches (150 × 137 mm.).
Watermark: none.
Inscribed on verso, at lower left corner, in graphite, probably a dealer's code, *BdBo / ss ils.wok.* Inscribed on old mount, in graphite, *Rembrandts Mother.*

Like the preceding drawing, this strong study of an elderly woman, who has momentarily closed

her book—no doubt the Bible—to ponder the passage she has just been reading, is assigned to various Rembrandt pupils as well as to the master himself. Fairfax Murray in 1905 in the introduction to the first volume of his catalogue commented that his retention of a number of drawings under Rembrandt's name would "doubtless find objectors; an example in point is the study of an old woman with a book on her knees, No. 194, which has been claimed, not without some reason, for Nicholas Maas [*sic*], but as it seems to be a study for a picture in the Hermitage, to which it is in no way inferior, I have chosen to retain the old name under which it was acquired for [*sic*] the Aylesford collection, at an exceptionally high price considering the date of its purchase." (Where it was acquired, Fairfax Murray does not reveal.) Lugt, too, in 1933 connected the Morgan drawing with the Leningrad picture but associated it and the painting with the name of Karel van der Pluym. The Leningrad painting (W. R. Valentiner, *Rembrandt*, Klassiker der Kunst, Stuttgart-Leipzig, 1909, 3rd ed., p. 444), however, is no longer credited to Rembrandt or Van der Pluym. Most recent opinion favors the execution of Abraham van Dyck, whose name it appears was first suggested by Hans Schneider (R.K.D.). Drawing and painting do not agree in all details, but the general concept and pose, especially the position of the hand and arm in relation to the half-opened book, are significantly similar. The source of Van Dyck's inspiration, as has been observed, undoubtedly lay in Rembrandt's drawing showing an old woman seated with a half-opened book on her knees and a cat playing at her feet, the sheet formerly in the Kunsthalle, Bremen (Benesch, no. 1166). Benesch dated that drawing 1656–57. Dr. Werner Sumowski generously made available the manuscript text of his entry for the Morgan drawing in his forthcoming seven-volume work *The Drawings of the Rembrandt School* published by Abaris Books, Inc. He comments on the Morgan drawing as Van Dyck's preliminary study for the Leningrad painting, classing both as relatively early work of the artist, though

beyond the period of his apprenticeship, and citing the influence of Nicolaes Maes as well as that of Rembrandt.

Among the drawings attributed to Van Dyck, the Morgan sheet is best compared with the study of the head and shoulders of a young woman formerly in the Kunsthalle, Bremen, a drawing apparently signed with the monogram and dated in the lower right corner; the date, however, was largely obliterated when that area of the drawing unfortunately was damaged by fire (Bernt, *Zeichner*, I, 1957, no. 204). Both drawings are executed in similar mixed media with a pleasing contrast of browns and reds, and common to each is the use of small passages of fine diagonal hatching, noticeable, for example, in the headdress and cuff of the sleeve of the Morgan figure.

PROVENANCE: Possibly Jonathan Richardson, Sr. (no mark; see Lugt 2183–84); possibly his sale, London, Mr. Cock, 22 January – 10 February 1747, lot 22 (2 February), "Four, Rembrandt, portrait of an old woman sitting, madonna, heads, etc." (to Chauncey for £0.3.4); possibly Simon Fokke; possibly his sale, Amsterdam, Van der Schley, 6 December 1784, Album O, lot 928 (as Rembrandt), "Een zittend bedaagd Vrouwtje halverlyf, rustende met de hand op een Bybel, 't Hoofd bedekt met een linnen Sluier, zy schynt iets aandachtig te overweegen; zeer kragtig met roet en Oostind. Inkt geteekend" (40 florins); Heneage Finch, fifth Earl of Aylesford (Lugt 58); his sale, London, Christie's, 17–18 July 1893, lot 266 (as Rembrandt), "Portrait of an Old Woman, called Rembrandt's Mother" (to Murray for £4.15); Charles Fairfax Murray; J. Pierpont Morgan (no mark; see Lugt 1509).

BIBLIOGRAPHY: Fairfax Murray, I, no. 194, repr., and Introduction, n.p., paragraph 3 (as Rembrandt, but related to domestic scenes by Maes); John Kruse and Karl Neumann, *Die Zeichnungen Rembrandts und seiner Schule im Nationalmuseum zu Stockholm*, The Hague, 1920, p. 82 (as Maes); Louis Demonts in *Les Accroissements des musées nationaux français, III: Le Musée du Louvre en 1920, dons, legs, et acquisitions*, 1921, n.p., under pl. 22b (as Maes); John Charles Van Dyck, *The Rembrandt Drawings and Etchings*, New York–London, 1927, p. 113 (as Maes); Lugt, *École hollandaise, Louvre*, III, 1933, under no. 1313 (as Karel van der Pluym); Benesch, 1954–57, V, p. 326, under no. 1166 (1973, p. 312, under no. 1166; as Abraham van Dyck).

EXHIBITIONS: Paris, *Rembrandt*, 1908, no. 398; Chicago, *Rembrandt*, 1935–36, no. 56; Worcester, *Rembrandt*, 1936, no. 56.

Acc. no. I, 194

146

Adriaen van de Velde
Amsterdam 1636 – 1672 Amsterdam

123. *Pastoral Scene at a Waterfall*

Point of brush, black and gray ink. Horizontal crease at upper margin; some light foxing.
9½ × 13¹⁵⁄₁₆ inches (242 × 354 mm.).
Watermark: hunting horn within a shield, surmounted by a crown (cf. Heawood 2725). See watermark no. 44.
Signed and dated, in pen and brown ink, at lower left, *A. V. Velde. F. | 1662.* Numbered on verso, at upper left margin, in graphite, *8*; inscribed at lower left corner, dealer's code, *dJ |JLS-LOS-:* and below that, in another hand, *|LfJ.*

Adriaen van de Velde, younger brother of Willem van de Velde the Younger (see No. 120), was only thirty-five when he died in January 1672, and only twenty-six when he composed this bucolic landscape showing herdsman and shepherdess with a variety of animals in an Italian setting. A year later in 1663, as William W. Robinson has recently pointed out, he based a painting on the highly finished drawing. Both painting and drawing, interestingly enough, were together in the Holford Collection in the mid-nineteenth century. The painting (Hofstede de Groot, IV, no. 216), more recently in the collection of Baron Heinrich Thyssen-Bornemisza, Lugano, and then of his daughter Baroness Gabrielle Bentinck, Paris, was sold at Christie's on 25 March 1977 as lot 61 to De Welt. It is executed in the small format preferred by the artist (18½ × 24 inches [47 × 61 cm.]), a little less than twice the size of the drawing; it differs from the drawing chiefly in the opening up of the composition on the right where in the distance the artist added several small figures and animals along with a few more trees. The staffage, human and animal, he transcribed without the alteration of a single detail. A gifted, sympathetic animal draughtsman, Van de Velde is reported by Houbraken to have made weekly excursions into the fields to sketch the cattle and the countryside (*De groote schouburgh der Nederlandtsche konstschilders ... III*, Amsterdam, 1721, p. 90), and the cows of the drawing as well as

the delightful group of the nanny goat and her kids were undoubtedly based on studies from nature. The goat family occurs without change in *Troupeau au pâturage*, a drawing in the Louvre likewise dated 1662, and two of the cows and the sheep are repeated in identical poses but differently placed in the same sheet (Lugt, *École hollandaise, Louvre*, II, 1931, no. 783). Van de Velde was also a capable figure draughtsman, much called upon to supply staffage for the landscapes of such contemporaries as Van Ruisdael, Hobbema, Koninck, Van der Heyden, and Wijnants. As the English edition of the present catalogue went to press, Dr. Hans-Ulrich Beck of Augsburg called attention to a copy of this drawing by Jacob van de Velden that appeared in his sale in Amsterdam on 3 December 1781 in Album B62 (to Ploos van Amstel for 61.10 florins).

PROVENANCE: Jonkheer Johan Goll van Franckenstein the Younger (1756–1821; his *No. 4025*, in brown ink on verso, Lugt 2987); Jonkheer Pieter Hendrik Goll van Franckenstein (1787–1832); his sale, Amsterdam, 1 July 1833, p. 75, Album T, lot 1 (to Woodburn for 900 florins); Samuel Woodburn (no mark; see Lugt 2584); C.J. Nieuwenhuys, Brussels, Belgium, and Oxford Lodge, Wimbledon, England (according to Charles Fairfax Murray); Robert Stayner Holford (Lugt 2243); his sale, London, Christie's, 11–14 July 1893, lot 676 (to Salting for £46); George Salting (no mark; see Lugt 2260–61); Charles Fairfax Murray; J. Pierpont Morgan (no mark; see Lugt 1509).

BIBLIOGRAPHY: Fairfax Murray, I, no. 149, repr.; William W. Robinson, "Preparatory Drawings by Adriaen van de Velde," *Master Drawings*, XVII, no. 1, 1979, p. 20, no. C-2.

EXHIBITION: Ann Arbor, Michigan, *Italy through Dutch Eyes*, 1964, no. 65, pl. XIX.

Acc. no. I, 149

124. *Study of a Mule*

Red chalk. Some light foxing.
7¾ × 9⅝ inches (196 × 245 mm.).
Watermark: foolscap with seven points (cf. Heawood 2003). See watermark no. 35.
Signed with initials, in red chalk, at lower left, *A.V.V.*

A number of Van de Velde's animal studies, already much prized in his own lifetime, are exe-

cuted in the red chalk of this skillful drawing of the trim little mule and the detail of the wooden saddle. The blinkered animal engrossed in the contents of its feedbag was as patient a model as the ruminant cattle the artist drew in the meadows. There are a half-dozen examples of the latter in the Library's collection, several of which William W. Robinson has shown Van de Velde utilized in his paintings (Acc. nos. III, 226, and III, 226a; "Preparatory Drawings by Adriaen van de Velde," *Master Drawings*, XVII, 1979, no. 1, pp. 22–23, nos. D-23 and 26). The Library also owns several of the artist's quick pen-and-wash sketches that preceded finished drawings of the type of No. 123. Robinson (p. 19, no. B-15) pointed out, for example, that Morgan Acc. no. I, 152b is preliminary to the finished drawing of 1671 in the Albertina (Inv. no. 10 145).

PROVENANCE: Jacob de Vos (1735–1831; no mark; see under Lugt 1450); his sale, Amsterdam, "in het Huis met de Hoofden," 30 October 1833, p. 62, Album V, lot 12, "Een staande Muilezel. Met rood krijt, door A. van de Velde" (to Hulswit for 60 florins); possibly sale, Gérard Leembruggen Jz., Amsterdam, Roos . . . , 5 March 1866, lot 656, "Une ane – Un mouton. Deux dessins à la sanguine" (to Gruijter for 12.25 florins); Jacob de Vos Jbzn (Lugt 1450); possibly his sale, Amsterdam, Roos, Muller . . . , 22–24 May 1883, lot 553, "Du Bétail. – Six dessins à la sanguine" (to Thibaudeau for J.P.H. for 300 florins according to J. P. Heseltine's copy of the sale catalogue, now in the Institut Néerlandais; Heseltine marked the lot with two stars [that is, very desirable] and wrote the word "dog" below, so presumably there was among the six sheets the drawing of a dog which he kept, and then disposed of the remaining drawings); Charles Fairfax Murray; J. Pierpont Morgan (no mark; see Lugt 1509).

BIBLIOGRAPHY: Fairfax Murray, I, no. 151, repr.

Acc. no. I, 151

Caspar Netscher
Heidelberg 1639 – 1684 The Hague

125. *Woman at a Window*

Point of brush, black ink, gray, pale yellow, and brown washes, touches of red chalk; extraneous brown ink on right sleeve. Silhouetted arched section containing the

147

figure pasted on another sheet on which the artist drew the rusticated stone arch.

9³⁄₁₆ × 6⁷⁄₈ inches (233 × 175 mm.).

Watermark: none visible through lining.

Signed with point of brush and black ink, at lower right of center, *CN*(interlaced)*etscher*. Inscribed on verso, in graphite, at lower left corner, *6a*; below that, in pen and brown ink, *Ecole du Païs-Bas / Netscher*; at lower right center, in graphite, *6/10/–* and below that, in another hand, *6629/R/X/X*.

Netscher, the German-born pupil of Gerard Ter Borch, began his career as a painter of genre and subject pictures but eventually became a successful portraitist whose services were much in demand in court circles at The Hague. Often, as here, he frequently posed his figures of women, children, or couples within the embrasure of an arched window opening, a compositional device popularized by Gerrit Dou and frequently employed by Metsu. The attractive Morgan sheet is connected with a small panel painting (9³⁄₄ × 7³⁄₄ inches), perhaps a school piece, that was formerly in the hands of Victor D. Spark in New York. The woman in the painting was surely painted from life but she is more than a portrait as the letter she holds in her hand is inscribed BATHSE. The toilet articles of flask and sponge, cursorily represented at her left in the drawing but more readily identifiable in the picture, are therefore discreet reference to David's observation of Bathsheba at her bath in the biblical account in Samuel 2:2–17. The woman of the painting, though identical in pose and dress, and even in her half-smiling expression that suggests an awareness of the artist, is heavier in body and countenance, and lacks the piquant charm of the lighter figure of the drawing.

It will be observed that the drawing was made in two stages; the architectural framework of yellow rusticated stone is drawn on the sheet of paper on which the silhouetted arched section containing the figure had been pasted beforehand. The painting, which may have been cut down, leaves off at the top of the arch just above the curtain and at the bottom near the edge of the rug, and the rectangular panel below the window ledge lacks the rosettes and scrolls that were added in the enframement of the drawing. Further, the stone of the window is not rusticated nor is there any indication of the brickwork. One might wonder if the artist, intrigued by the charm of the likeness he had achieved in the drawing, devised an architectural setting in color to set off the spontaneously brushed portrait as an independent work.

PROVENANCE: Paignon Dijonval (1708–1792), Paris; Charles-Gilbert, Vicomte Morel de Vindé (no mark; see Lugt 2520); sold in 1816 to Samuel Woodburn (no mark; see Lugt 2584); Thomas Dimsdale (Lugt 2426); Samuel Woodburn; Miss James, London; her sale, London, Christie's, 22–23 June 1891, lot 217; Charles Fairfax Murray; J. Pierpont Morgan (no mark; see Lugt 1509).

BIBLIOGRAPHY: Bénard, *Cabinet de M. Paignon Dijonval*, 1810, p. 34, no. 1071; Fairfax Murray, I, no. 156, repr.; J. G. van Gelder, *Dutch Drawings and Prints*, New York, 1959, p. 49, no. 123, repr.

Acc. no. I, 156

126. *Portrait of the Artist's Daughter Isabella*

Point of brush and pen, brown ink and wash, over preliminary indications in black chalk; extraneous spots of gray wash at left.

4¹⁄₁₆ × 4¹⁄₈ inches (103 × 105 mm.).

Watermark: none.

Inscribed on verso, in pen and brown ink, across lower edge, *Netscher geteykent naer Isabella Netscher / Anno 1673. in Septemb.*; numbered above inscription, in graphite, *24*; numbers, in pen and brown ink, at upper right corner, crossed out, *2 7 o[?]*; at left center edge, inscribed in graphite, *SxScL*. Inscribed on old mount, in an old hand, at center, in graphite, *ES*.

There is nothing of the artifice of the fashionable portraitist in Netscher's intimate small likeness of his three-year-old daughter, whose soft rounded features he drew in profile. The sixth-born of his twelve children, she was the first of his three daughters, born with her twin brother Alexander on 26 August 1670 and christened Isabella Amaranth. A certain poignancy attaches to the portrait for despite the poetic significance of the name Amaranth (in Pliny the name of some real or imaginary unfading flower,

hence everlasting), the little girl died some time before 18 March 1678 when another child, also christened Isabella Amaranth, was born. Her twin Alexander did not survive either; a second child of that name was born 15 January 1677. Nine of Netscher's children, however, survived him to share in an inheritance of eighty thousand florins.

PROVENANCE: Sale, W. N. Lantsheer (The Hague) and Jeronimo de Vries (judge at Amsterdam), Amsterdam, Frederik Muller & Co., 3–4 June 1884, lot 234 (96 florins); W. F. Piek, Amsterdam; his sale, Amsterdam, Frederik Muller & Co., 1–2 June 1897, lot 181 (to Vincent van Gogh, the bookseller, for 25 florins); Charles Fairfax Murray; J. Pierpont Morgan (no mark; see Lugt 1509).

BIBLIOGRAPHY: Fairfax Murray, I, no. 157, repr.

Acc. no. I, 157

hour and a half—it took him to walk to Es from 's Hertogenbosch in North Brabant. One surmises that the year 1681 was a mild one in Holland since De Grave, undoubtedly a precisionist by nature, showed the trees still in leaf at the end of November, rendering the foliage with his usual formula of looping strokes of pen and brush. He further observed the one open shutter, that on the right window of the upper story of the house.

PROVENANCE: Walter Schatzki, New York.

BIBLIOGRAPHY: Morgan Library, *Twelfth Report to the Fellows, 1962*, 1963, pp. 81–82; Morgan Library, *Review of Acquisitions 1949–1968*, 1969, p. 148.

EXHIBITION: Washington, D.C., and elsewhere, *Seventeenth Century Dutch Drawings*, 1977, no. 82, repr.

Acc. no. 1962.2

Josua de Grave

Amsterdam 1643 – 1712 The Hague

127. *House at Baerschot*

Pen and brown ink, gray wash, over faint indications in black chalk on two pieces of paper pasted together at right quarter.
6⅞ × 17⁷⁄₁₆ inches (174 × 443 mm.).
Watermark: fragment of arms of Amsterdam, with three crosses within a shield (cf. Heawood 348–365); illegible countermark. See watermark no. 5.
Signed, dated, and inscribed by the artist, at lower center, *Josua de Grave: 1681 11 maent | 20-dagh* [20 November]; at upper right, *1: Thuÿs te Baerschot | 2:Dorp: Es: omtrent anderhalf- | uur:gaens van: s'hartogenbos:*. Numbered by the artist, at the center, above the house, *1:*; at the left, above the village church, *2.*

A great many of De Grave's drawings were executed during the years 1672–76 when he served as an engineering officer with the army of the States General under Prince William III of Orange, the Stadholder who later (1689) became King of England. It was possibly in this capacity that he acquired the practice of annotating his drawings very precisely as to place and date. In this characteristically neat view of a country house on the outskirts of the village of Es, he added further information as to the time—an

Johannes Leupenius, attributed to

Amsterdam 1643 – 1693 Amsterdam

128. *View of the Sea over Rooftops*

Pen and brown ink, brown wash.
4³⁄₁₆ × 7¾ inches (106 × 197 mm.).
Watermark: none.
Numbered on verso, in graphite, at lower left, *188.*

The identity of the artist, who, from a vantage point among the chimney pots, drew this unusual view of rooftops with the sea—or a river —in the distance, is problematical. The drawing is listed here under the name of Leupenius, surveyor and mapmaker as well as etcher, to whose hand the drawing was assigned in the latter part of the nineteenth century when it appears to have been in either the collection of J. H. Cremer, at one time Dutch Consul General in Switzerland, or of a Mr. F—— of London. It seems preferable to retain the traditional attribution for the present rather than to consign the sheet to the anonymity of the Rembrandt School. However, the Morgan sheet bears little relationship to such signed drawings by Leupenius as that dated 1665 in the Alber-

149

tina and the signed but undated example in the Rijksprentenkabinet, Amsterdam (Chicago, *Rembrandt after Three Hundred Years*, 1969, nos. 190–91, repr.). Probably the names of other artists of the Rembrandt circle should be considered, among them Jacob Koninck and Abraham Furnerius. In connection with the last name, one might cite as a comparison *The Rhine at Doorwerth* in the Institut Néerlandais (Brussels, Bibliothèque Royale Albert Ier, and elsewhere, *Dessins de paysagistes hollandais du XVIIe siècle . . .*, 1968–69, exhibition catalogue by Carlos van Hasselt, I, no. 57, II, pl. 75). Whoever the draughtsman, he was a man of some independence in his choice of subject matter. One is hard put to find another lofty city view of the period other than that suggested by Jan van Gelder, namely, Hercules Seger's unique etching, *View of the Noorderkerk from the Window*, in the Rijksprentenkabinet, Amsterdam, although a Rembrandt School drawing from the Dyce Collection in the Victoria and Albert Museum, London (*Dyce Collection: A Catalogue of the Paintings, Miniatures, Drawings . . .*, London, 1874, p. 65, no. 432; Gernsheim Corpus, no. 53 331), likewise shows an aggregation of houses and their chimneys seen by an artist looking down on them and their gardens.

PROVENANCE: Sale, J. H. Cremer, the late Monsieur F—— of London, and L. T. Zebinden of Zwolle (this last collection begins with lot 309), Amsterdam, Frederik Muller & Co., 15 June 1886, lot 188; W. F. Piek, Amsterdam; his sale, Amsterdam, Frederik Muller & Co., 1–2 June 1897, lot 157 (to Vincent van Gogh, the bookseller, for 26 florins); Charles Fairfax Murray; J. Pierpont Morgan (no mark; see Lugt 1509).

Acc. no. I, 222a

Caspar van Wittel
Amersfoort 1653 – 1736 Rome

129. *View of Urbino*

Pen and brown ink, over graphite, gray wash, squared in red chalk, on three sheets of paper pasted together. Some foxing. Verso: Sketch in pen and brown ink, over graphite, of S. Bernardino degli Zoccolanti and a villa in the environs of Urbino.
10⅞ × 43¾ inches (277 × 1110 mm.).
Watermark: fleur-de-lis within a double circle surmounted by a *V* (cf. Heawood 1591). See watermark no. 17.
Numbered on verso, probably by Vincenzo Pacetti, in lower left corner, in black chalk, *263*; and inscribed, in another hand, in upper right corner, *Urbino*.

The artist has represented a view of Urbino, rising high from the summit of two hills and surrounded by impressive walls, as the town offers itself to travelers arriving from Tuscany and Umbria. The most striking feature is the southwest wall of the Palazzo Ducale, between the two characteristic high turrets, built in the second half of the fifteenth century at the order of Federico da Montefeltro. To the left of the Palazzo Ducale, the Duomo is seen with its cupola, campanile, and three high apses. At the far left of the middle sheet of the drawing, the Porta di Valbona is shown, and, in the background behind it, the church of S. Francesco. Outside the walls, at the extreme right of the drawing, is the church of S. Bernardino degli Zoccolanti where the Dukes of Urbino are buried; there is also another sketch of the church on the verso.

This panorama, drawn with the pen in brown ink over a sketch in pencil, with occasional washes in gray, clearly demonstrates the artist's working method. Sitting at a distance, Van Wittel first sketched in pencil the outlines of the hilly countryside, the scattered groves, and the main part of the town. After that he reinforced the essential lines with the pen, emphasizing the structure of the palace, the major churches, and the houses. Often he merely indicated one or two windows or arches instead of the whole sequence. The drawing is executed on three sheets of paper pasted together, as is often the case with Van Wittel's panoramas on this large scale.

The sketchy manner, the way in which the artist grasps the quintessence of the view, the regular scalloping of the tree tops, and the use mainly of pen probably indicate an early stage in his development. Compare the stylistically closely related view of Ariccia in Berlin, D.D.R., datable before 1686 (Giuliano Briganti, *Gaspar*

van Wittel, Rome, 1966, no. 9ᵈ; An Zwollo, *Hollandse en Vlaamse veduteschilders te Rome 1675–1725*, Assen, 1973, fig. 196). The *View of Urbino* is one of a group of large-scale views, to which belong among others a view of Anzio in the Rijksprentenkabinet, Amsterdam, also from the Fatio Collection, Geneva (Briganti, no. 3ᵈ; Zwollo, fig. 194), and some views of Frascati and Bracciano in the Biblioteca Nazionale, Rome. One of the two Frascati views, both of which are squared in red chalk like the present drawing (Briganti, nos. 190ᵈ and 193ᵈ), is dated 1685. Caspar van Wittel arrived in Rome about 1674 as a young man and spent most of his life there until his death in 1736. These panoramic drawings indicate that already in his early years he was roaming the Campagna and traveling farther afield, filling his sketchbook with landscapes and views that struck him particularly.

In the "Vita" written by Lione Pascoli (1730–36) it is stated that Caspar van Wittel went to Urbino, taking his son Luigi with him, when the latter was about eighteen years old, that is to say about 1718 (Zwollo, Appendix I, p. 204). However, as the style of the drawing points to an earlier phase, this panorama may suggest an even earlier visit to Urbino, perhaps in the 1680's.

Text by An Zwollo

PROVENANCE: Bartolommeo Cavaceppi (d. 1799), Rome; Vincenzo Pacetti (d. 1820), Rome; Michelangelo Pacetti (b. 1793; Lugt 2057 and Lugt S.), Rome; Paul Fatio, Geneva.

BIBLIOGRAPHY: Morgan Library, *Eighth Report to the Fellows*, 1958, pp. 73–74; Morgan Library, *Review of Acquisitions 1949–1968*, 1969, p. 174.

Acc. no. 1956.10

Cornelis Dusart
Haarlem 1660 – 1704 Haarlem

130. *The Chairmender*

Pen and point of brush, brown ink and wash, over preliminary indications in graphite.
7⅞ × 6⅛ inches (201 × 155 mm.).
Watermark: none visible through lining.
Inscribed on verso, in graphite, at upper center, *35*; below that in another hand, *29*; and below that in still another hand, *Dusart.*; in lower left corner, in pen and brown ink, *o /*.

Dusart, many of whose drawings deceptively ape the manner of Adriaen van Ostade, his teacher (see Nos. 88–91), is seen here working in a more individual style. There are a number of these quick, lively, almost caricatural sketches, executed with strong contrasts of light and dark, and representing hawkers and peddlers. None of Dusart's numerous prints, however, though they include series of the Months, the Ages of Man, the Five Senses, etc., are devoted to a sequence of trades. Other typical examples of these street types are found in the Rijksprentenkabinet, Amsterdam; the Kunsthalle, Hamburg; the Albertina, Vienna; and in the museum at Weimar. The Morgan traveling artisan jauntily carries his wares on his head and a bundle of straw under his arm with which to reweave the chair seats.

PROVENANCE: Paignon Dijonval (1708–1792), Paris; Charles-Gilbert, Vicomte Morel de Vindé (no mark; see Lugt 2520); sold in 1816 to Samuel Woodburn (no mark; see Lugt 2584); Edward Vernon Utterson (Lugt 909); his sale, London, Sotheby's, 29 April – 1 May 1852, lot 292 (to Colnaghi); Charles Fairfax Murray; J. Pierpont Morgan (no mark; see Lugt 1509).

BIBLIOGRAPHY: Bénard, *Cabinet de M. Paignon Dijonval*, 1810, p. 104, no. 2317; Wilhelm Bode and W. R. Valentiner, *Handzeichnungen altholländischer Genremaler*, Berlin, 1907, no. 29, repr.; Fairfax Murray, I, no. 161, repr.

Acc. no. I, 161

PLATES

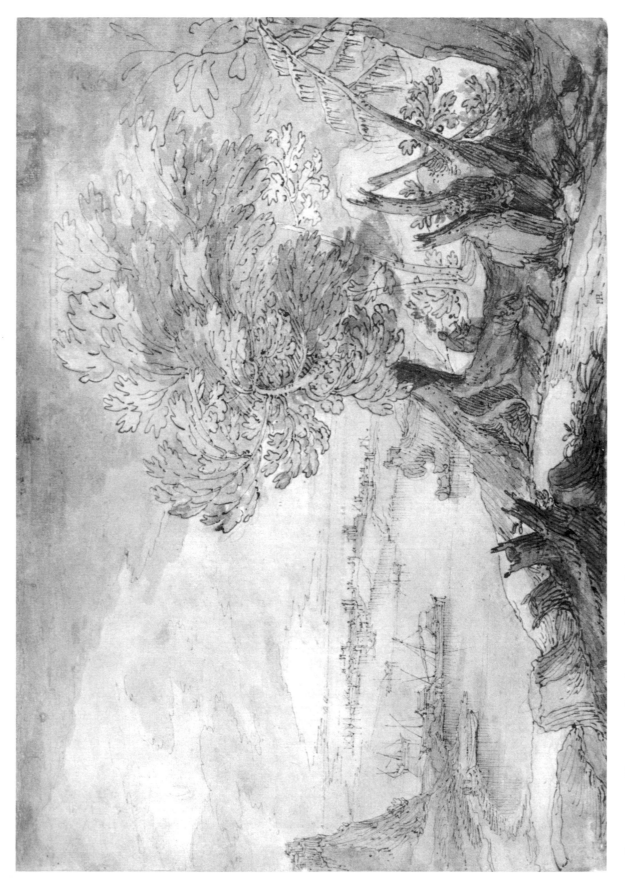

1. Lodewijk Toeput Landscape with St. John on Patmos

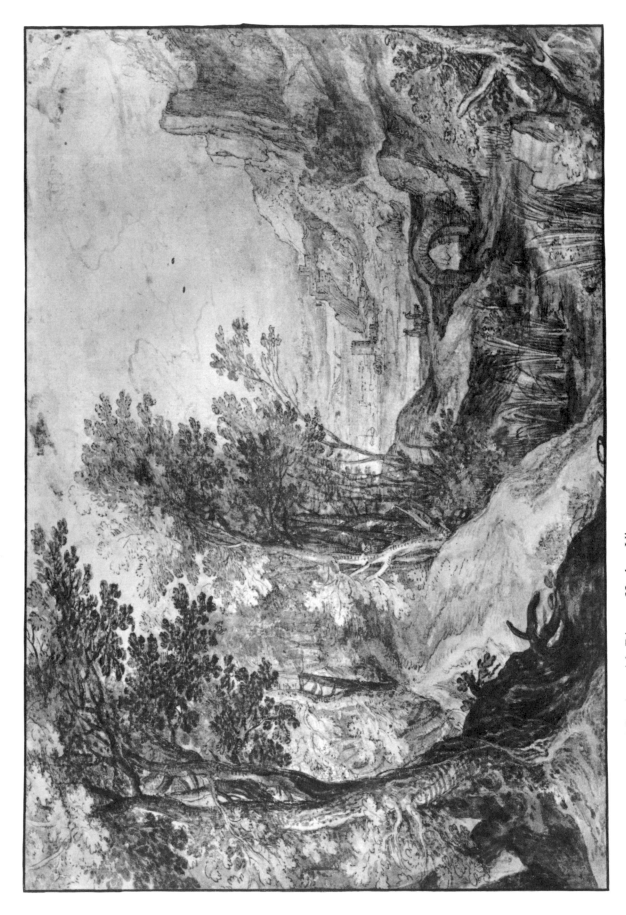

2. PAUL BRIL Wooded Ravine with Distant Harbor View

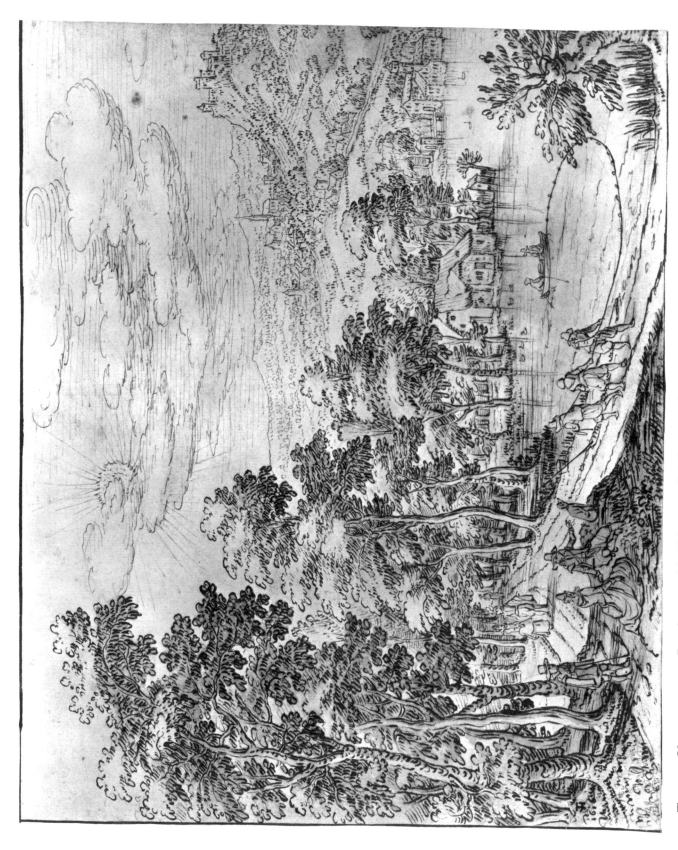

3. Tobias Verhaeght Landscape with Fishermen Seining on a Lake

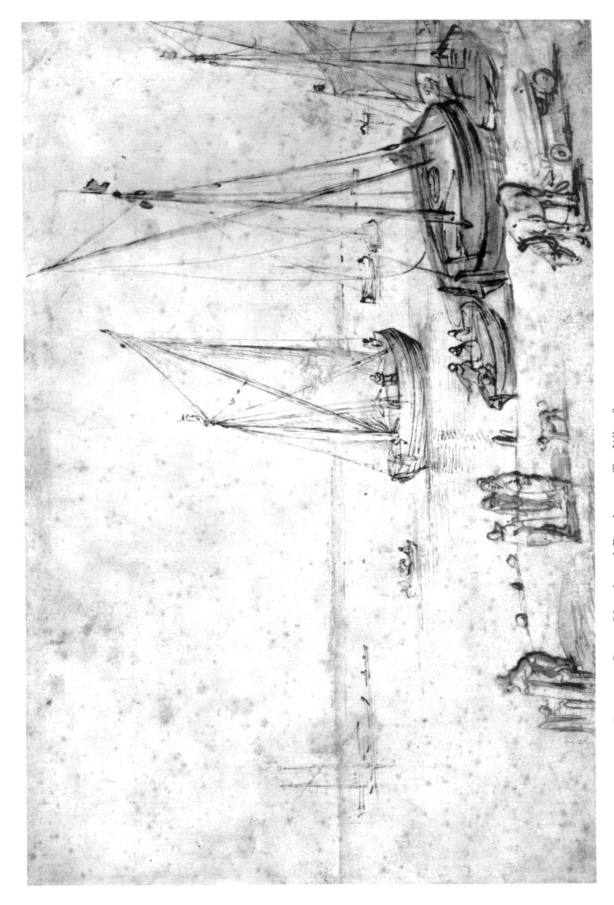

4. Jan Brueghel the Elder Cargo Vessels and Rowboats off a Wharf

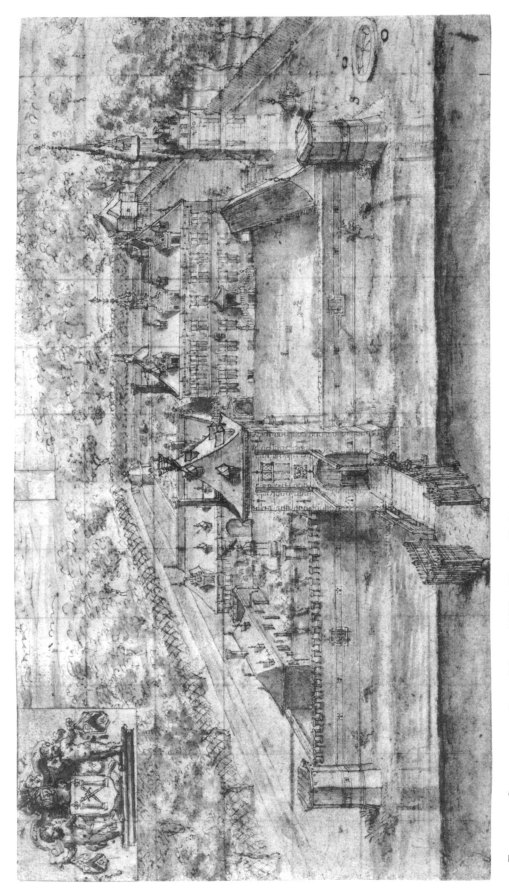

5. Flemish School, c. 1600 View of "Het Blauw Hof" at Logenhage

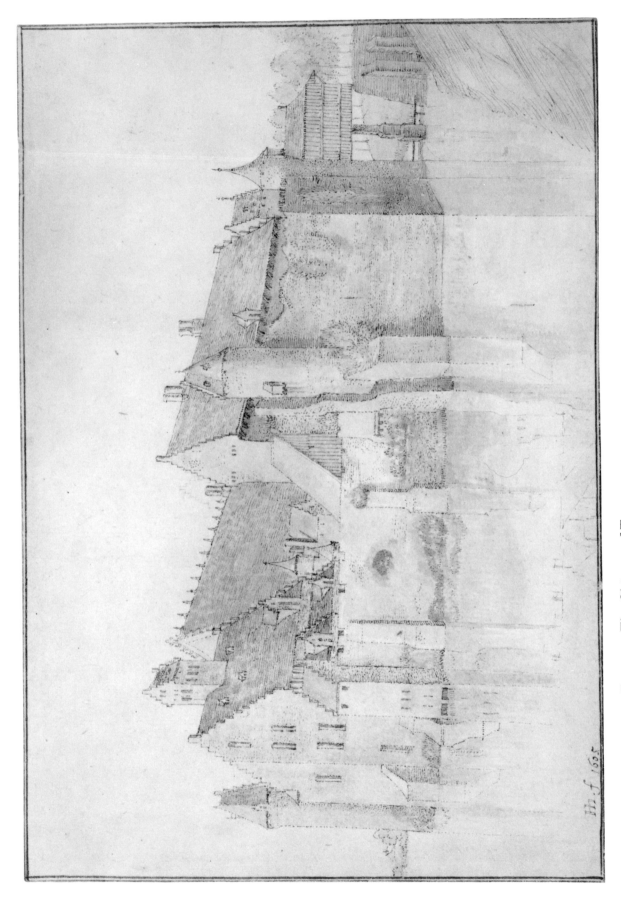

6. Hendrik Hondius the Elder The Château of Tervueren

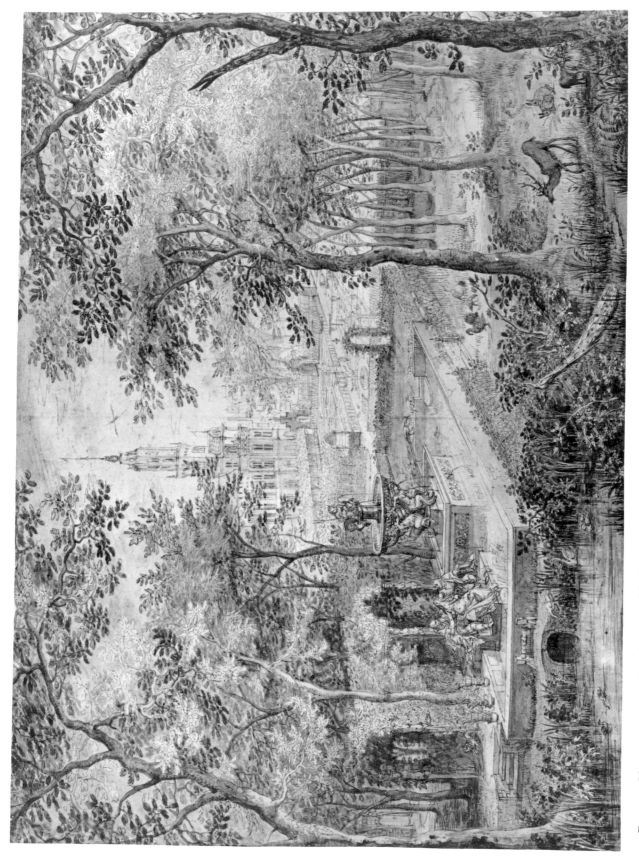

7. DAVID VINCKBOONS Landscape with Susanna and the Elders

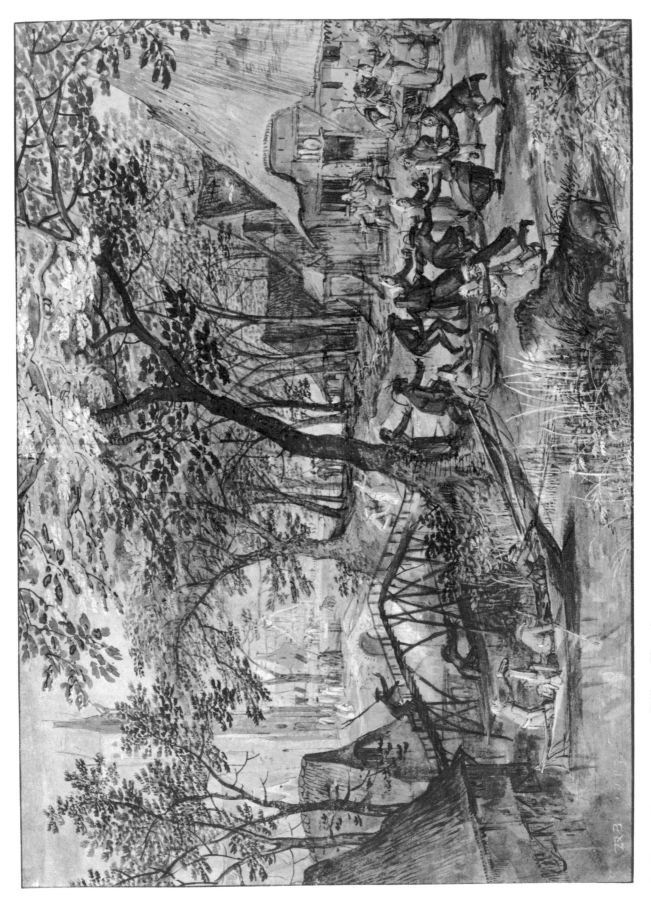

8. David Vinckboons Village Kermis

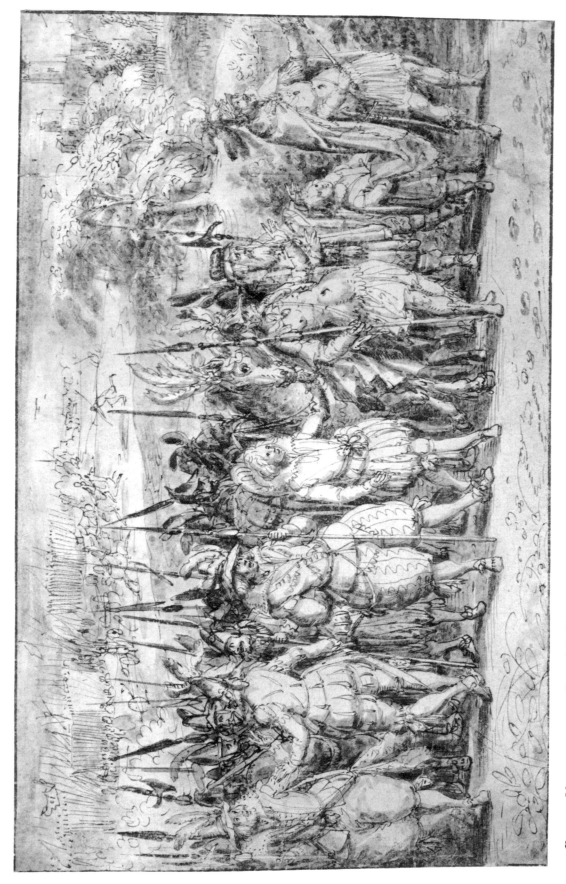

9. DAVID VINCKBOONS Consul Fabius Receiving His Father, Quintus Fabius Maximus

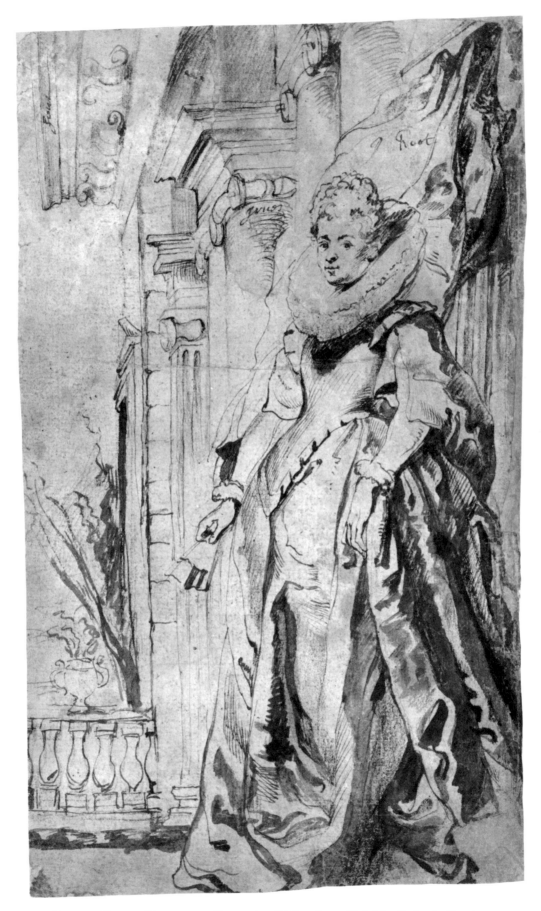

10. PETER PAUL RUBENS Portrait of Marchesa Brigida Spinola Doria

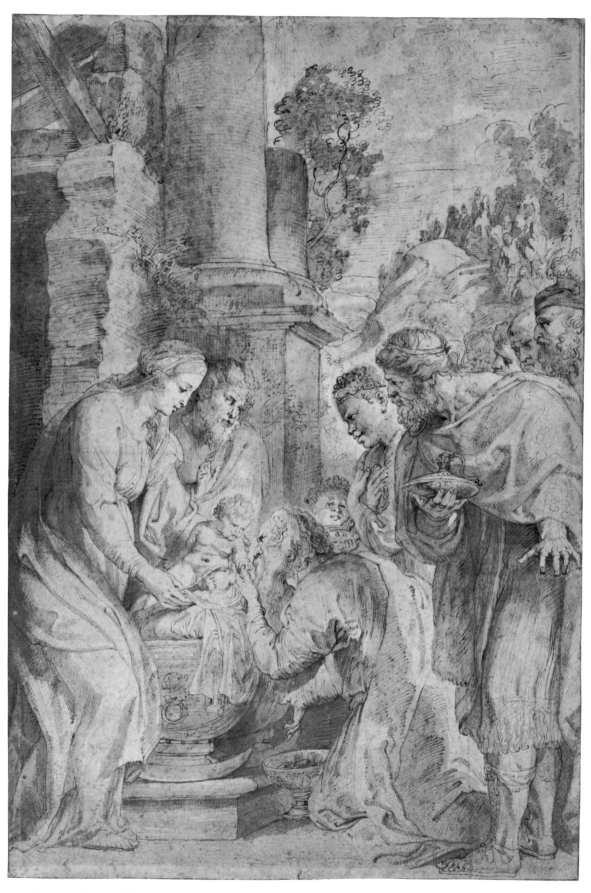

11. PETER PAUL RUBENS The Adoration of the Magi

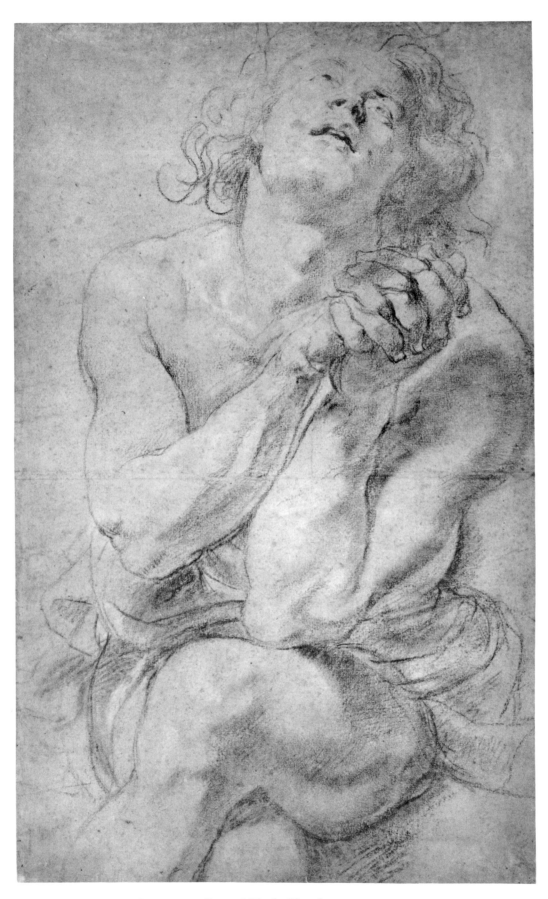

12. PETER PAUL RUBENS Seated Nude Youth

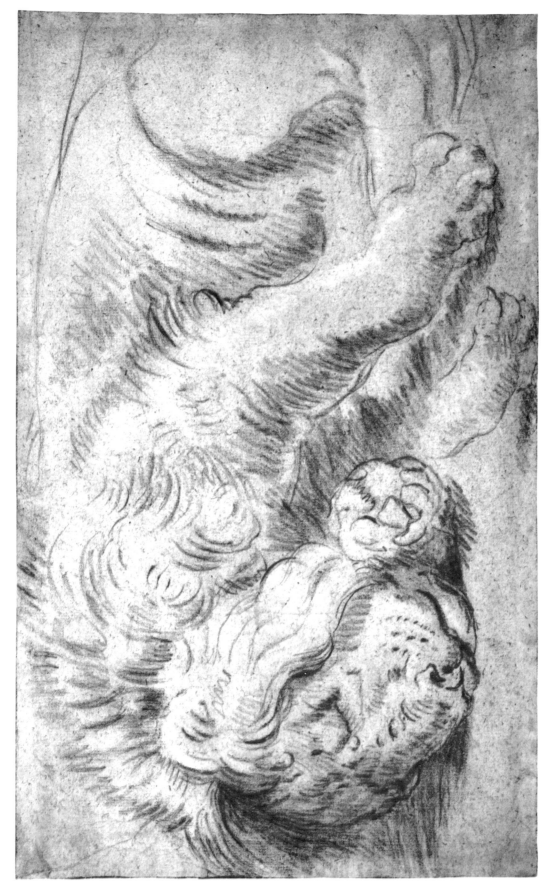

13. Peter Paul Rubens Sleeping Lion

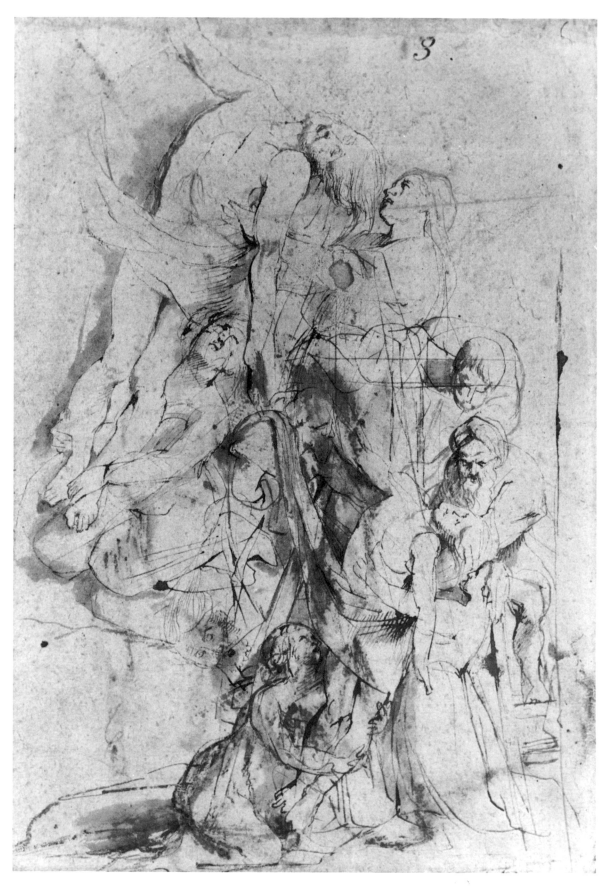

14. PETER PAUL RUBENS Studies for "The Descent from the Cross"

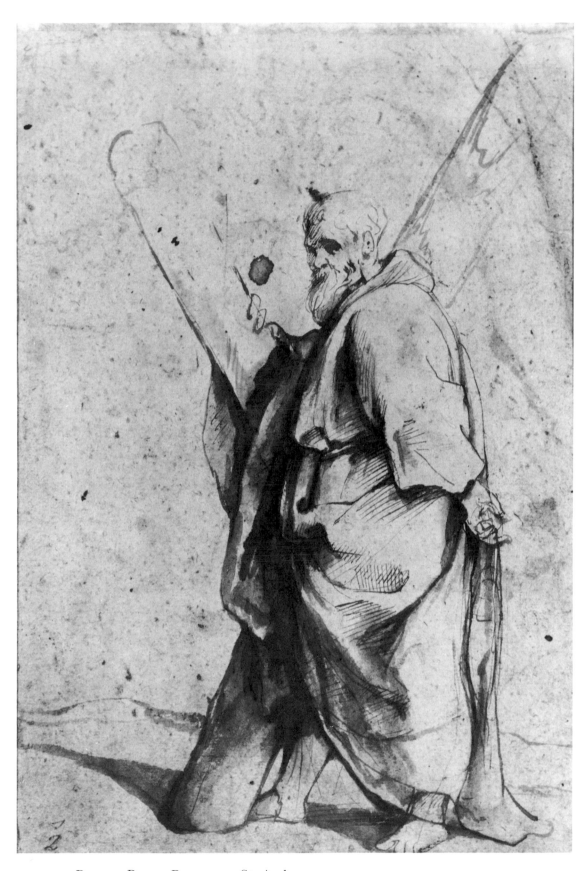

14 verso. PETER PAUL RUBENS St. Andrew

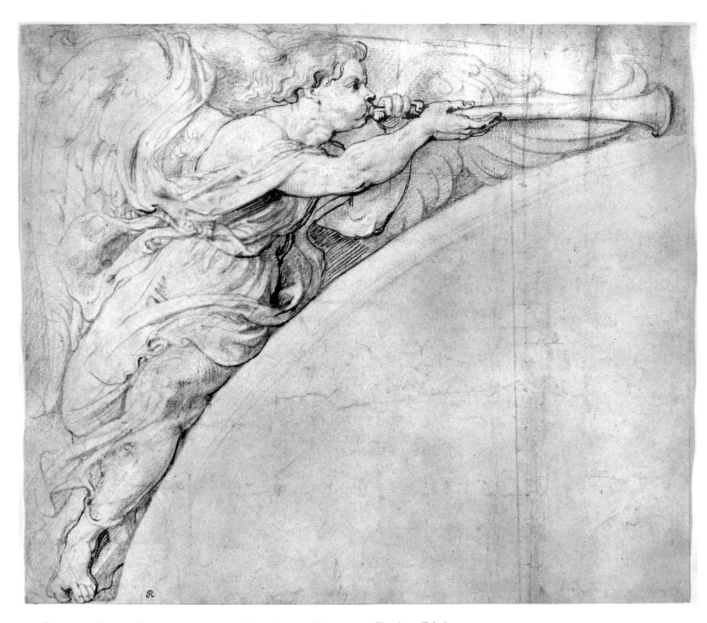

15. PETER PAUL RUBENS Angel Blowing a Trumpet, Facing Right

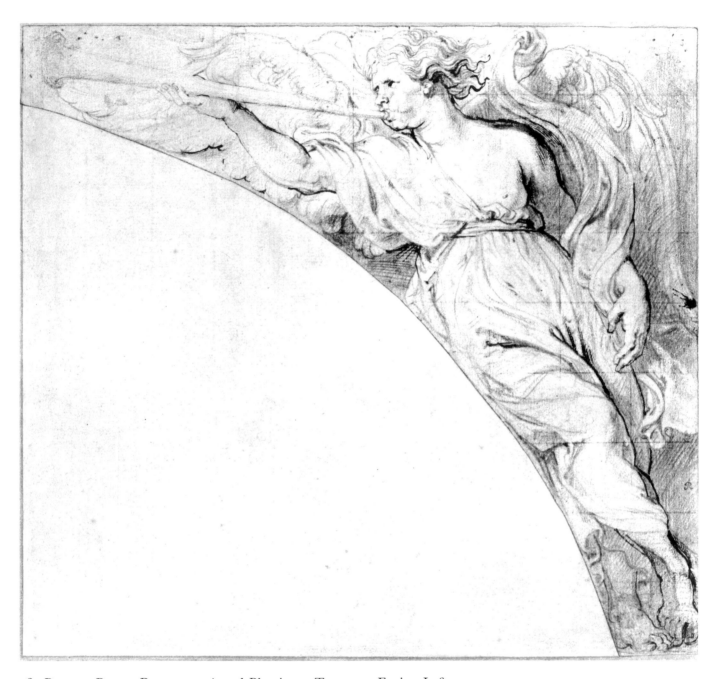

16. PETER PAUL RUBENS Angel Blowing a Trumpet, Facing Left

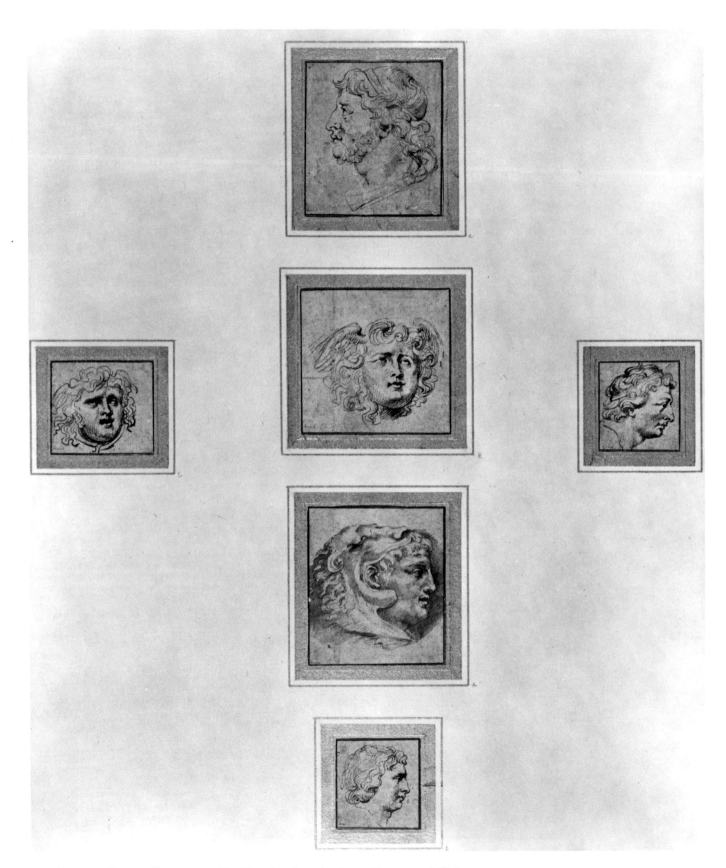

17. PETER PAUL RUBENS Six Heads after Antique Gems and Coins

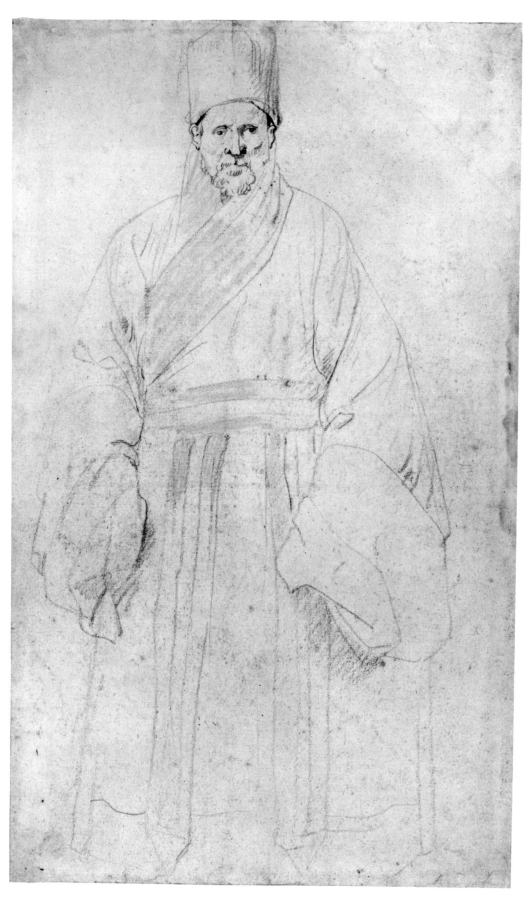

18. PETER PAUL RUBENS Jesuit Priest in Chinese Costume

19. Flemish School, c. 1610 Landscape with Farm Buildings: "[Het] Keysers Hof"

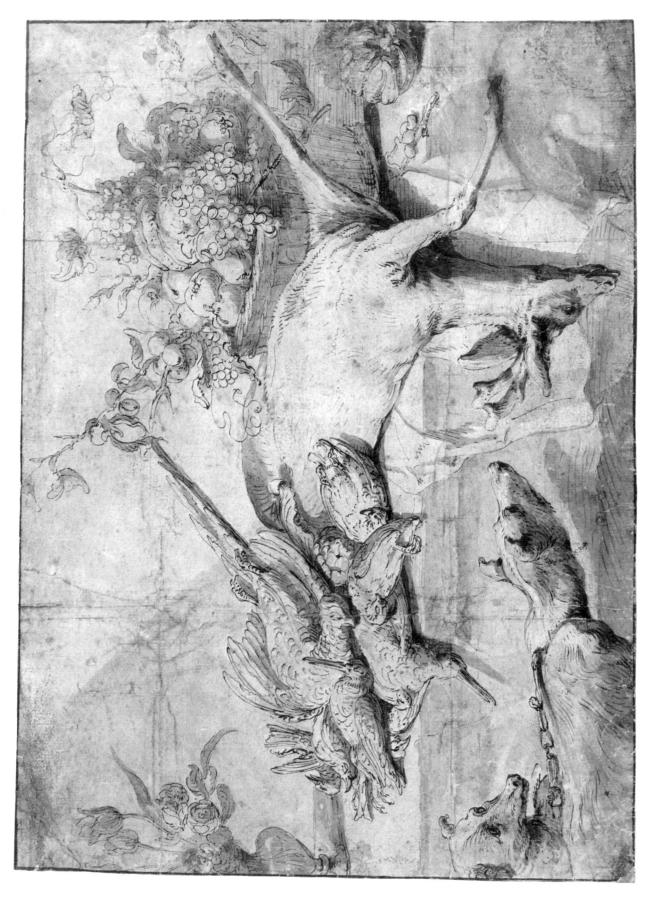

20. FRANS SNIJDERS Still Life with Dead Game Birds and Deer

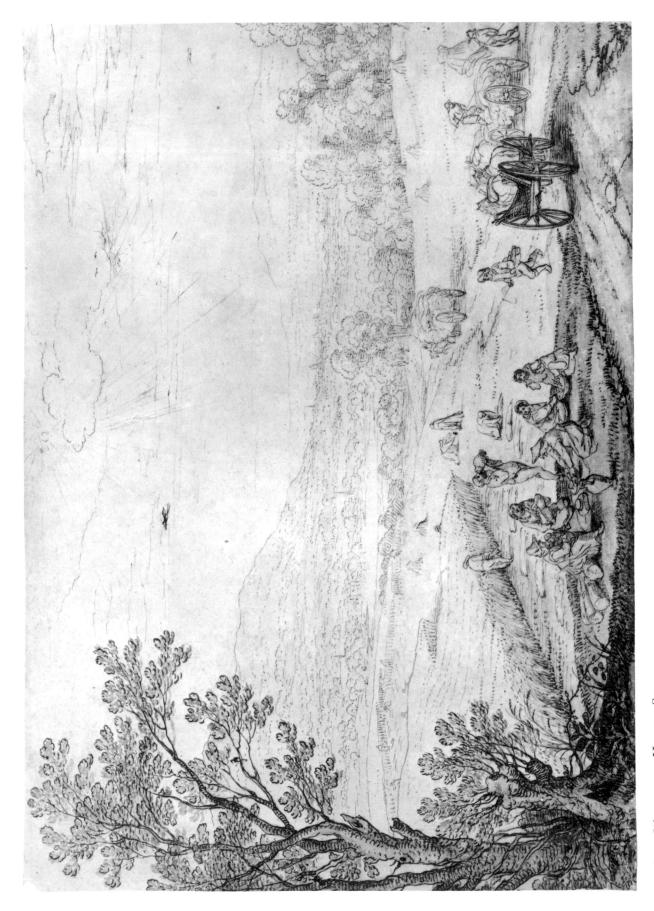

21. Jan Wildens Harvest Scene

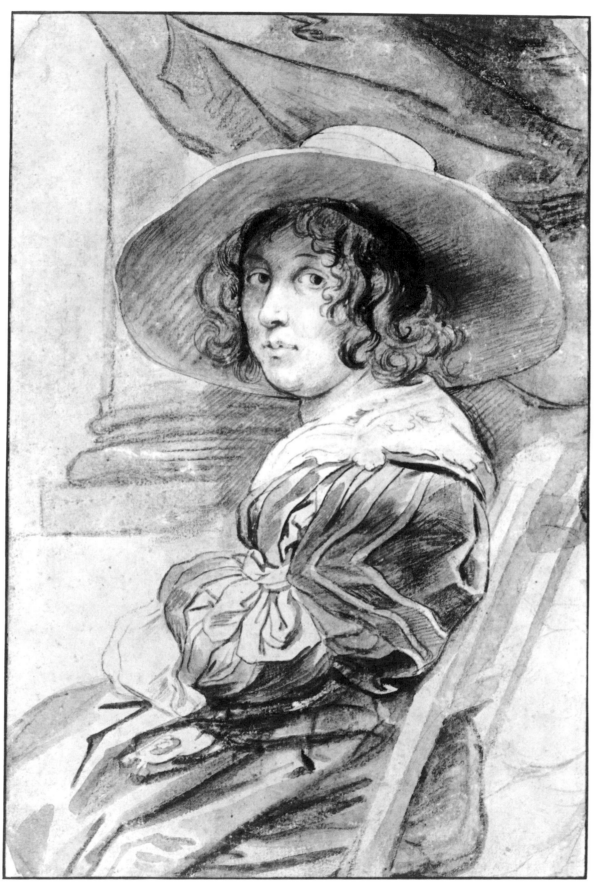

22. JACOB JORDAENS Portrait of a Young Woman

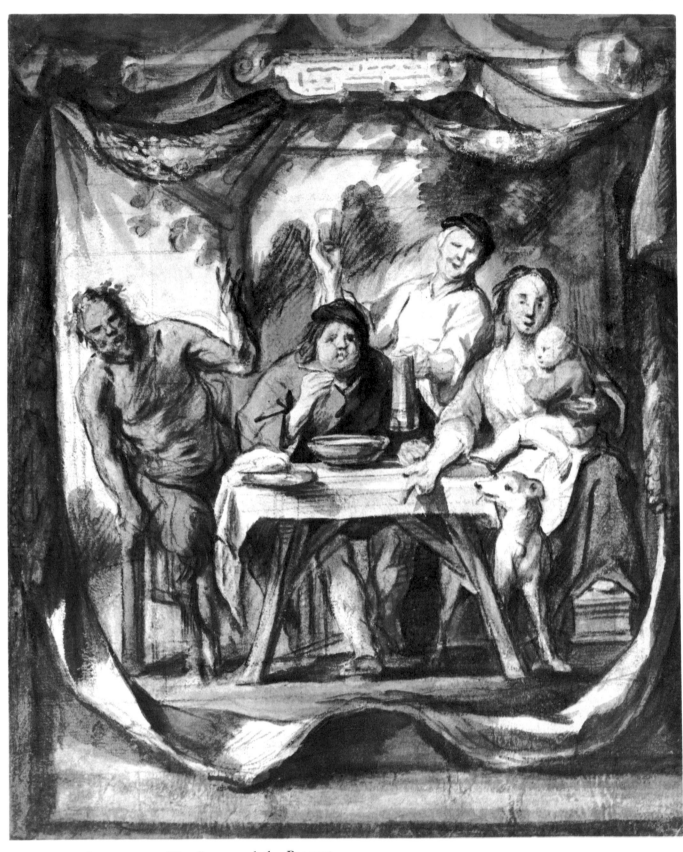

23. JACOB JORDAENS The Satyr and the Peasant

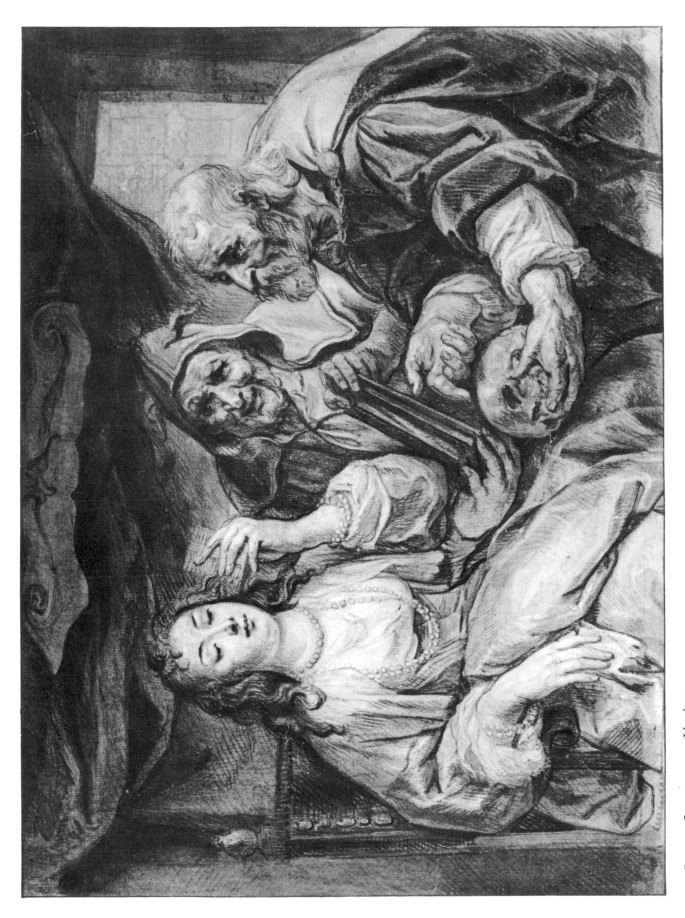

24. Jacob Jordaens Vanitas

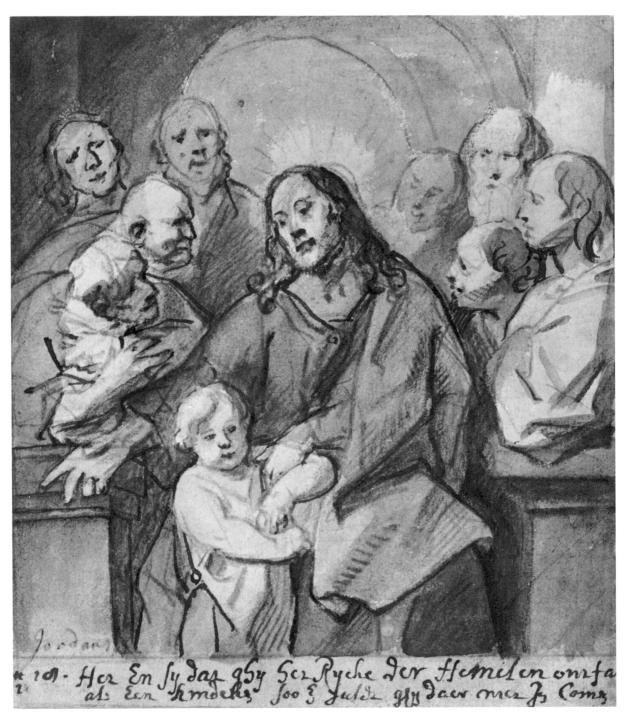

25. JACOB JORDAENS "Except ye be . . . as little children . . ."

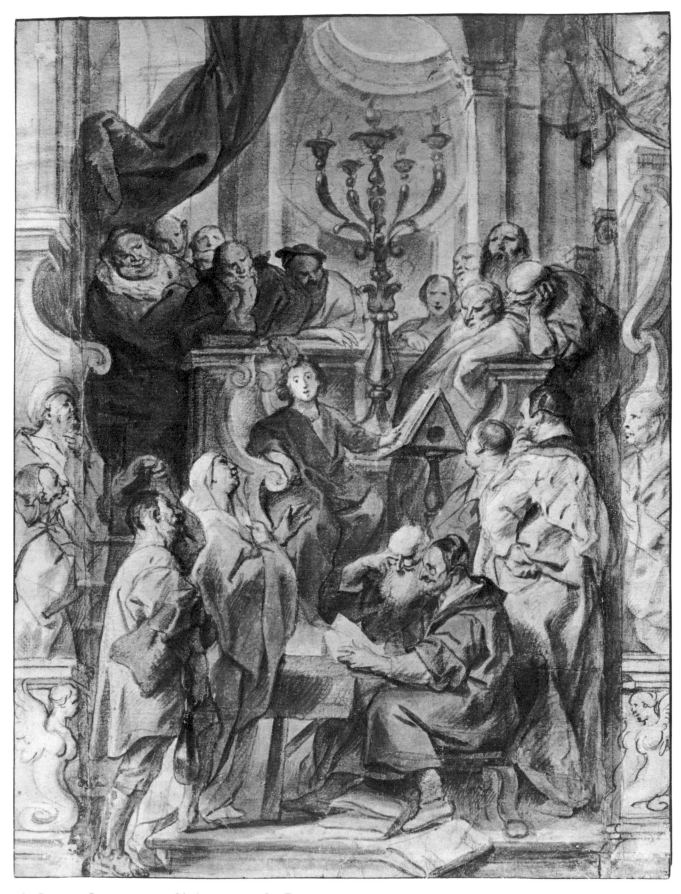

26. Jacob Jordaens Christ among the Doctors

27. Lucas van Uden Woodland with Monastic Buildings

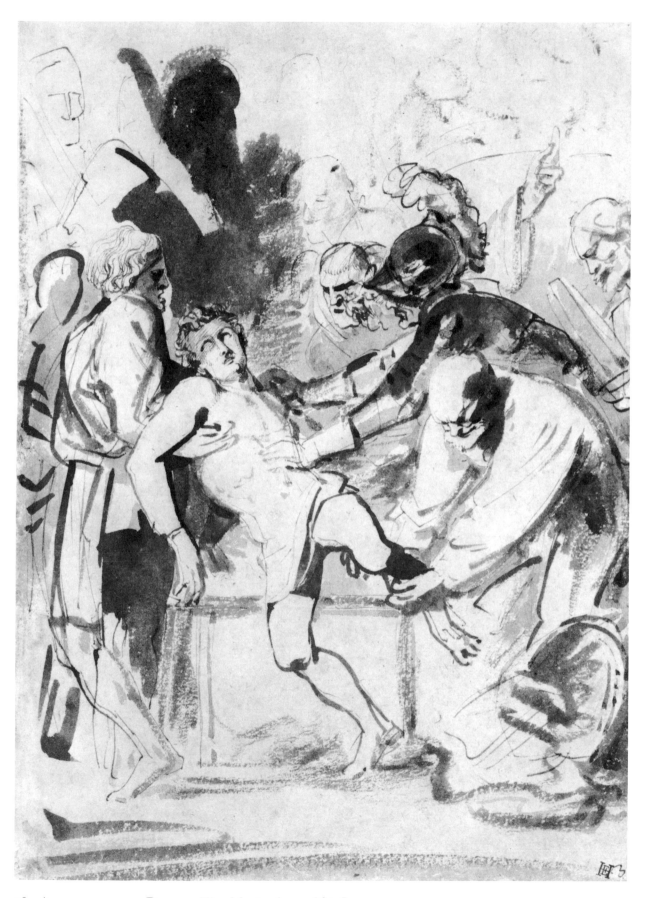

28. ANTHONY VAN DYCK The Martyrdom of St. Lawrence

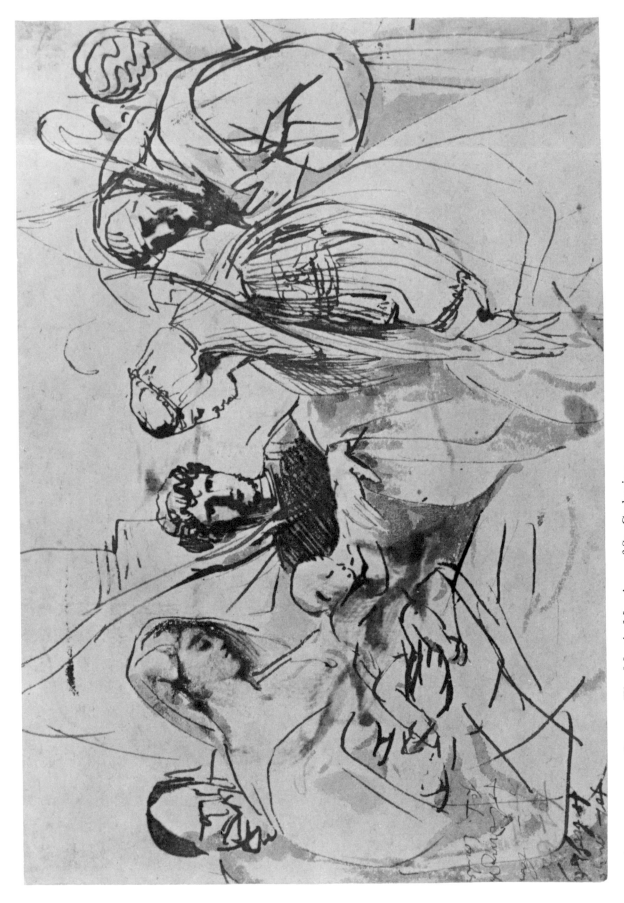

29. ANTHONY VAN DYCK The Mystic Marriage of St. Catherine

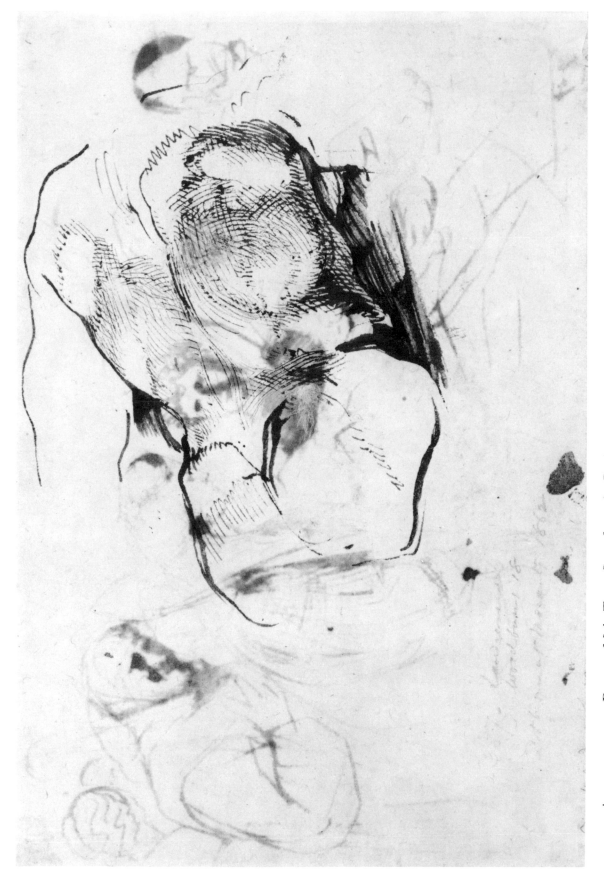

29 verso. Anthony van Dyck Male Torso Seen from the Back and Above

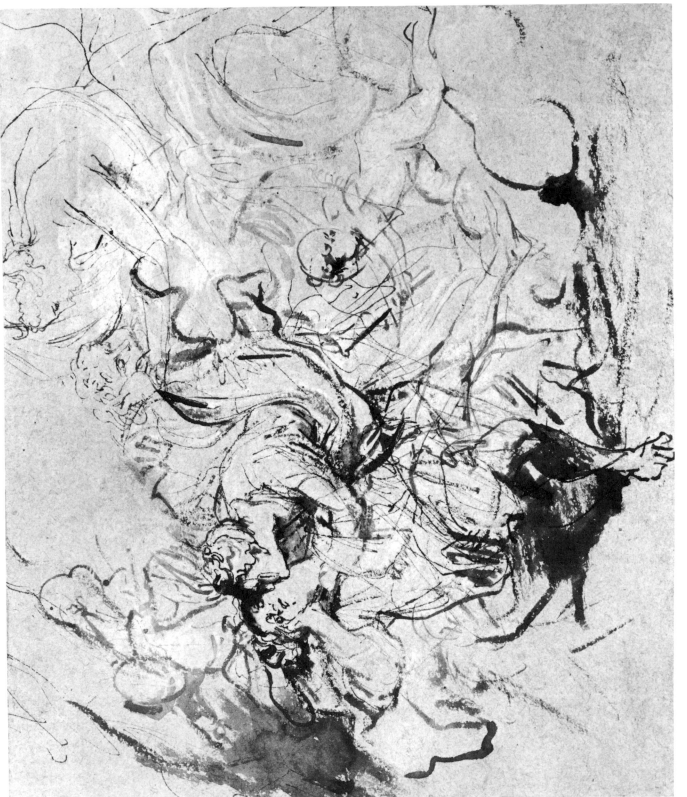

30. Anthony van Dyck Diana and Endymion

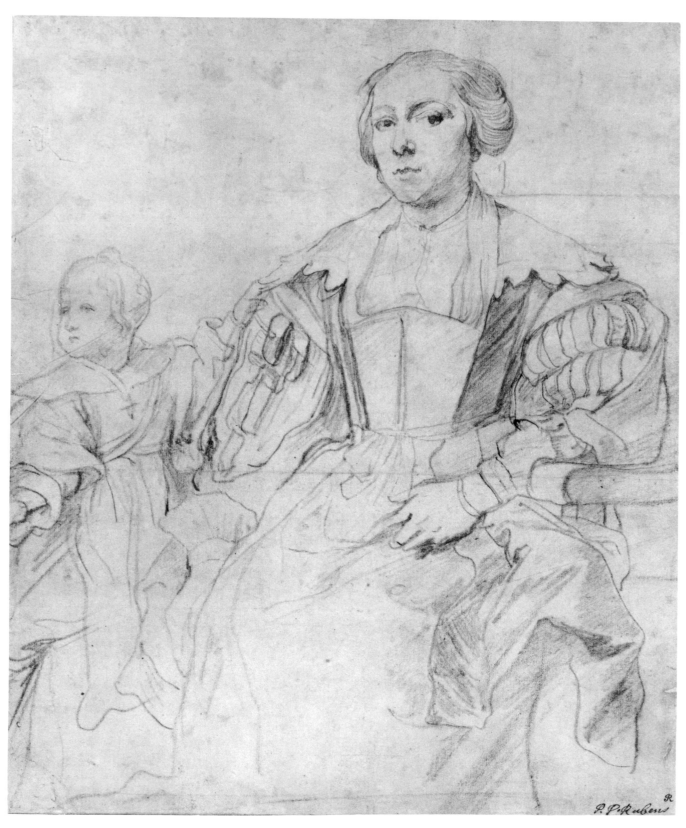

31. ANTHONY VAN DYCK Portrait of a Woman and Her Daughter

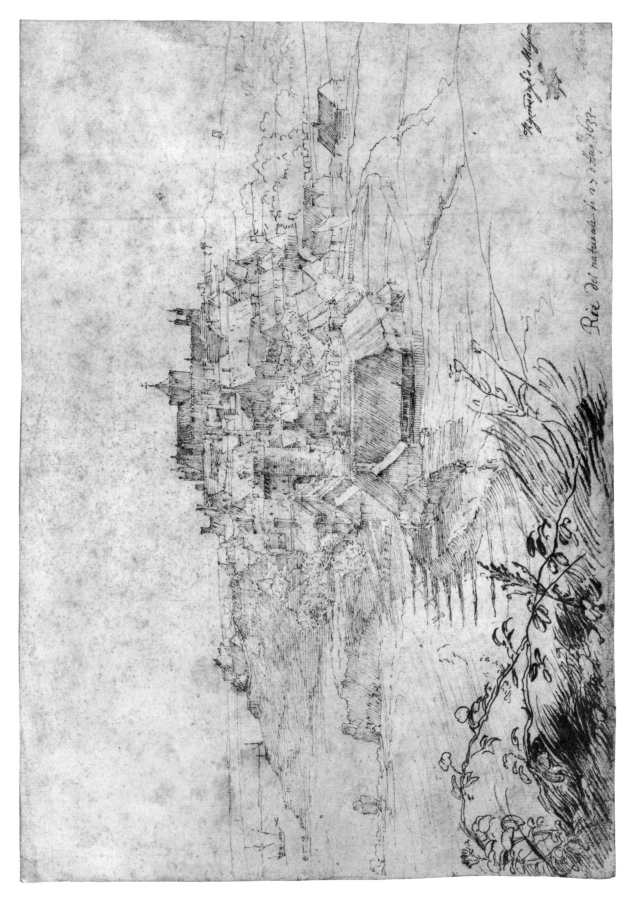

32. ANTHONY VAN DYCK View of Rye from the Northeast

33. Anthony van Dyck Study for the Dead Christ

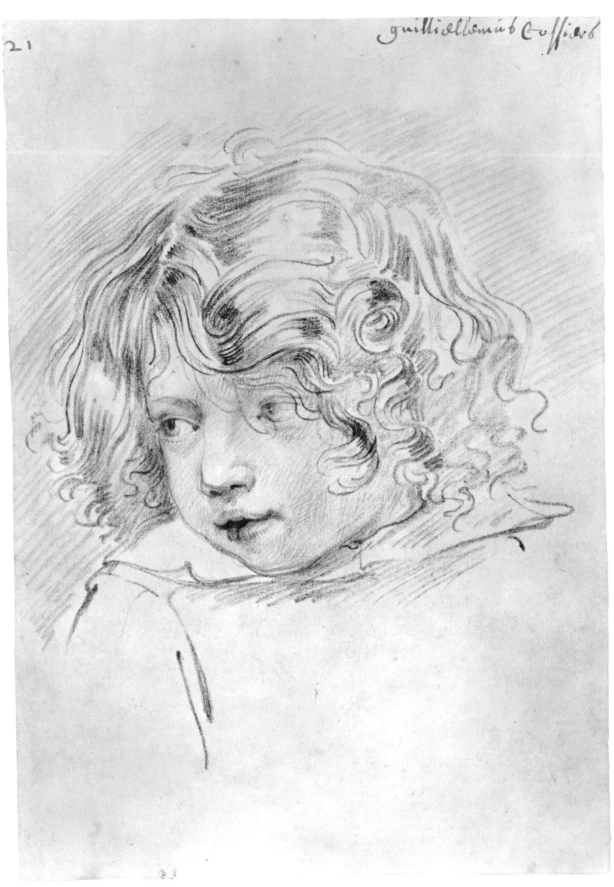

21

guilliellemus Cossiers

34. JAN COSSIERS Portrait of the Artist's Son Guilliellemus

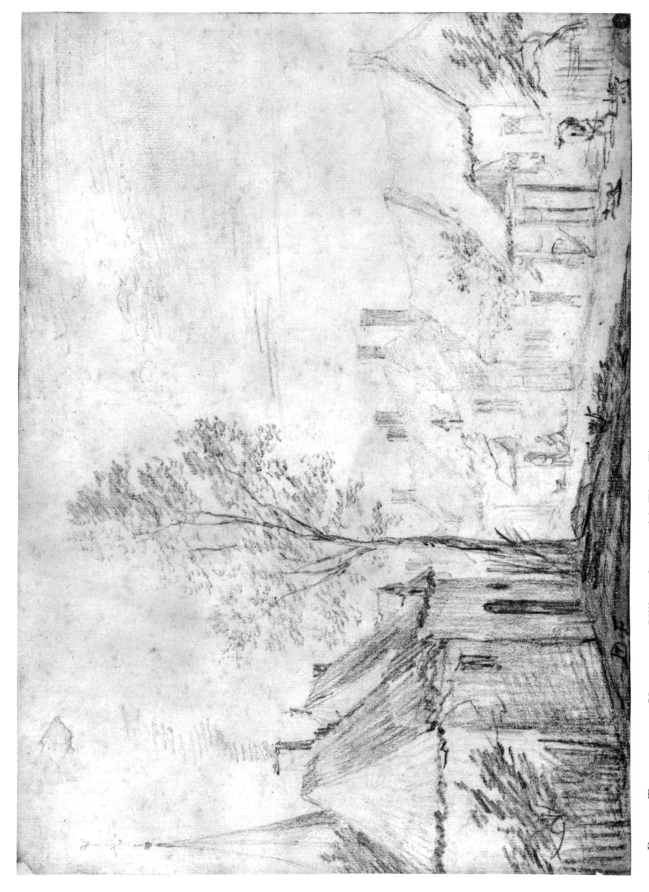

35. DAVID TENIERS THE YOUNGER Village Street with Three Figures

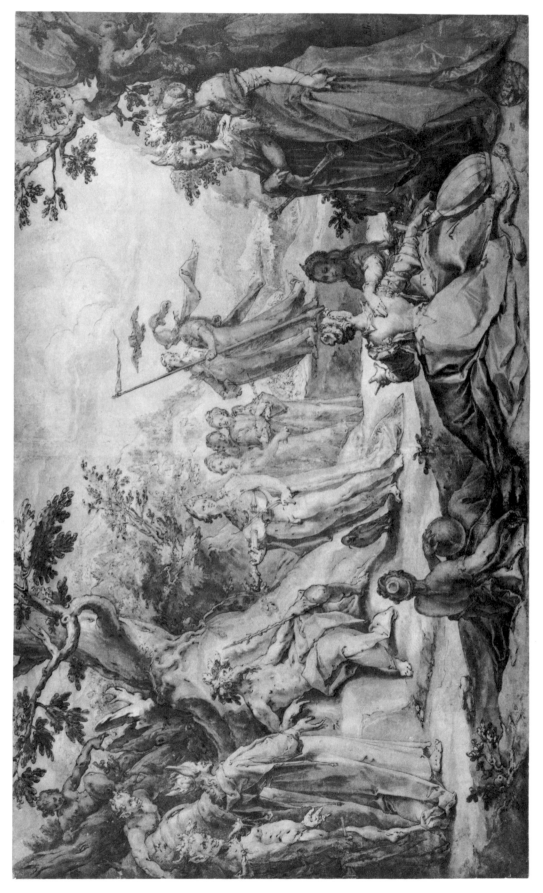

36. HENDRICK GOLTZIUS The Judgment of Midas

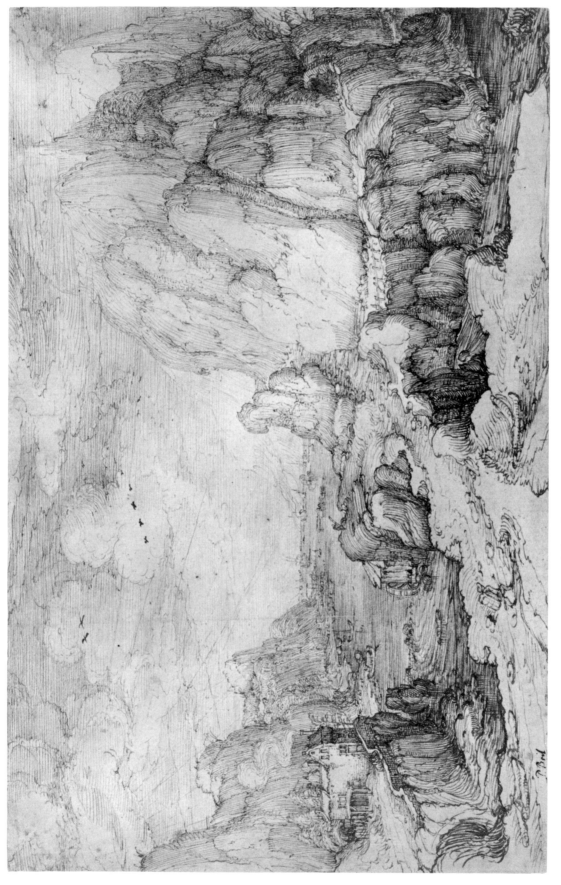

37. HENDRICK GOLTZIUS Mountainous Coastal Landscape

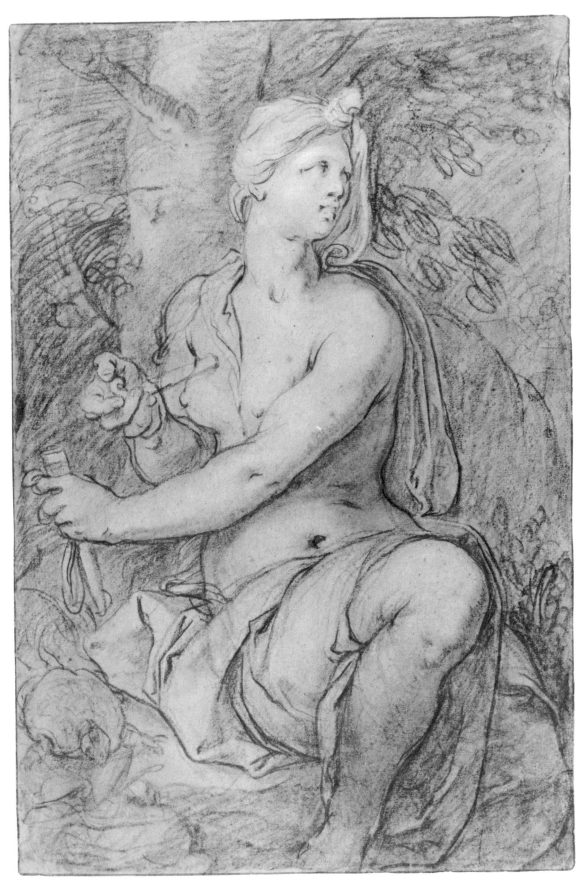

38. Hendrick Goltzius Lucretia as the Sense of Touch

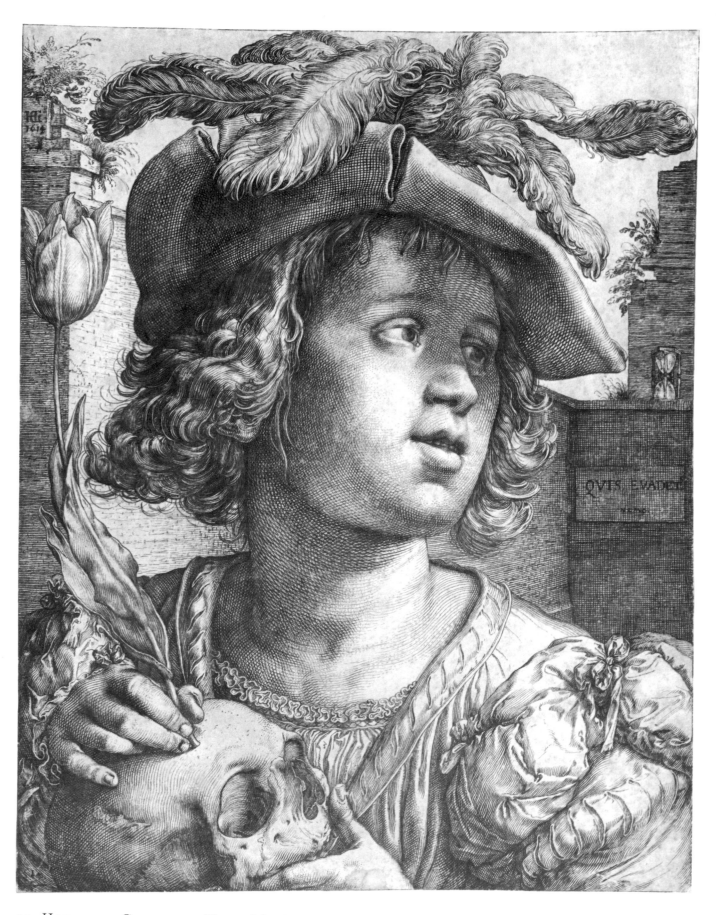

39. HENDRICK GOLTZIUS Young Man Holding a Skull and a Tulip

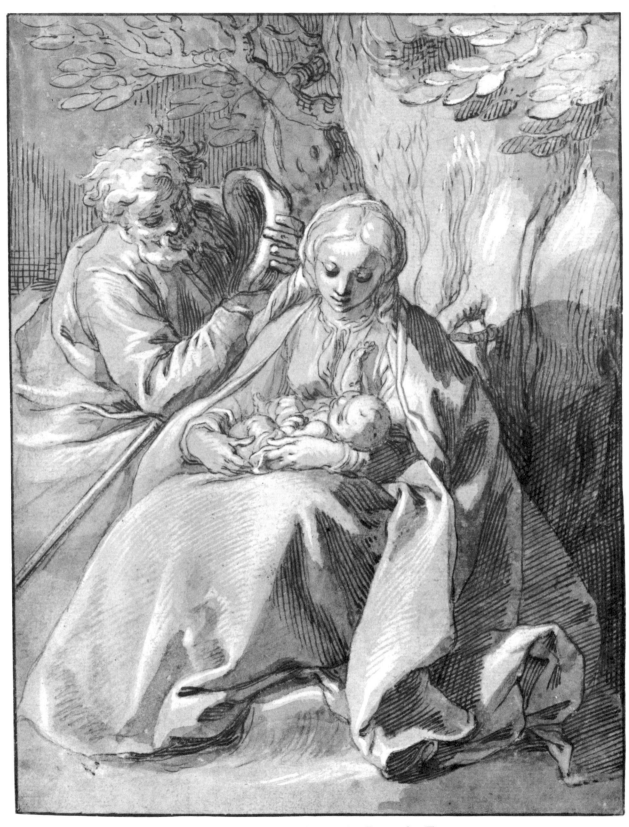

40. ABRAHAM BLOEMAERT The Holy Family at the Foot of a Tree

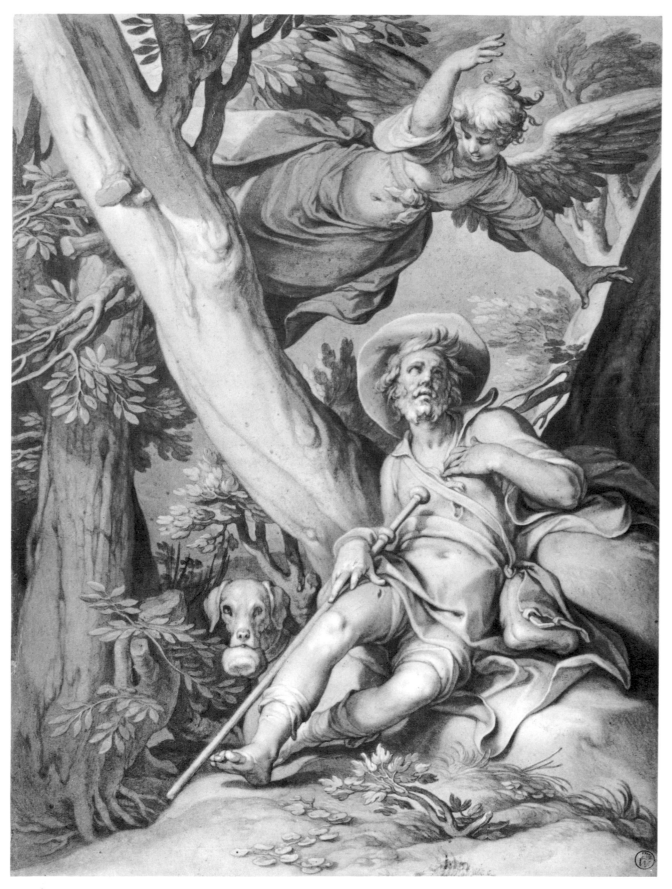

41. ABRAHAM BLOEMAERT St. Roch

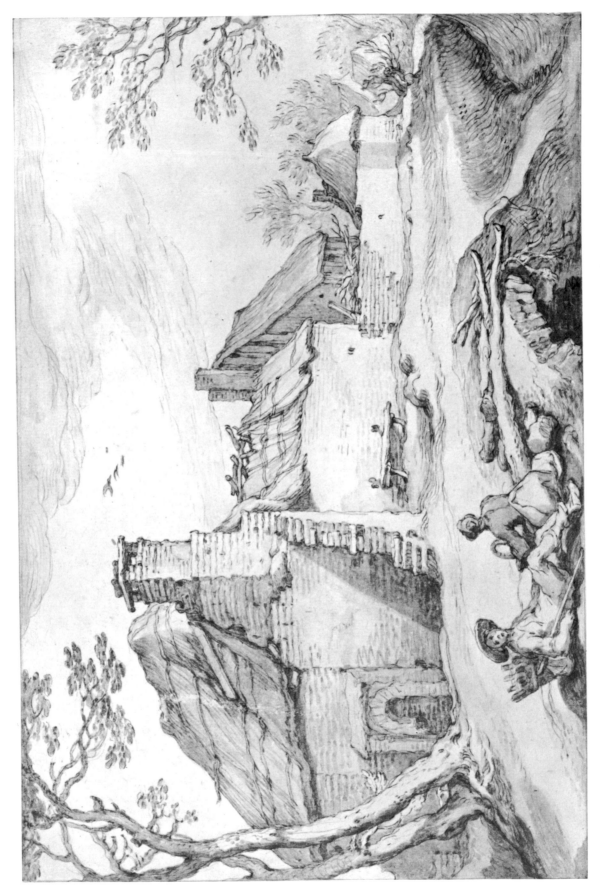

42. ABRAHAM BLOEMAERT Landscape with Farm Buildings

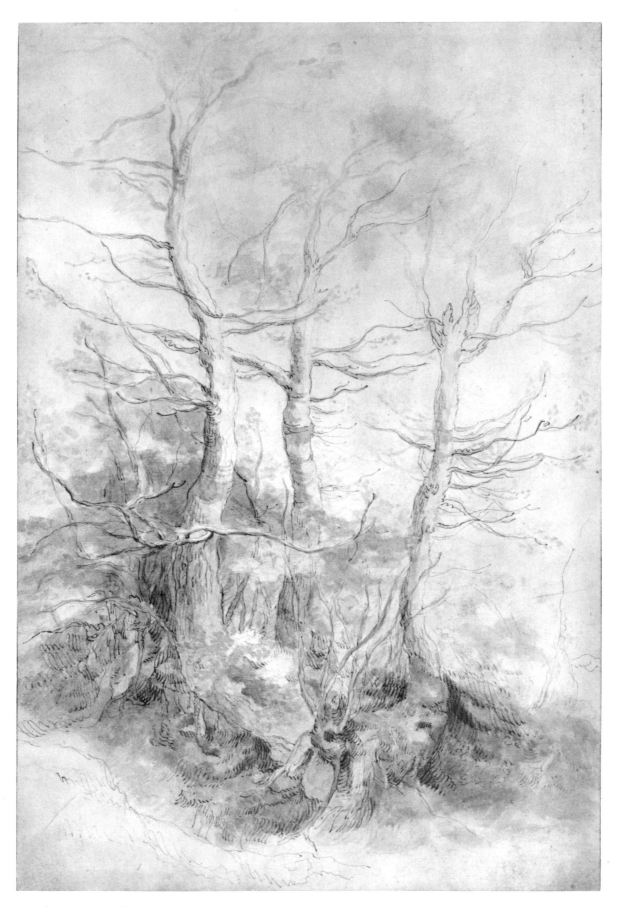

43. ABRAHAM BLOEMAERT A Clump of Three Trees

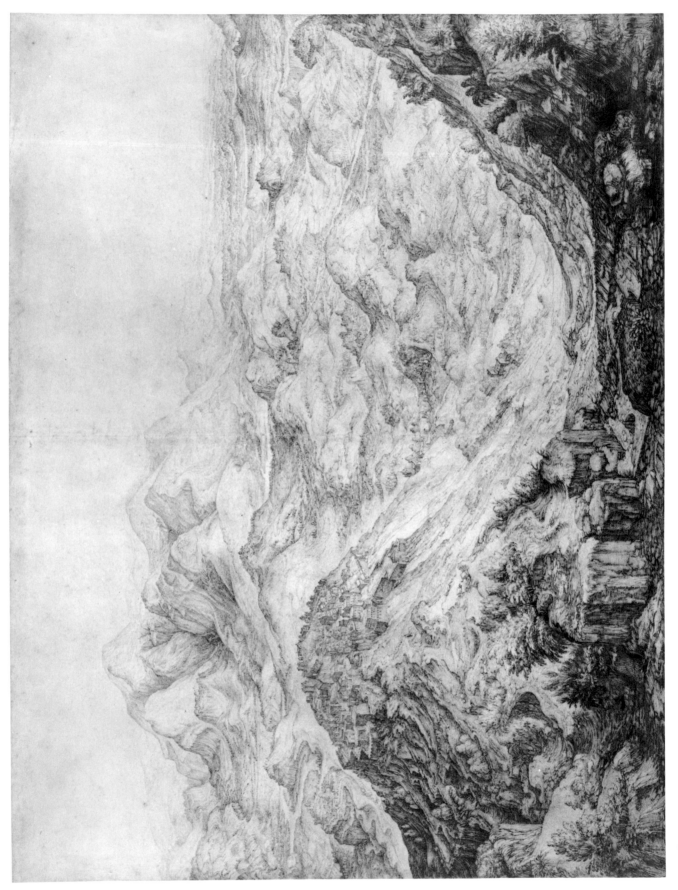

44. JACQUES DE GHEYN II Mountain Landscape

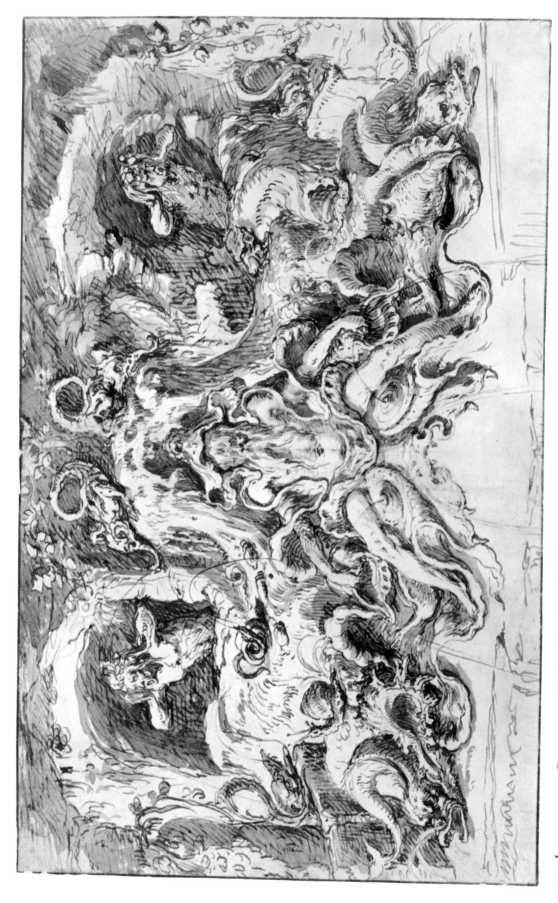

45. JACQUES DE GHEYN II Design for a Garden Grotto

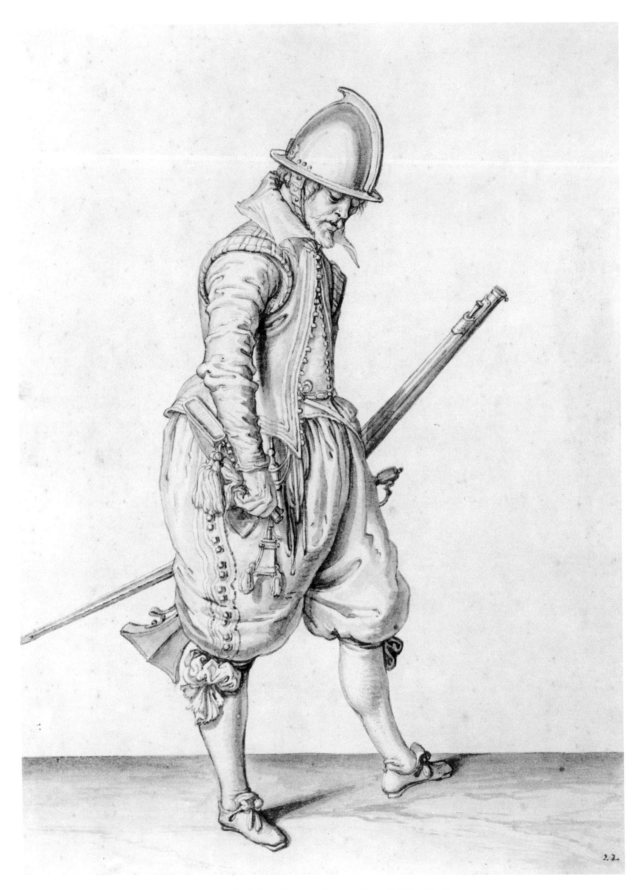

46. Jacques de Gheyn II A Soldier Preparing to Load His Caliver

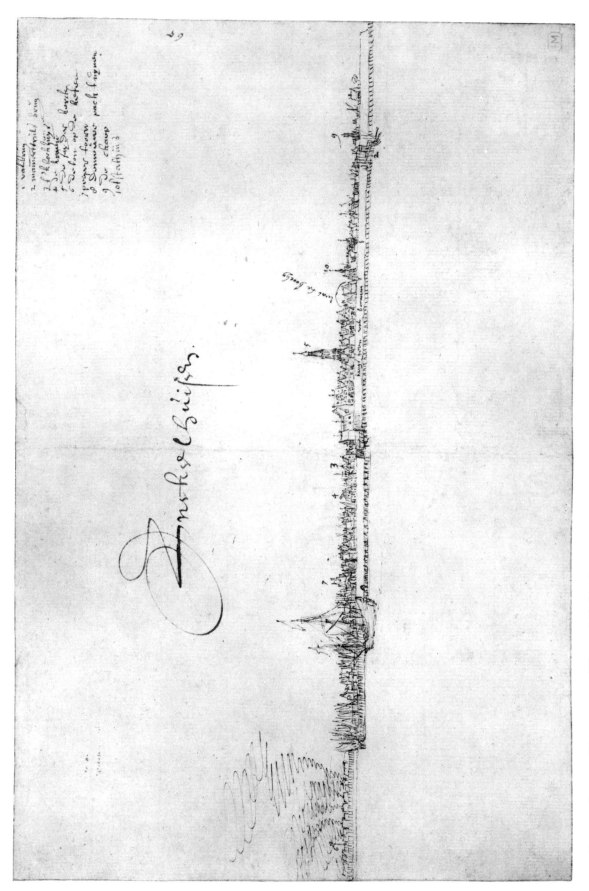

47. Claes Jansz. Visscher View of Enkhuizen

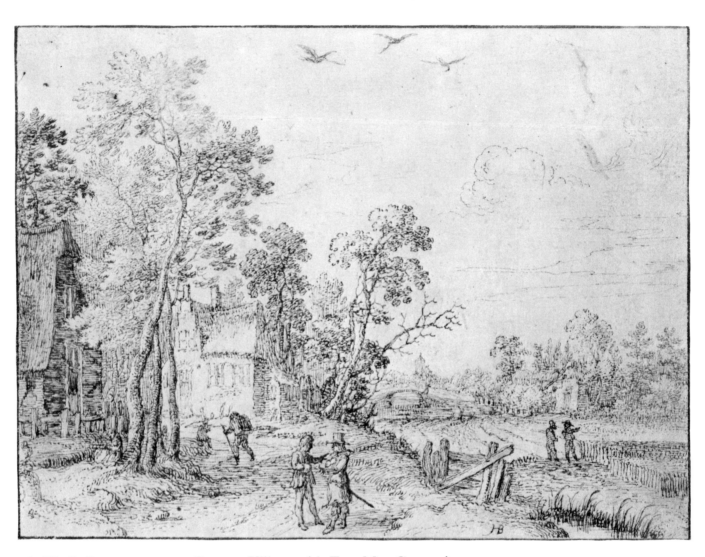

48. H. B. Blockhauer Country Village with Two Men Conversing

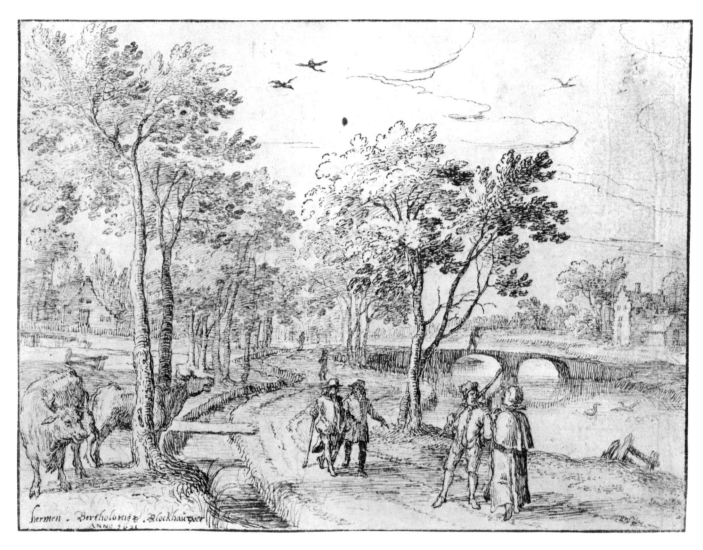

49. H. B. Blockhauer Landscape with Figures on a Winding River Road

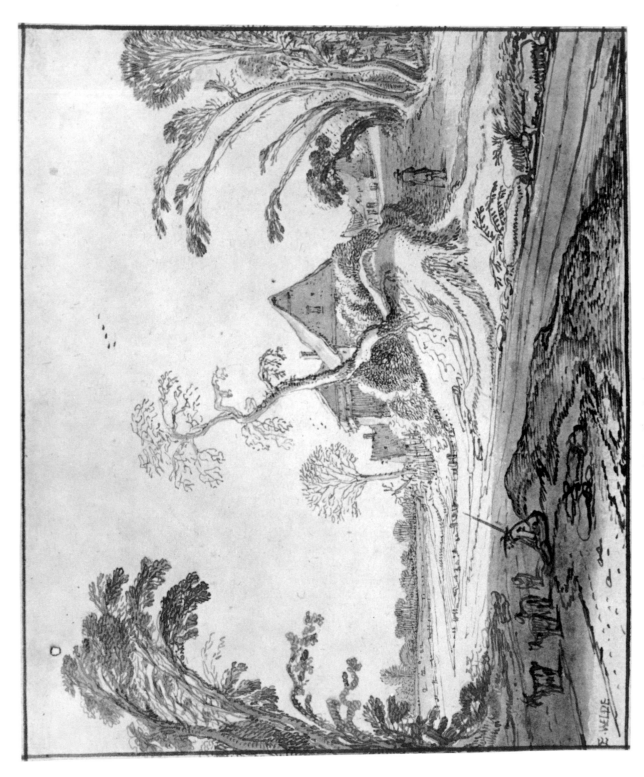

50. ESAIAS VAN DE VELDE Landscape with a Goatherd

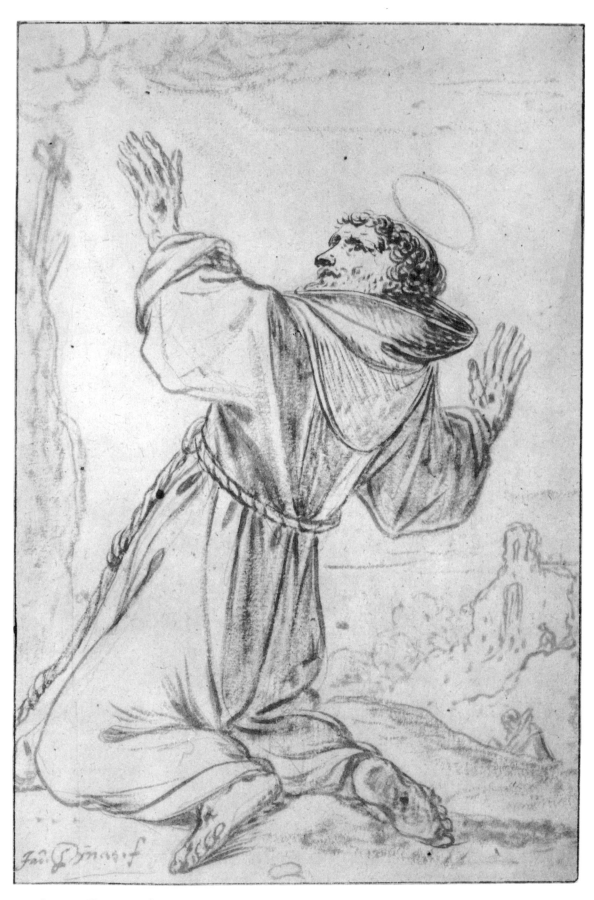

51. JACOB PYNAS St. Francis Receiving the Stigmata

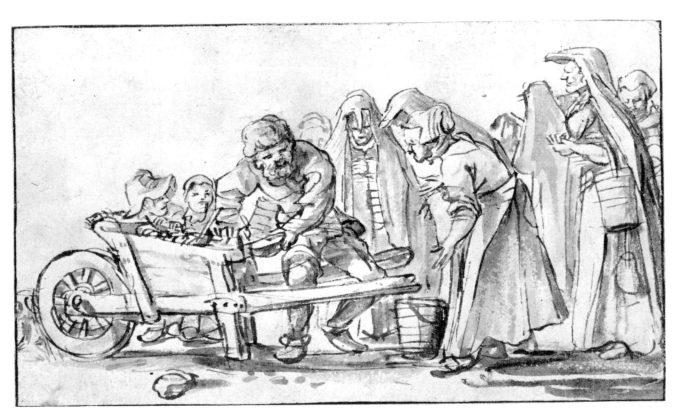

52. WILLEM BUYTEWECH The Mussel Seller

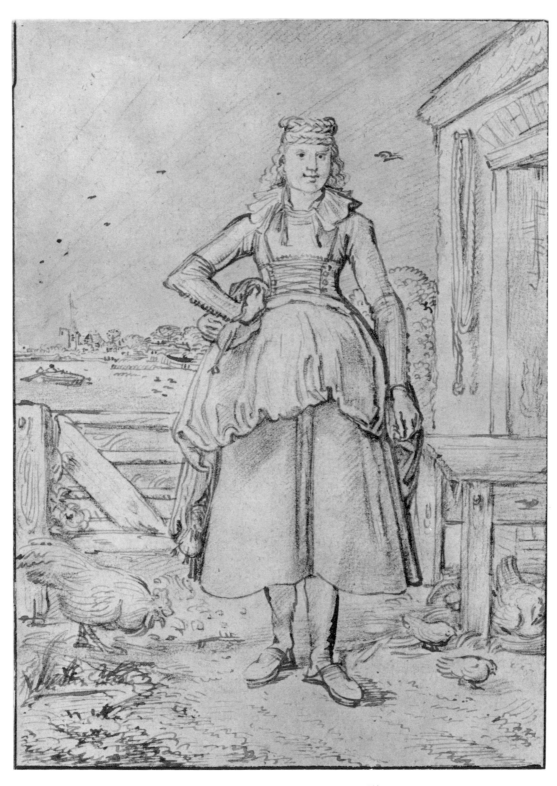

53. WILLEM BUYTEWECH A Peasant Woman of De Zijpe

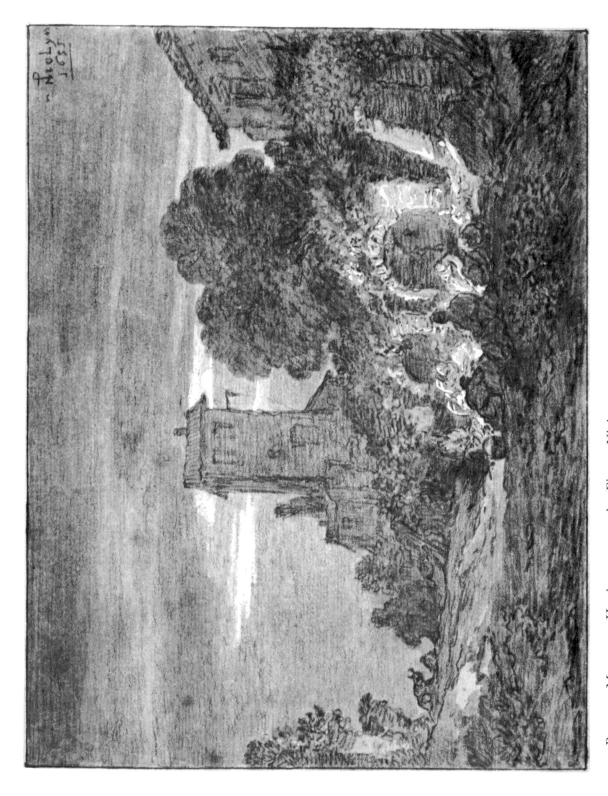

54. PIETER MOLIJN Herdsmen around a Fire at Night

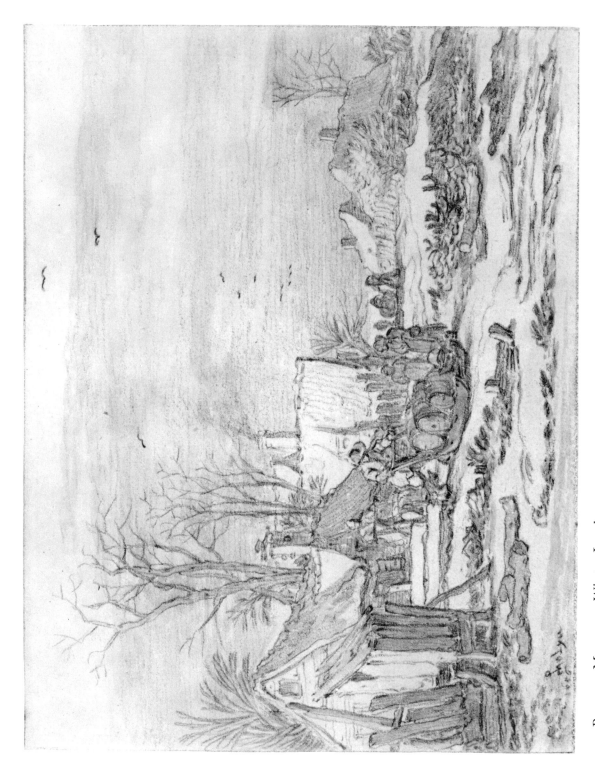

55. PIETER MOLIJN Winter Landscape

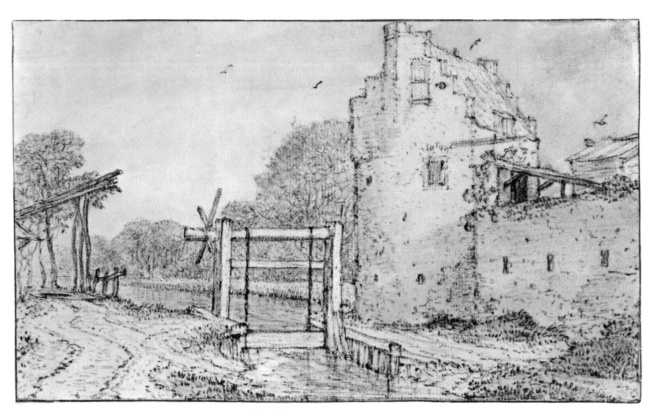

56. Jan den Uyl Canal with a Sluice Gate

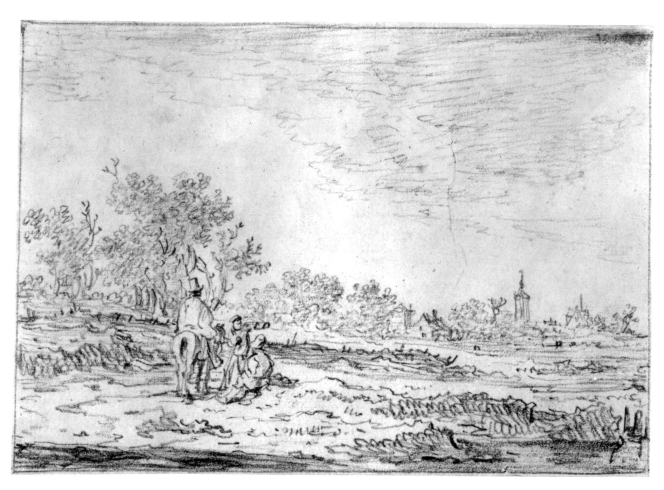

57. JAN VAN GOYEN Rider Inquiring the Way to The Hague

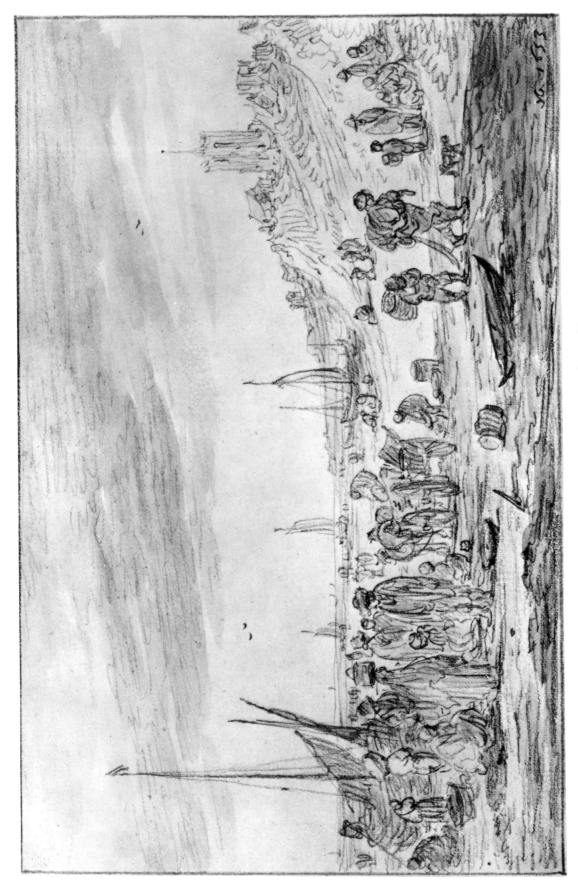

58. JAN VAN GOYEN Fishermen and Market Women on the Beach at Egmond aan Zee

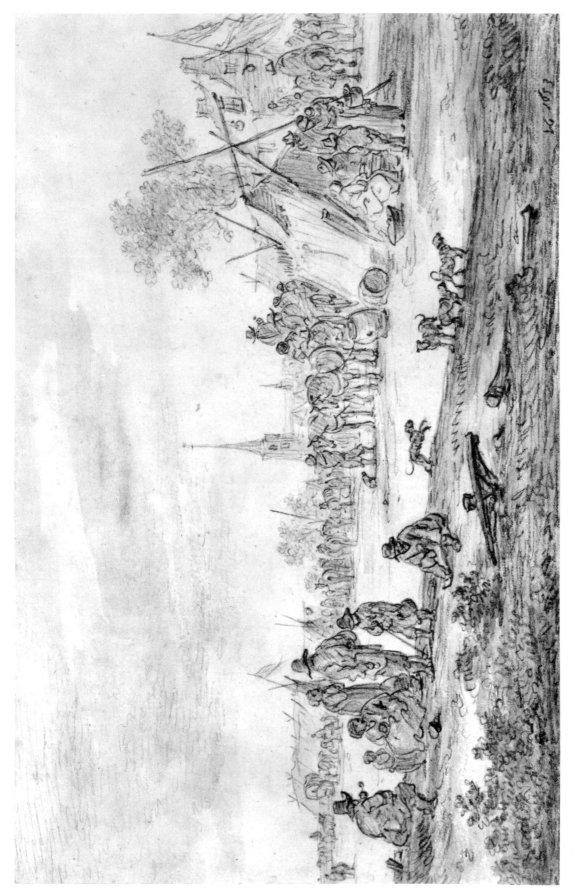

59. JAN VAN GOYEN The Horse Market at Valkenburg near Leyden

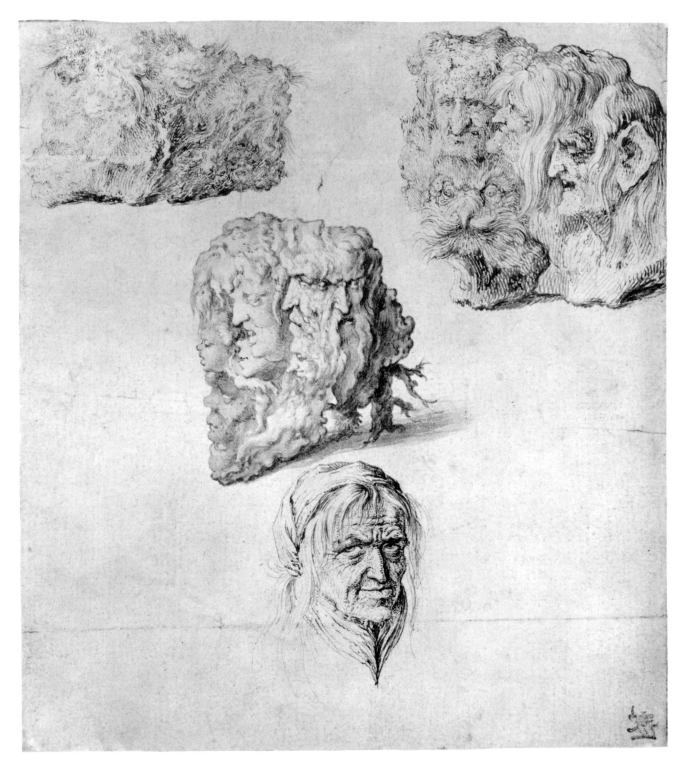

60. JACQUES DE GHEYN III Three Groups of Grotesque Heads; Head of an Old Woman

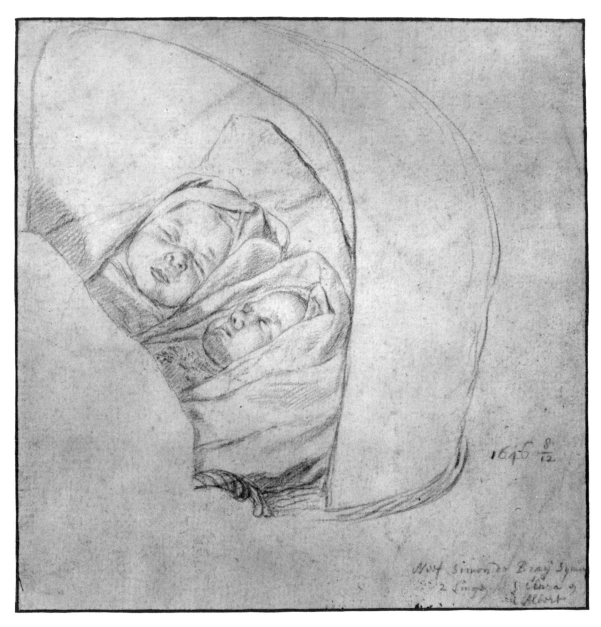

61. SALOMON DE BRAY The Twins Clara and Albert de Bray

62. BARTHOLOMEUS BREENBERGH The Temple of the Sibyl at Tivoli

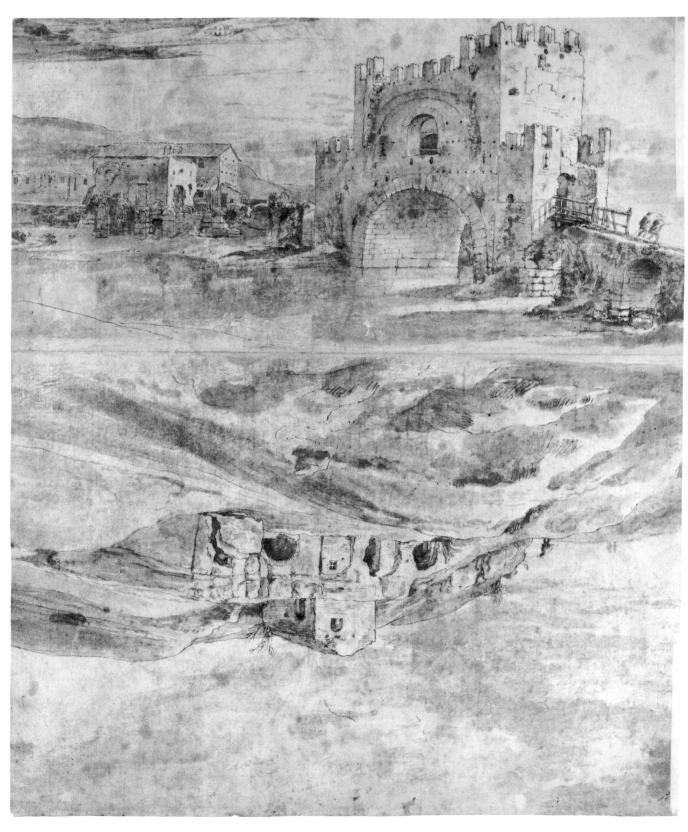

62 verso. BARTHOLOMEUS BREENBERGH
 Ponte Nomentano; Barren Landscape with Half-Ruined Building

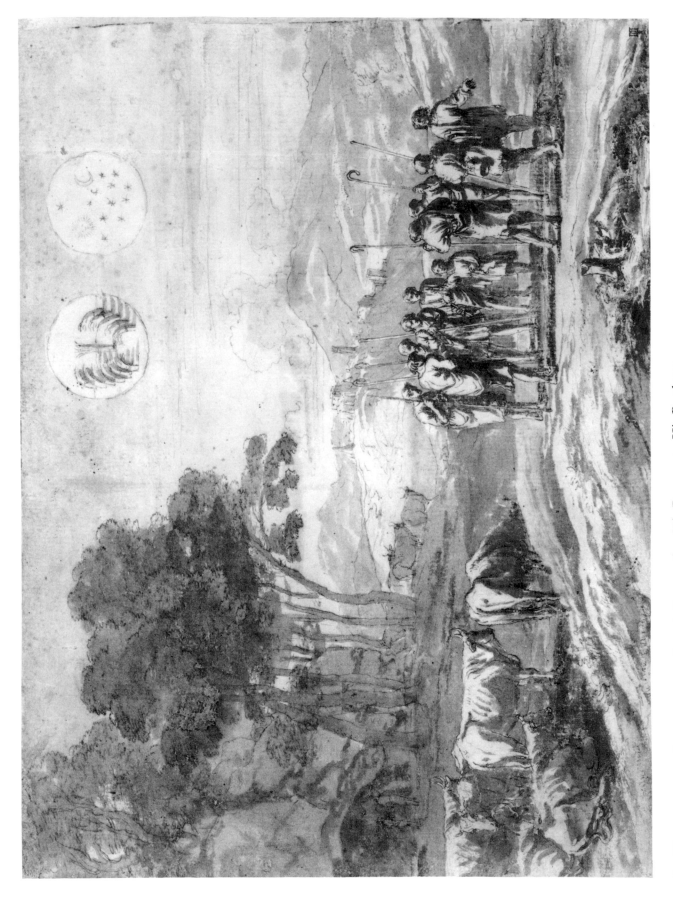

63. Herman van Swanevelt Joseph Recounting His Dreams to His Brethren

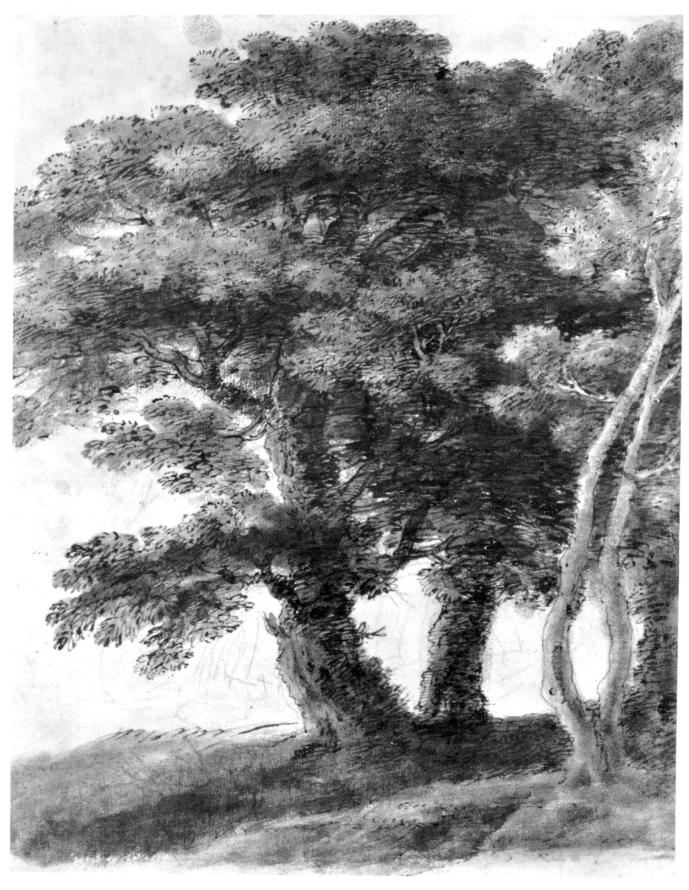

64. Herman van Swanevelt A Clump of Trees

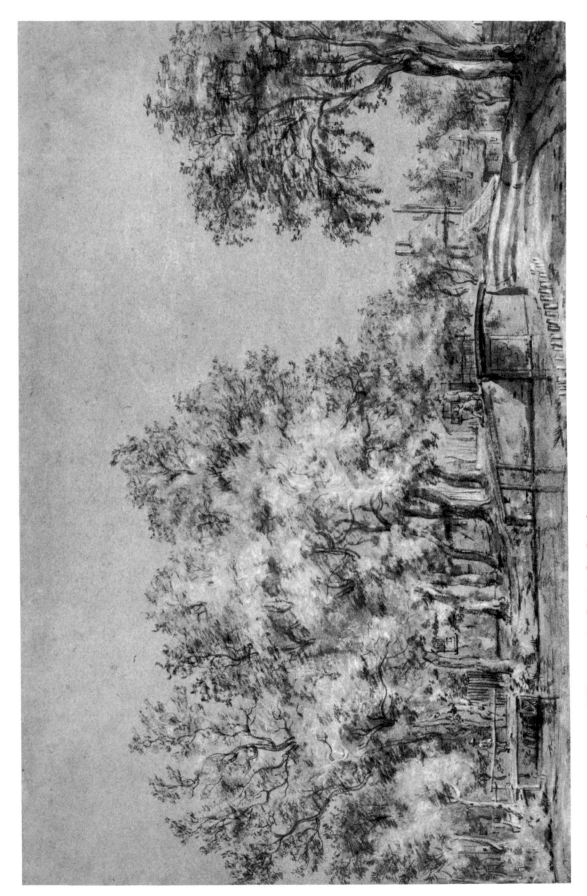

65. Simon de Vlieger Village on the Bank of a Canal

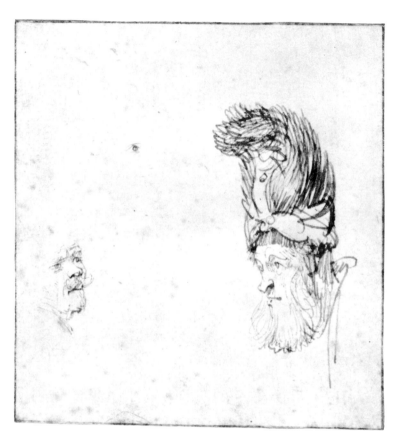

66. Rembrandt van Rijn
 Head of a Man in a High Fur Hat; Self-Portrait

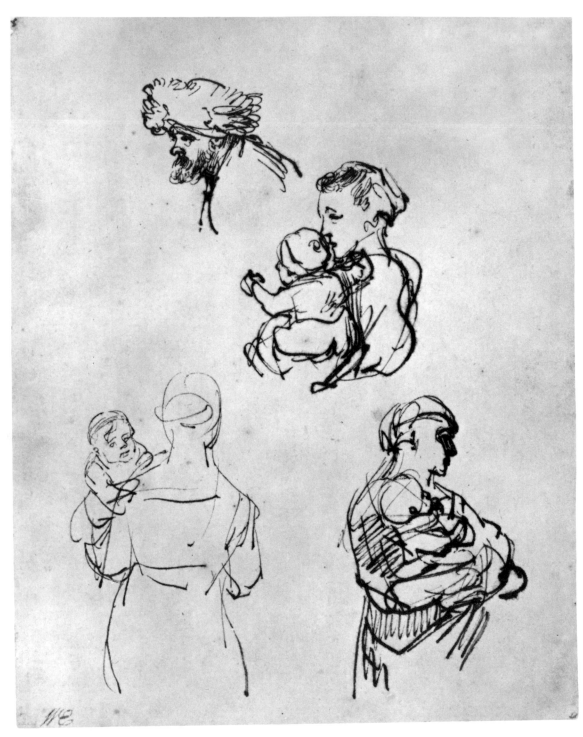

67. Rembrandt van Rijn Three Studies of Women, Each Holding a Child

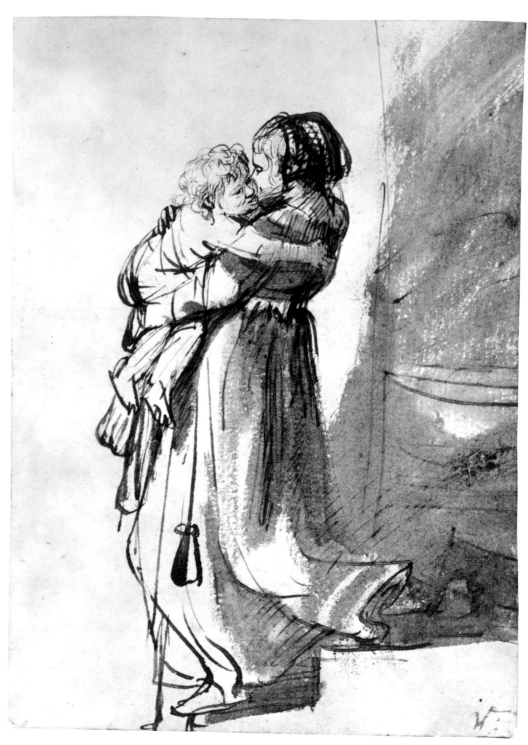

68. REMBRANDT VAN RIJN Woman Carrying a Child Downstairs

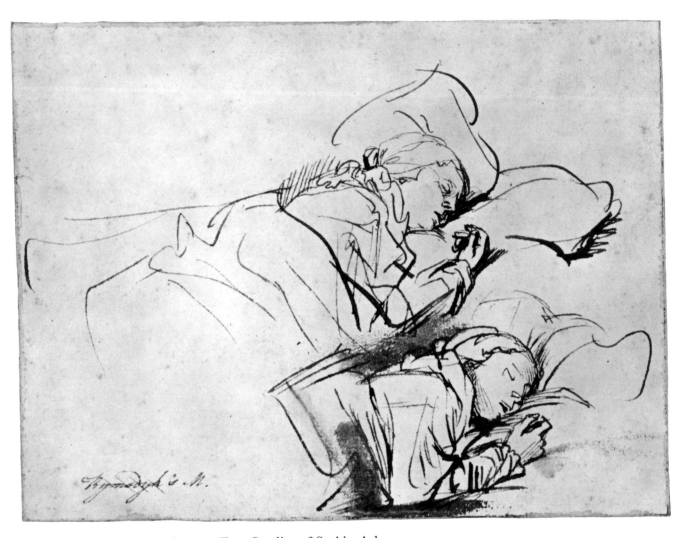

69. Rembrandt van Rijn Two Studies of Saskia Asleep

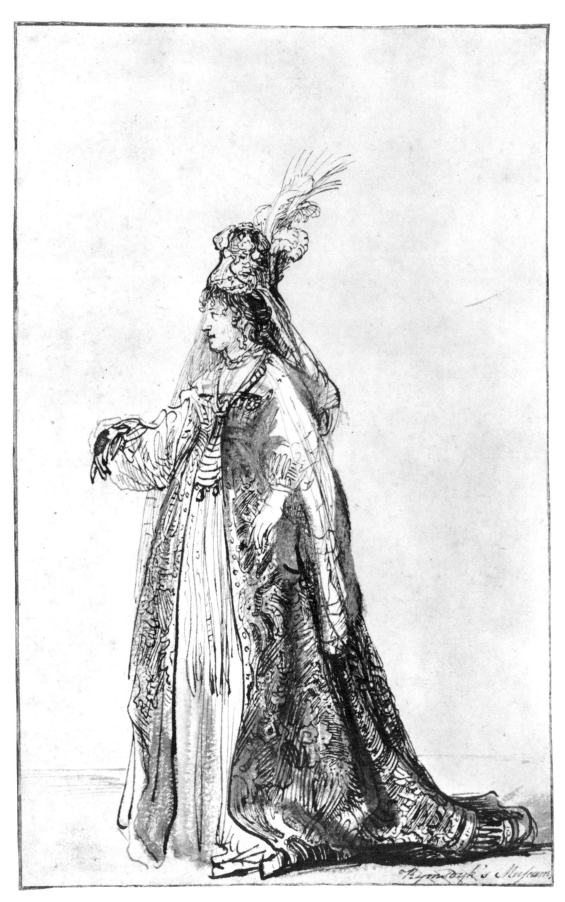

70. Rembrandt van Rijn Actor(?) in the Role of Badeloch

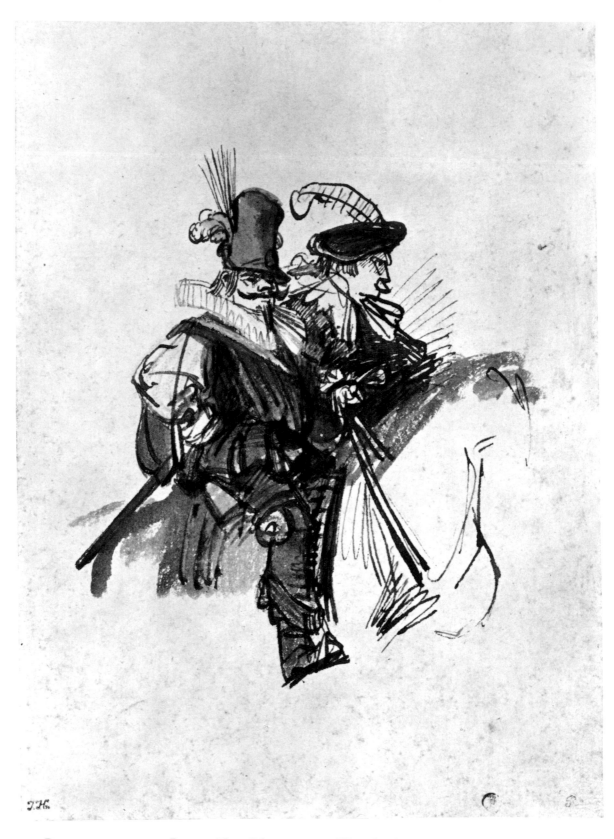

71. REMBRANDT VAN RIJN Two Mummers on Horseback

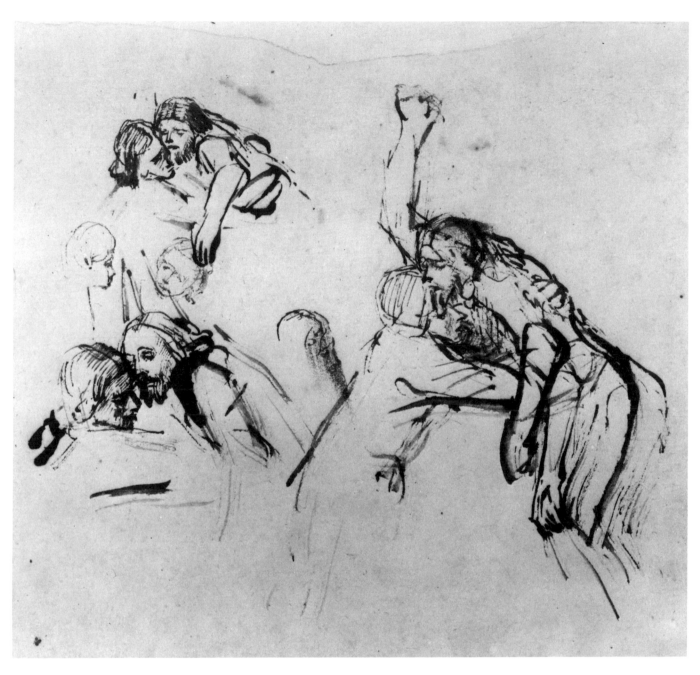

72. Rembrandt van Rijn Three Studies for a "Descent from the Cross"

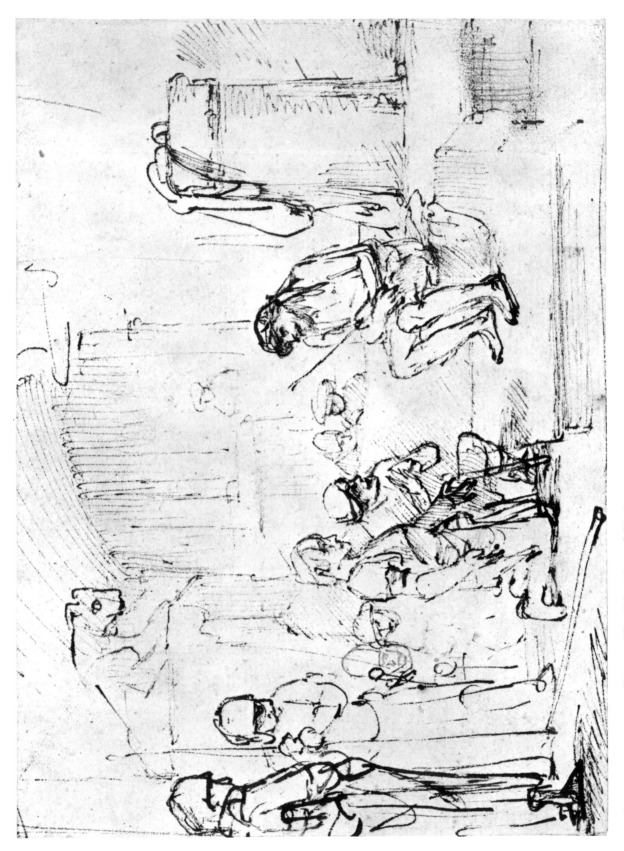

73. Rembrandt van Rijn The Mocking of Christ

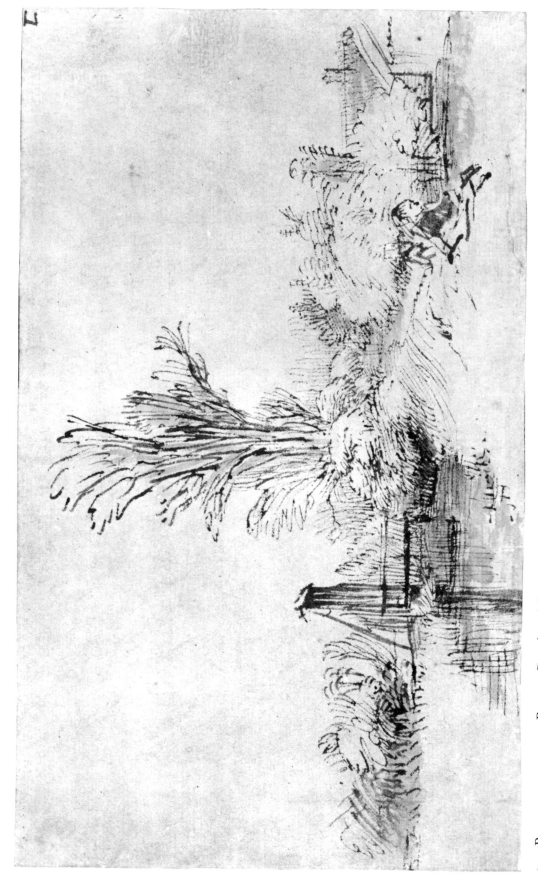

74. REMBRANDT VAN RIJN Canal and Bridge beside a Tall Tree

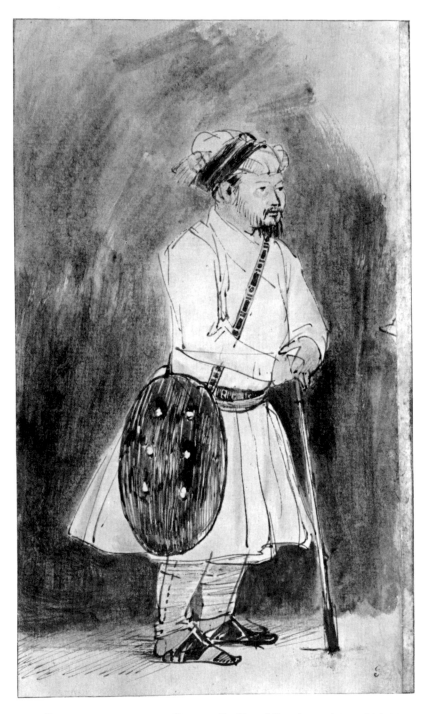

75. REMBRANDT VAN RIJN Indian Warrior with a Shield

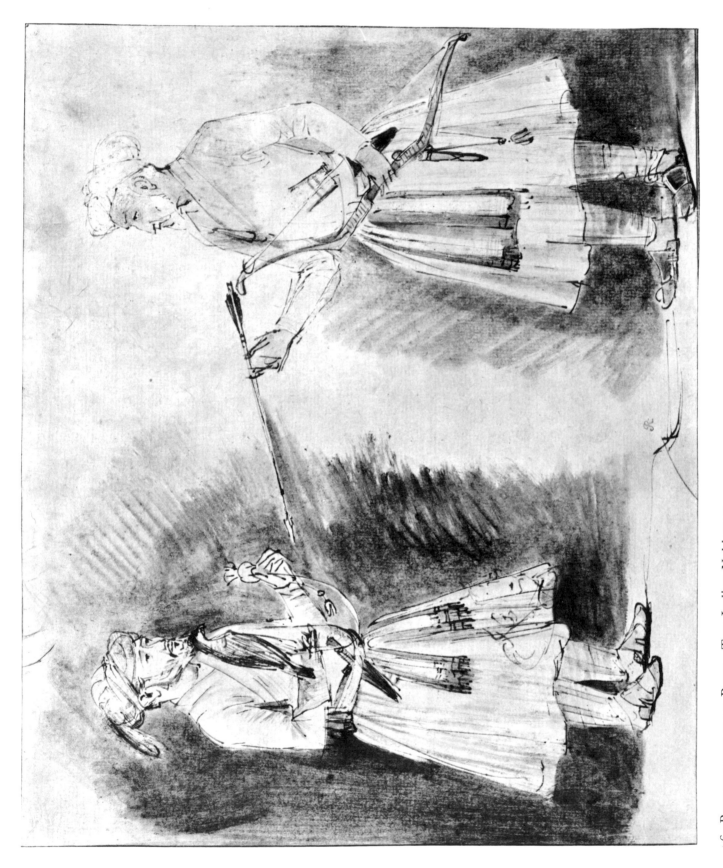

76. Rembrandt van Rijn Two Indian Noblemen

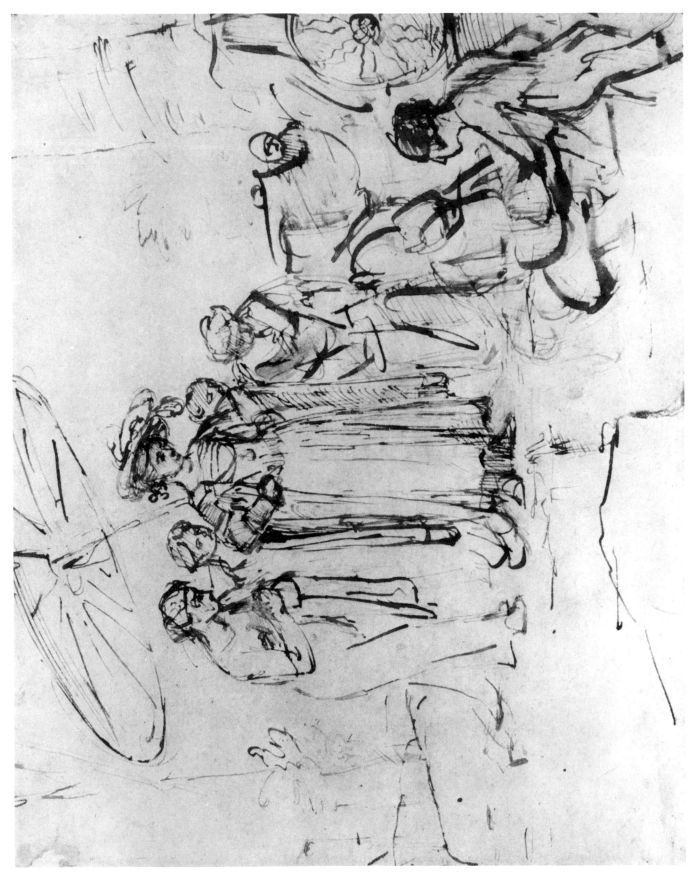

77. REMBRANDT VAN RIJN The Finding of Moses

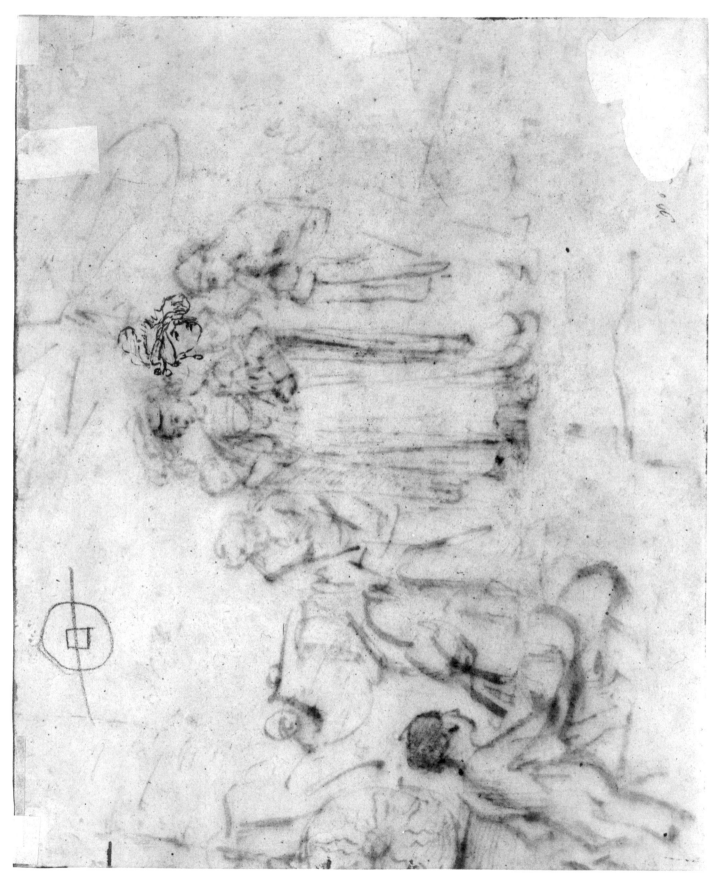

77 verso. Rembrandt van Rijn Head of a Woman in a Plumed Hat

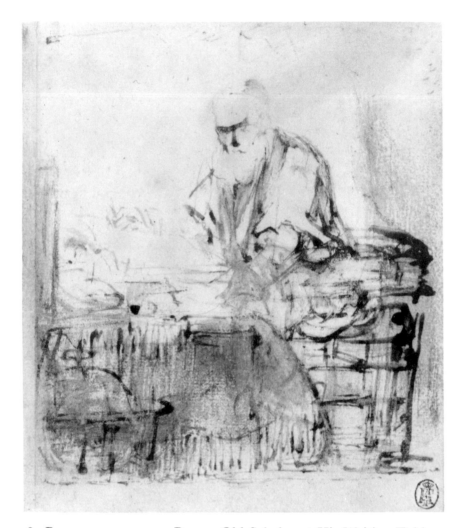

78. Rembrandt van Rijn　Old Scholar at His Writing Table

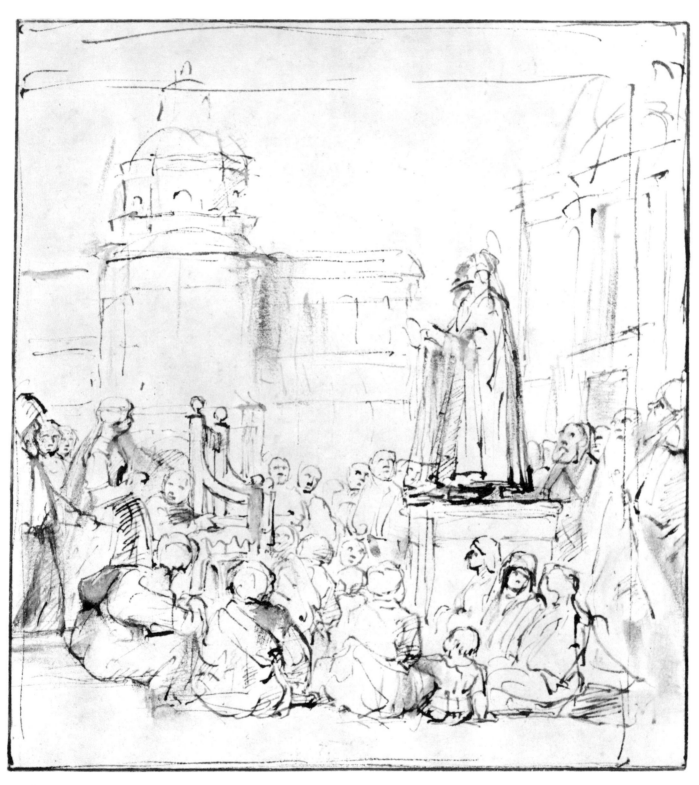

79. REMBRANDT PUPIL St. Mark Preaching

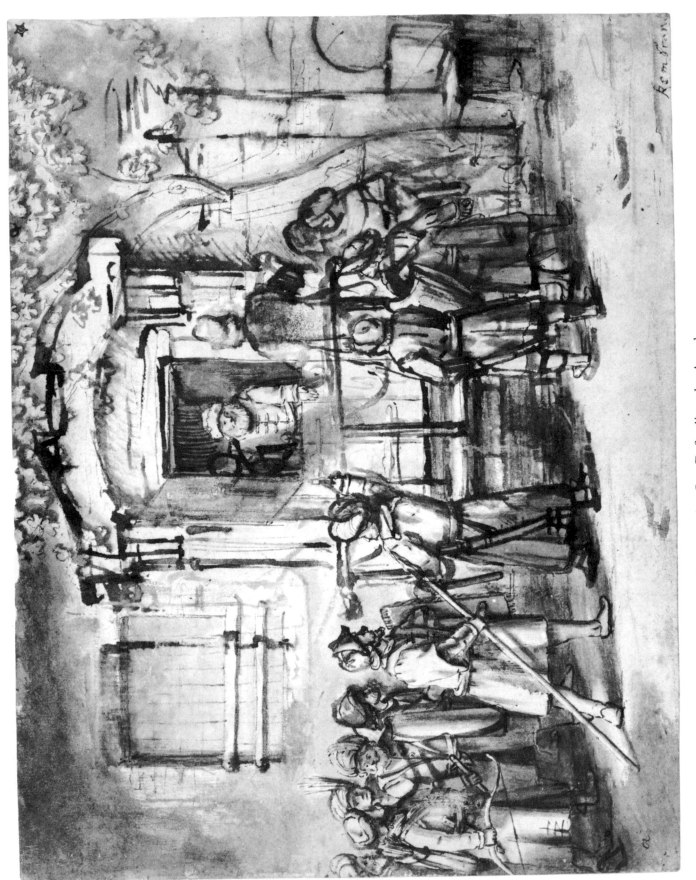

80. REMBRANDT PUPIL, with corrections by Rembrandt Lot Defending the Angels

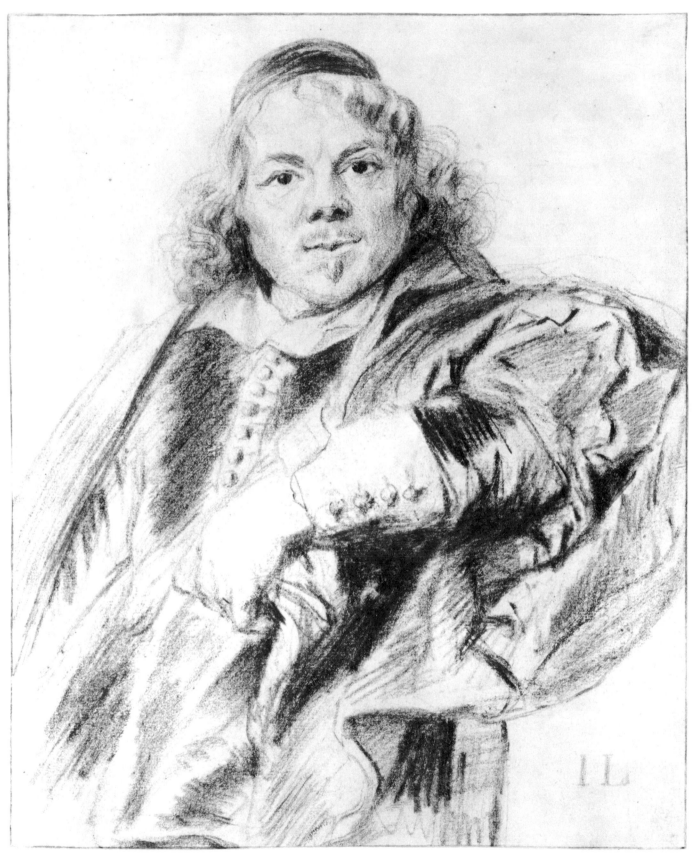

81. Jan Lievens the Elder Portrait of a Man

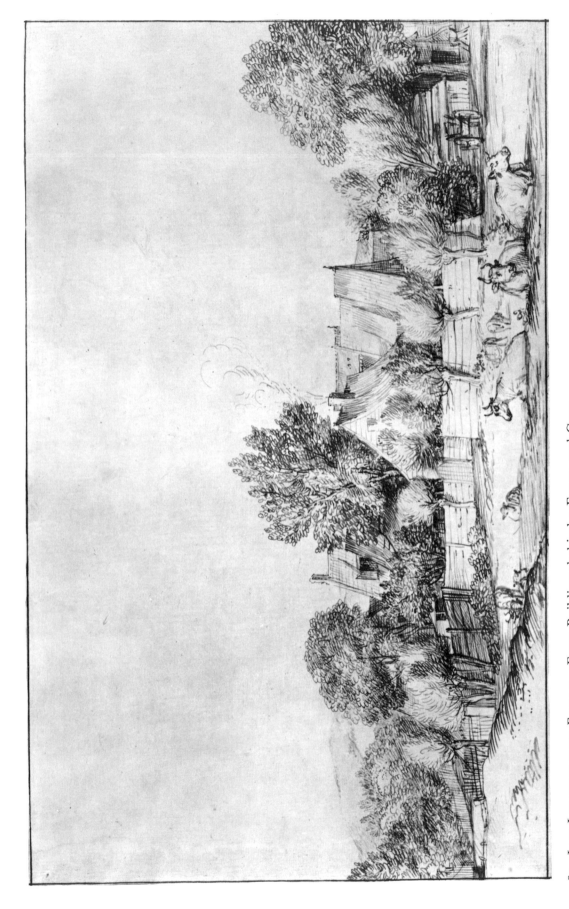

82. Jan Lievens the Elder Farm Buildings behind a Fence, and Cows

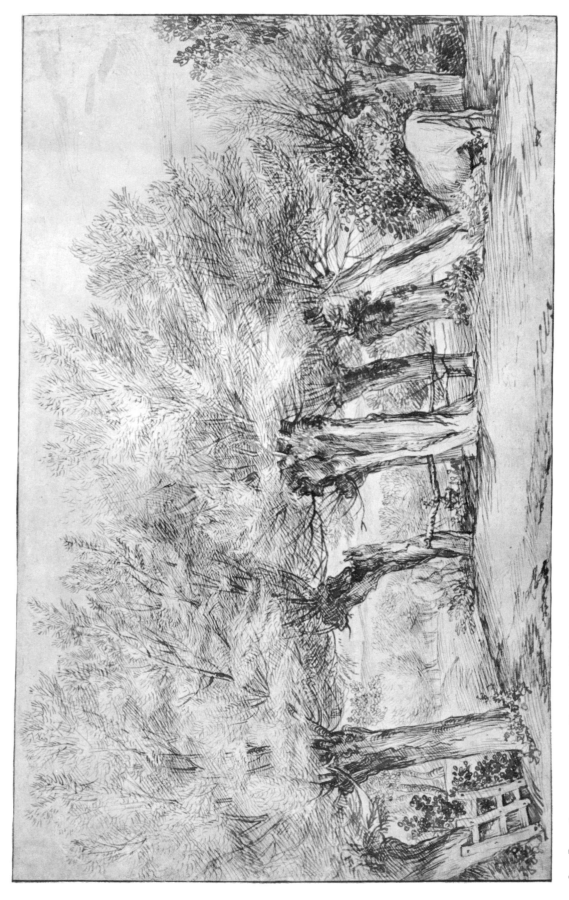

83. Jan Lievens the Elder Pollard Willows and Two Cows

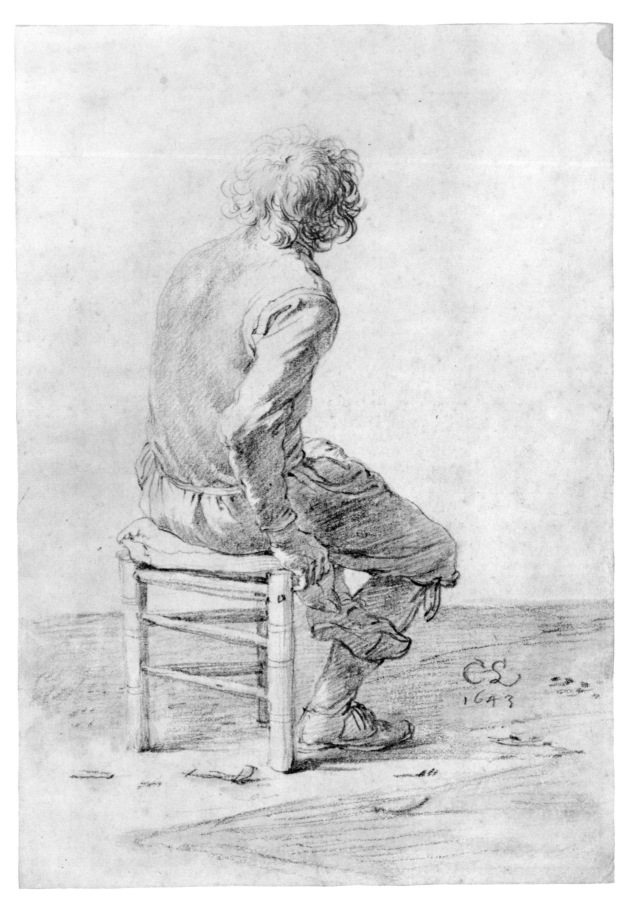

84. CORNELIS SAFTLEVEN Young Man Seated on a Stool

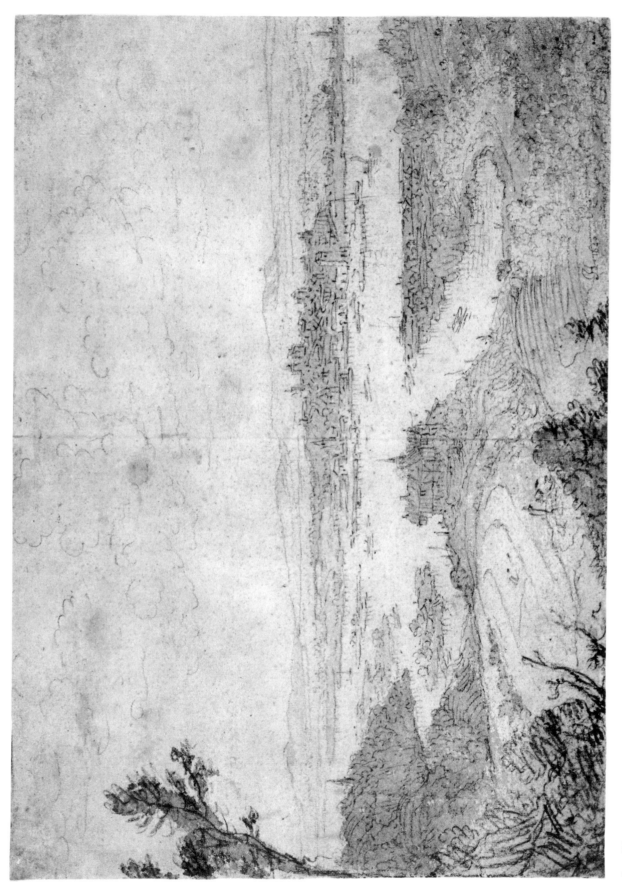

85. Herman Saftleven Distant View of a Town on a River

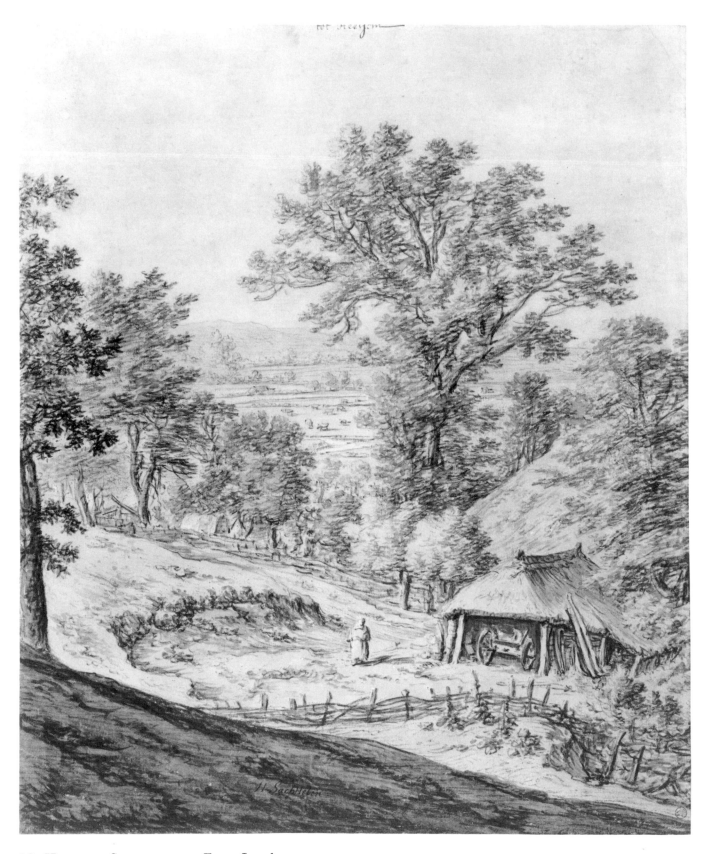

86. HERMAN SAFTLEVEN Farm Landscape

87. HERMAN SAFTLEVEN View in Montfoort

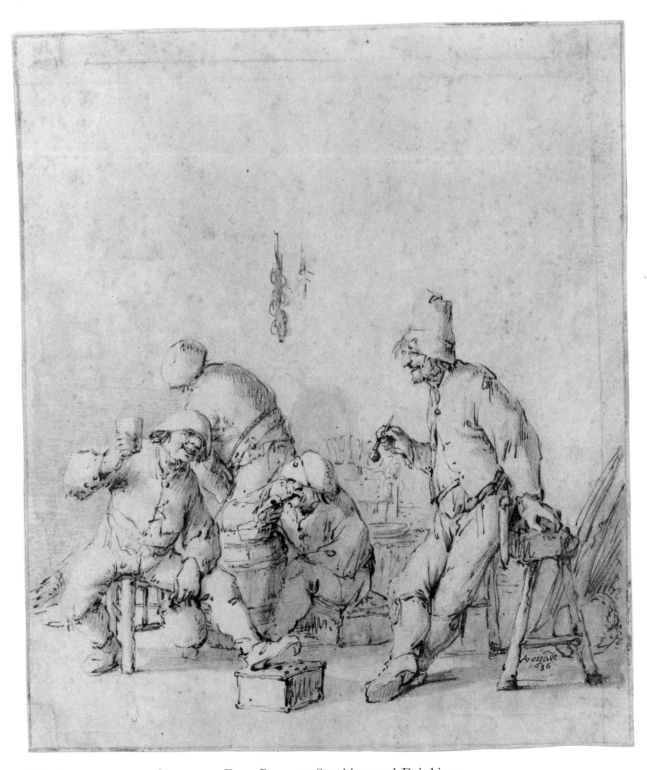

88. ADRIAEN VAN OSTADE Four Peasants Smoking and Drinking

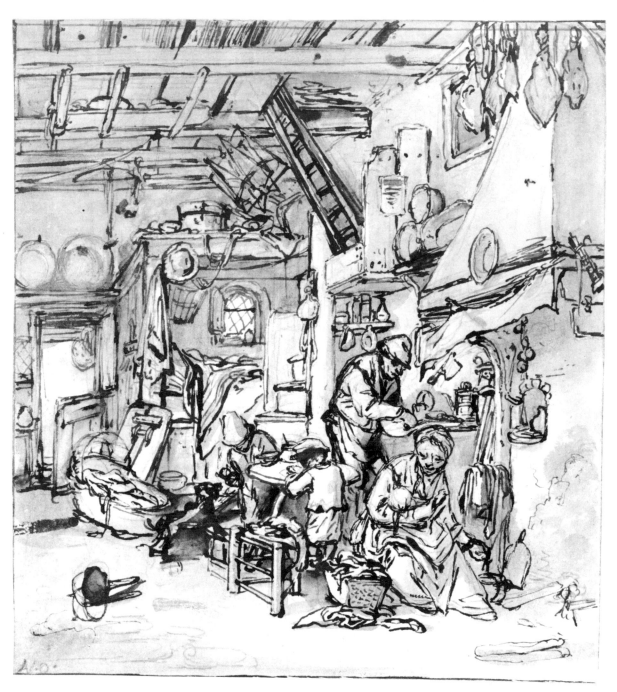

89. ADRIAEN VAN OSTADE The Family

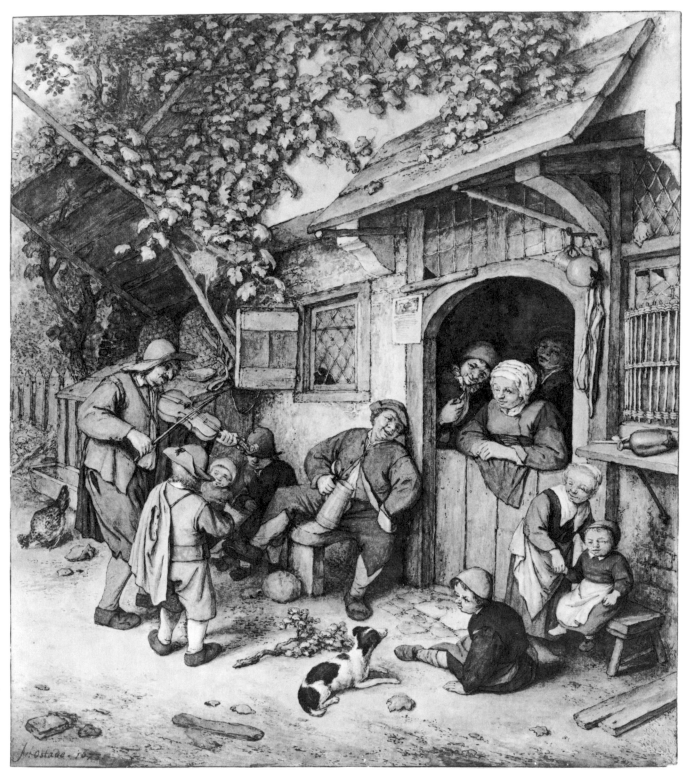

90. ADRIAEN VAN OSTADE Strolling Violinist at an Ale House Door

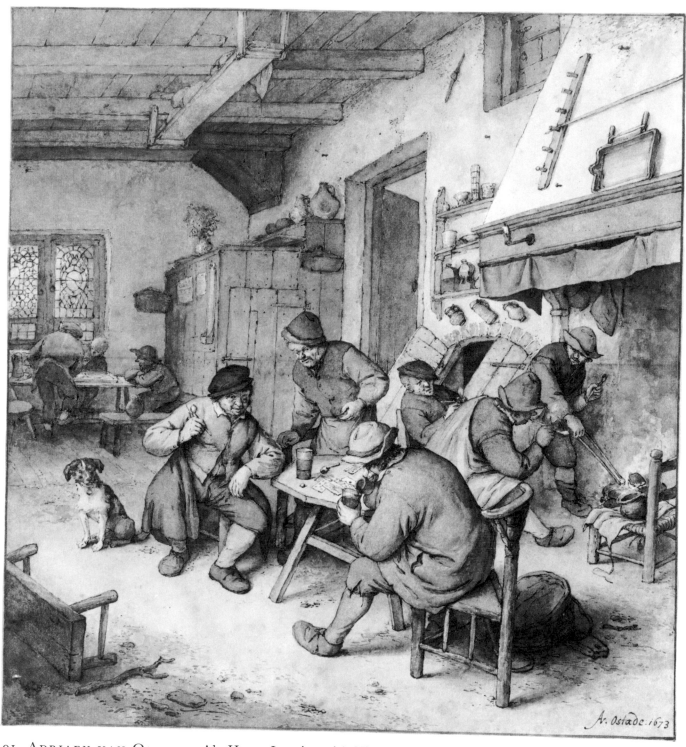

91. ADRIAEN VAN OSTADE Ale House Interior with Nine Peasants

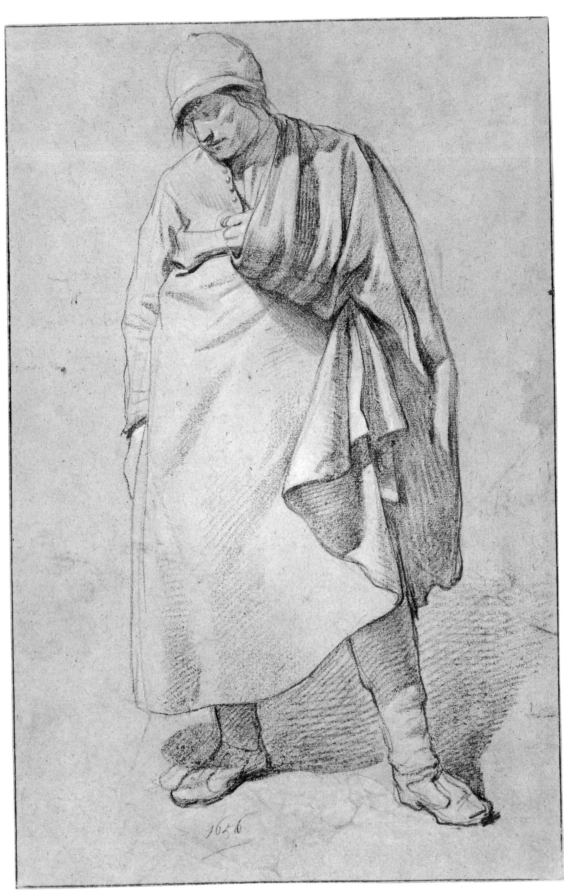

92. Leendert van der Cooghen Standing Man in a Cloak

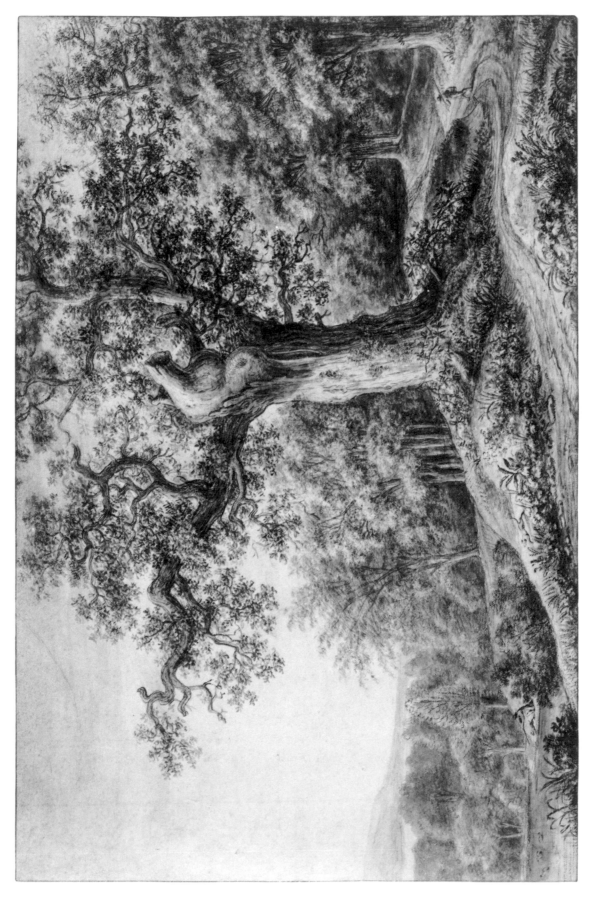

93. ANTHONIE WATERLOO Woodland Scene with a Duck Hunter

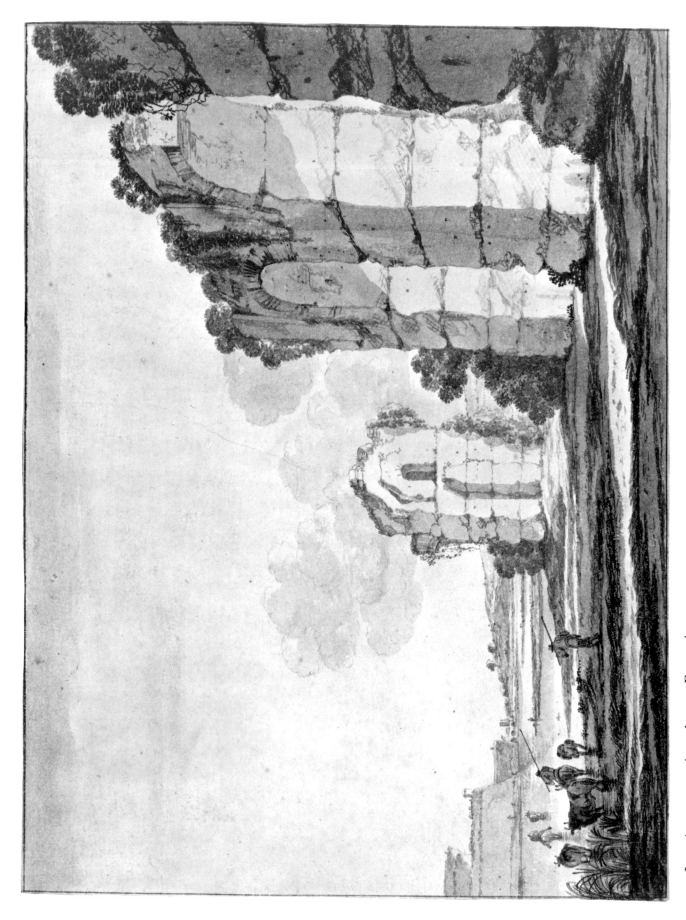

94. Jan Asselijn Aqueduct at Frascati

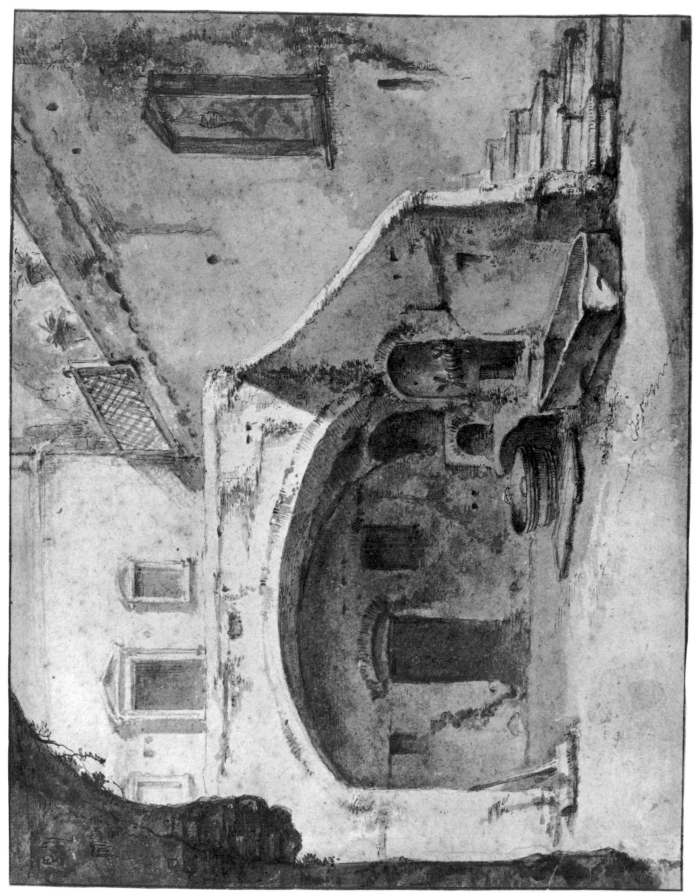

95. THOMAS WIJCK Italian Courtyard

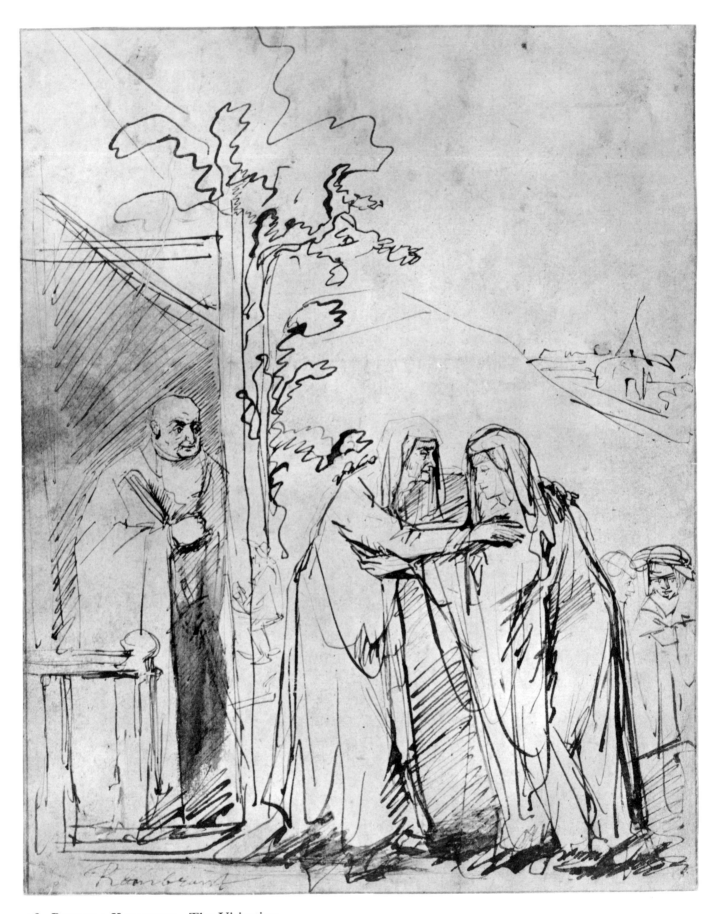

96. PHILIPS KONINCK The Visitation

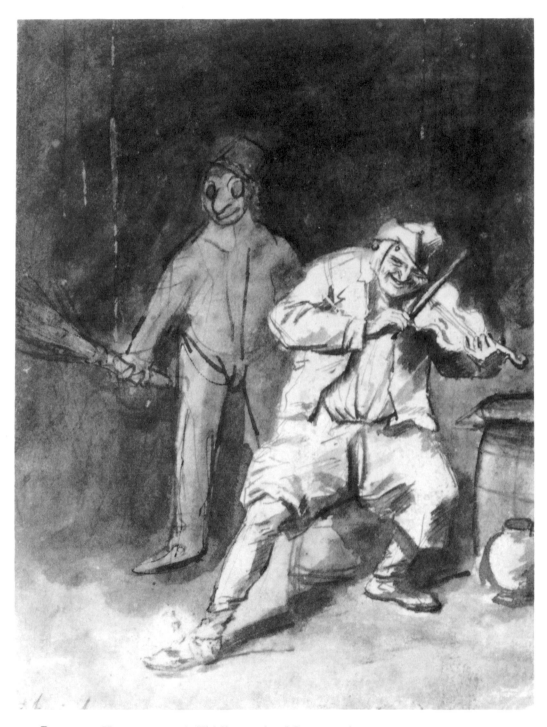

97. PHILIPS KONINCK A Fiddler and a Masquerader

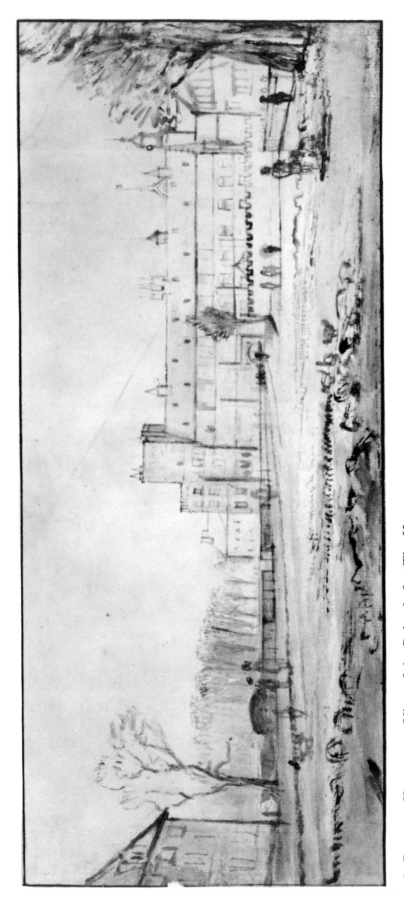

98. Philips Koninck View of the Buitenhof at The Hague

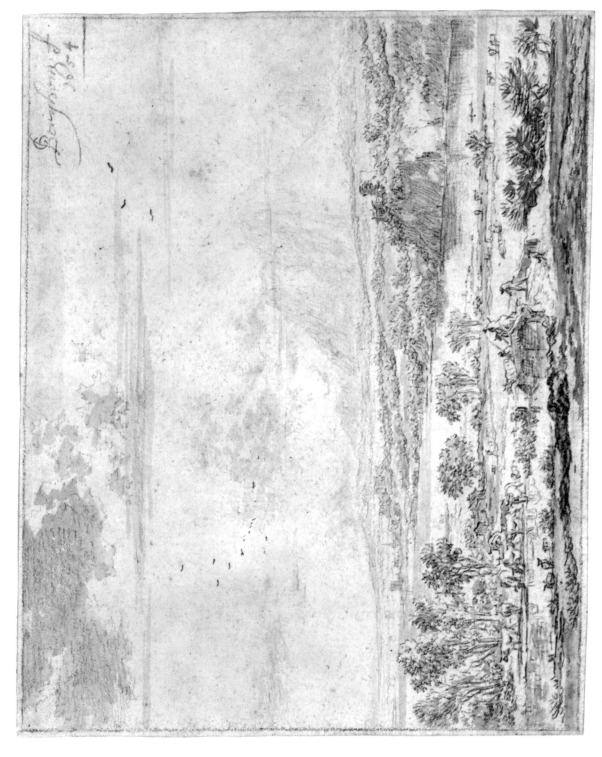

99. Nicolaes Berchem View of a River with Distant Mountains

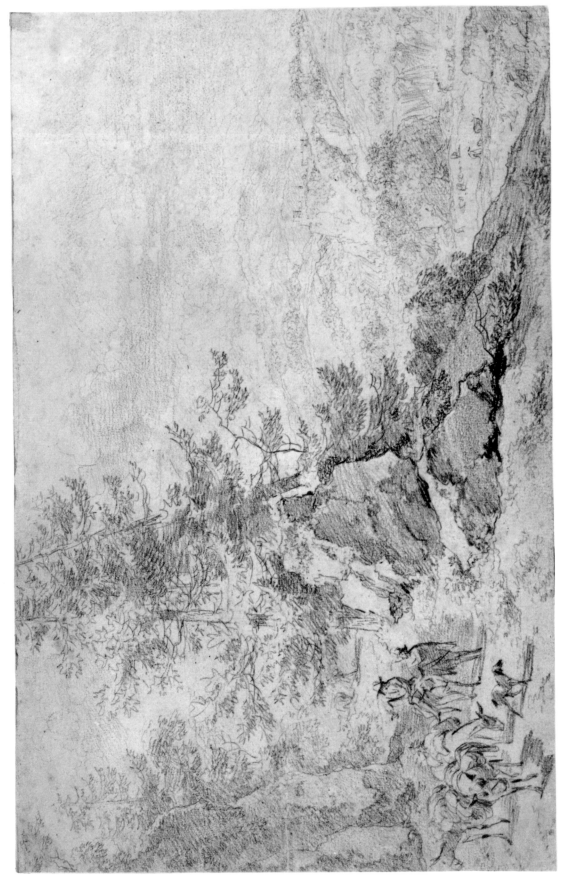

100. NICOLAES BERCHEM Pack Mules Descending a Mountain Road

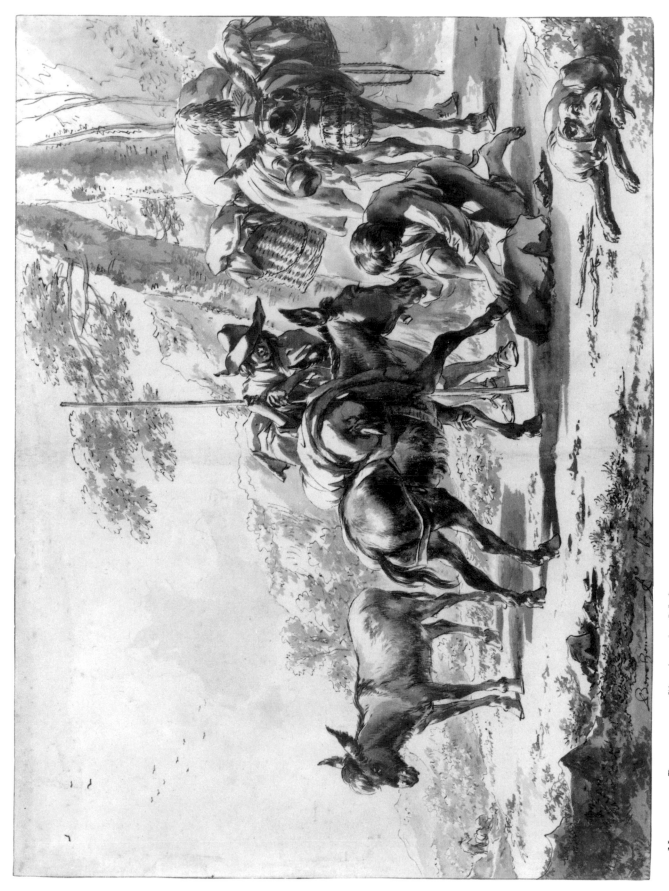

101. NICOLAES BERCHEM Shoeing the Mule

102. NICOLAES BERCHEM Landscape with Tobias and the Angel

103. Nicolaes Berchem(?) The Ruined Castle of Brederode

104. AELBERT CUYP Landscape with a Watermill

105. AELBERT CUYP Study of Cows and Milk Cans

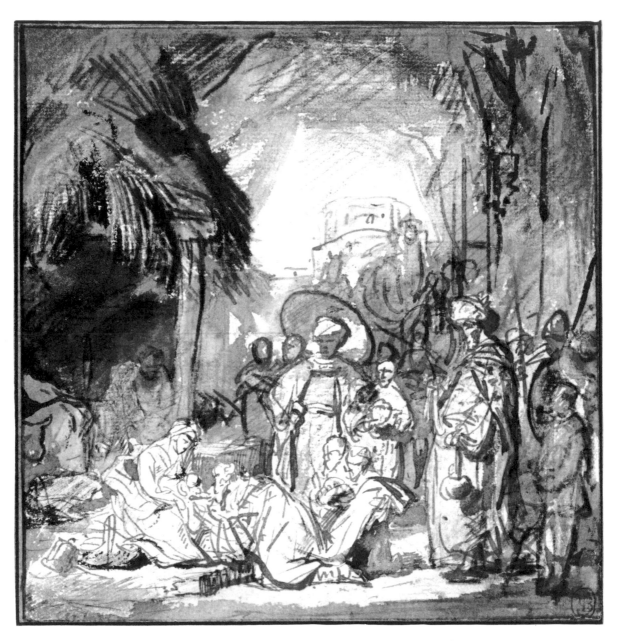

106. GERBRAND VAN DEN EECKHOUT The Adoration of the Magi

107. ALLAERT VAN EVERDINGEN Farm Landscape with Sheep

108. Isaac van Ostade Eight Boors Drinking

109. KAREL DUJARDIN Study of a Long-Haired Young Man

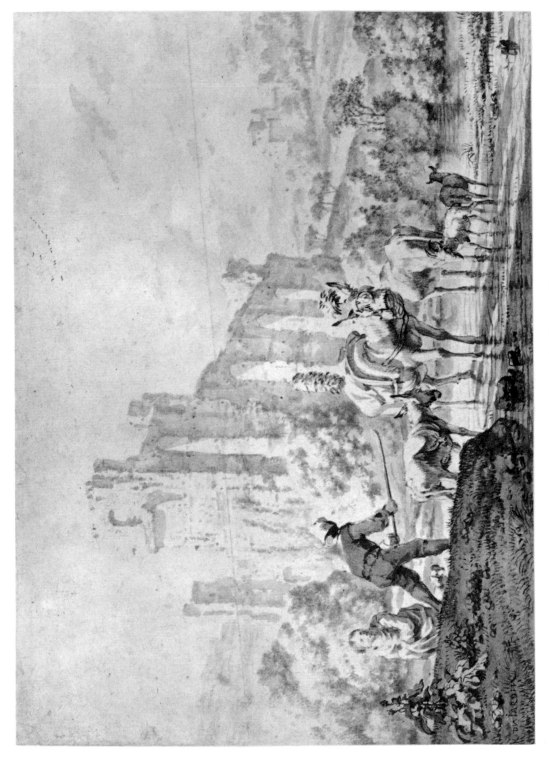

110. KAREL DUJARDIN Muleteer and Shepherdess with Animals at a Stream

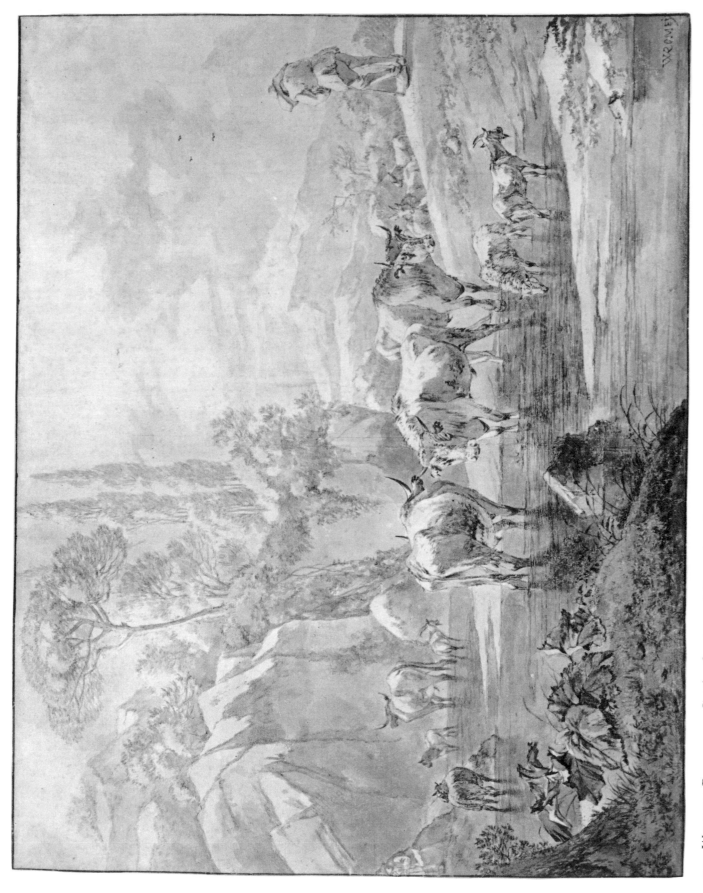

111. WILLEM ROMEIJN Cattle, Goats, and Sheep in a Stream

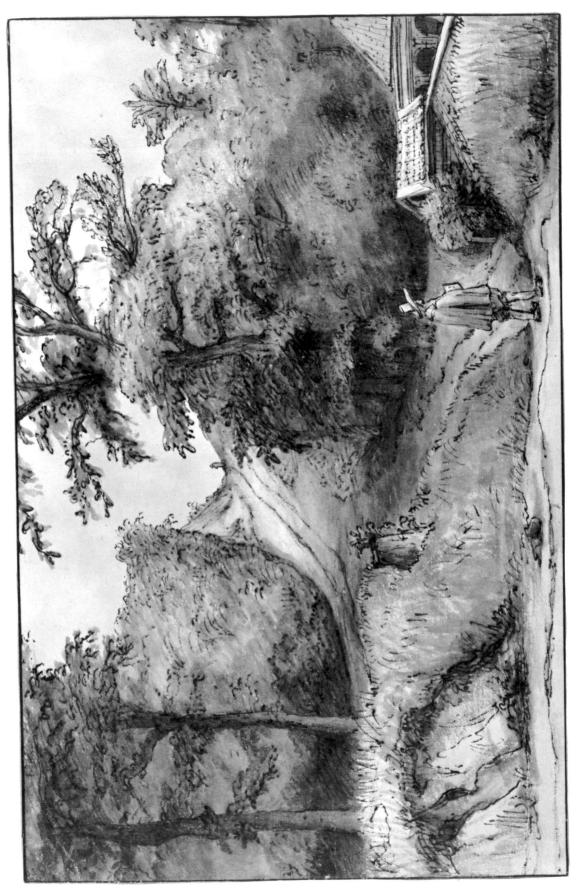

112. LAMBERT DOOMER The Spring at Cleves

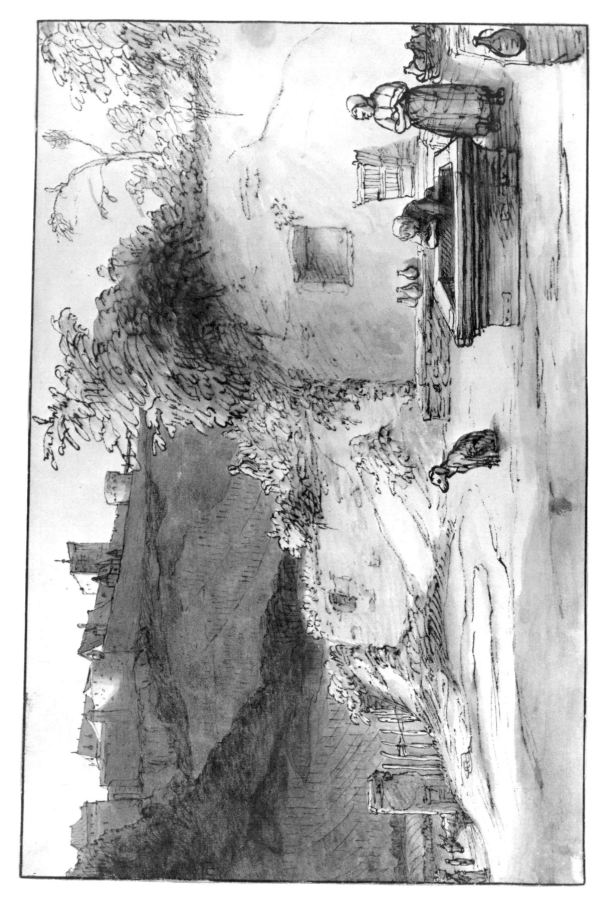

113. LAMBERT DOOMER Well and Fortress at Ehrenbreitstein

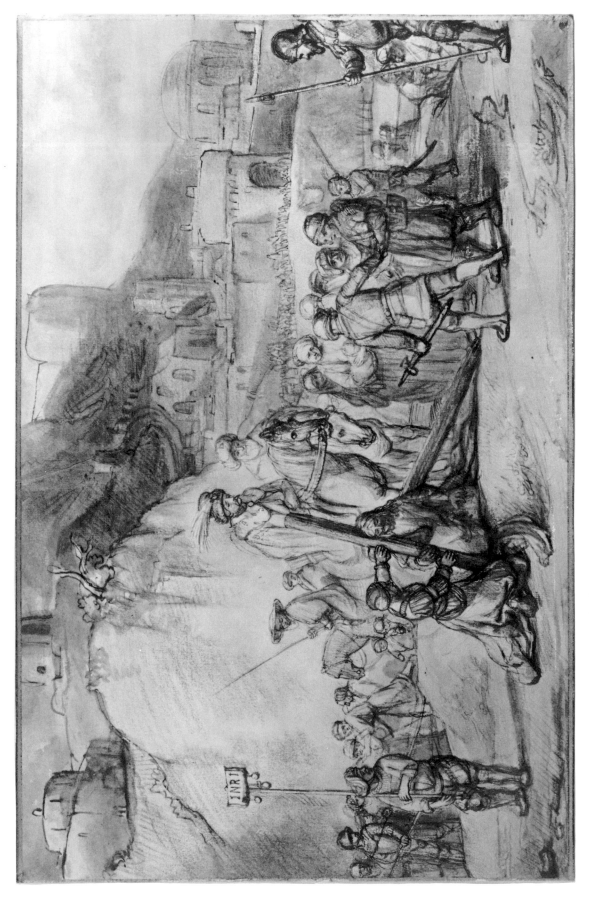

114. SAMUEL VAN HOOGSTRATEN Christ Sinking beneath the Cross

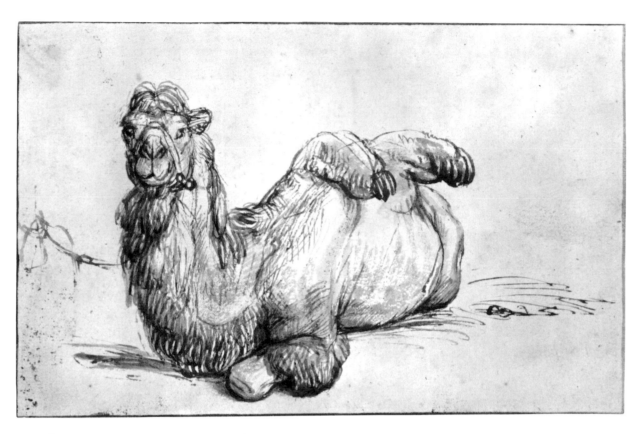

115. SAMUEL VAN HOOGSTRATEN, attributed to Camel Seen from the Front

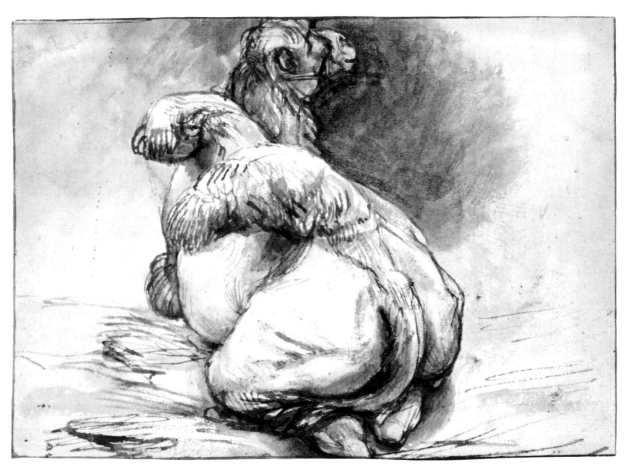

116. SAMUEL VAN HOOGSTRATEN, attributed to Camel Seen from the Rear

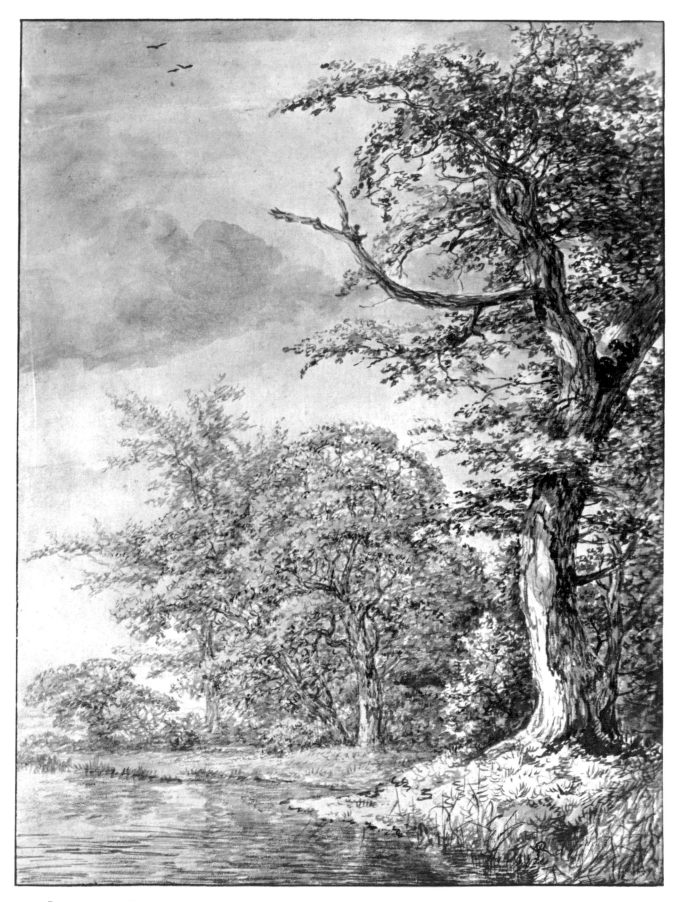

117. Jacob van Ruisdael Sun-Dappled Trees on a Stream

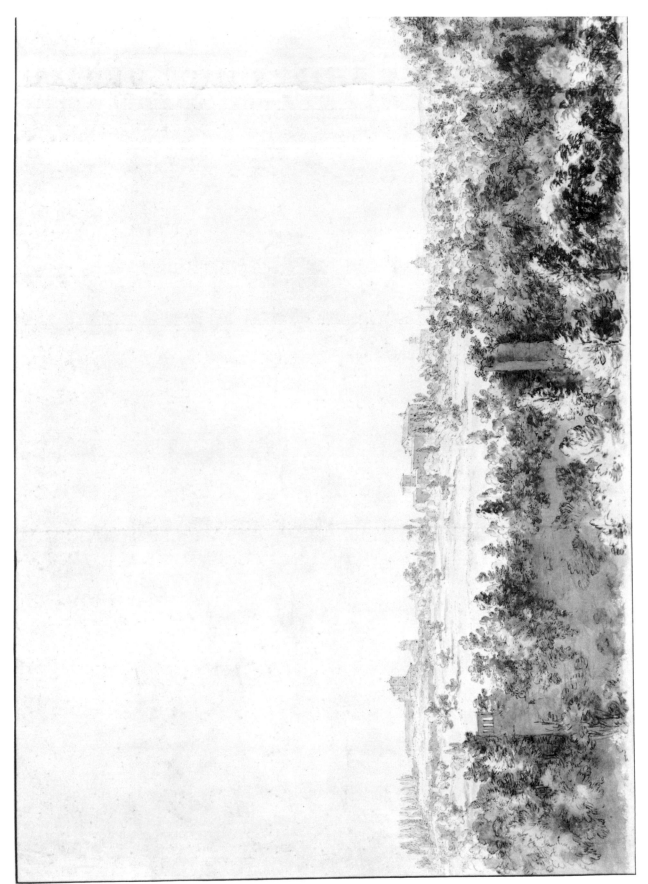

118. Jan de Bisschop View of Rome (1)

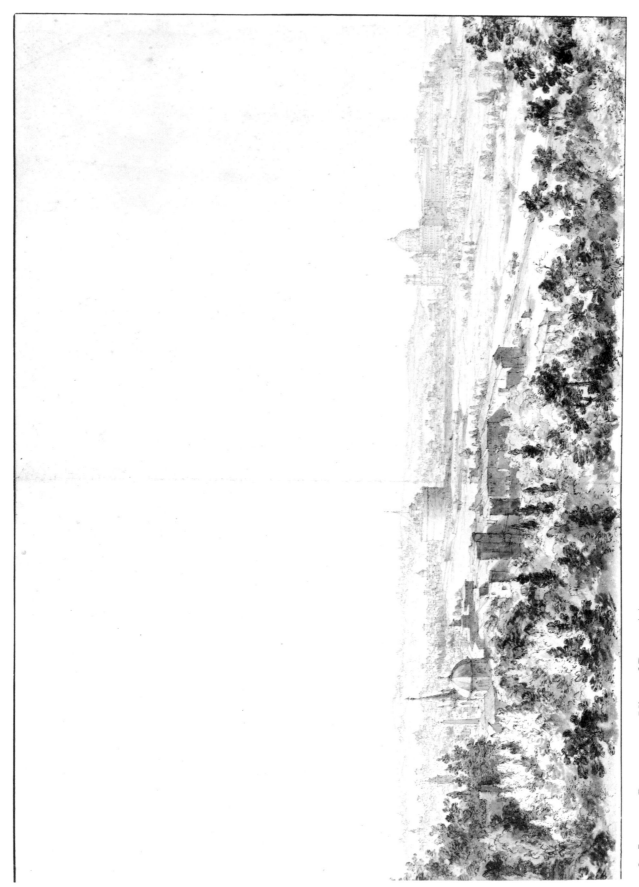

118. Jan de Bisschop View of Rome (2)

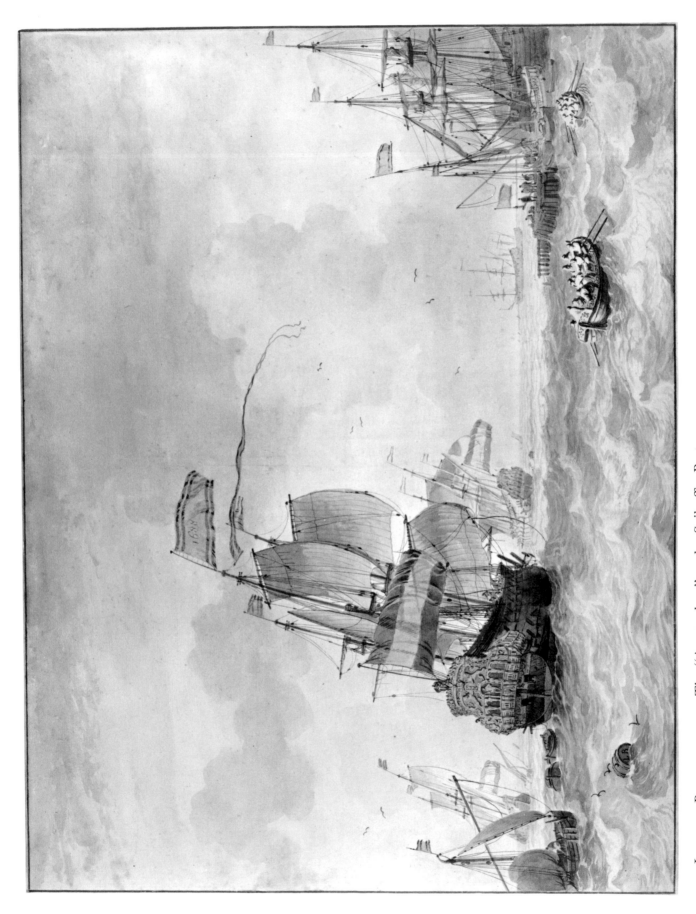

119. LUDOLF BACKHUYZEN The "Amsterdam" under Sail off a Port

120. WILLEM VAN DE VELDE THE YOUNGER Ships in a Heavy Sea

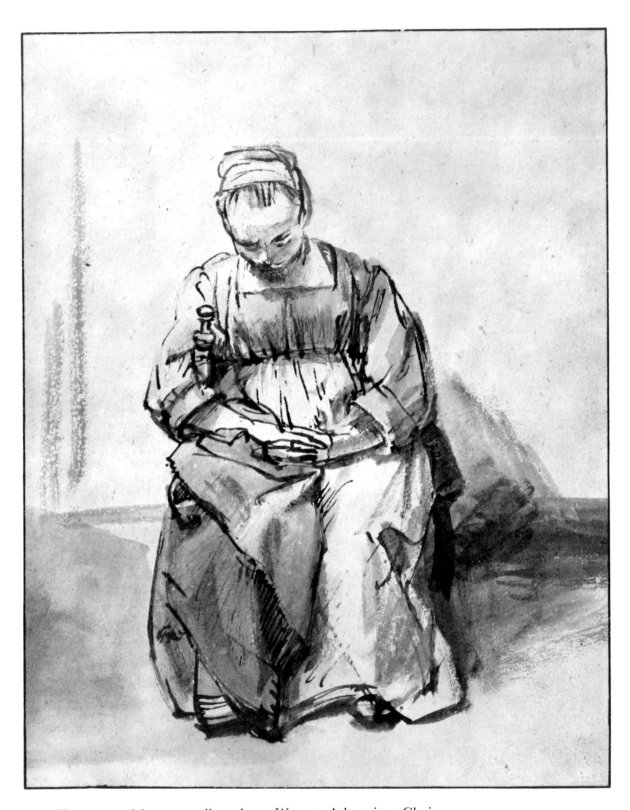

121. NICOLAES MAES, attributed to Woman Asleep in a Chair

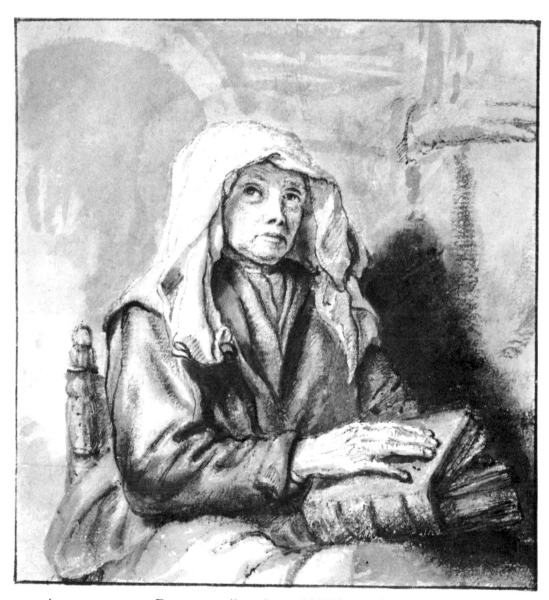

122. ABRAHAM VAN DYCK, attributed to Old Woman Seated, Holding a Book

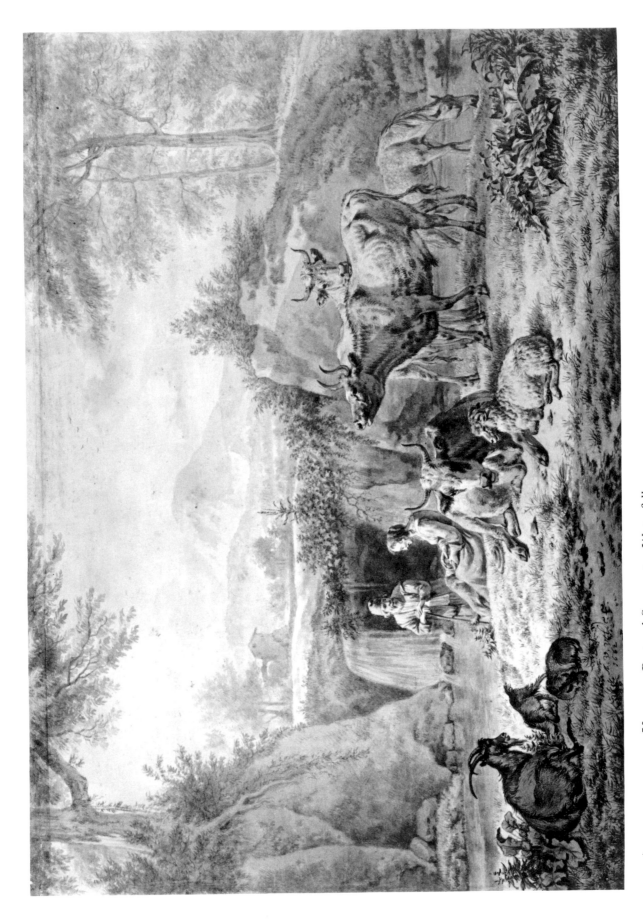

123. ADRIAEN VAN DE VELDE Pastoral Scene at a Waterfall

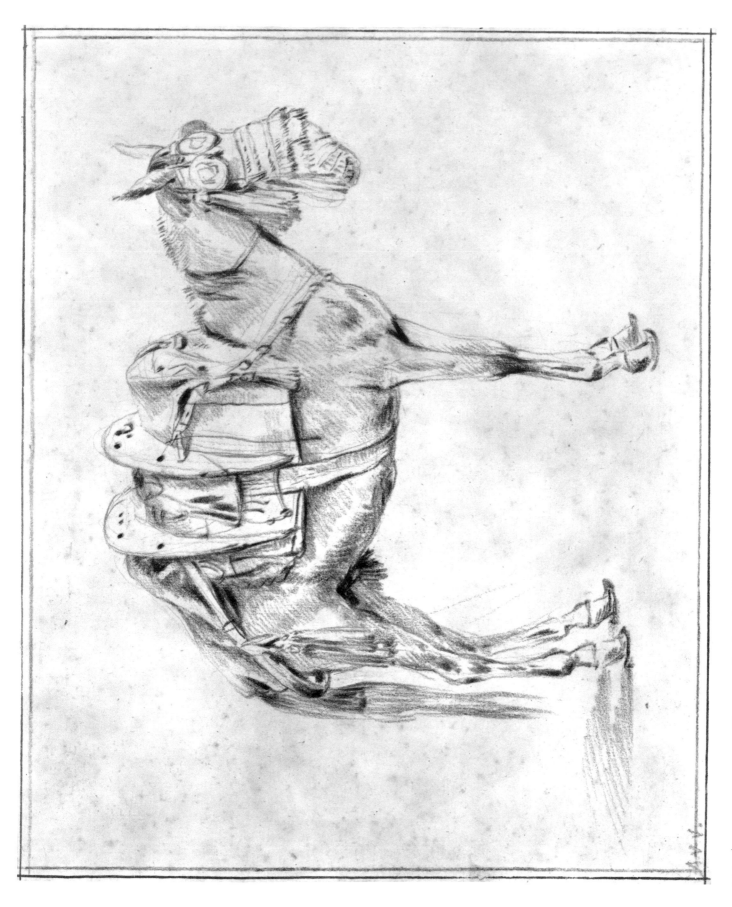

124. Adriaen van de Velde Study of a Mule

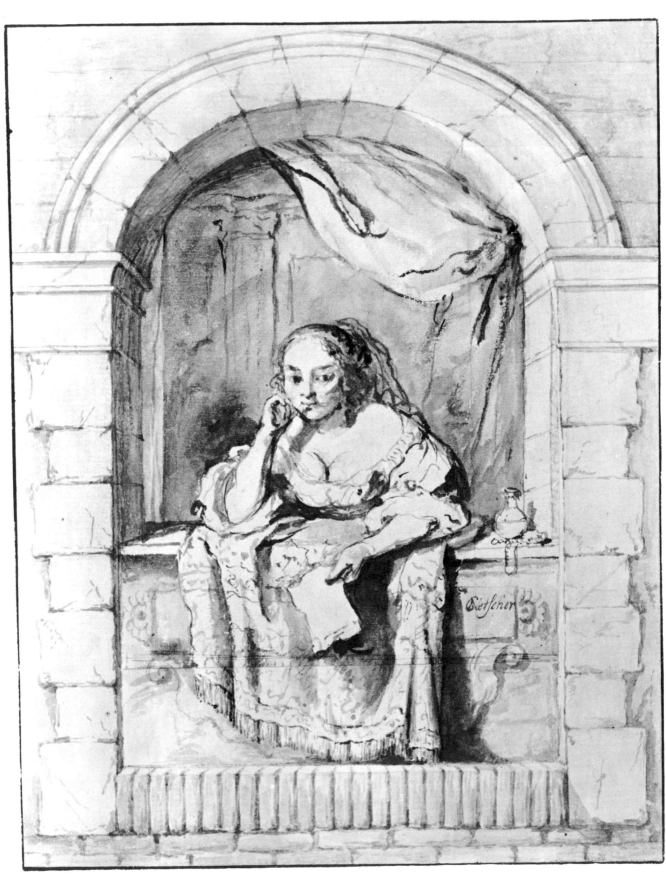

125. CASPAR NETSCHER Woman at a Window

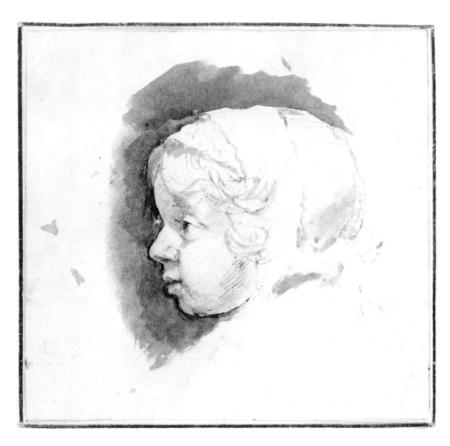

126. CASPAR NETSCHER
Portrait of the Artist's Daughter Isabella

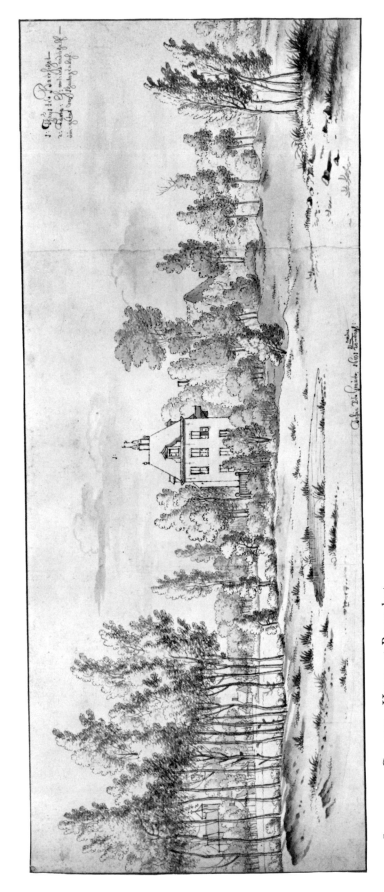

127. Josua de Grave House at Baerschot

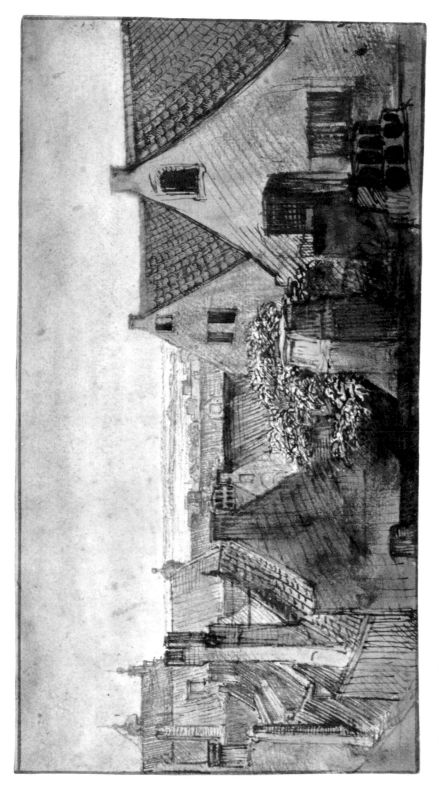

128. Johannes Leupenius, attributed to View of the Sea over Rooftops

129 verso. CASPAR VAN WITTEL View of the Environs of Urbino

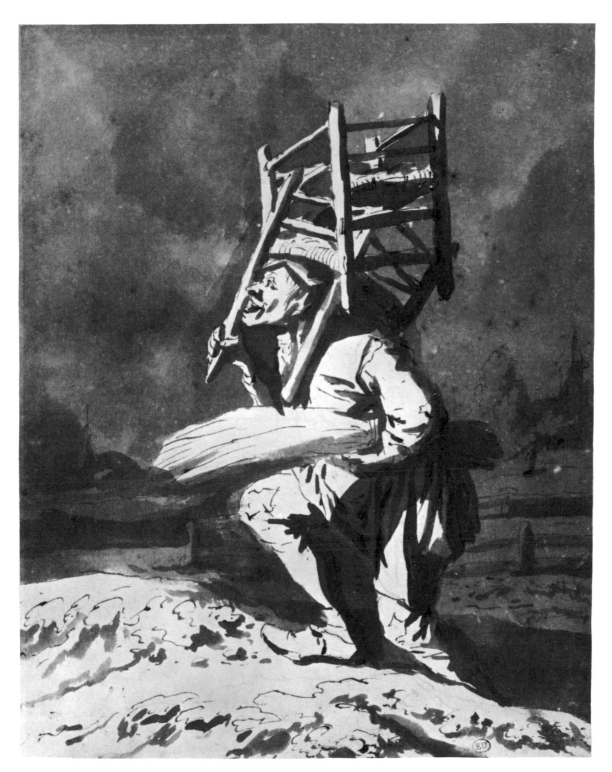

130. CORNELIS DUSART The Chairmender

INDEX OF ARTISTS

INDEX OF FORMER OWNERS

Names between quotation marks are those of buyers at sales

297

WATERMARKS

1. H. VAN SWANEVELT (No. 63)

2. REMBRANDT (No. 67)

PR

3. L. BACKHUYZEN (No. 119)

4. A. VAN OSTADE (No. 91)

5. J. DE GRAVE (No. 127)

6. T. WIJCK (No. 95)

7. J. DE GHEYN II (No. 45)

8. L. TOEPUT (No. 1)

9. S. VAN HOOGSTRATEN (No. 115)

10. REMBRANDT PUPIL (No. 79)

11. H. HONDIUS (No. 6)

12. A. BLOEMAERT (No. 43)

13. P. P. RUBENS (No. 11) 14. W. BUYTEWECH (No. 52)

15. C. J. VISSCHER (No. 47)

16. D. VINCKBOONS (No. 7)

17. C. VAN WITTEL (No. 129)

18. J. PYNAS (No. 51)

19. REMBRANDT (No. 77)

20. S. DE BRAY (No. 61)

21. A. VAN OSTADE (No. 90)

22. H. SAFTLEVEN (No. 85)

23. A. VAN OSTADE (No. 88)

24. A. CUYP (No. 104)

25. REMBRANDT (No. 69)

26. J. DE GHEYN III (No. 60)

27. P. MOLIJN (No. 54)

28. H. SAFTLEVEN (No. 86)

29. J. DE BISSCHOP (No. 118)

30. P. MOLIJN (No. 55)

31. N. BERCHEM (No. 99)

32. REMBRANDT PUPIL (No. 80)

33. J. LIEVENS (No. 81)

34. D. TENIERS (No. 35) 35. A. VAN DE VELDE (No. 124)

36. N. BERCHEM (No. 101) 37. P. KONINCK (No. 96)

38. H. SAFTLEVEN (No. 87)

39. J. ASSELIJN (No. 94)

40. FLEMISH SCHOOL (No. 19)

41. F. SNIJDERS (No. 20)

42. J. WILDENS (No. 21)

43. K. DUJARDIN (No. 110)

44. A. VAN DE VELDE (No. 123)

45. A. VAN DYCK (No. 31)

46. A. VAN EVERDINGEN (No. 107)

47. K. DUJARDIN (No. 109)

LR

48. J. VAN GOYEN (No. 58)

I R

49. J. VAN GOYEN (No. 59)

50. N. BERCHEM (No. 102)

51. H. GOLTZIUS (No. 37)

52. P. P. RUBENS (No. 12)

53. P. P. RUBENS (No. 15)

54. A. VAN DYCK (No. 28)

55. P. KONINCK (No. 98)

56. J. BRUEGHEL (No. 4)

57. REMBRANDT (No. 78)

Design, composition, and letterpress printing by The Stinehour Press
Halftone photography and offset printing by The Meriden Gravure Company